SCOTLAND
FROM THE SKY

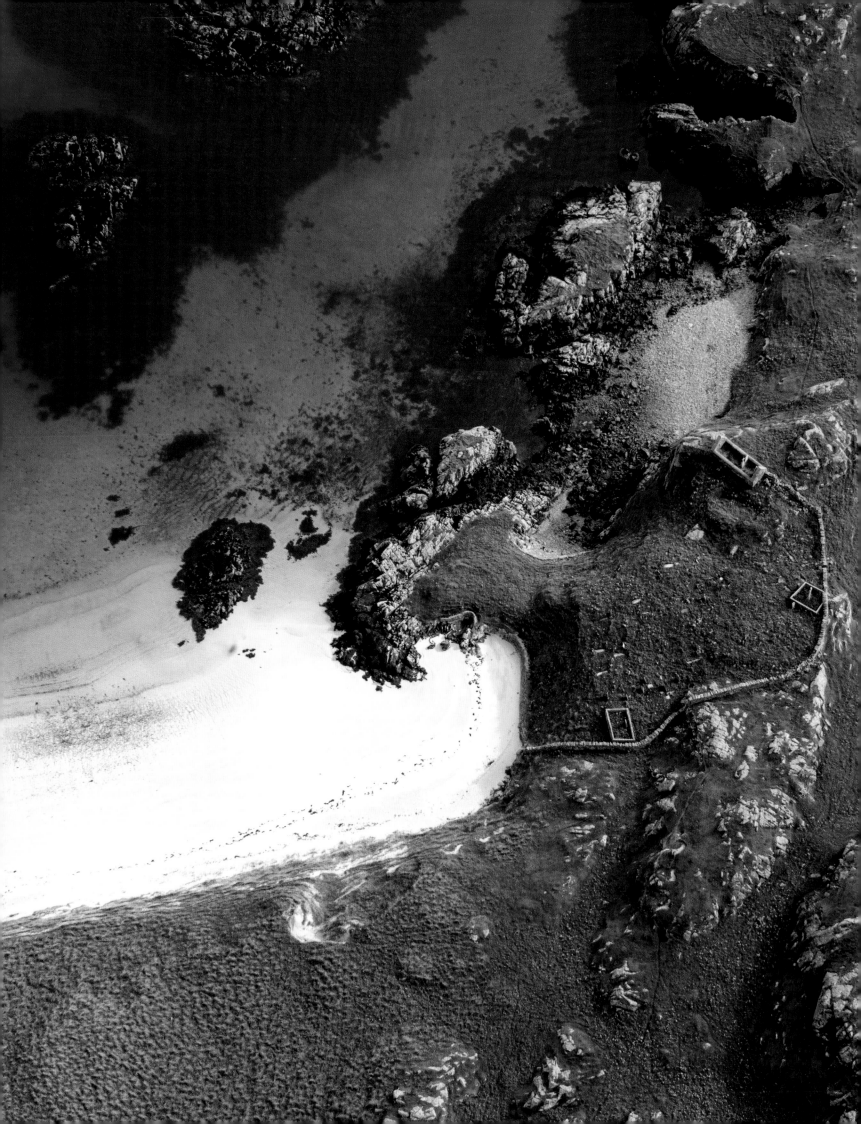

JAMES CRAWFORD

SCOTLAND FROM THE SKY

HISTORIC
ENVIRONMENT
SCOTLAND

ÀRAINNEACHD
EACHDRAIDHEIL
ALBA

Published in 2018 by Historic Environment Scotland
Enterprises Limited SC510997

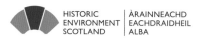

Historic Environment Scotland
Longmore House
Salisbury Place
Edinburgh EH9 1SH

Registered Charity SC045925

British Library Cataloguing-in-Publication Data. A catalogue record for this
book is available from the British Library.

ISBN 978 1 84917 252 3

Typeset in Garamond and Helvetica Neue
Proofread by Mairi Sutherland
Indexed by Linda Sutherland
Printed in Italy by L.E.G.O.

JACKET FRONT COVER
Suilven, Assynt
2013 HES AERIAL SURVEY DP156629

JACKET BACK COVER – MAIN IMAGE
Central Glasgow
1947 HES RAF COLLECTION SC802946

FRONTISPIECE
Burial ground and remains of chapel on
Little Bernera, Lewis
2015 HES AERIAL SURVEY DP222053

PRINTED CASE
Gleann Tulacha, Lochan Fada, Fionn Loch
and Dubh Loch, Wester Ross
1988 HES ALL SCOTLAND SURVEY SC1124079

CONTENTS

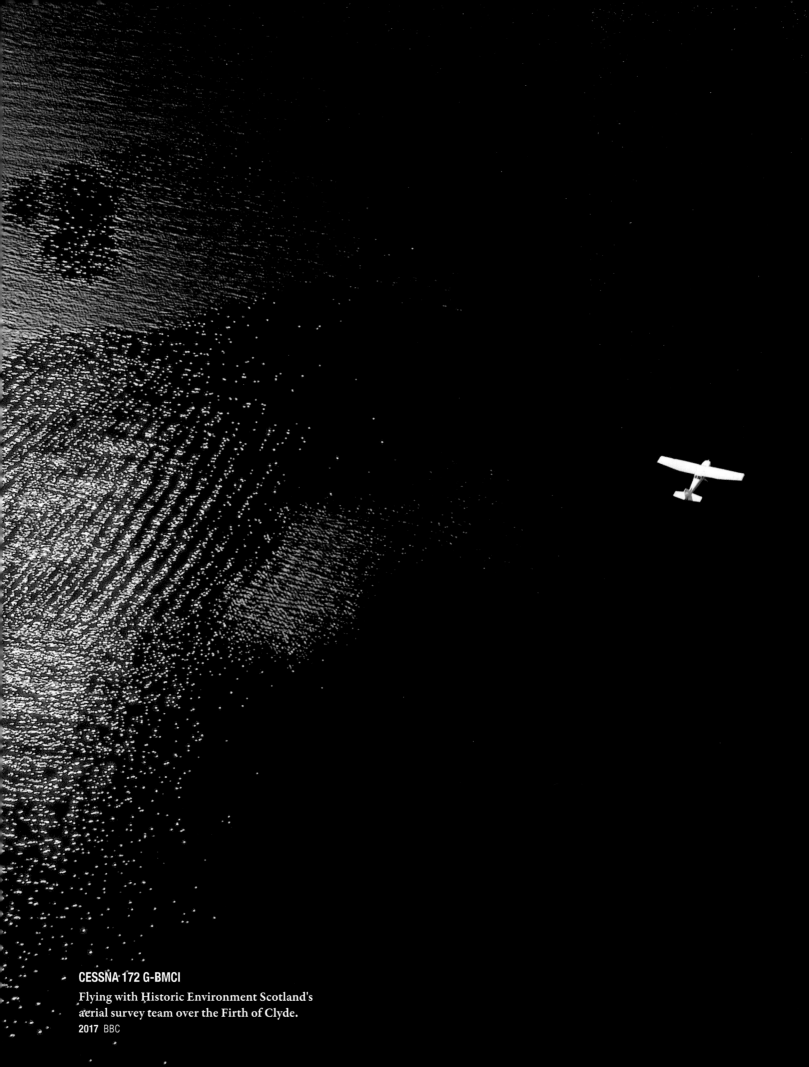

CESSNA 172 G-BMCI

Flying with Historic Environment Scotland's
aerial survey team over the Firth of Clyde.
2017 BBC

INTRODUCTION

Prepare yourself for a journey into the skies above Scotland. Over the next three hundred pages you will travel in both space and time, starting in the years around the First World War, and moving all the way up to the present day. As you go, you will see just what our pioneering aviators saw as they stared out from their cockpits. And more than that, you will also explore what they were trying to find. Because, from above, Scotland can be many different things, depending on what you choose to look at – and who is doing the looking.

Some gaze down and see a place of beauty, a picturesque dream to be enjoyed and celebrated – and marketed and sold. Others see an industrial powerhouse, a smoky, muscular accumulation of shipyards, factories and manufacturers. Look again and Scotland is a frontline to defend against invasion, gouged by trenches and studded with armaments. Or it is the unknown, a territory to investigate, record – and conquer. It can be a scene of urban chaos, a problem to solve, redesign and manipulate in the name of modernity. It can be a resource to harness – or exploit – for food, fuel and power. And it can be a manuscript, written on again and again: a landscape full of earthwork hieroglyphics, just waiting to be read and deciphered.

Accompanying the BBC documentary series *Scotland from the Sky,* this book is about the many people who have pursued and explored the view from above. It is also, crucially, about how they captured it through photography. At the heart of the story is Scotland's National Collection of Aerial Photography, held in the archives of Historic Environment Scotland. For over a decade I've worked with this collection, researching its history and exploring its secrets. Containing over 1.6 million images, it is made up of material spanning nearly a hundred years – produced or used for incredibly diverse purposes. Brought together here, however, it offers a unique record of a Scotland that has changed enormously over the past century: and sometimes beyond all recognition.

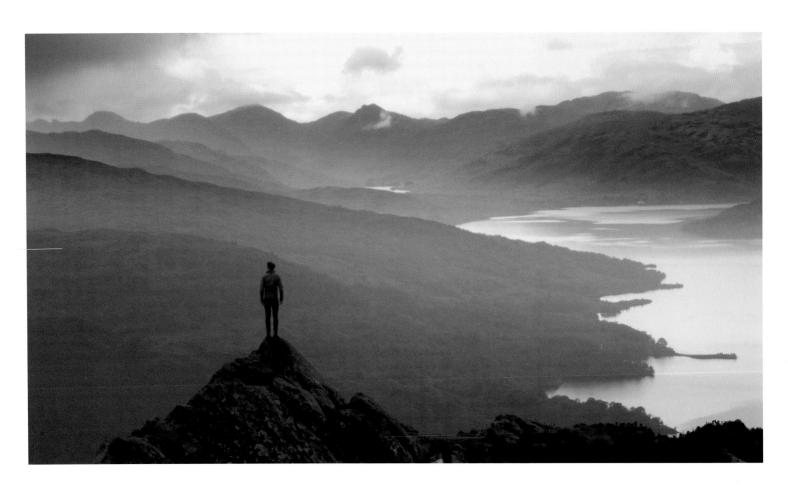

BEN A'AN AND LOCH KATRINE, THE TROSSACHS

For almost all of human history, this was how you achieved the view from above. It was very simple – you just climbed up to the top of the highest hill that you could find ...

2017 BBC

This book is also an account of my own journey. In the process of filming *Scotland from the Sky,* I had the remarkable opportunity to travel across the country, searching out the people and locations that would bring the story to life. I moved from lost gardens in Dumfries and Galloway and a lonely hill fort in the Borders, to dummy airfields in Caithness and an abandoned 'Viking' peninsula on the Isle of Skye. I climbed hills and high-rises, followed crumbling roads through Highland glens, hailed a taxi – deliberately – to a traffic jam on the M8, raced a speedboat up the River Tay, and sailed on a paddle steamer down the Clyde coast. And, of course, I took to the skies: in helicopters, light aircraft, a vintage Tiger Moth and a First World War biplane. I flew over towns, cities, lochs, mountains, castles, coastlines – and even the village where I grew up.

From the air, the Scotland that I thought I knew became something else. I felt the arresting power of the view from above, the strange sensation of being at once distanced from and connected to the world below. It is only from the sky that you can see – *really see* – just how much our landscapes have been shaped by human intervention. At a glance, the past and present collide all around you. Height, quite literally, broadens your horizons: the familiar is detonated by perspective, blown open by the sheer extent of what is being laid out beneath you. Our ancestors thought that this was a view reserved for the gods. But now – and in particular since the invention of powered flight at the beginning of the twentieth century – it is ours.

It is no surprise, then, that so many have found this perspective so revelatory. In the course of my research, I came across an achingly poignant memory from the very early days of aviation: a pilot in the First World War, Cecil Lewis, who recalled flying over the trenches. 'The war below us was a spectacle', he said. 'We aided and abetted it, admiring the tenacity of men who fought in verminous filth to take the next trench thirty yards away. But such objectives could not thrill us, who, when we raised our eyes, could see objective after objective receding, fifty, sixty, seventy miles beyond … There was so much beyond. Viewed with detachment, it had all the elements of a grotesque comedy – a prodigious and complex effort, cunningly contrived, and carried out with a deadly seriousness, in order to achieve just nothing at all.'

There was so much beyond. This is the essence of the view from above. It forces you to look further, and in looking further, to search for meaning – even when, as Cecil Lewis realised so vividly of the war, that meaning is futility. Over the last hundred years, many have followed the likes of Lewis into the air. And, in the process, they have uncovered whole new ways of seeing. They have used the experience to understand and shape the Scotland we know today; and are continuing to use it to mould the Scotland of tomorrow. This is a fascinating – and little known – story of war, innovation, adventure, cities, landscapes and people. This is the story of Scotland, from the sky.

* * *

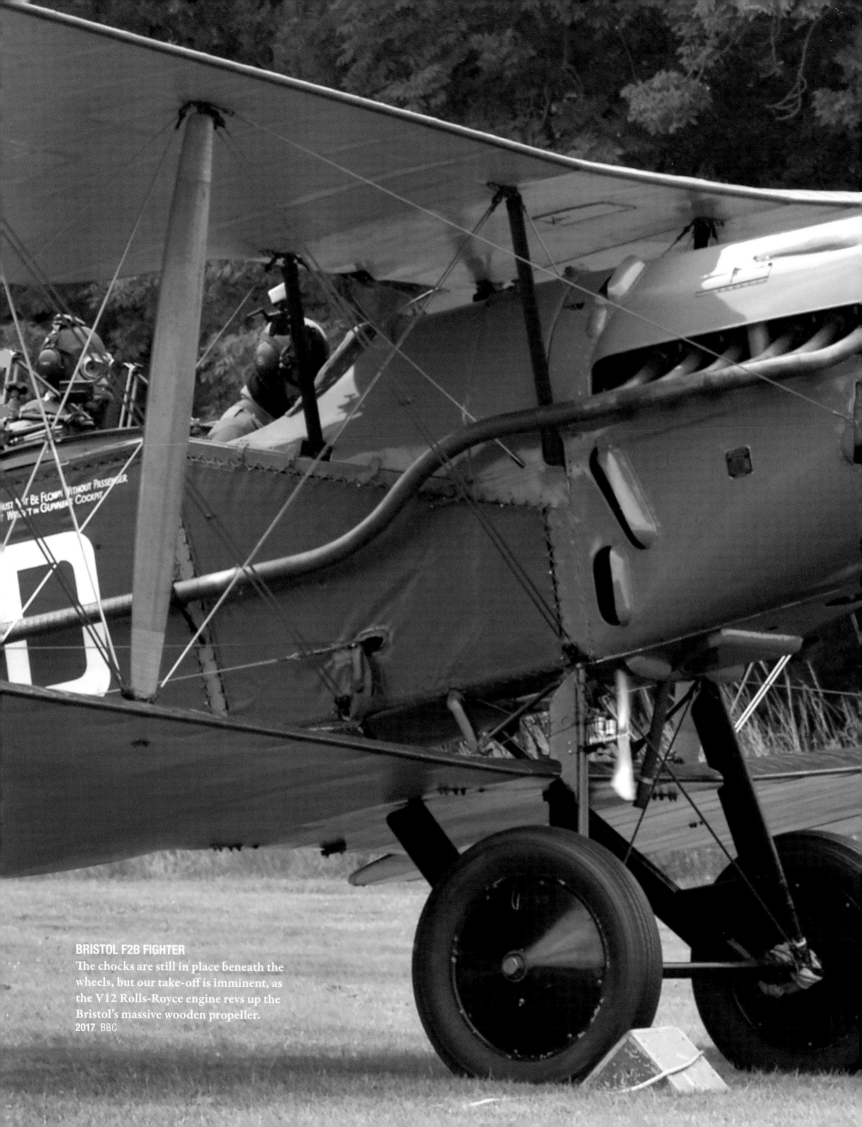

BRISTOL F2B FIGHTER
The chocks are still in place beneath the
wheels, but our take-off is imminent, as
the V12 Rolls-Royce engine revs up the
Bristol's massive wooden propeller.
2017 BBC

BEGINNINGS

It was an all-out assault on the senses. The growling power of the V12 Rolls-Royce engine rumbled through the hard metal seat to vibrate my body like a tuning fork. But that was nothing compared to the incessant fury of the air rushing towards me at 100-miles-an-hour. With no windshield to protect me, it landed blow after blow, knocking my head this way and that. Every time I raised my long-lens camera to take a picture, the air caught it and threw me back against the sharp rim of the rear cockpit. I had no option but to loosen the shoulder straps of my seatbelt and use the extra range of movement to brace my arms against the triangular metal strut behind me – a strut that had once mounted a machine gun. I tried to bring my eye to the camera's viewfinder, but all I could see was a green and brown blur racing past some 500 feet below. My 'mission' was to photograph four flags hidden somewhere in the airfield's expansive grounds. And I was trying to do it from a First World War Bristol F2B Fighter. An aircraft that was exactly 100 years old – the only original of its kind that can still fly today.

The point of all this was to get a sense – albeit a crude one – of what it must have been like for the young men who, a century before, first combined flight and photography. While cameras had previously been taken into the skies in (often tethered) hot air balloons, it was the invention of *powered* aircraft that really revolutionised aerial photography. The timing, however, could not have been worse. This fledgling discipline would grow up in the most desperate of circumstances. In the killing fields of the Great War.

Millions faced off across a few hundred yards of no man's land. 'The unheroic dead who fed the guns' the war poet Siegfried Sassoon called them. Casualties were catastrophic and success was measured in inches. Everything was focused on finding weak spots in trench lines running from the English Channel to Switzerland. And what better way than from the air? The intelligence war had a new weapon. Look up from those trenches and you might

find you were being watched. But, for those doing the watching, it was a very precarious business.

Aerial reconnaissance needed two men – a pilot and an observer. The observer started off as navigator, spotter, radio operator, machine gunner and even sketcher. But soon he was simply the photographer. He sat in the back, in open, un-armoured fuselage. Exactly where I was sitting, in exactly the same aircraft. That, of course, was where the similarities ended. I was using a modern, compact DSLR camera with an automatic zoom lens. The observer used a heavy glass plate camera that was bigger than a briefcase – often developing the negatives while still in the air. Another small matter was that *no one was shooting at me*. Had I been sitting in that same Bristol a hundred years earlier, the chances are that I would have been dead within the week.

Being an observer was one of the most dangerous roles in the war. By the spring of 1917, only one out of every three reconnaissance pilots was still flying. But every single observer had been killed or injured. By this time a photographic map of the entire Western Front had been put together and was updated daily. From the skies, the trenches looked like an endless row of teeth, or a child's drawing of castle battlements – surrounded everywhere by the black dots of shell holes. Two and a half million photographs were taken in 1918 alone, contributing to a staggering total of ten million produced over the course of the whole conflict.

The sacrifices made by these reconnaissance crews have been largely forgotten. Instead it was the exploits of the fighter pilots – their mid-air duels with the likes of the infamous 'Red Baron' – that were reported regularly in

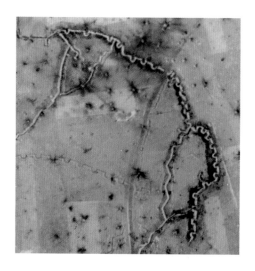

FIRST WORLD WAR TRENCHES

The distinctive scars of trenches – surrounded by the black stains of shell craters – cover the landscape in this 1915 photograph, taken high above the fields of France.
1915 IMPERIAL WAR MUSEUM

FLYING IN THE BRISTOL

Pilot Jean-Michel Munn banks the Bristol as I struggle to steady my camera against the onrushing wind.
2017 BBC

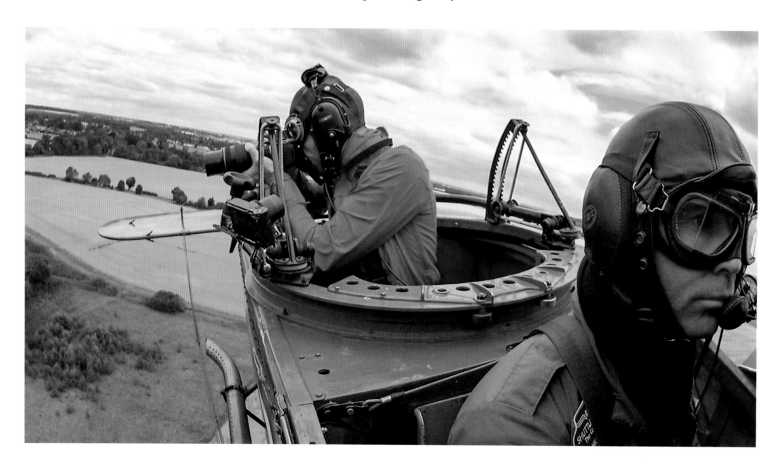

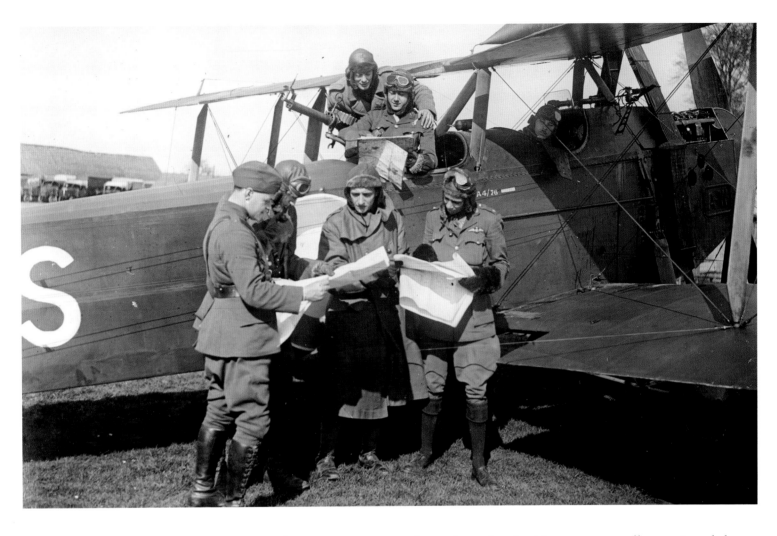

THE ROYAL FLYING CORPS

Pilots and observers of the Royal Flying Corps – which later joined with the Royal Naval Airforce to form the RAF – consult maps in advance of a treacherous flight over the Western Front. Many of these men would not survive beyond their first weeks of service.

1918 IMPERIAL WAR MUSEUM

the newspapers as good morale stories. And it was never really mentioned that one of the main reasons that they were in the sky at all was to protect the aerial photographers: ensuring that the vital pictures they took made it safely back to base.

These were sobering thoughts as I wrestled with the elements at the back of the Bristol. My pilot, Jean-Michel Munn, had to maintain a steady course to give me even the slimmest chance of spotting and then photographing the hidden flags. After he'd taken us on several wide circuits of the aerodrome I had managed to negotiate the severe buffeting to take a series of shaky, blurred pictures of the hidden flags. But I was under no illusions – had we been in the middle of a warzone, we would have been easy prey. As one Great War observer put it chillingly: 'in the air, you could see death coming'.

We'd probably only been flying for around half an hour when Jean-Michel brought us in low over a field of golden corn to touch back down on the grass landing strip. When the engine was finally turned off, the sudden silence – and stillness – was shocking. I removed my flying helmet and goggles. To say I looked windswept would be an understatement. Jean-Michel turned to me and put things in perspective. 'Because of our airspeed', he said, 'it's like you've been trying to take photographs in a hurricane.' Just thirty minutes of it was exhausting. Can you imagine spending hours in the air, day after day, in all seasons, in all weather conditions, flying through flak and bullets above

a seemingly never-ending human cataclysm? Thousands of men experienced exactly that. A great many never came back.

But, for those that did, the techniques they'd developed high above no man's land didn't end with the war. The pilots remembered, the photographers remembered. They'd risked everything acquiring their new skills. And they weren't going to stop.

A few days after my flight in the Bristol Fighter, I took another vintage mode of transport. This one was rather more sedate. In fact it was – quite literally – a pleasure cruise. I was sailing down the Clyde on board the last ocean-going paddle steamer in the world: the famous *Waverley*. And I was on the trail of one particular group of de-mobbed wartime aviators.

Ninety years earlier a biplane had followed a similar paddle steamer – the *Duchess of Fife* – as it travelled from the centre of Glasgow out into the Firth of Clyde. At the very instant that it came to dock at the seaside town of Largs, a photographer a few hundred feet above pressed his shutter release. It's obvious from his image that the day was beautifully sunny. A small crowd is gathered on the town's big L-shaped pier and, apart from the steamer's wake, the water is still as glass. Straight away it makes you think of holidays, of trips to the seaside, of escaping the city. It's a picture-postcard moment, a perfect snapshot of a great Glasgow tradition. But it's also the first time that anyone had ever captured it from the air.

THE *WAVERLEY* ON THE FIRTH OF CLYDE
A modern drone captures our journey on the *Waverley* to Largs. Almost a century earlier, an Aerofilms biplane followed another steamship on this same route out into the Firth of Clyde.
2017 BBC

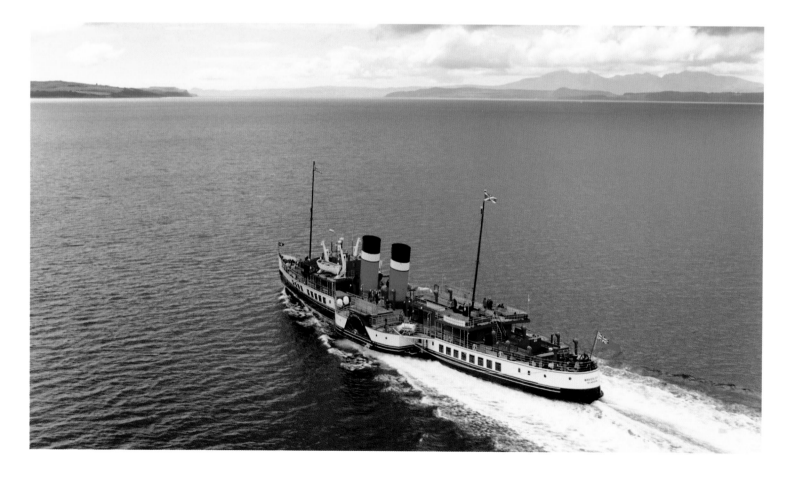

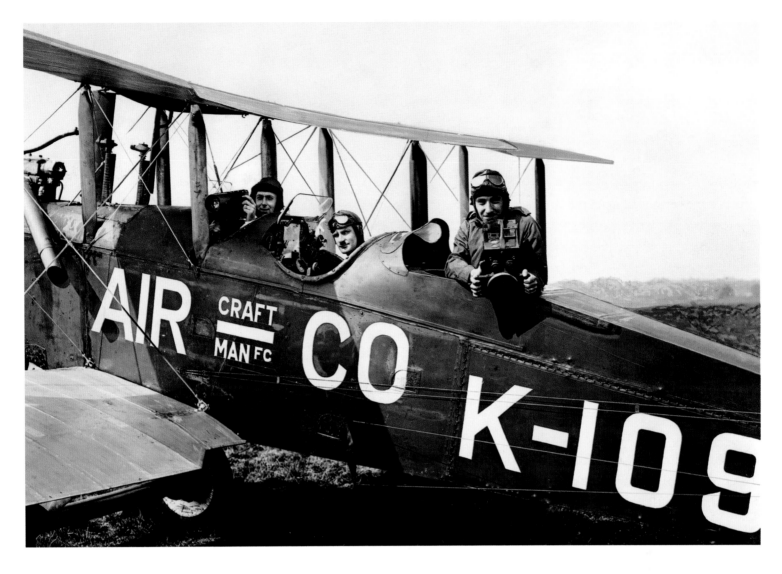

AEROFILMS

Francis Wills sits in the front cockpit of the aircraft, holding up his camera. In the rear, behind pilot Henry Shaw, is the cinematographer Claude Friese-Greene, with a film camera designed to capture moving images. This promotional shot was taken in July 1919, just two months after Wills and Claude Grahame-White launched Aerofilms as a business.

1919 ENGLISH HERITAGE AEROFILMS COLLECTION

Today, of course, we don't see this picture in the same way that the people of 1927 would have seen it. Back then, perhaps only a few thousand Scots had ever been in the sky. Just the tiniest fraction of the population had experienced this view. For the rest, it must have seemed a thing of wonder, of awe. That, certainly, was the hope of the men in the aircraft flying low over Largs. They worked for the world's first commercial aerial photography company: Aerofilms.

Its founders were two First World War veterans – the pilot and famous aviation pioneer Claude Grahame-White; and a former Royal Flying Corps observer Francis Wills. They began in 1919 in London, flying ex-military aircraft at extremely low altitudes over the city's iconic sites and monuments – and then returning to the Flying Club in Hendon to develop their photographs in a hotel bathroom. They produced just seventeen glass negatives in their first six months in business. But by the beginning of the 1930s, this number had exploded to over 30,000. It was an astonishing output. Although not, perhaps, astonishing to Grahame-White and Wills. As one of their many advertising slogans exclaimed: 'there is no limit to the possibilities of the unusual aerial photograph!'.

Aerofilms deliberately conjured a potent, seductive vision of place and identity – and then sold it on with admirable flair. Certainly, their pictures

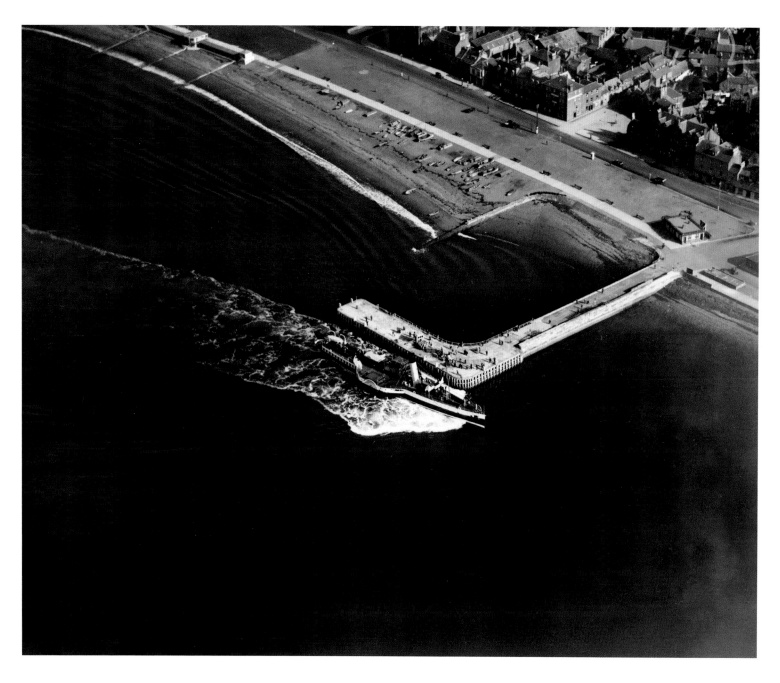

transformed landscapes that had only ever been seen before from the ground, offering a sweeping, majestic sense of scale. Throughout the 1920s, they had been flying further and further beyond London, always looking to find new customers. And in the process they were building a comprehensive photographic picture of the whole of Britain, a massive aerial jigsaw. Scotland held some of the key missing pieces.

The 1927 flight above Largs was one of their very first forays north of the border. They kept a record of their progress in the company log books. Pilot and photographer would fly along, ticking off a list of targets. Once they were back on the ground, the prints were pasted into the logs in sequence, annotated with dates and handwritten notes. What were they photographing? Essentially, whatever they believed they could sell. Exploring the logs is like consulting an indiscriminate flick-book of the past: hundreds upon hundreds of photographs can be found in every blocky, leather bound volume, the prints curling at their

LARGS PIER, 1927

Aerofilms arrived in Scotland in 1927. They were looking, quite specifically, to capture 'picture-postcard' moments. What was different was that, for the very first time, they were doing it from the air.
1927 HES AEROFILMS SC1246318

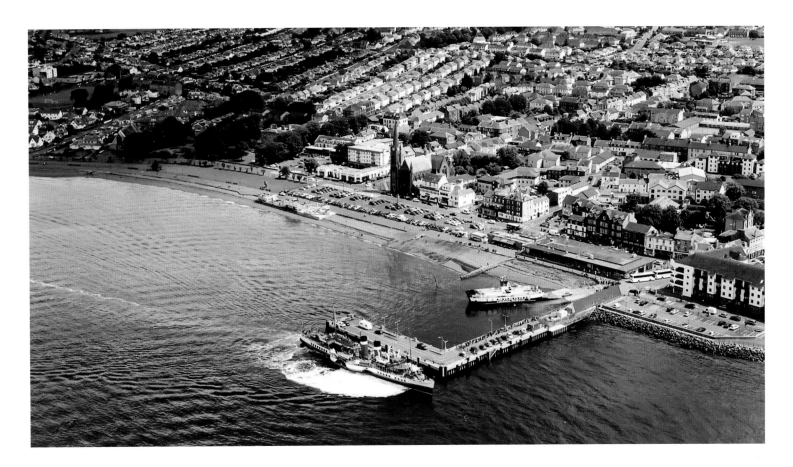

LARGS PIER, 2017

Using a drone, we attempt to reframe the 1927 photograph, seeing how the town has changed over the past century.

2017 BBC

tips, the pages hard and yellowing. One minute you are passing over lochs, mountains, villages, castles and country houses. The next it's towns, cities, factories, steelworks, shipyards and warehouses.

From the start, heavy industry provided Aerofilms with some of its best customers. Yes, over one wing, photographers could look out and see romantic vistas, visions of what Walter Scott described memorably as 'the land of the mountain and the flood'. But at the same time, over the other, there was a different Scotland, the one that made and manufactured on an incredible scale – the Scotland of the great industrial machine. 'Looking Down to Build Business Up' was one of Aerofilms' key marketing slogans. 'The aerial photograph strikes a new note in modern business propaganda' they said. And in the first half of the twentieth century, nowhere in Scotland offered richer pickings than Glasgow.

Aerofilms showed the city doing what it did best: *building things.* In a series of pictures from the late 1920s you can see the Finnieston Crane, Glasgow's iconic strongman, performing its special trick of loading steam locomotives on to boats, to be shipped all over the world. In other images the Clyde is thronged with traffic as it passes through Govan, the busiest it had ever been – and ever would be. Further down the river, at Kilbowie, they captured the sprawling, city-like complex of the Singer Sewing Machine Factory, employer to a staggering sixteen thousand people. And right beside Singer's was the famous John Brown's Shipyard. Aerofilms flew over this site year after year, watching bare hulls and forests of steel struts grow into massive ocean-going vessels. On 24 March 1936, they even followed Cunard's flagship new liner, the *Queen Mary*, on its first journey. They were not alone above the Clyde that day however. Every available

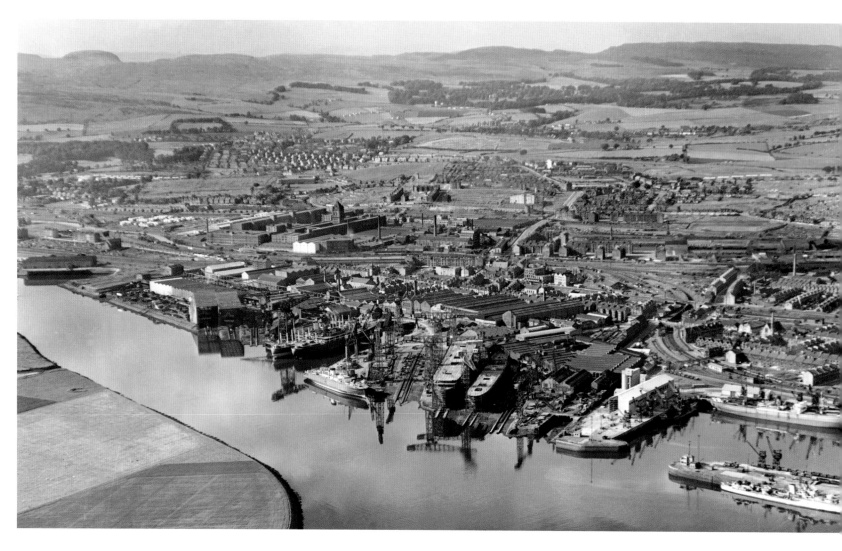

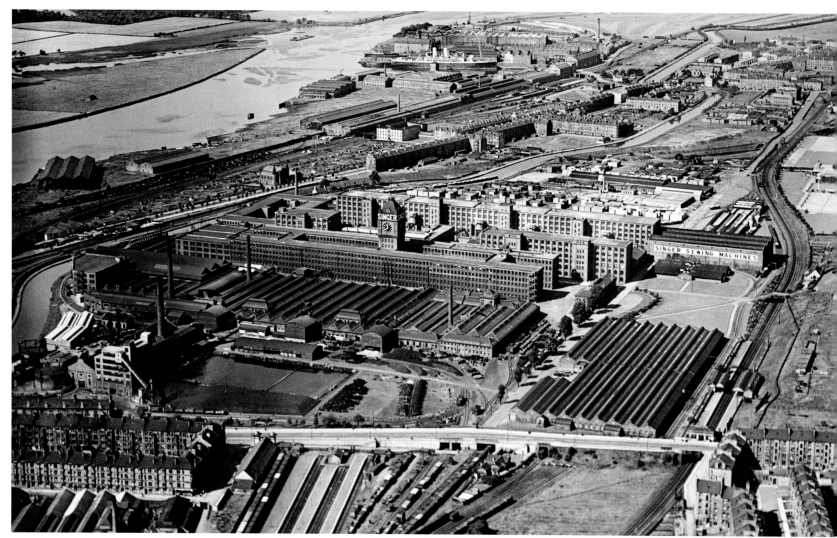

aircraft at Renfrew Airfield was hired out to photographers and film crews. It prompted the Air Ministry, for the first time ever, to impose air traffic controls to manage all the cameras jostling for position in the skies.

The view from above is good at making the world look pristine, model-perfect. From up high, you often can't see the cracks. But down on the ground – at the exact same time as Aerofilms were photographing John Brown's and Singer's – nearly a third of Glaswegians were out of work. The world was still reeling from the Great Depression, and the social and economic fabric of Britain was undergoing rapid and irreversible change.

My journey down to Largs on the *Waverley* offered a stark reminder of this. Even before we cast off from the steamer's mooring alongside Pacific Quay, I looked out to the overgrown, crumbling remains of three huge graving docks – still filled with dark, limpid water. I knew the Aerofilms photographs of this exact spot from the end of the 1920s: images so alive with bustle and energy that you can almost hear the shouts, the hum of engines, the pealing cry of metal on metal. Nine decades later and these docks have not even been reclaimed by the city for something new. They are just simply abandoned.

Of course, many parts of the Clyde *have* undergone huge redevelopment and modernisation. As we got underway, it was a new icon – the spiky, steel and glass facade of the Riverside Museum – which watched us sail by. But it was followed instantly, just across the mouth of the Kelvin, by a great patch of scrub grass. It was the same at Scotstoun, Whiteinch, Yoker: weed-sprouting fragments of the past, still clinging on in the midst of the twenty-first century city. At Clydebank, of course, you can't avoid it. The Titan cantilever crane, which once helped build the *Queen Mary*, casts its great shadow out over the river. Now it's a preserved piece of industrial heritage, a monument to a lost community – and a tourist attraction. The same can't be said for John Brown's. Or the Singer Factory just a few hundred metres inland: a million square feet of workspace – all gone. If it wasn't for photographs like the ones taken by Aerofilms, all memory of how these sites dominated the landscape would dwindle and fade away.

The *Waverley* pressed on, under the high arch of the Erskine Bridge – itself only built in the 1960s – past Dumbarton, Greenock, Gourock; curving round the lighthouse at Cloch Point, powering out into the widening Firth. We passed through a heavy summer rain shower, the air saturated with a warm mist. By Inverkip the sun had broken through again, lighting up the glistening wet hills of Bute and Cumbrae in the distance. I thought again of the Aerofilms photographer, almost a century before, following this same route, leaning out of his biplane every few minutes to snap one landmark after another. On he went, over Wemyss Bay, over Largs, down past Saltcoats to Troon and Ayr. At the time, all he was interested in – all Aerofilms were interested in – was raw commercialism. They had no idea that they were also capturing history. That, almost by accident, their collection would become one of the best and most comprehensive records of a Scotland now lost to us.

JOHN BROWN'S SHIPYARD AND THE SINGER SEWING MACHINE FACTORY

These two massive industrial concerns – separated by the ribbon of the Forth & Clyde Canal – once entirely dominated Clydebank. Singer's had its own fire brigade, police station and ambulances; a pipe band, football teams and a host of clubs. Today, all trace of the factory is gone – replaced by green avenues and a modern business park – while at John Brown's, the one survivor is the lonely figure of the colossal Titan cantilever crane, now repurposed as a tourist attraction.

1947 & 1934 HES AEROFILMS SC1437776, SC1257704

Loss, of course, can come in many different forms. On the Clyde it was social and economic change – along with our restless need to renew and rebuild – that altered fundamentally the physical fabric of the riverside. But sometimes loss can be as simple as turning away from the past to look to the future: leaving things just as they were, to be reclaimed, ever so slowly, by nature. That was what I was looking for when I travelled to Caithness, in the far north-eastern corner of the Scottish mainland. To a peat bog. Somewhere inside it, I had been told, you could find a remarkable relic of one of the Second World War's forgotten fronts.

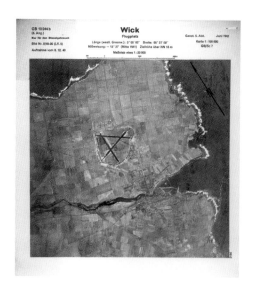

Stopping my car at the end of a single-track farm road, I pulled on my wellies then hauled myself awkwardly up over a barbed wire fence. A local man, Rob More – now in his early nineties – had explained where to look. First you had to track alongside a burn, following a narrow channel between the barbed wire on one side and a small forestry plantation on the other. At the point where the fence met another one running at right angles to it, there was a place to climb through into a field filled with heather, dense scrub grass, wildflowers and peat. And that was all. Apart from some low-rise, crumbling buildings in the distance and a line of hills inland, there was nothing to see.

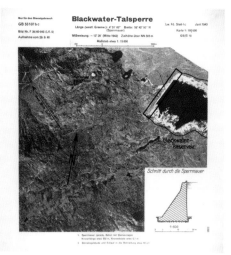

But Rob had recounted how, almost eighty years earlier, a group of men had brought a team of horses on to this peat bog. Somehow, they had ploughed straight lines through this field. Then they had rolled the lines and spread quarry dust and limestone on top. Even when they'd first completed this arduous task, anyone standing here would have struggled to see much. But that wasn't the point. Because what the men had created was intended, quite specifically, to be seen from the air. Three broad paths – meeting to form a rough, triangular 'A' shape. At night, this handiwork was lit up with powerful electric lights. A beacon to attract eyes in the sky; eyes that were looking to find, photograph – and destroy – British defences. The peat bog was an elaborate decoy, a replica of the real target: the three runways of Wick Airfield, six miles to the north.

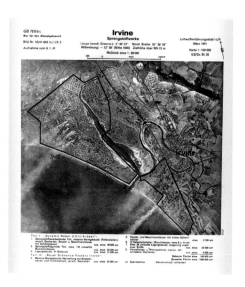

Two decades on from the Great War, and the military had remembered the power of the view from above. Aerial photography had been mobilised once again. This time, however, it wasn't just about flying over individual battlefields. Because in the new era of total war, everywhere had become a battlefield. It had started as early as the summer of 1938, when a Lufthansa civilian aircraft toured around the coast of Scotland – supposedly to map out new routes for the German airline. What it was really doing was using concealed cameras to photograph key strategic locations.

As war began, the aerial spying intensified even further. The Germans had systematically identified bombing targets across the whole country. And it wasn't just obvious sites like the Forth Bridge, the Clydebank shipyards, the oil refinery at Grangemouth, or the Rolls-Royce Spitfire engine factory at Hillington. They had also mapped out locations as far afield as Orkney,

Nur für den Dienstgebrauch

GB 40 9 b
 mit 70 14 b
 82 75 b
 82 76 b
Bild Nr. F 596 L 098
Aufnahme vom 2. 10. 39

Glasgow-Ost
Verschiebebahnhof „Glasgow-St. Rollox" (GB 40 9)
St. Rollox Works, Waggonwerke (GB 82 75)
Cowlairs Works, Lokomotiv-Fabrik (GB 82 76)
Steel Co. of Scotland Ltd., Blochairn Works, Hüttenwerk
(GB 70 14)
Länge (westl. Greenw.): 4° 12′ 16″ Breite: 55° 52′ 20″
Mißweisung: — 13° 00′ (Mitte 1943) Zielhöhe über NN 61 m

Maßstab etwa 1:16 500

Lw. Fü. Stab I c April 1943

Karte 1 : 100 000

GB/S 26/27

'TARGET SCOTLAND'

As early as the summer of 1938, German aerial intelligence began photographing strategic sites across the country. Images were annotated with details of individual businesses, chillingly identifying them as potential targets – as you can see from the photograph of Glasgow above, which mentions by name the St Rollox and Cowlairs Works and the Steel Co. of Scotland. On the left, other images show locations ranging from Wick and Irvine to the Blackwater Dam in Lochaber. All of Scotland was in the crosshairs.

1940, 1940, 1941 & 1939 HES LUFTWAFFE COLLECTION SC449545, SC797390, SC799774, SC799774

WICK AIRFIELD
2017 BBC

Shetland, Lewis and South Uist, annotating the pictures in neat handwriting and outlining key buildings in black pen. This was 'Target Scotland'.

Not to be outdone, Britain was taking pictures too. In September 1938, against the backdrop of the 'Munich Crisis', none other than Aerofilms founder Francis Wills was put on standby as the photographer for an undercover flying mission to monitor German troop movements. When Neville Chamberlain stood in front of the doors of Number 10 to boast of 'peace for our time', this secret mission was cancelled. But it didn't stop Wills and his whole company being co-opted by the Air Ministry as the backbone of a new military intelligence unit. In the years between the wars, no one else had built up as much aerial photography experience as the Aerofilms staff. They were a unique asset. This time, however, there would be no taking photographs from the open cockpits of rickety biplanes. Secret testing had developed a special squadron of Supermarine Spitfires. The fastest aeroplanes in the sky had been turned into high-speed, high-altitude, mobile spy cameras. These Spitfires were based all over the country – including at Wick Airfield. Today Wick is a small, quiet airport handling passenger flights to Aberdeen and Edinburgh. But it was once the centre of a massive military complex, and the staging post for one of the most important intelligence missions of the war.

Just before 11am on 21 May 1941, a Spitfire took off from Wick's main runway, heading north. At the controls was Flying Officer Michael Suckling. He was just 20 years old. He stopped for refuelling at Sumburgh on Shetland and then set a course for the Norwegian town of Bergen. Two hours after take-off, above a remote fjord, he found his prey: the *Bismarck*, the most feared

660 N/I83. I.PRU. 21·5·41. F/20" P.↑

a height of 25,000ft, he pressed the
trigger on his camera. Another hour
later and he was back at Wick. The
photographic negative was developed
within minutes, and Suckling stuffed
the print into his flight suit and set
off to personally deliver it to Coastal
Command. His Spitfire ran out of
fuel at Nottingham, so he landed and
drove to London though the night.

This single photograph set in
motion a massive naval pursuit. The
Bismarck rushed for the open waters
of the North Atlantic, with a host
of British destroyers in its wake.
There was no escape. Six days after
Suckling took his photograph, the
Bismarck, and two thousand of her
crew, lay at the bottom of the sea.
This was a massive coup for British
Aerial Intelligence, and a huge blow
to the morale of the German Navy.
Few weapons, it seemed, were quite as
simple, effective – and deadly – as a
pilot, an aircraft and a camera.

THE *BISMARCK*

This single photograph, taken 25,000ft
above a Norwegian fjord, set in motion
one of the largest search and destroy
missions in naval history. Six days later,
the *Bismarck* would be no more. It was
a stark demonstration of the power of
aerial photography. Aircraft could now
operate faster and further behind enemy
lines than ever before. What could – and
couldn't – be seen from the sky was of vital
importance.

1941 HES NCAP-000-000-290-703

It wasn't all about attack, however. On the home front, aerial pictures
proved an invaluable tool for helping to protect military operations. An entire
RAF unit – known as the Camouflage Directorate – was dedicated to creating
diversions like the dummy airfield at Wick, or concealing real sites from enemy
bombers. Former Aerofilms staff were involved once again, with a co-opted pilot
and photographer flying across the country taking 'before' and 'after' pictures
of disguised sites. They needed to see if camouflage schemes – many of which
had been devised by a select team of architects, artists and theatre set-designers –
actually worked.

This was the all-consuming impact of modern warfare: the landscape of
Britain was transformed into one massive island fortress. It was the same across
all of Europe – the scale of the transformation was incredible. And so too was
the scale of the destruction. The Allies alone dropped some 2.7 million tons
of bombs. In July 1943, the German city of Hamburg was subjected to one of
the single heaviest assaults in the history of aerial warfare – appropriately, and
terrifyingly, codenamed *Operation Gommorah*. It was the systematic destruction
of entire urban landscapes. The fabric of cities across the continent was being
erased from existence. Military sites were obliterated. But so too were some of
the greatest examples of European architecture.

Not everyone was prepared to let this just happen. What those in the skies were seeking out and knocking down, others on the ground were trying desperately to keep up. In 1946, a man called Kenneth Steer walked through the wasteland of the bombed-out city of Cologne in western Germany. Towering over the devastation was a masterpiece of gothic architecture, the colossal thirteenth century cathedral. It was one of the few buildings left standing. But only just. (That its 500m-high twin spires acted as a handy navigation aid for RAF pilots may partly explain why it survived.)

Steer's job was to save the cathedral, to keep its blasted and fire-blackened stonework from collapsing down into the rest of the rubble. He was one of some 400 specially picked servicemen and civilians on the Monuments, Fine Arts and Archives programme. Nicknamed the 'Monuments Men', they were tasked with saving great architecture, artworks and antiquities from destruction.

Steer was also an archaeologist. In 1938, at the age of 25, he had started working for the Royal Commission on the Ancient and Historical Monuments of Scotland – tasked with finding and recording the country's most important ancient sites and structures. Like many academics, when war broke out he was given a position in Military Intelligence, and from 1943 to 1945 he was the Head of Aerial Photographic Interpretation for the Allied landing campaign in Italy.

His handwritten wartime notebooks are now held in the archives of Historic Environment Scotland. Alongside his text he pasted in aerial pictures – pictures showing attacks on Rommel's supply chain in North Africa, for instance. But there are other, more curious images that also feature. One photograph, from the Allied advance through Italy, shows what Steer describes as Etruscan tombs viewed from above – ruins left by an ancient civilisation that pre-dated the Romans. The archaeologist in Steer couldn't contain his excitement.

In 1946, as Steer worked to stabilise Cologne Cathedral, using rubble from surrounding buildings to shore up its walls, so many things must have been slotting into place in his mind. He had used aerial photography to help beat the Nazis, to target and destroy. But he had also seen its great potential for discovery, for finding – and saving – the traces of the past under threat from the modern world. And not just by the brutal excesses of war.

The Scotland Steer returned to in the late 1940s was suffering from its own form of post-traumatic stress – stripped of trees, studded with concrete fortifications, its soil worked to exhaustion to feed a blockaded nation. The government of the day had become obsessed with transforming the landscape to guarantee future self-sufficiency. They wanted to increase tree coverage by 1,000%; grant farmers huge new tracts of land for growing crops; flood entire valleys to harness hydroelectric power. Eleven million acres – over half of Scotland's entire landmass – was earmarked for the project.

Back in his job as an archaeologist for the Royal Commission, Steer called for an immediate and countrywide emergency survey of Scotland – using aerial photography to guide the way. He knew that the RAF had photographed

The ancient broch, fort and settlement at Edin's Hall in the Borders was visited by Kenneth Steer and his 'emergency' team in September 1950. Here you can see the great skill – and artistry – in this fast-paced plane-table drawing, in particular when set against the real view from above, as captured by a drone camera.
1950 & 2017 HES DP148104, BBC

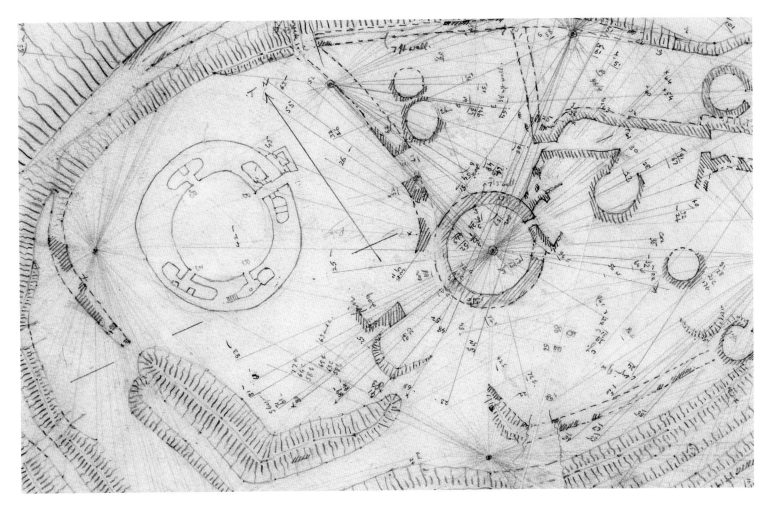

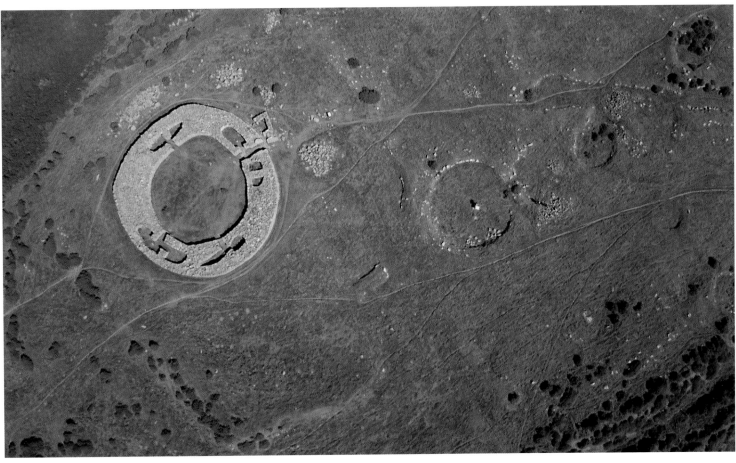

the whole country, starting in 1944 (and continuing up to 1950). And what's more, they had photographed it in 3D. They had flown over Scotland taking multiple top-down, overlapping photographs. This was a technique dating back to Victorian times, when it was something of a parlour trick. War had turned it into a scientific tool. Viewing the photographs through a device called a stereoscope gave depth and scale to imagery, brought the landscape to life. And for archaeologists, it was a revelation – the past rose up out of the present, lines and geometric shapes appeared which hinted at structures that were man made. Steer believed that there were thousands, even tens of thousands, of ancient sites that were previously unknown. But under the government initiative, he said, 'the bulk of the unrecorded material will not merely be levelled, but will be totally eradicated'.

Steer and his team first pored over the imagery, pinpointing all the sites that looked most promising. Then, travelling in an ex-army jeep, they headed out into the Scottish countryside. By the summer of 1950, this emergency survey was well underway. Work that would normally take days was completed in hours. Sites were visited in teams of two – often it was Steer himself, working with his long term partner Charles Calder. Sometimes they were already too late. Straight away they found that an ancient fort at Dalkslaw in the Lammermuir Hills – spotted in an Aerofilms photograph from 1929 – was gone, completely ploughed out by farming. Another, just north of Duns at Marygoldhill, was disappearing underneath a new forestry plantation.

Steer filled notebooks with hand-written descriptions of the sites, while Calder, an architect by training, made hasty, but meticulously detailed, measured drawings. Calder worked in pencil, producing top-down plans, the scale determined by the size and complexity of the site. These plans offer a wonderful sense of both accuracy and artistry. Although fast-paced, functional drawings, they retain a unique sense of skill and beauty. They are like a tiny bridge between the present and the past, a kind of conversation with our ancestors.

The emergency survey team found themselves walking between two worlds: the ancient and the modern. And they were doing it at the head of a rapidly rising tide of mass, state-sponsored landscape change, which was washing away the traces of the past, like sandcastles on a beach. All the same, they kept finding and recording more and more sandcastles. Above the tideline, on lonely hilltops – some earmarked as 'marginal land', others untouched – they could feel the modern world, the millennia that had passed, melt away.

The emergency survey kept going for eight years, driven by the unrelenting enthusiasm of Steer and his team – and the remarkable rate of their discoveries. Over 700 sites were visited and recorded across Scotland, almost half of them entirely new. Of those, the vast majority were saved and preserved, and can still be seen and explored today. Key to it all was aerial photography: the first time it was used for archaeological discovery in Scotland on a systematic, mass scale.

It wasn't just the past, however, that was under threat. The post-war drive to put the land to work intensified – and began to have just as much impact on those living in the present.

KENNETH STEER
Writing in 1947, Steer announced that 'the Air Ministry's decision to undertake an Air Photography Survey of Great Britain is of epoch-making importance for archaeological research in these islands'. He was particularly excited that the survey was designed to produce stereoscopic photographs. 'To the uninitiated' he continued, 'the first sight of a well-preserved hill fort' by stereoscope was nothing short of a 'magical vision'.
1976 HES SC1058568

CHARLES CALDER
1947 HES SC1121381

I had driven off the map. Just before the A87 passes through Glenshiel, I turned on to a privately owned track that curves up and round the mountainous southern shore of Loch Cluanie. The further I went, the more the road deteriorated, the tarmac giving way to potholes and overgrown rubble. Here and there, however, I could still spot the solid signs of old infrastructure – little stretches of sturdy roadside walls, a beautiful stone bridge over a stream. The route continued up and over a saddle between two peaks and then dropped down into another valley. Out of sight of the main road, this place had an air of illicit, untravelled solitude. Off to my right now was a second loch – Loch Loyne. The road tracked roughly parallel to its banks, but ever so gradually I could see that I was veering down towards the waterside.

By this point, the potholes were coming every few seconds, the car pinballing from side to side. The road dropped into a little dip, then climbed a blind rise where it passed alongside a higher rocky outcrop. I pulled to a stop. The tarmac ahead of me had disintegrated almost entirely, reduced to a scattering of sandy-coloured loose rock. I climbed out and began walking. After about forty yards, the tarmac reappeared, much smoother than before – its surface solid and largely unblemished. I walked on for another few metres. The road continued, but pursuing a route that I could not follow. As gentle waves lapped at my boots I watched the tarmac slope gently downwards: a dark line, disappearing beneath the surface of Loch Loyne.

THE 'ROAD TO THE ISLES', LOCH LOYNE
Low water levels reveal the traces of a submerged landscape – including the surviving fragments of a major road that once crossed this Highand loch.
2017 BBC

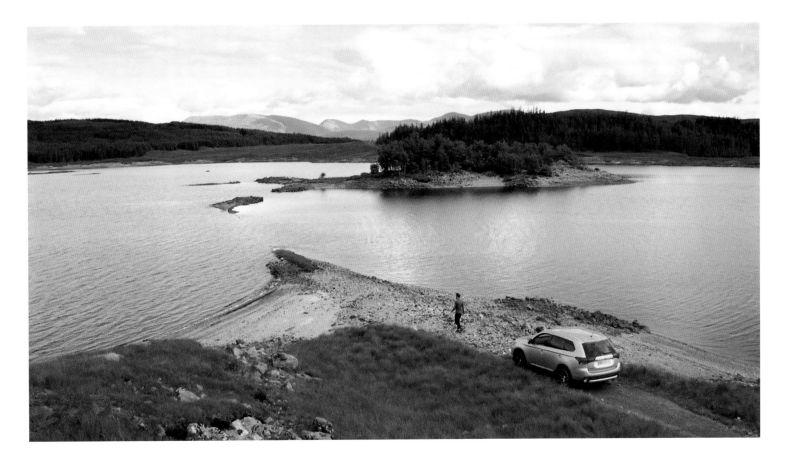

It was a dramatic sight. And an eerie setting: an empty valley on an early summer evening – the surrounding mountains silent and implacable. A road to nowhere. Except that once, it *had* been a road to somewhere. More than just that. Go back some sixty years, and if you were driving from Skye to Edinburgh, then it would have been by this route. There's an old RAF photograph, taken in 1947, which shows the road winding its way through the landscape. And in the picture, it does not disappear into the loch. It heads on down the glen to Invergarry: the main road linking the Western Highlands to the south of Scotland.

What happened? Was it just abandoned, left to crumble away? Well yes, in a sense. But it was more than that. What that RAF photograph also shows is that Loch Loyne was once much smaller than it is today. Something caused it to grow substantially. Something made its water levels creep inexorably upwards – until they had drowned the old crossing. That something, of course, was electricity.

Between 1946 and 1965, some 54 new power stations and 78 new dams were built all across the Highlands. Tunnels were cut through some 300km of solid rock, alongside the construction of another 300km of aqueducts and pipelines. Aerial photography had been instrumental in planning the work – and as construction began, it continued to show huge dam after huge dam emerging at remote loch-heads. The Gaelic motto of the North of Scotland Hydro-Electric Board was *Neart nan Gleann.* Power from the Glens. The view from above captured what this really meant – manipulation of the modern landscape on a colossal scale.

I turned the car and retraced my route back to Loch Cluanie. There was one more thing I had come to see. Waiting for me in a lay-by was Duncan MacLeod.

THE END OF THE LINE, LOCH LOYNE
Waves lap over the last little stretch of tarmac before the road sinks beneath the water.
2017 BBC

LOCH LOYNE BEFORE HYDRO
This RAF image shows just how much the hydroelectric schemes changed the landscape of northern Scotland. The road you can see here winding through the landscape to cross the River Loyne would soon be overrun by the rising waters of the loch.
1947 HES RAF SCOT CPE SCOT UK 0288 4358

1358

LOCH CLUANIE

Low water levels reveal a lunar landscape of sand and rock beneath the green hillsides of the glen.

2017 BBC

He had a grown up in a croft in this glen, and had worked its hills for decades as a gamekeeper. He led me through the thick undergrowth towards the lochside. It had been an unusually dry start to the summer. Below a green perimeter, the land gave way to lunar expanses of sand and rock. Successive lines of grey, brown and black were etched in layers down the shoreline, showing how the levels had continued to drop. We finally reached the water. Walking alongside it, our steps left deep impressions in damp silt the colour and consistency of wet cement. At one point we passed hundreds of tree roots, their forms shrivelled and twisted, their trunks all gone. 'Chopped off', Duncan told me, 'so the tops wouldn't show up above the water.' He pointed up ahead. There was another little stretch of road emerging from the rocks and passing through the clearly visible sides of a stone built bridge. And then, just like at Loch Loyne, it dropped down into the waves. But beyond there was something more. Two squat shapes poking up out of the dark waters of the loch. It took a second to work out what they were – and then it was obvious. They were chimneys.

'I knew the people who lived in that house' Duncan told me. 'They were Macraes and they were shepherds. Two brothers, a mother, and one of the brothers had a wife. Three children.' When the Cluanie Dam was built, the Macraes were flooded out of their home. 'In those days work wasn't easy to get', he continued, 'and with the house being a tied house they had nowhere to go. I remember they moved from house to house after that, and they were in two different houses further east of here. Because they had nowhere to go.' Duncan remembered playing inside the house as a child. 'And I used to play

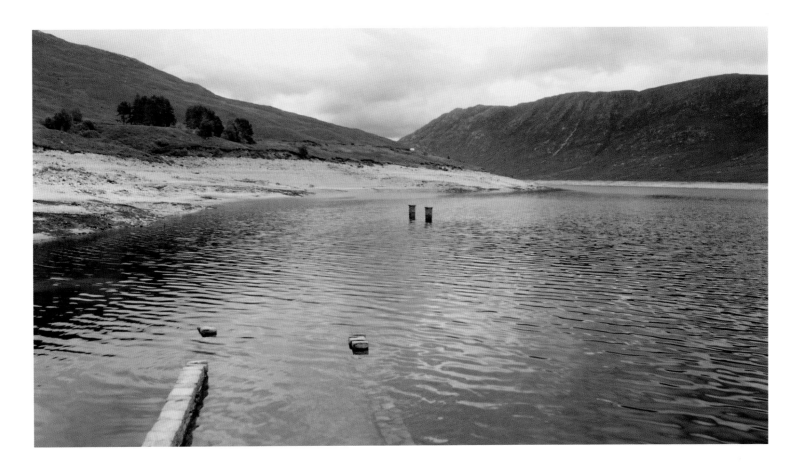

shinty here on the road' he said, gesturing down into the loch. 'It was one of the only flat areas. There were no cars and you could probably play for an hour before a car would come.' We turned away from the chimneys and Duncan led me back along the route of this old road. Mostly it was gone now, but here and there ripples of tarmac appeared through the sands. Throughout the 1950s the level of the loch had continued to rise. A new high road – the modern A87 – was built as a replacement. But Duncan's dad was stubborn, and he continued to drive the low road. Until one day it was gone.

'I remember the last day that we came along here, and all of a sudden we came on the loch, and the loch had come over the road in the night. And so we just turned back. There was another road leading up and it took us on to the new road.' Duncan looked off down the shore. 'It stuck in my memory', he continued. 'I remember it quite vividly, my father's emotion. It was the last time he was going along this road, and that was it. The end of a story for him. The end of a story.'

TWO CHIMNEYS, LOCH CLUANIE

A stone bridge descends into the dark loch. In the distance, the two columns rising above the water are the chimneys of a house that has now been submerged for over half a century. The construction of the dam here in 1957 raised the water levels by a remarkable 29m.

2017 BBC

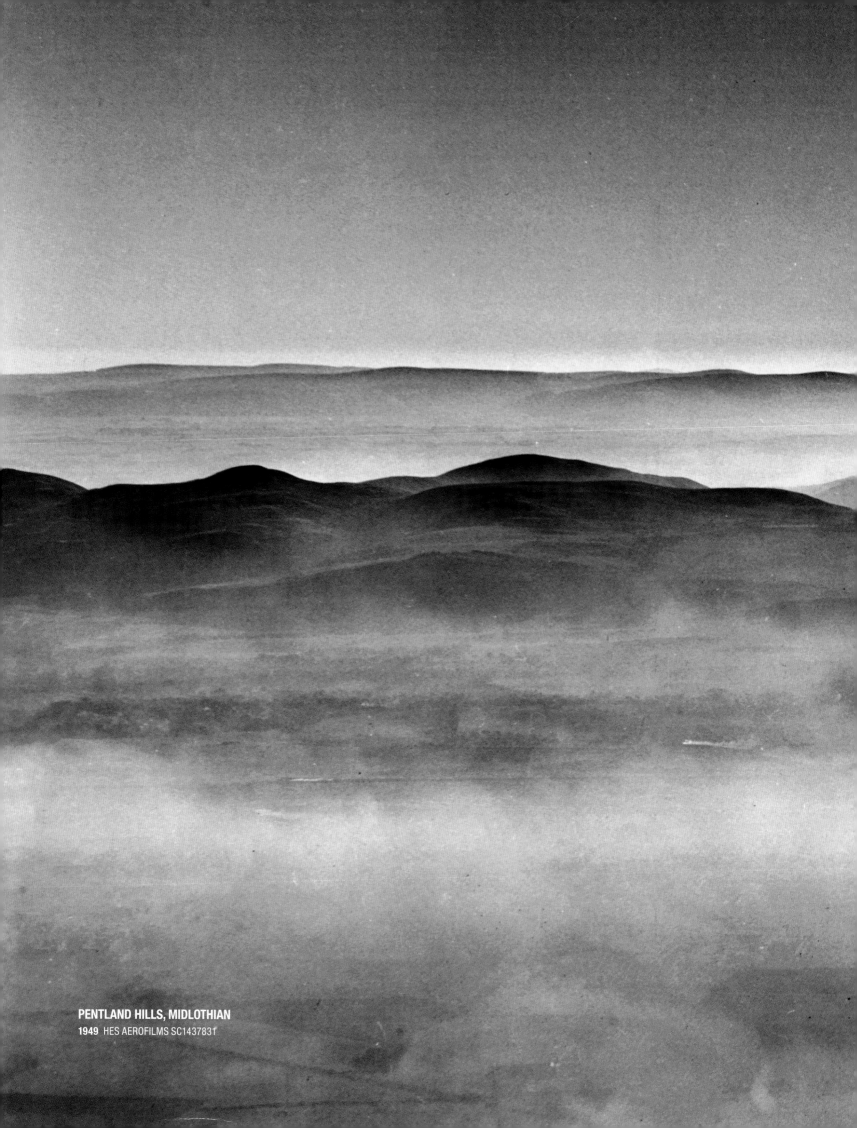

PENTLAND HILLS, MIDLOTHIAN
1949 HES AEROFILMS SC1437831

1

BEGINNINGS
IMAGERY FROM THE HISTORIC ENVIRONMENT SCOTLAND COLLECTIONS

In the selection of imagery that follows, you will see some of the earliest aerial photographs ever taken of Scotland. This is a chance to join the Aerofilms pilots and photographers in their open-cockpit biplanes; watch the nation change before your eyes as you fly through the 1920s, 30s, 40s and 50s. You will also see RAF imagery of the country mobilising for war, alongside modern photographs demonstrating how the remnants of this conflict still litter our coastlines. And finally, you will fly over some of the great post-war hydro schemes, witnessing them under construction in the 1950s, and also as they appear today, decades after they transformed large tracts of the Highland landscape.

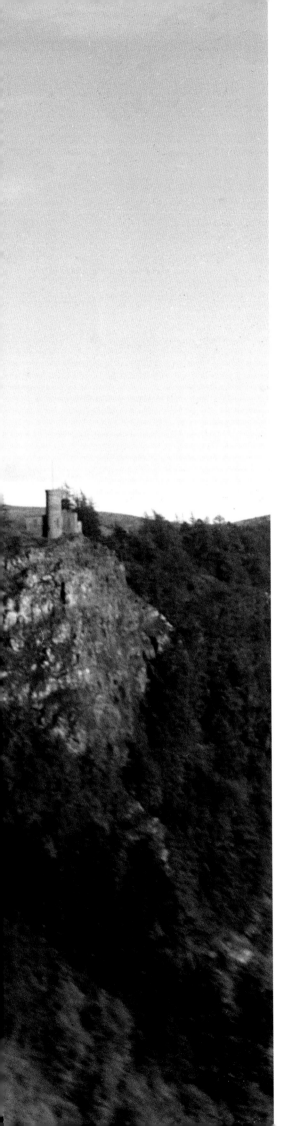

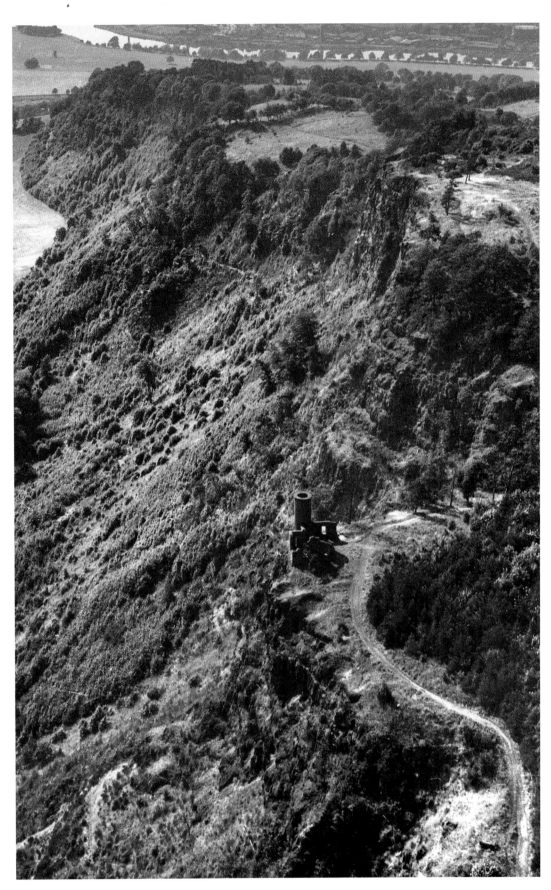

KINNOULL TOWER, KINFAUNS

The blur of a biplane wing intrudes on this early Aerofilms photograph of Kinnoull Tower – the pilot is so low that he appears to be beneath the level of the cliffs. A second shot, taken twenty years later, shows the tower from above, with the curve of the River Tay in the distance as it passes Perth.

1927 & 1947 HES AEROFILMS SC1259203, SC1268713

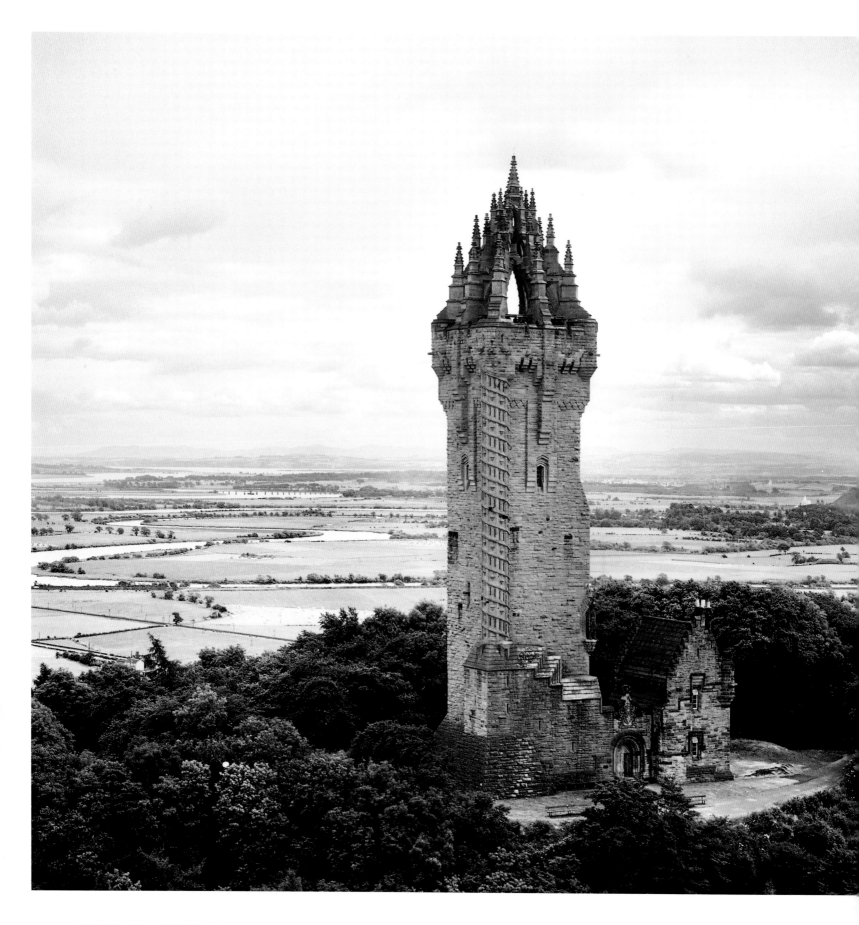

THE WALLACE MONUMENT, STIRLING
1928 & 1949 HES AEROFILMS SC1256685, SC1437735

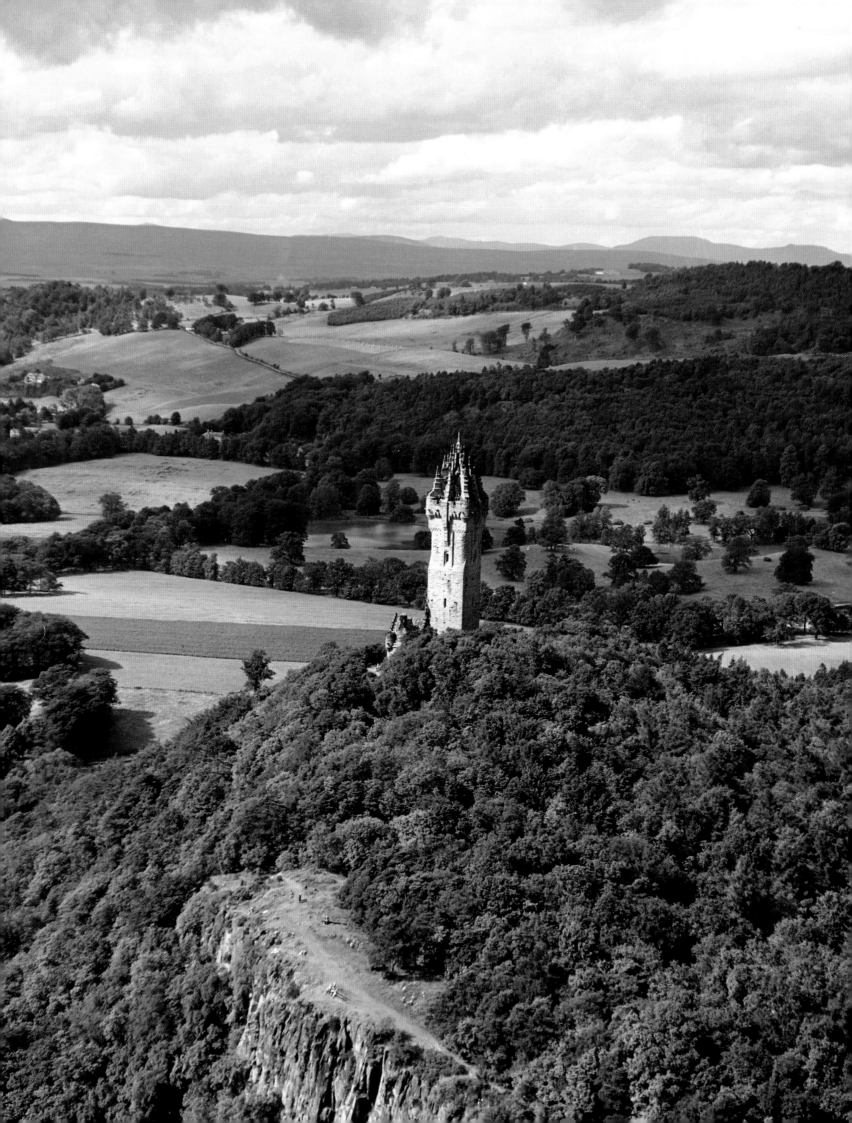

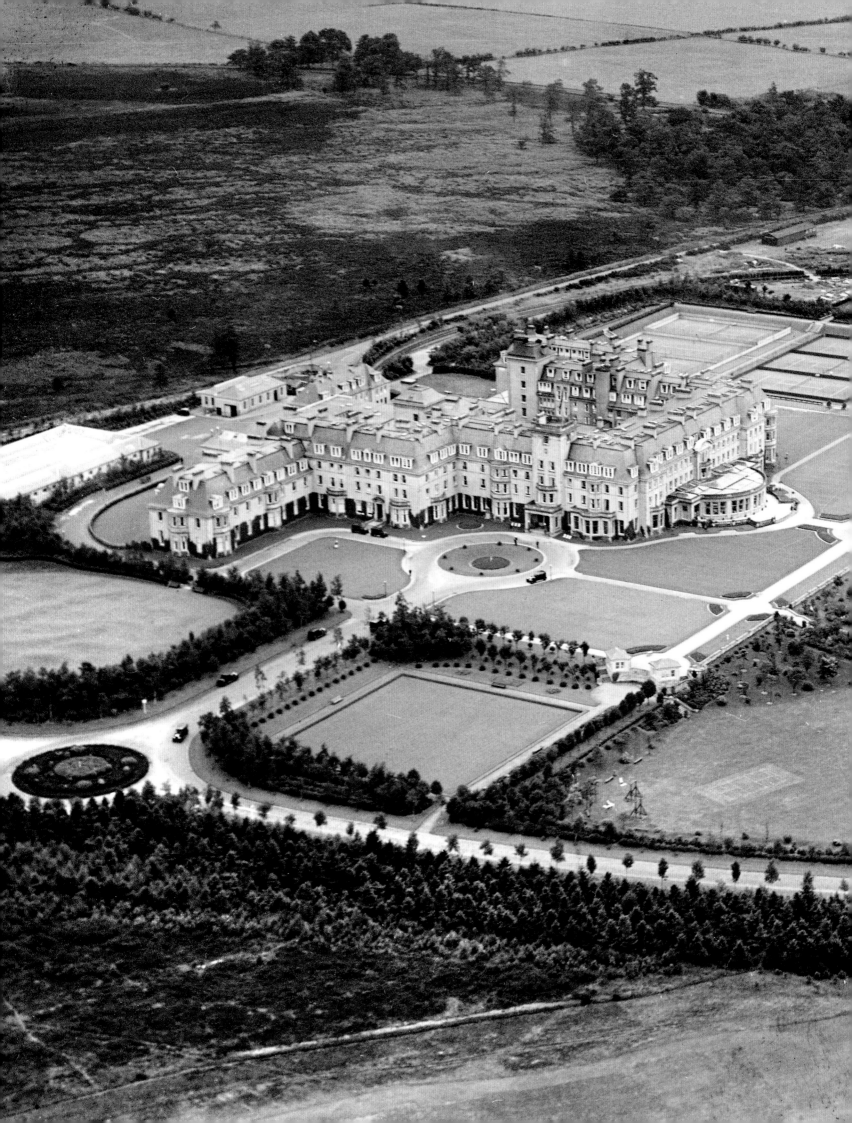

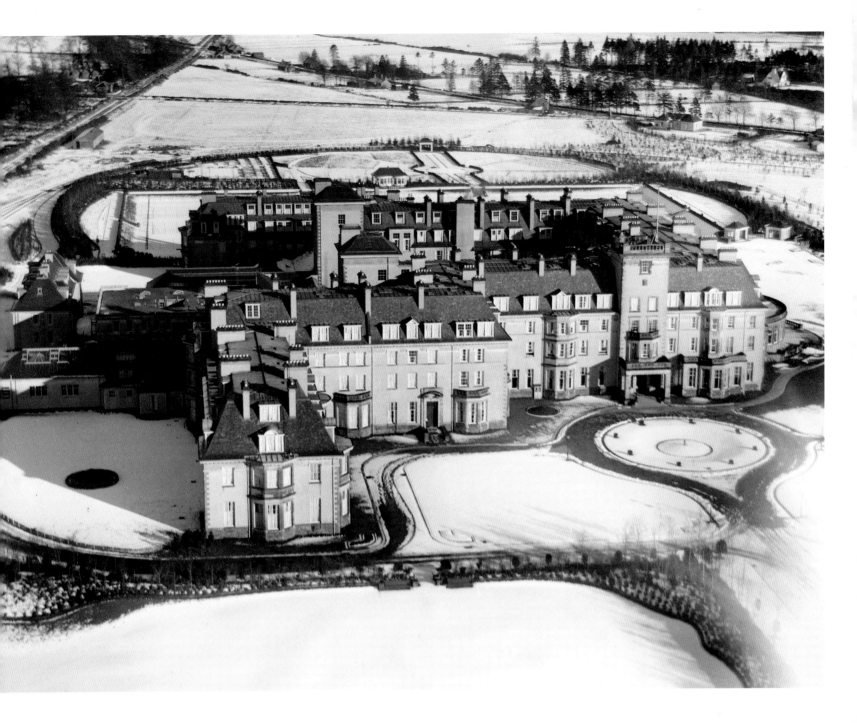

GLENEAGLES HOTEL, AUCHTERARDER
1930 & 1928 HES AEROFILMS SC1257024, SC1256203

*Exploring the Aerofilms
logs is like consulting an
indiscriminate flick-book
of the past.*

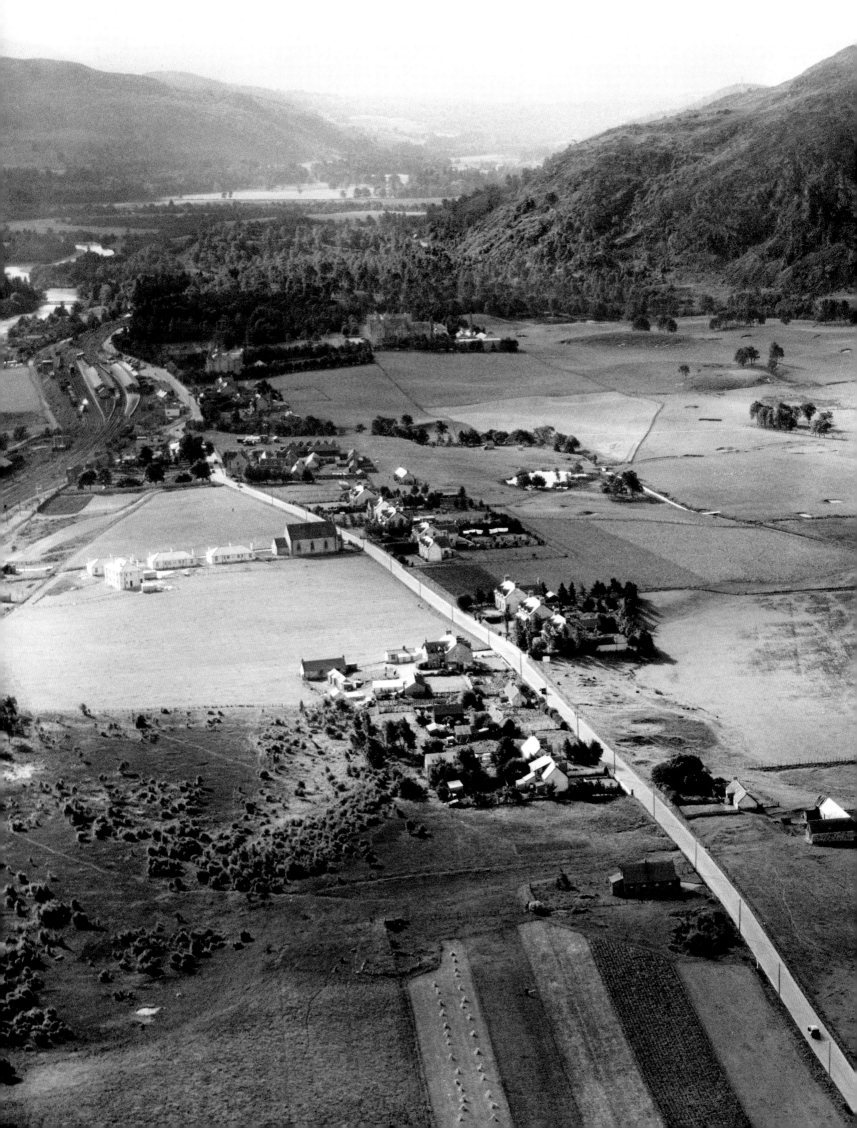

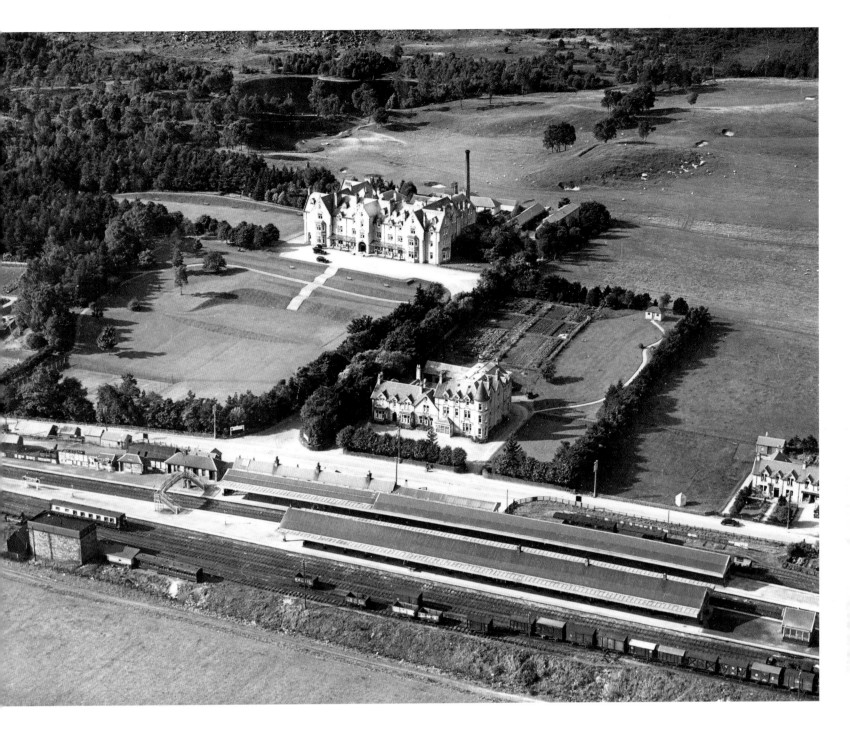

AVIEMORE, CAIRNGORMS

Time and again the Aerofilms photographs open a window onto a Scotland that is irretrievably lost. Take these 1930s pictures of Aviemore – just a handful of houses cluster around Grampian Road, while fields and a golf course are spread out across land now cut through by the tarmac expanse of the A9.

It was the arrival of the railway at the end of the nineteenth century that began the transformation of this tiny settlement. The Cairngorm Hotel and the Aviemore Station Hotel (above) were the harbingers of the tourist industry that has come to dominate the life of this Highland town.
1932 HES AEROFILMS SC1257537, SC1257544

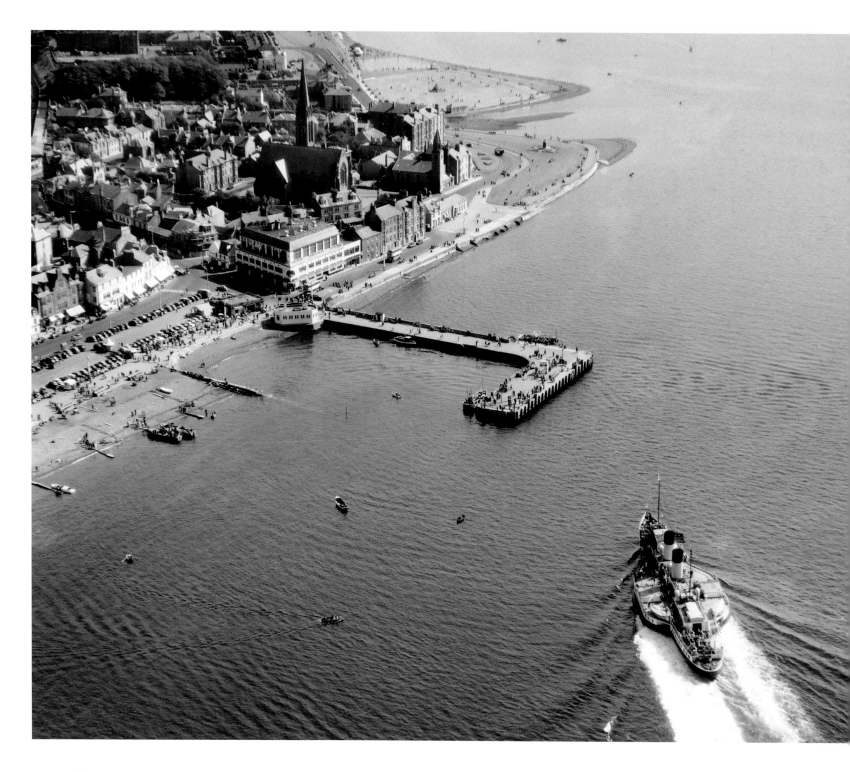

LARGS

The paddle steamer *Jupiter* approaches
Largs pier on a beautiful summer's day in
1956. After first photographing the town
in 1927, Aerofilms returned here many
times over the decades, all the way up to
the late 1950s.

1956 HES AEROFILMS SC1438482

THE FIRTH OF CLYDE

Looking west from Largs across the Firth
of Clyde, the islands of Cumbrae, Bute
and Arran appear like stepping stones
leading out to the faint silhouette of
Kintyre on the far horizon.

1948 HES AEROFILMS SC1438558

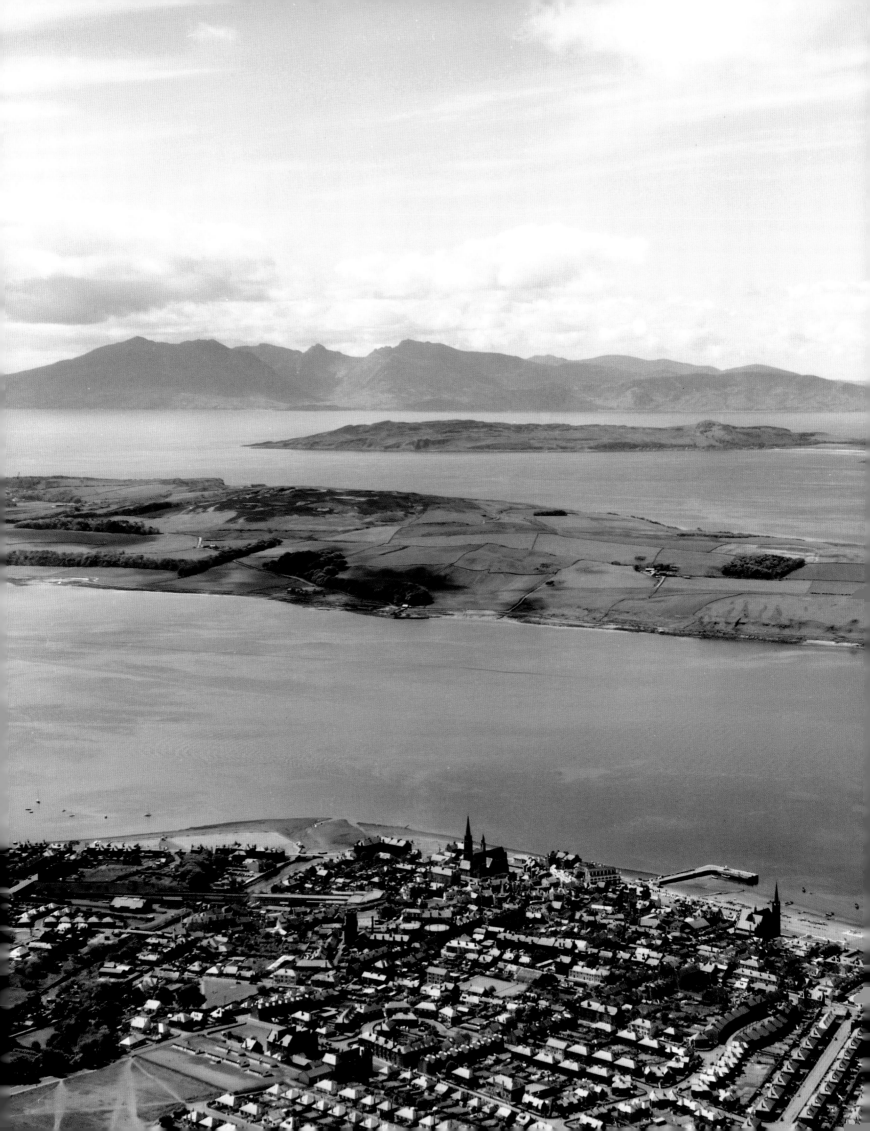

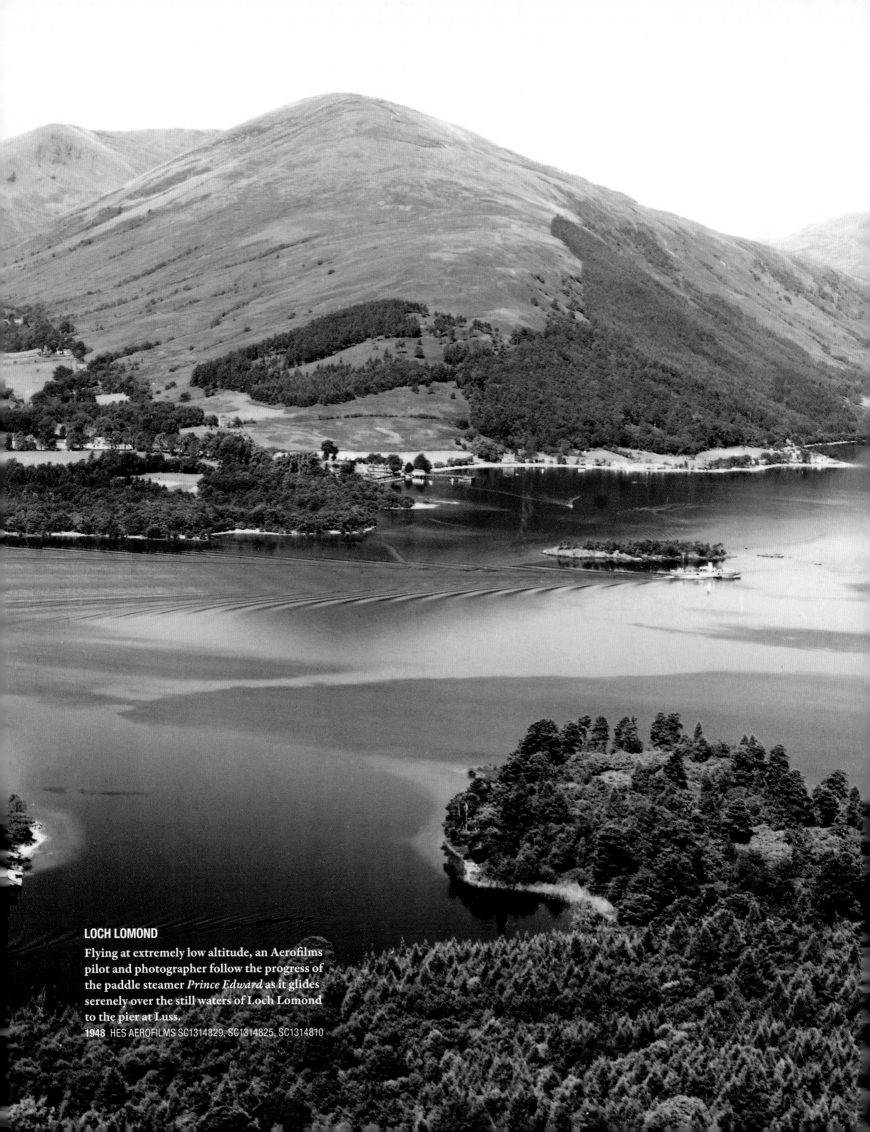

LOCH LOMOND

Flying at extremely low altitude, an Aerofilms pilot and photographer follow the progress of the paddle steamer *Prince Edward* as it glides serenely over the still waters of Loch Lomond to the pier at Luss.

1948 HES AEROFILMS SC1314829, SC1314825, SC1314810

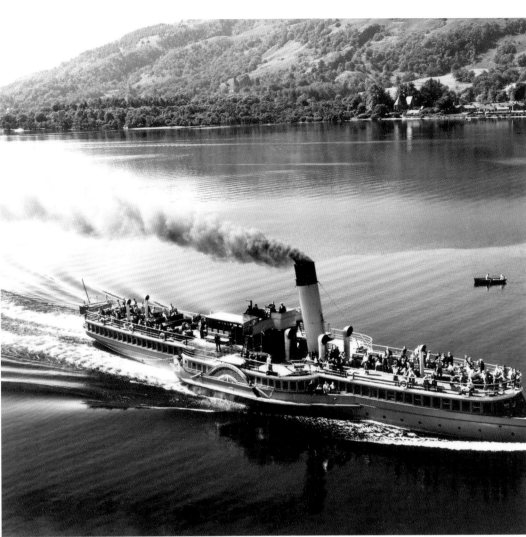
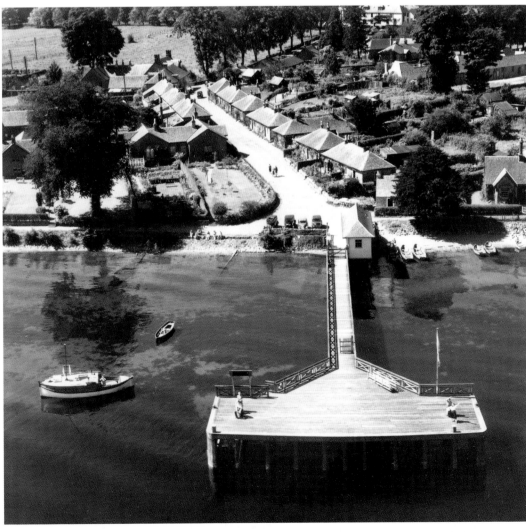

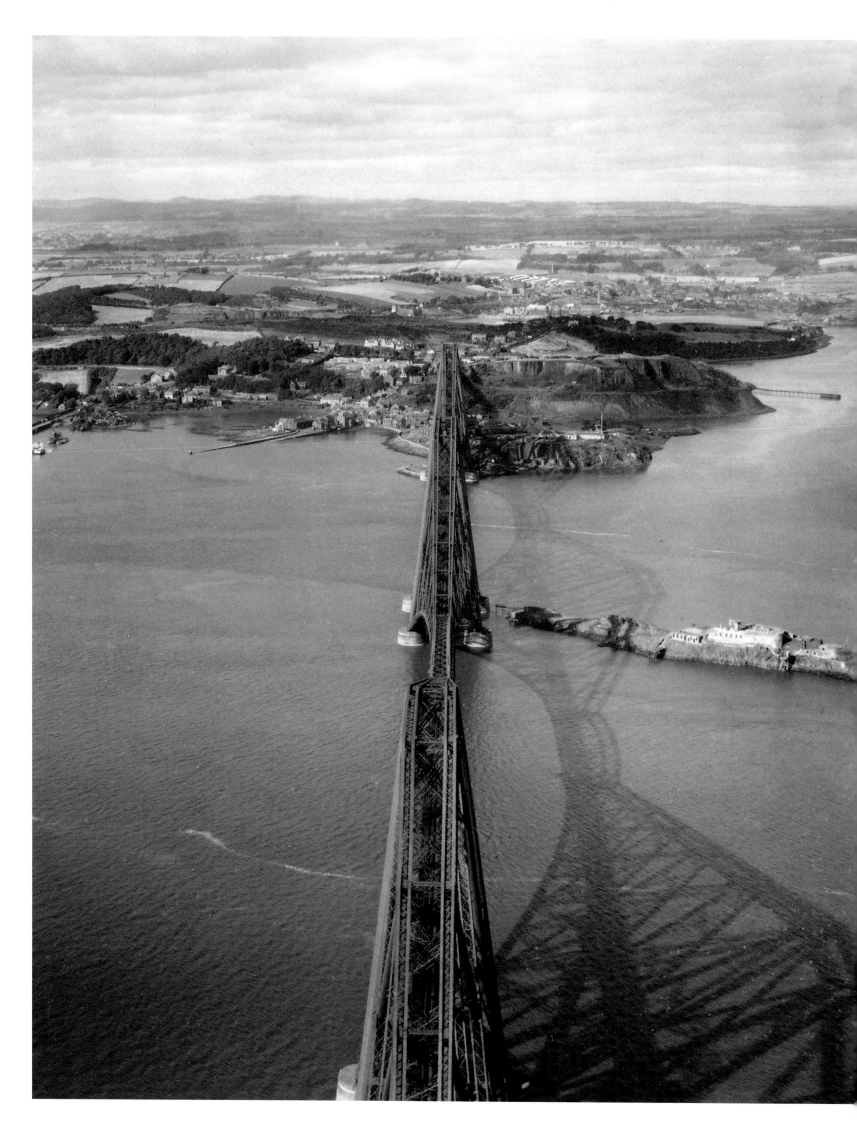

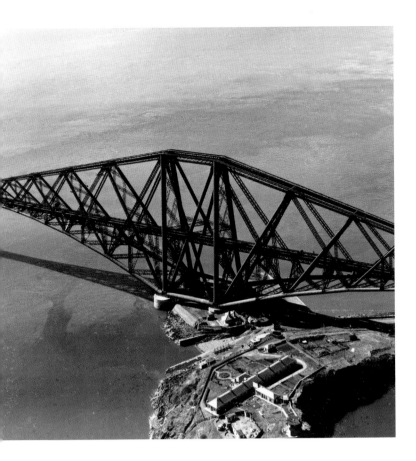

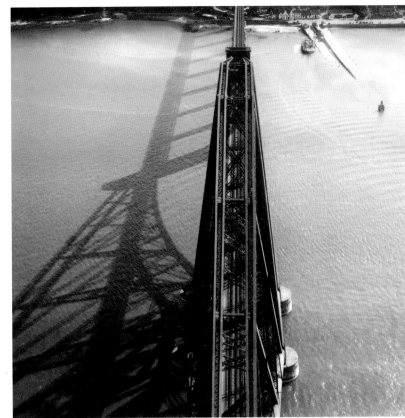

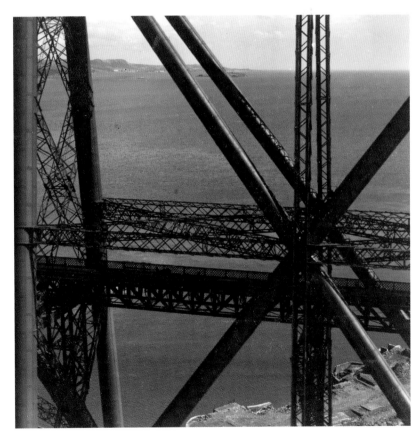

THE FORTH BRIDGE

Aerofilms were always on the hunt for iconic Scotland – and icons don't come much bigger than the colossal cantilevers of the Forth Bridge. These remarkable shots from a late 1940s fly-by demonstrate the daredevil nature of the company's work. The aircraft passes just above the bridge and then drops down to fly alongside the superstructure.

948 HES AEROFILMS SC1314960, SC1314756, SC1314961, SC1314757, SC1314758

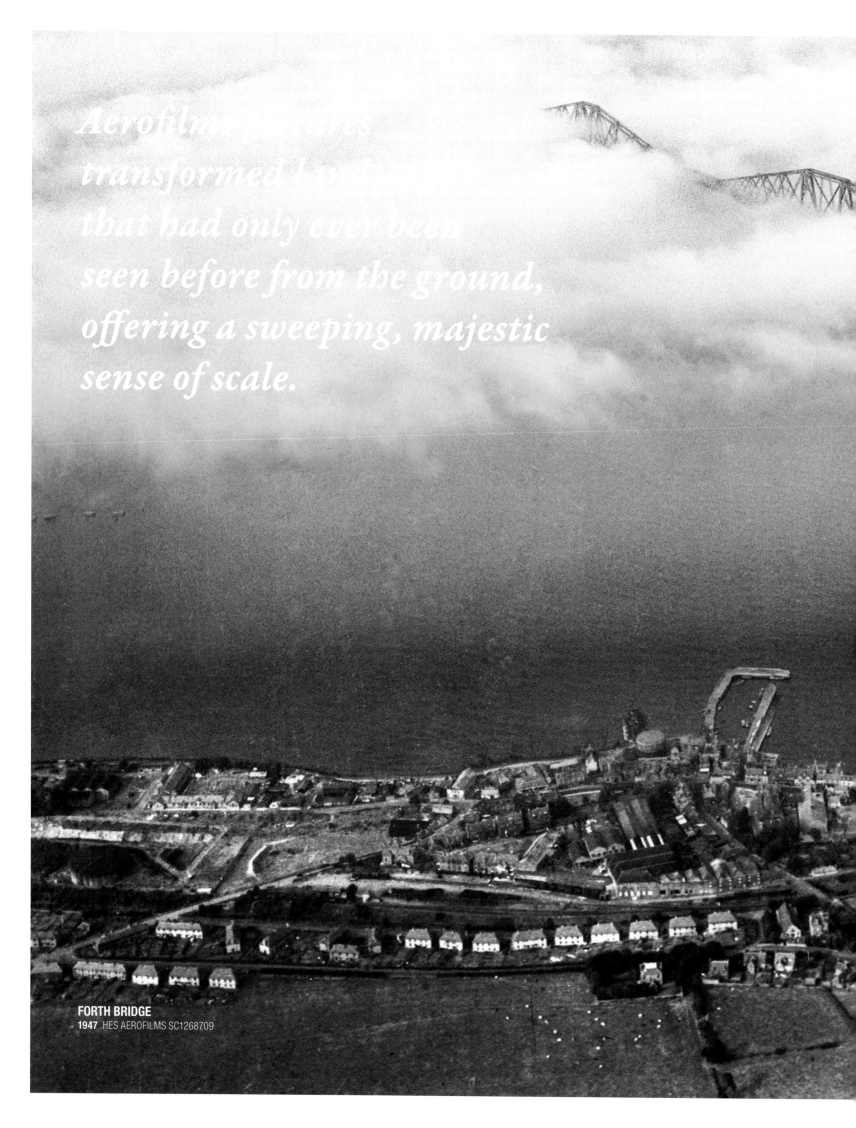

*Aerofilm...
transformed
that had only ever been
seen before from the ground,
offering a sweeping, majestic
sense of scale.*

FORTH BRIDGE
1947 HES AEROFILMS SC1268709

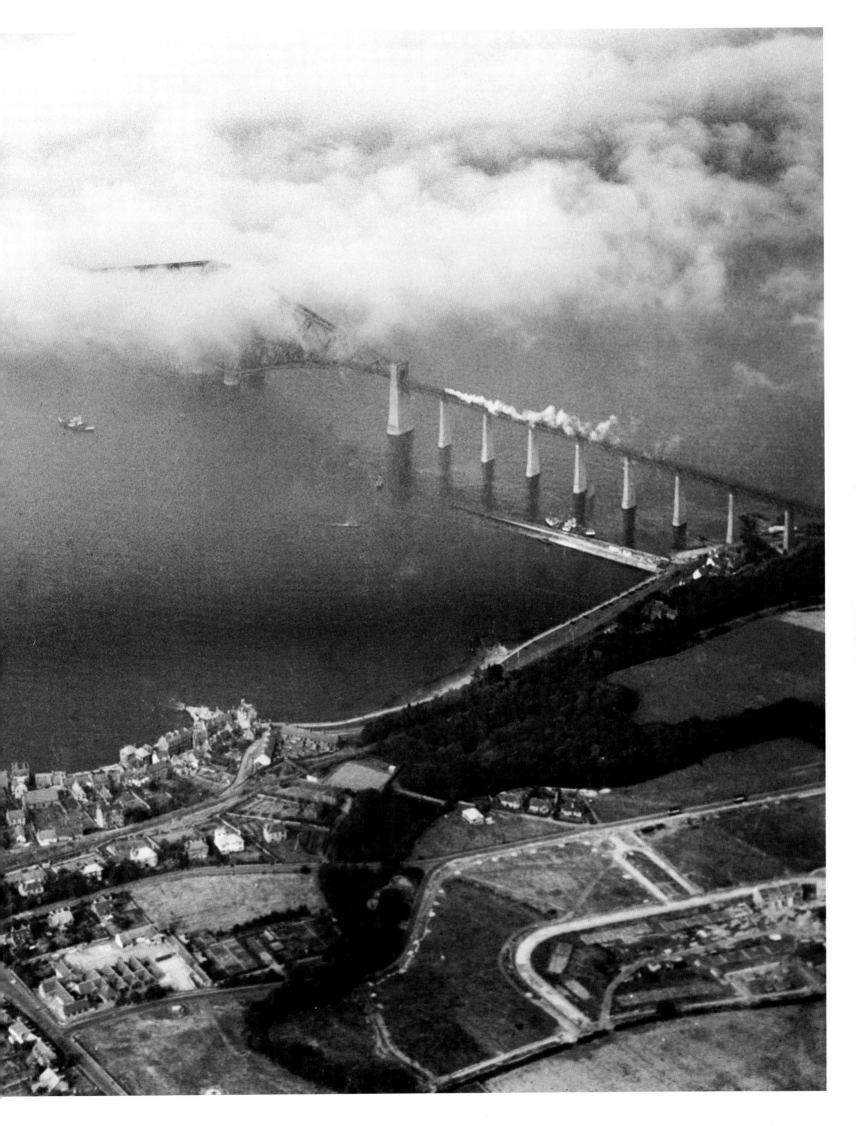

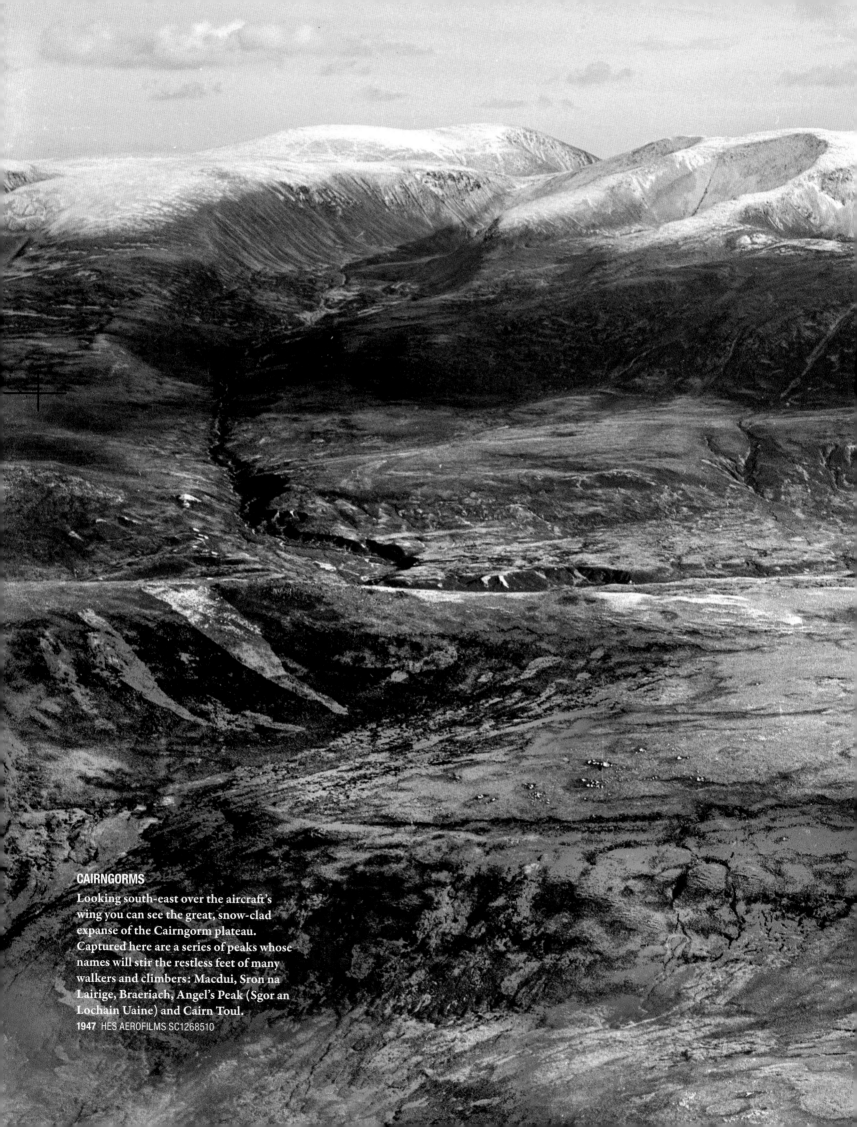

CAIRNGORMS

Looking south-east over the aircraft's
wing you can see the great, snow-clad
expanse of the Cairngorm plateau.
Captured here are a series of peaks whose
names will stir the restless feet of many
walkers and climbers: Macdui, Sron na
Lairige, Braeriach, Angel's Peak (Sgor an
Lochain Uaine) and Cairn Toul.

1947 HES AEROFILMS SC1268510

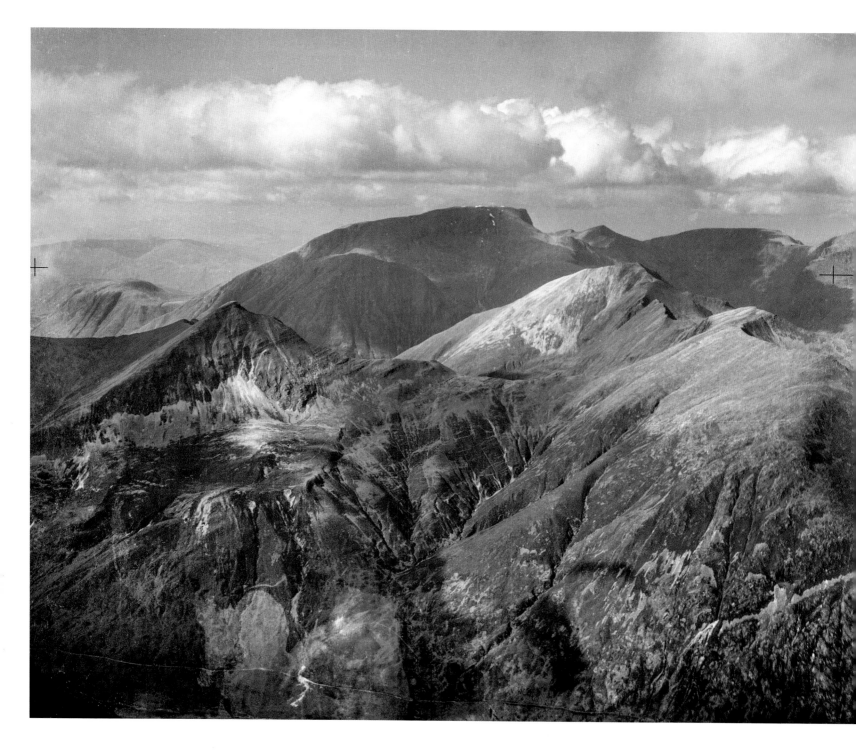

BEN NEVIS

Britain's highest peak was, inevitably, on the Aerofilms target list. Here it is photographed at a distance from the south, rising behind the summits of Stob Ban and Sgurr a' Mhaim (above), and then again (right), at much closer range, from the south-east, looking up the steep-sided approach of Coire Leis.

1947 & 1953 HES AEROFILMS SC1268504, SC1438108

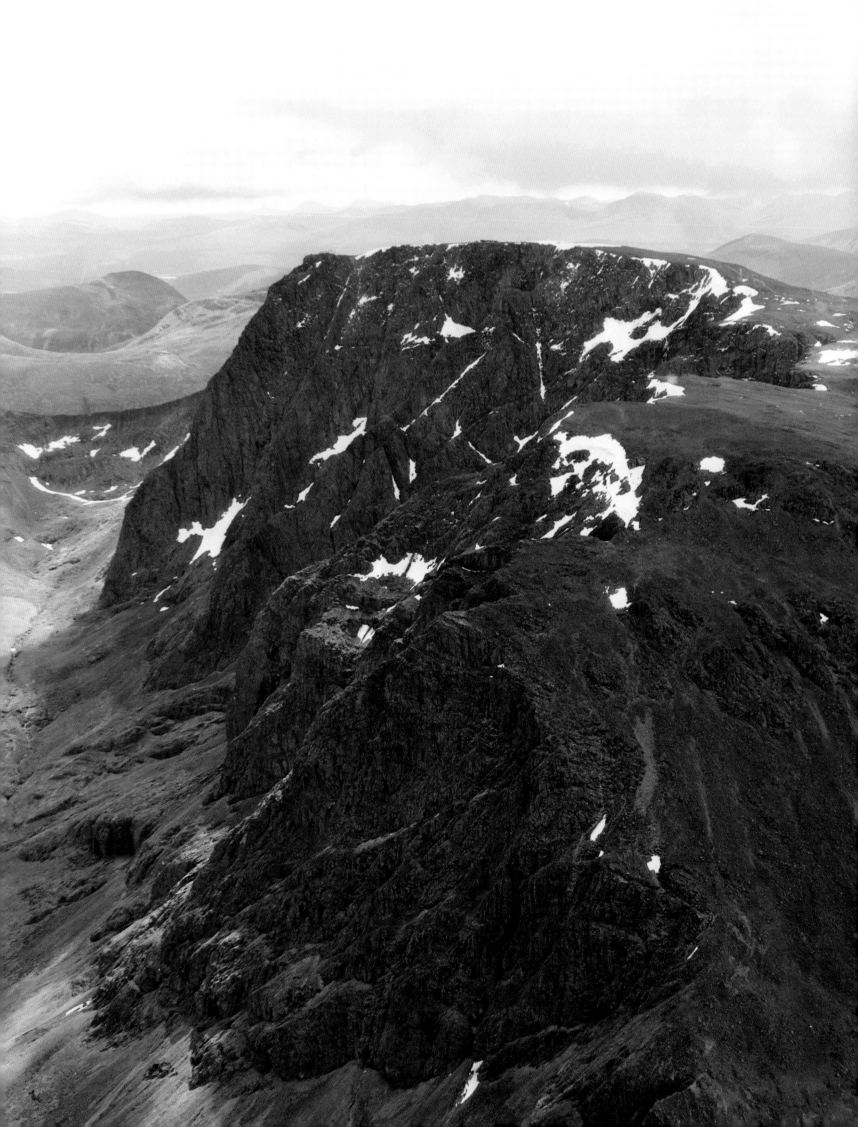

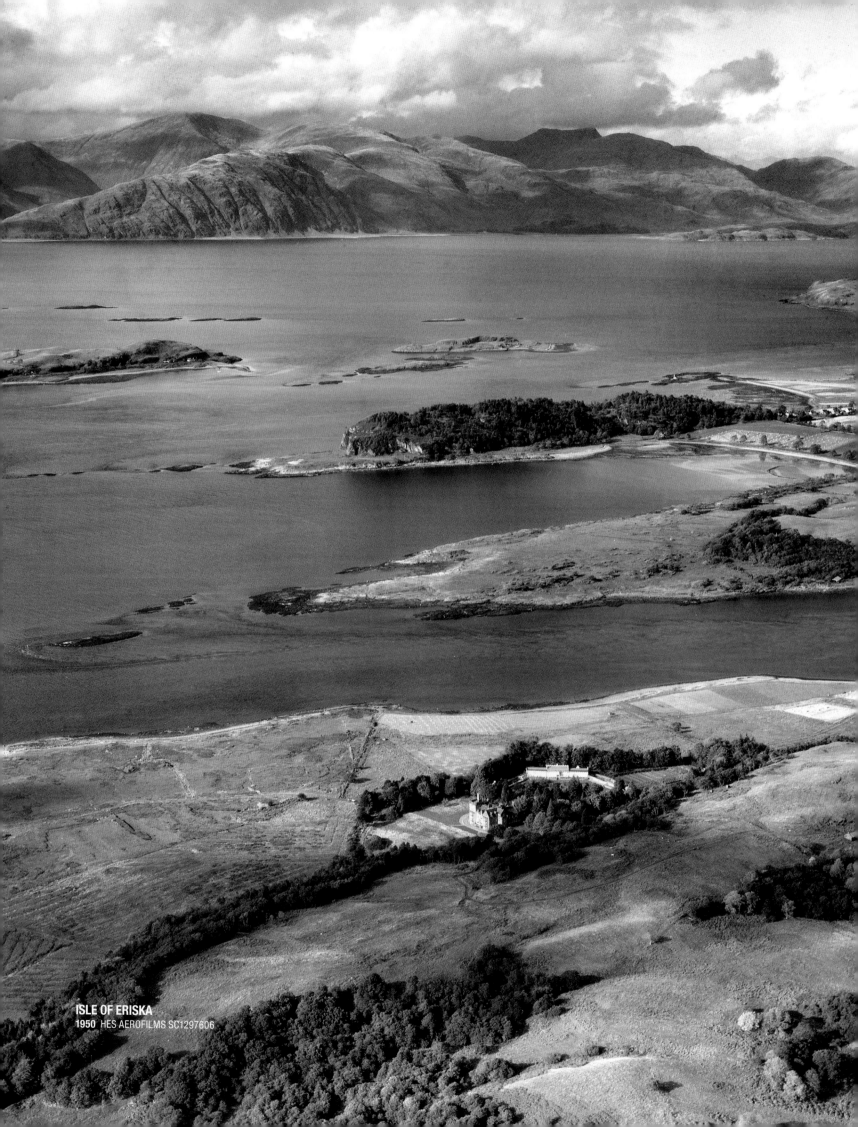

ISLE OF ERISKA
1950 HES AEROFILMS SC1297606

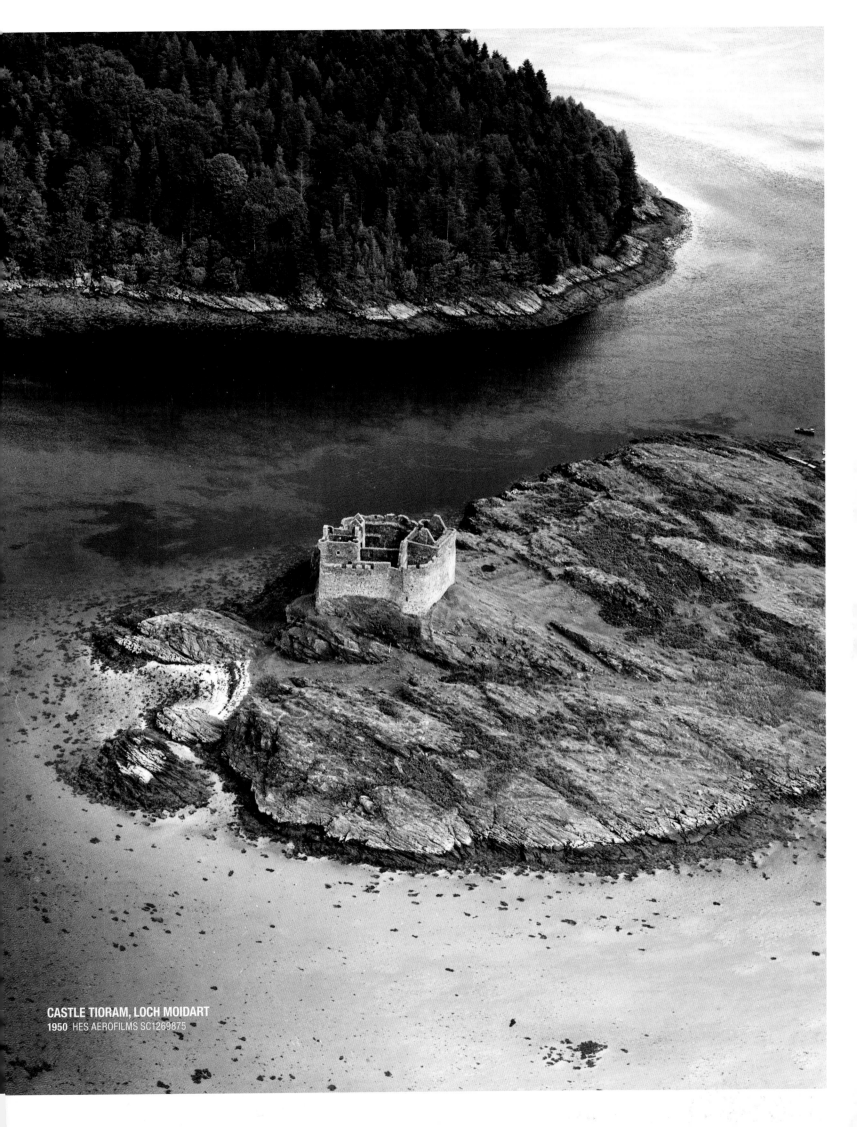

CASTLE TIORAM, LOCH MOIDART
1950 HES AEROFILMS SC1269875

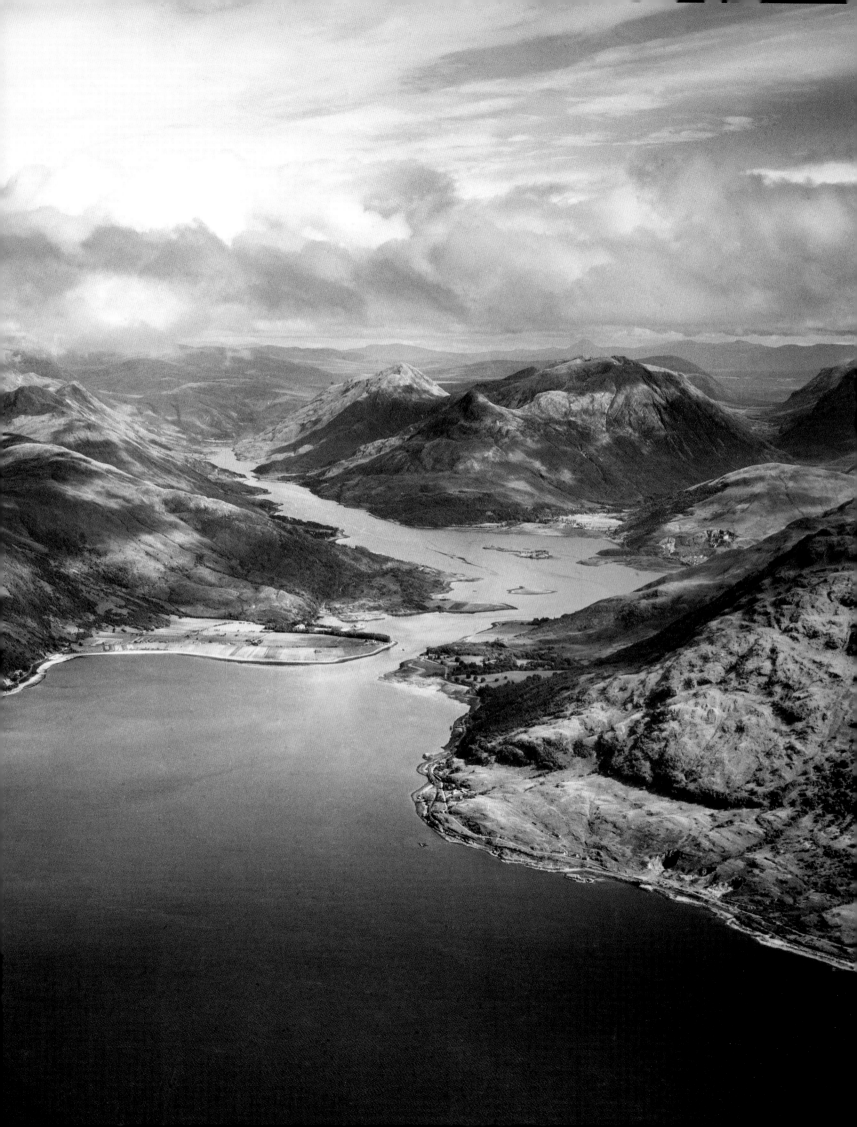

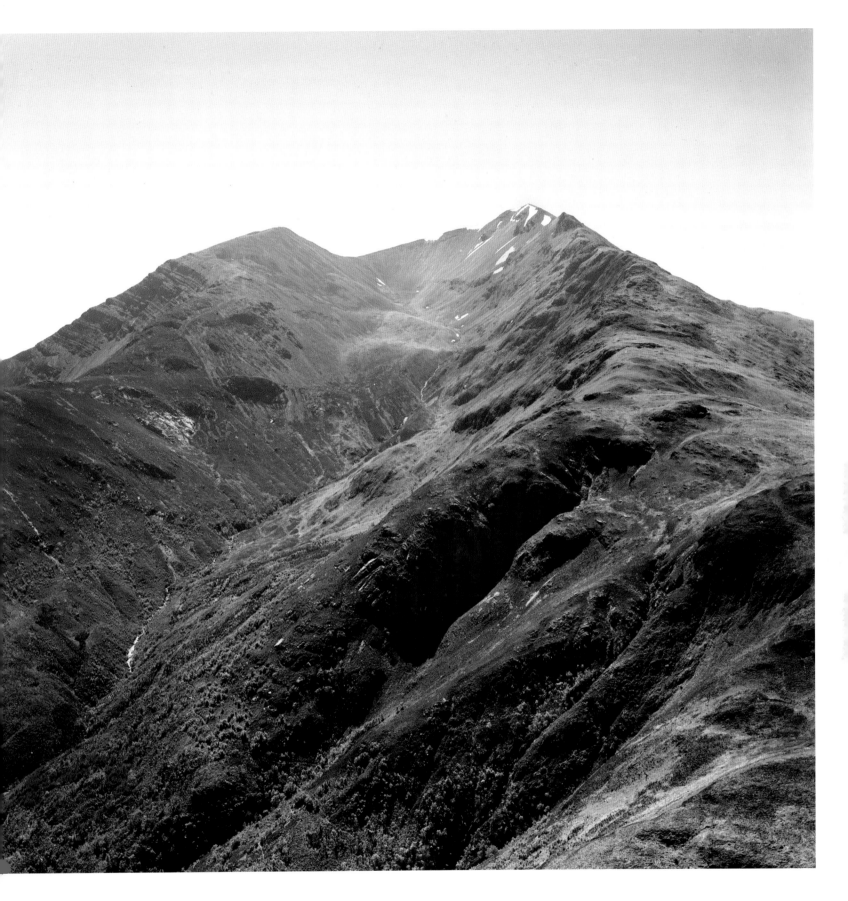

BALLACHULISH AND LOCH LINNHE

Looking inland from a flight along the rugged Lochaber coast, the photographer captures beautifully the snaking course of Loch Leven on the left and the dark funnel of Glencoe on the right – both descending to meet Loch Linnhe as it opens out to the sea.

1949 HES AEROFILMS SC1451911

BEINN A' BHEITHIR, BALLACHULISH

Towering over the village of South Ballachulish – *and* the aircraft taking this picture – is Beinn a' Bheithir, the 'Mountain of the Thunderbolt', with its two distinctive Munro peaks, Sgorr Dhearg (shown here) and Sgorr Dhonuill.

1950 HES AEROFILMS SC1269530

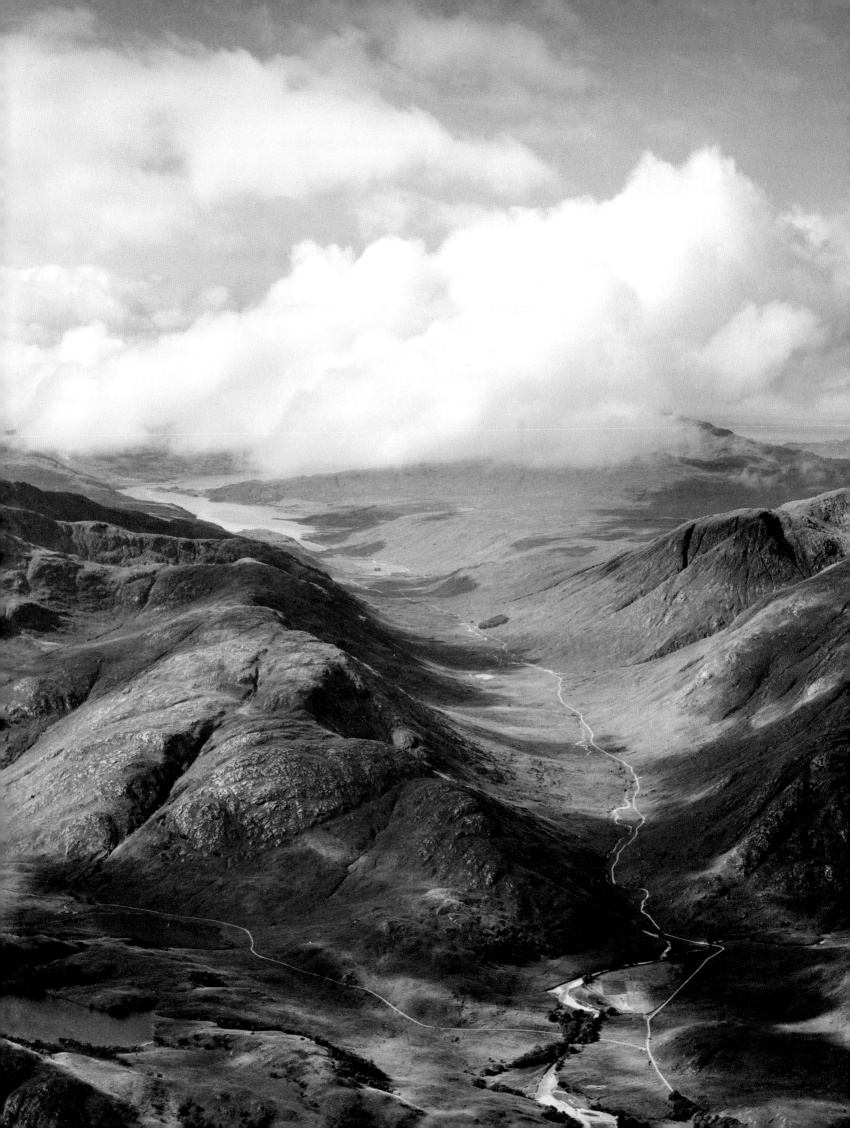

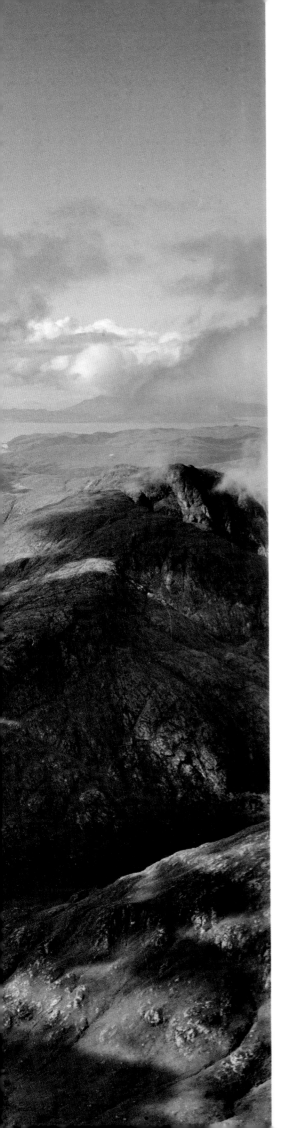

GLEN TARBERT, ARGYLL

While the work of Aerofilms was driven by raw commercialism and determined by opportunism, there is no doubting the enduring beauty of many of their photographs. This view of Glen Tarbert uses light and shadow to stunning effect, echoing the pictures of the renowned photographer of American landscapes, Ansell Adams. In black and white you can almost feel the hard texture of the rocky, sun-dappled mountains, while the cloudbanks mustering on the horizon bring a defined, cotton-boll softness that balances the whole image.

1949 HES AEROFILMS SC1451915

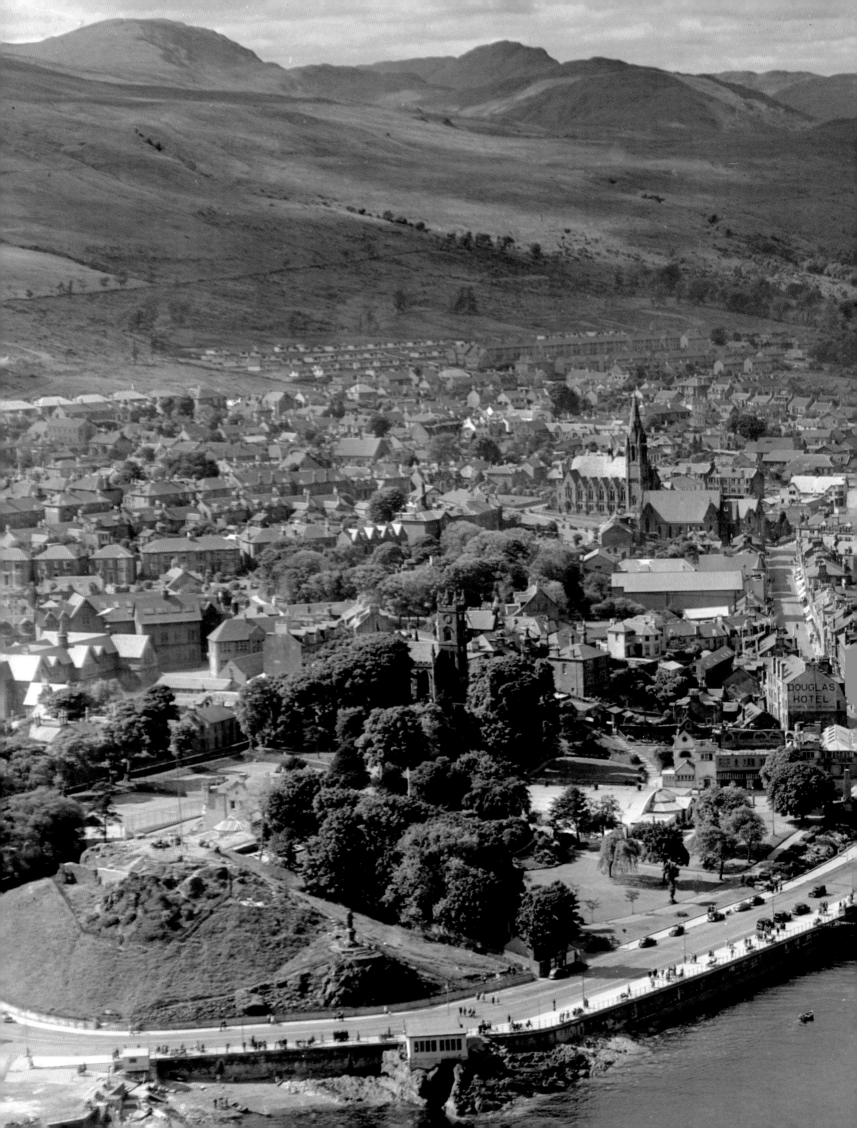

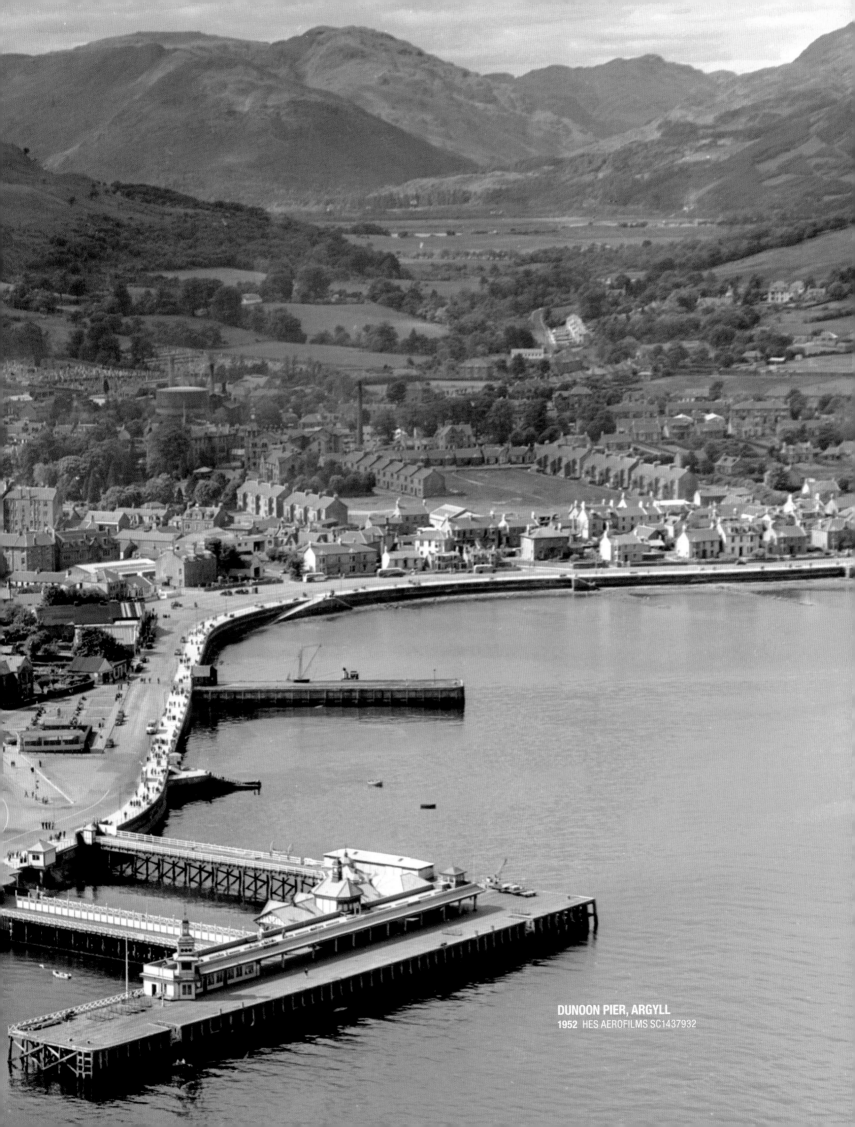

DUNOON PIER, ARGYLL
1952 HES AEROFILMS SC1437932

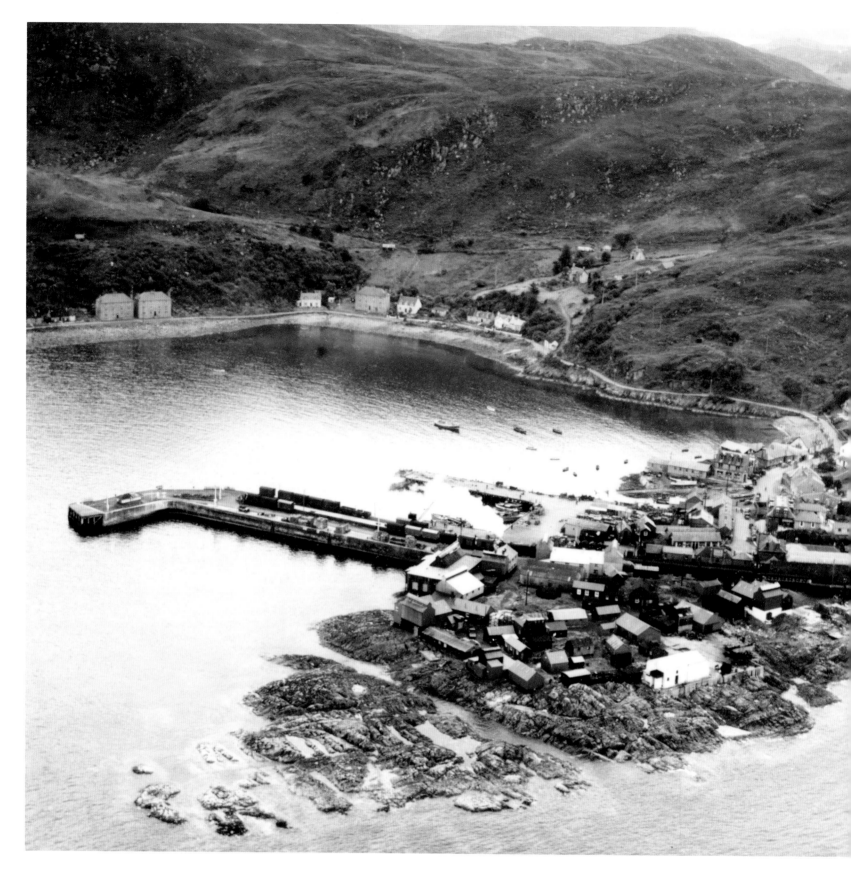

MALLAIG HARBOUR, LOCHABER
1951 HES AEROFILMS SC1315315

OBAN, ARGYLL
1950 HES AEROFILMS SC1269518

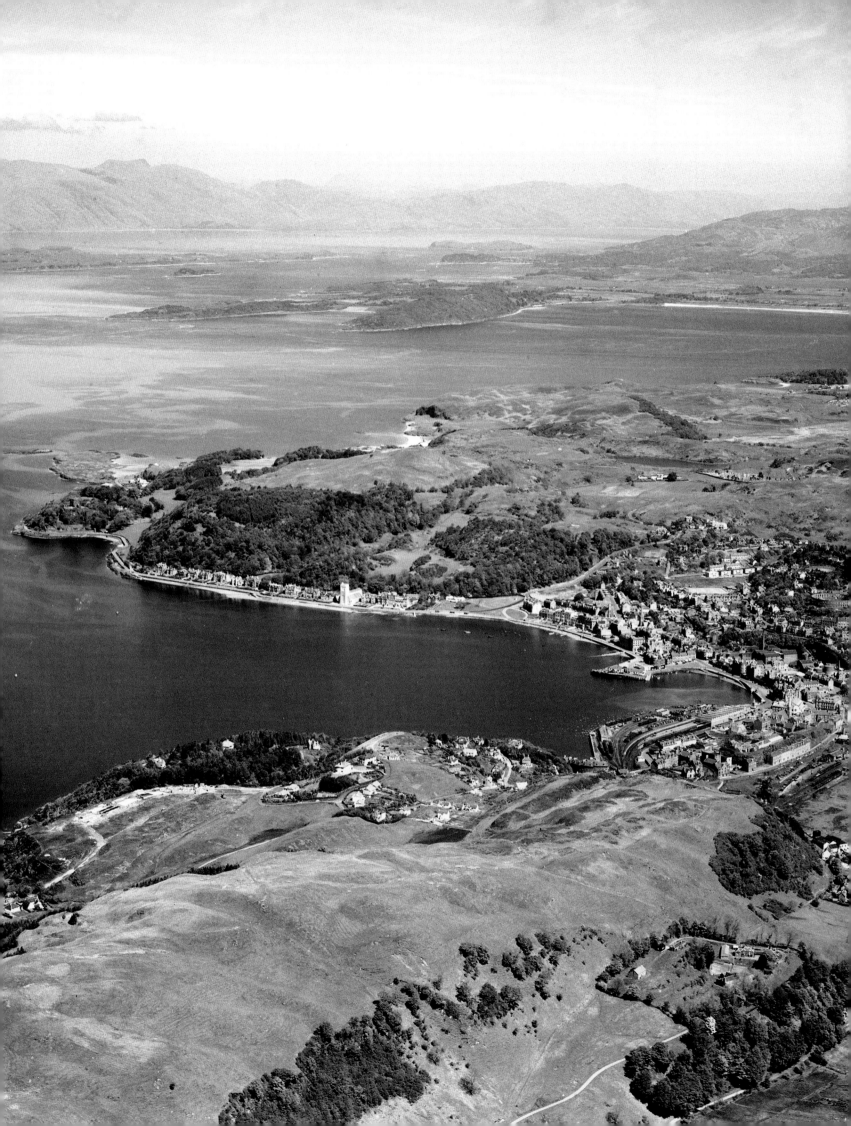

STRATHCONON

From the sky you can see how the meltwater from the receding snowfields of Strathconon flows down innumerable runnels to brim the waters of Loch na Caoidhe on the left, An Gorm-loch on the right. When confronted by images like this, it is hard not to feel envious of the Aerofilms pioneers, flying in their open-cockpit aircraft over such relentlessly breathtaking scenery. Owing to the ever-changing nature of flight technology and the progressive introduction of air-traffic restrictions, theirs was an experience that, to this day, remains almost entirely unrepeated.

1950 HES AEROFILMS SC1269566

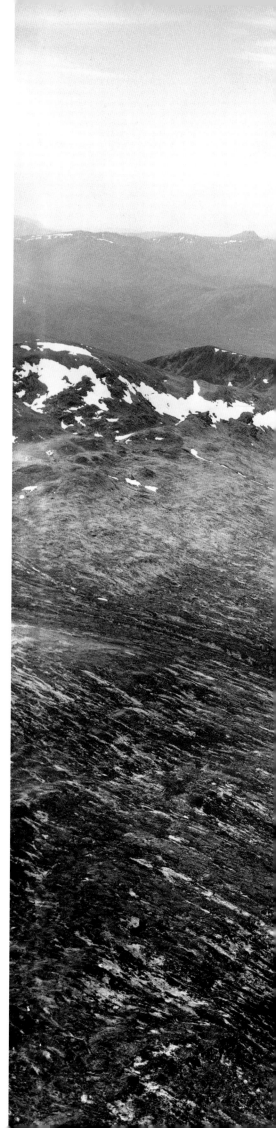

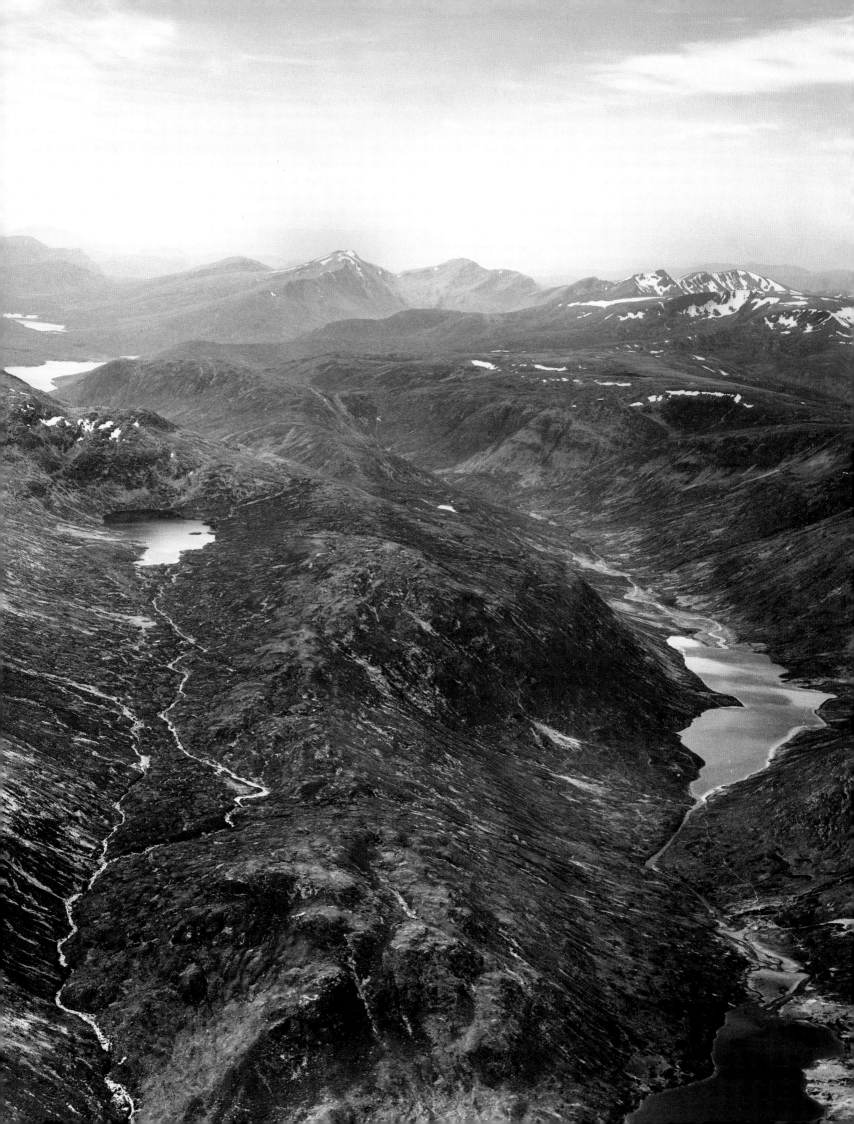

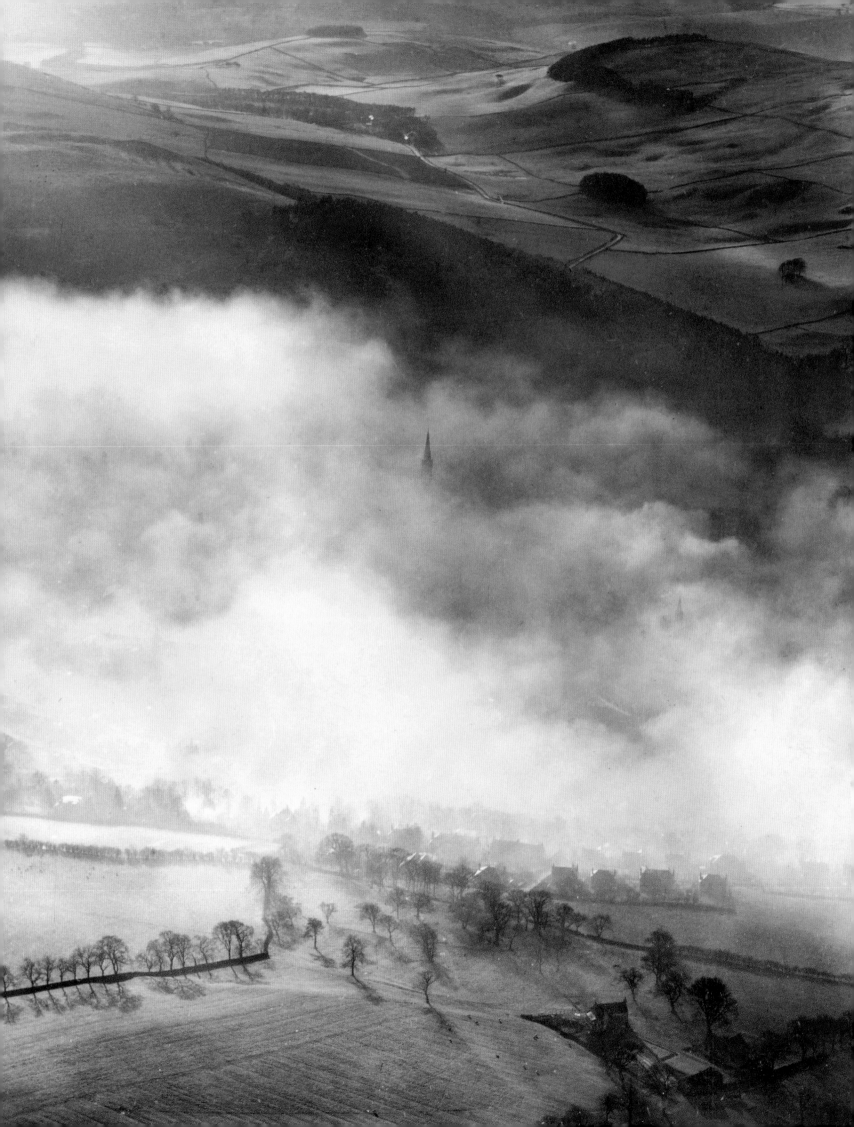

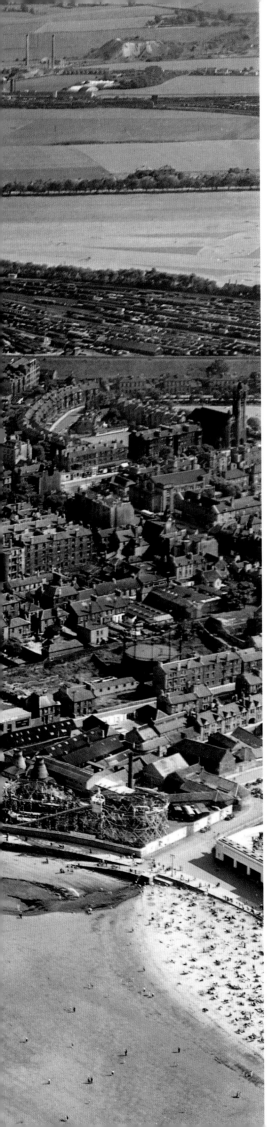

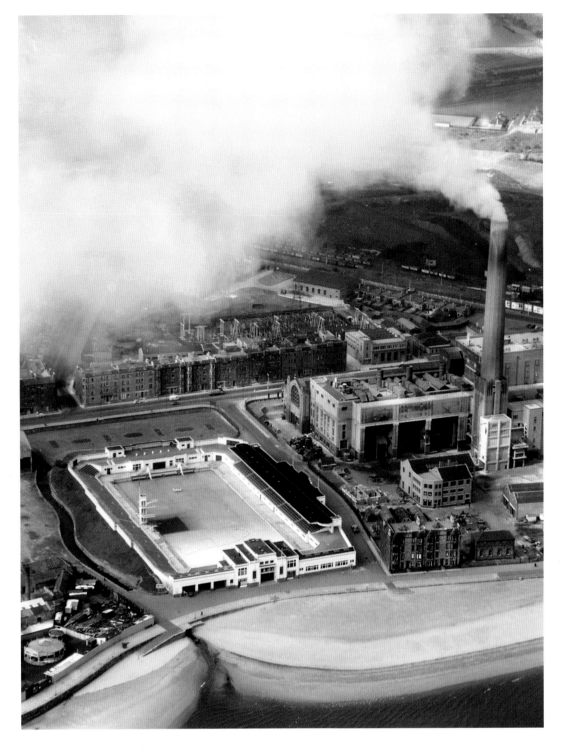

PORTOBELLO, EDINBURGH

Crowds spill out from the promenade onto a wide expanse of beach on a beautiful summer's day in 1953. From the mid 1930s to the late-1970s, Portobello's star attraction was its giant, Art Deco, outdoor swimming pool (above). It boasted an artificial wave machine, and was heated by waste energy from the adjoining Portobello Power Station. Competition from cheap foreign package holidays saw its popularity wane, however, and it closed in 1979. It lay derelict for almost a decade, before it was finally demolished in 1988.

1953 & 1958 HES AEROFILMS SC1438555, SC1438555

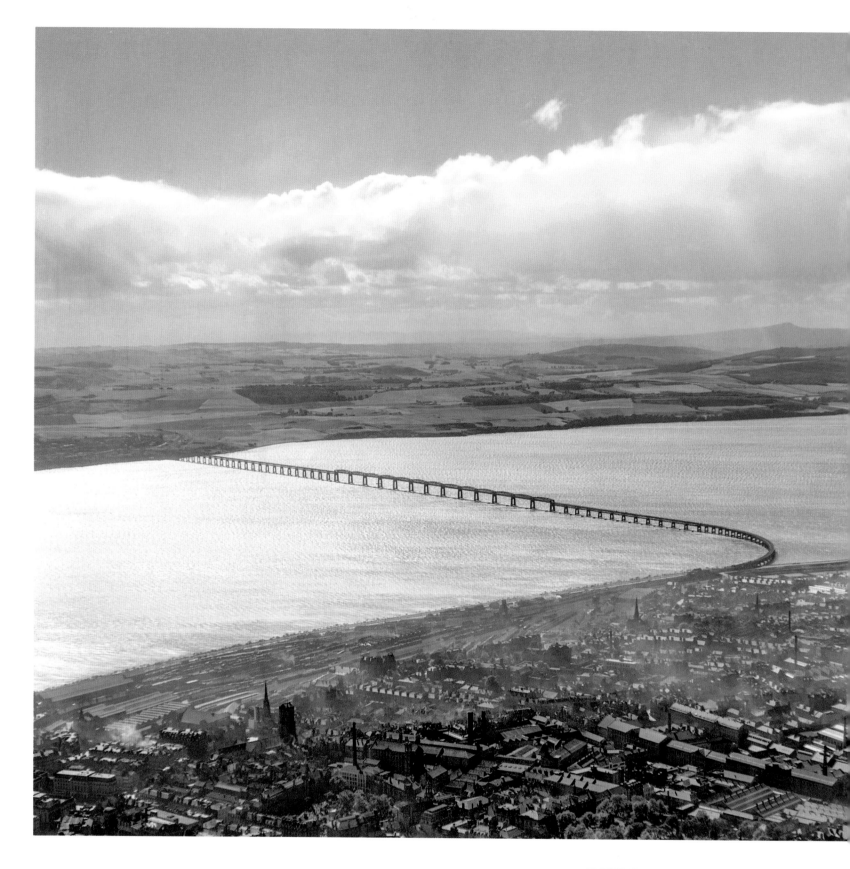

THE TAY BRIDGE, DUNDEE
1952 & 1949 HES AEROFILMS SC1438019, SC1269314

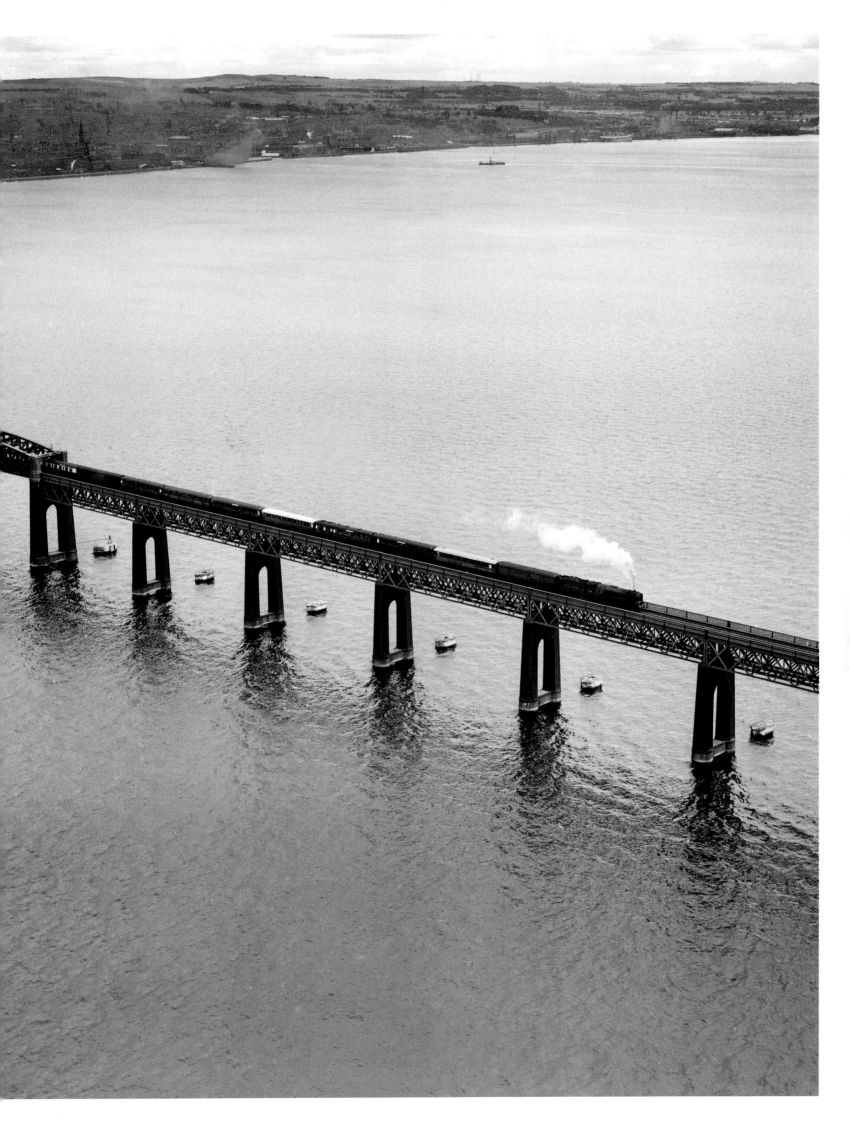

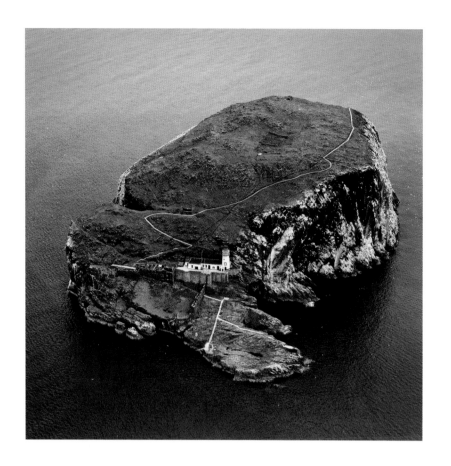

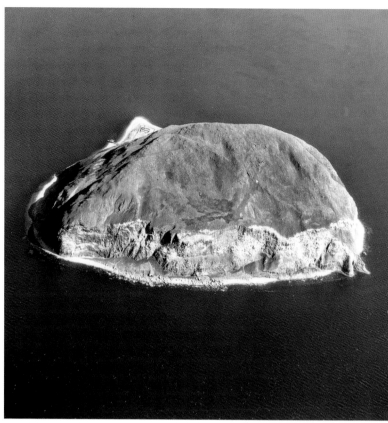

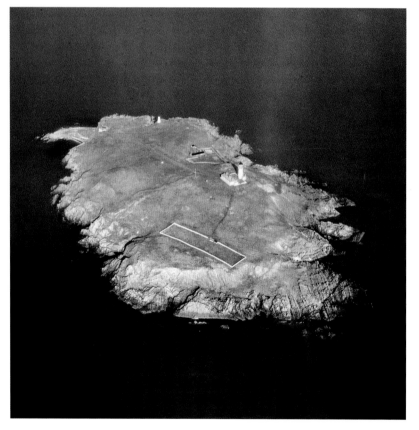

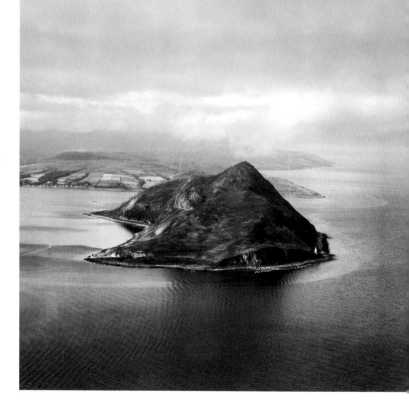

BASS ROCK, NORTH BERWICK
1950 HES AEROFILMS SC1269678

LITTLE ROSS, KIRKCUDBRIGHT, DUMFRIES & GALLOWAY
1947 HES AEROFILMS DP096785

AILSA CRAIG, AYRSHIRE
1947 HES AEROFILMS SC1438179

HOLY ISLAND, ARRAN
1947 HES AEROFILMS SC1268773

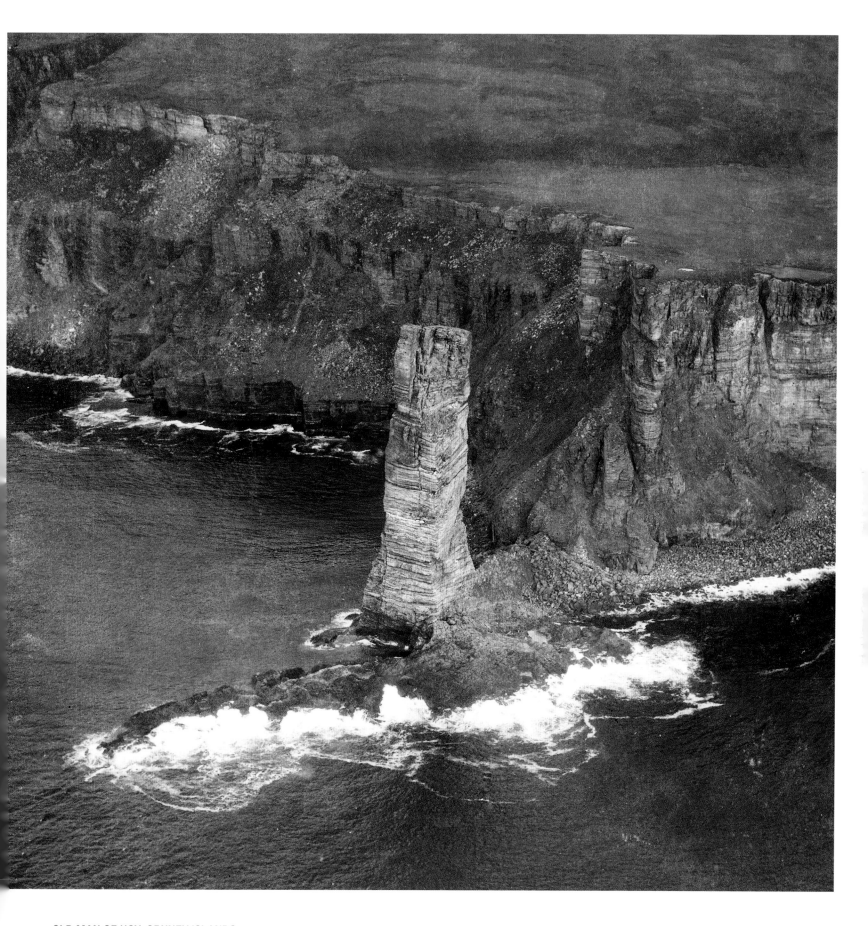

OLD MAN OF HOY, ORKNEY ISLANDS

As the decades passed, Aerofilms flew further and further afield, traversing Scotland's coastlines and seeking out picturesque imagery of remote islands.

By the late 1940s, they had reached the Orkney Islands, taking this spectacular shot of the famous sea stack, the Old Man of Hoy.

1947 HES AEROFILMS SC1268499

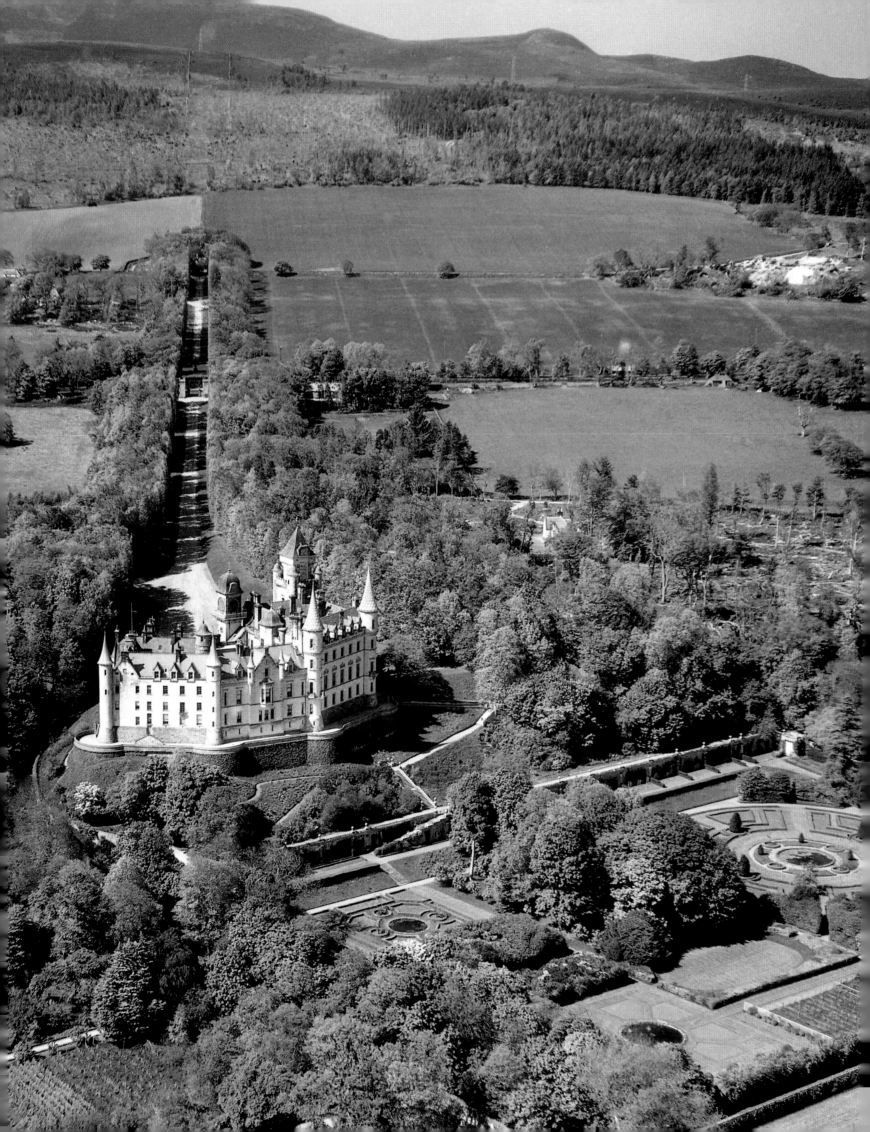

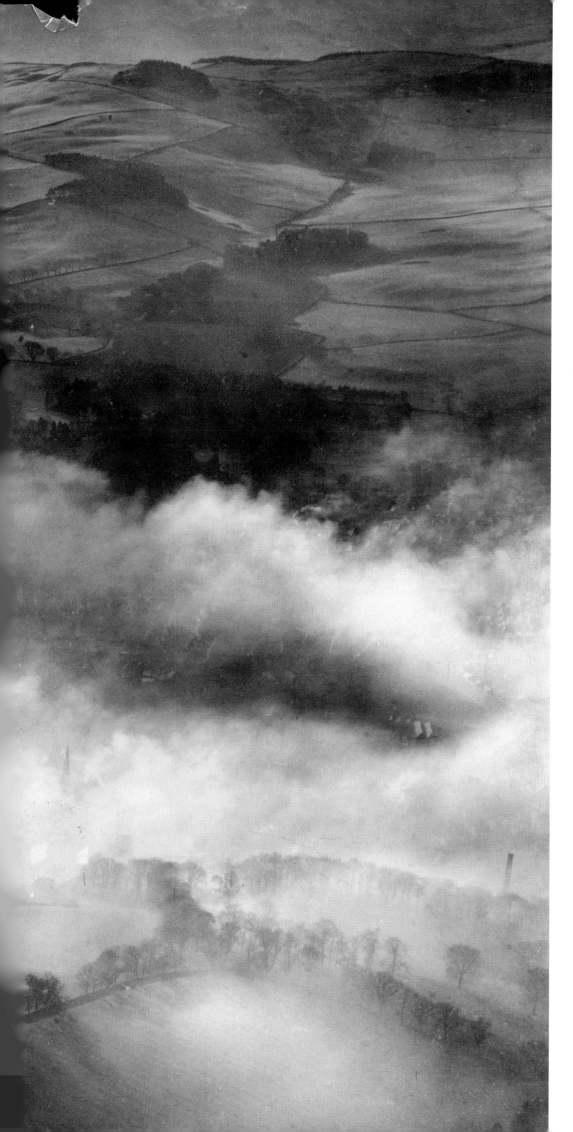

GALASHIELS, BORDERS

Morning mist clings to the valley of the Gala Water, shrouding almost the whole town from view – with the exception of three church spires, just poking through. Beyond, to the south-west, the low sun picks out rutted undulations in fields leading off towards the Southern Uplands.

1951 HES AEROFILMS SC1315205

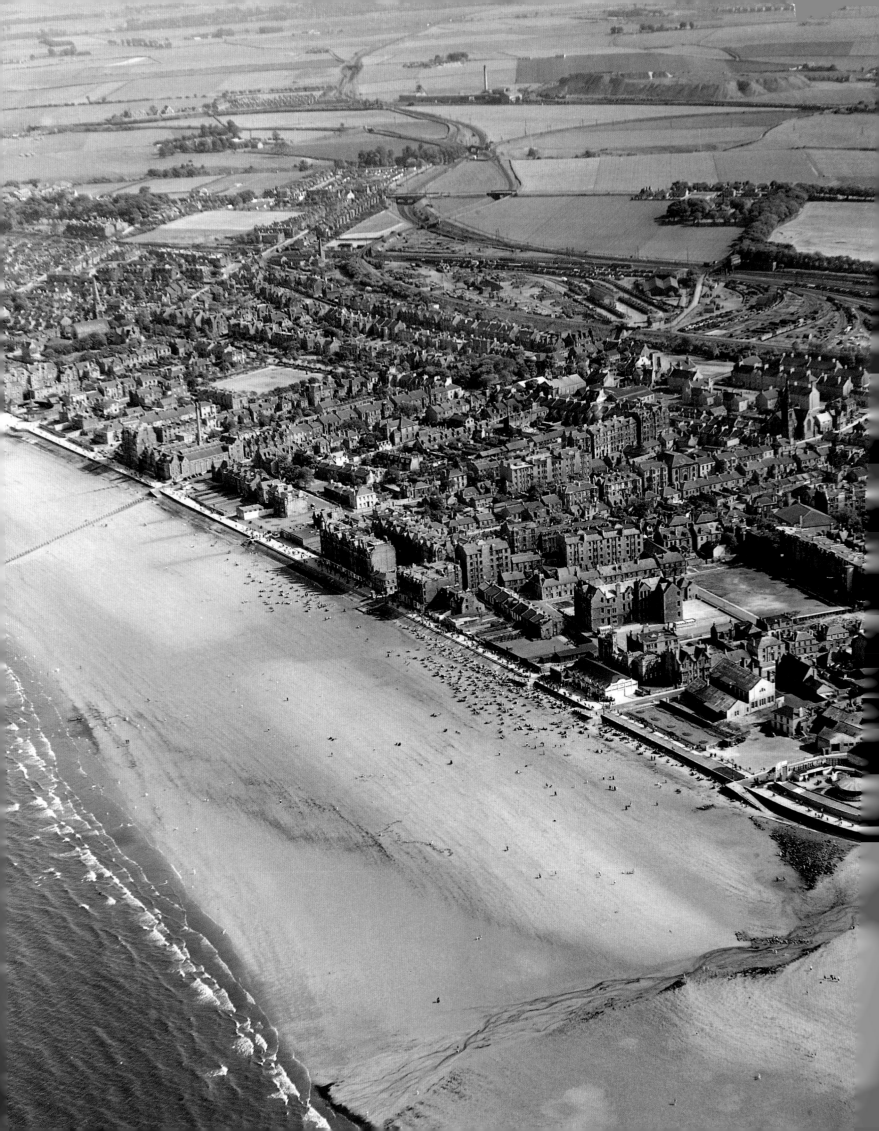

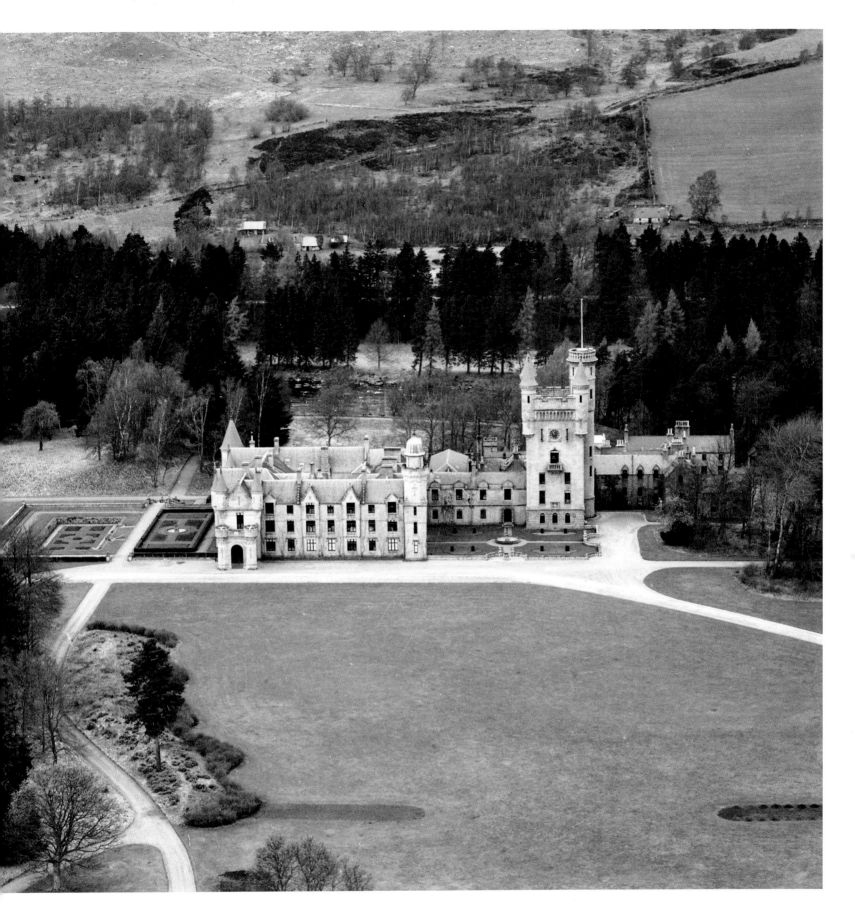

BALMORAL CASTLE, ABERDEENSHIRE
1948 HES AEROFILMS SC1438437

DUNROBIN CASTLE, SUTHERLAND
1955 HES AEROFILMS SC1268880

MONTGOMERIE HOUSE, SOUTH AYRSHIRE

The shadow of the Aerofilms aircraft sweeps over the driveway of this ostentatious country house near the village of Tarbolton. The owner's sleek black Cadillac is parked right by the front steps. The van parked off to one side is the Morris Z of a Post Office telephone engineer making a house call. As well as capturing the sweep and scale of Scotland's early twentieth century landscapes, the Aerofilms images offer a wealth of tiny domestic details. Rather more obviously, this photograph is a record of a building now lost to us. Montgomerie House was gutted by fire in 1969 and later demolished. Go to the site today and there is almost no trace at all – just a little copse of trees, criss-crossed by paths which surround one little stretch of the old driveway.

1947 HES AEROFILMS SC1268820

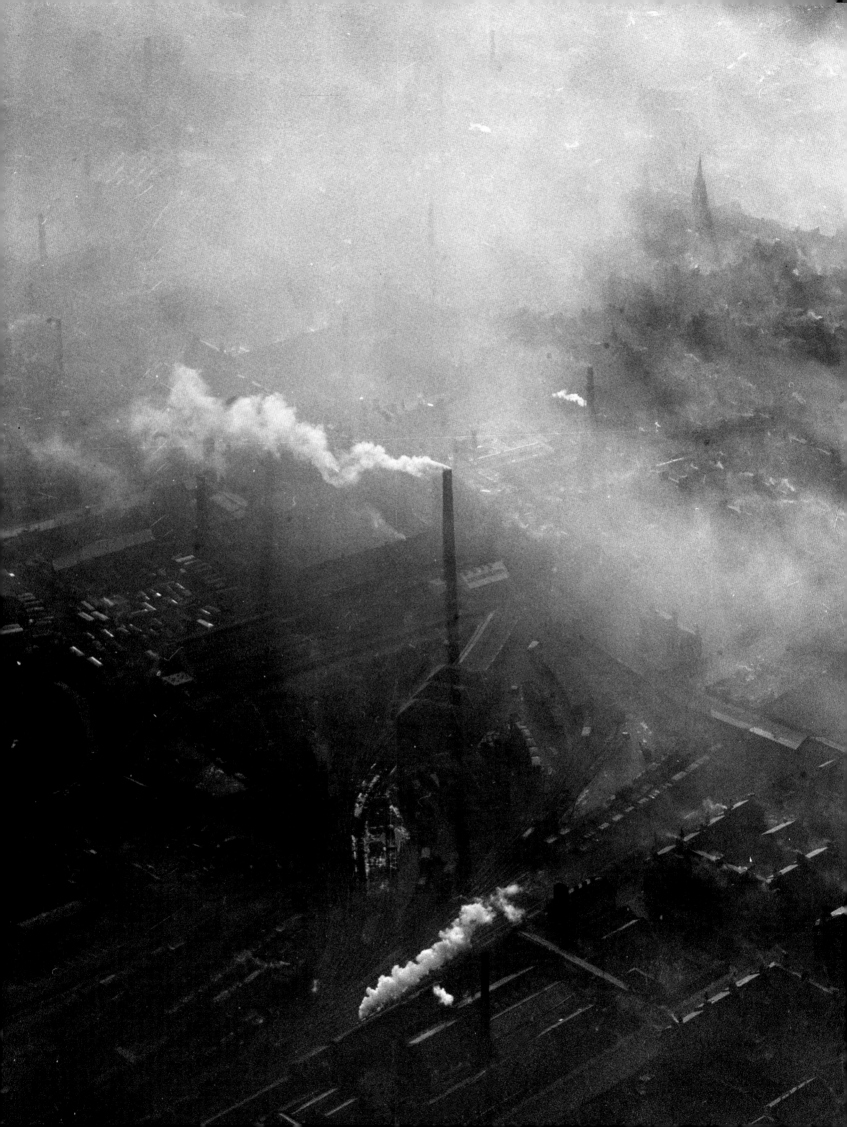

If it wasn't for the photographs taken by Aerofilms, all memory of how these sites dominated the landscape would dwindle and fade away.

GLASGOW, GALLOWGATE

A cityscape dominated by drifting smoke. Two sources of the all-consuming smog announce themselves most immediately in this image – the huge chimney of the Campbellfield Pottery Works, and, just below it, the distinctive trail left behind by a departing steam train.
1952 HES AEROFILMS SC1297842

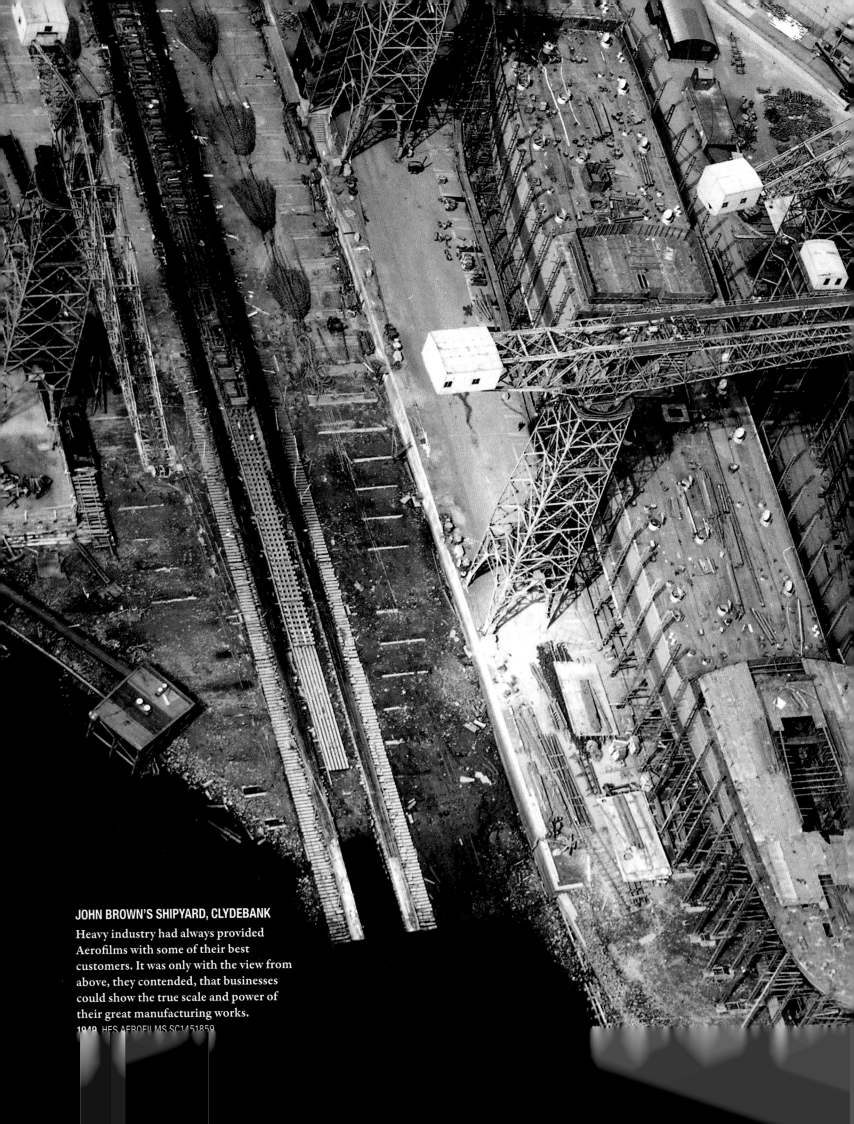

JOHN BROWN'S SHIPYARD, CLYDEBANK

Heavy industry had always provided Aerofilms with some of their best customers. It was only with the view from above, they contended, that businesses could show the true scale and power of their great manufacturing works.

1949 HES AEROFILMS MS SC1451859

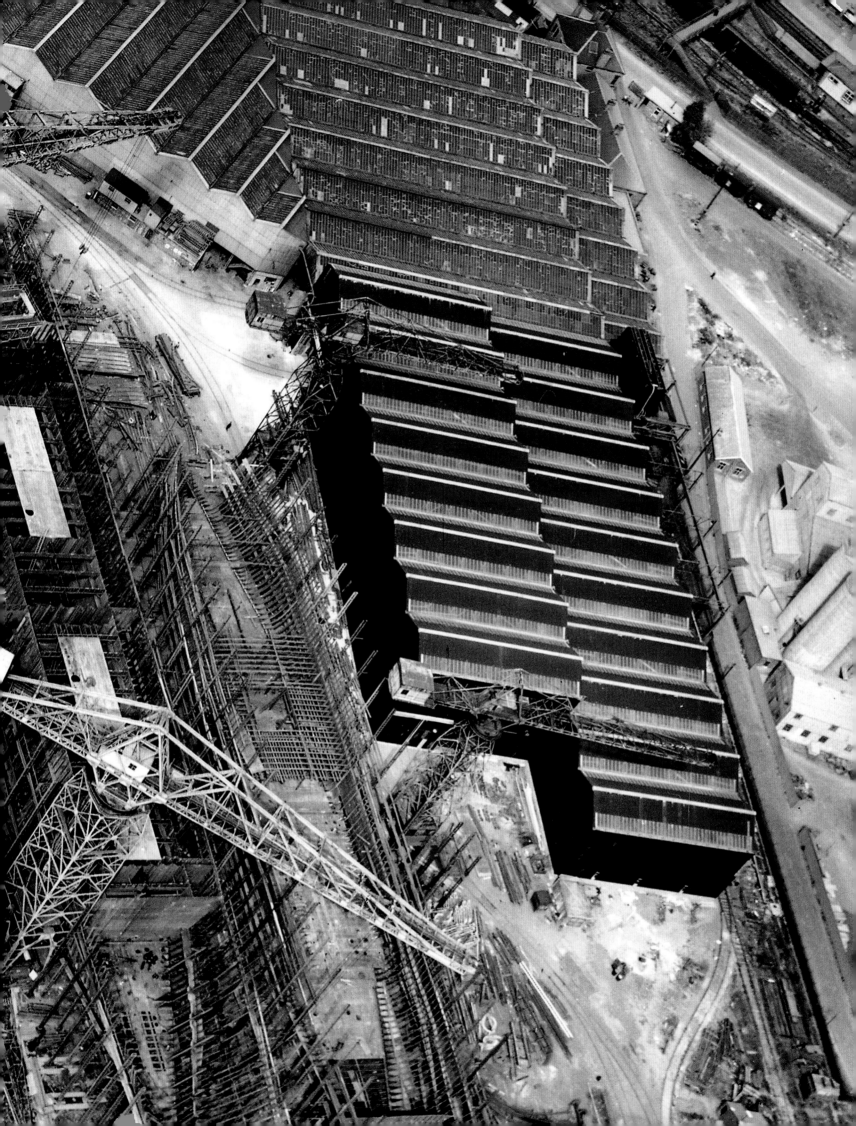

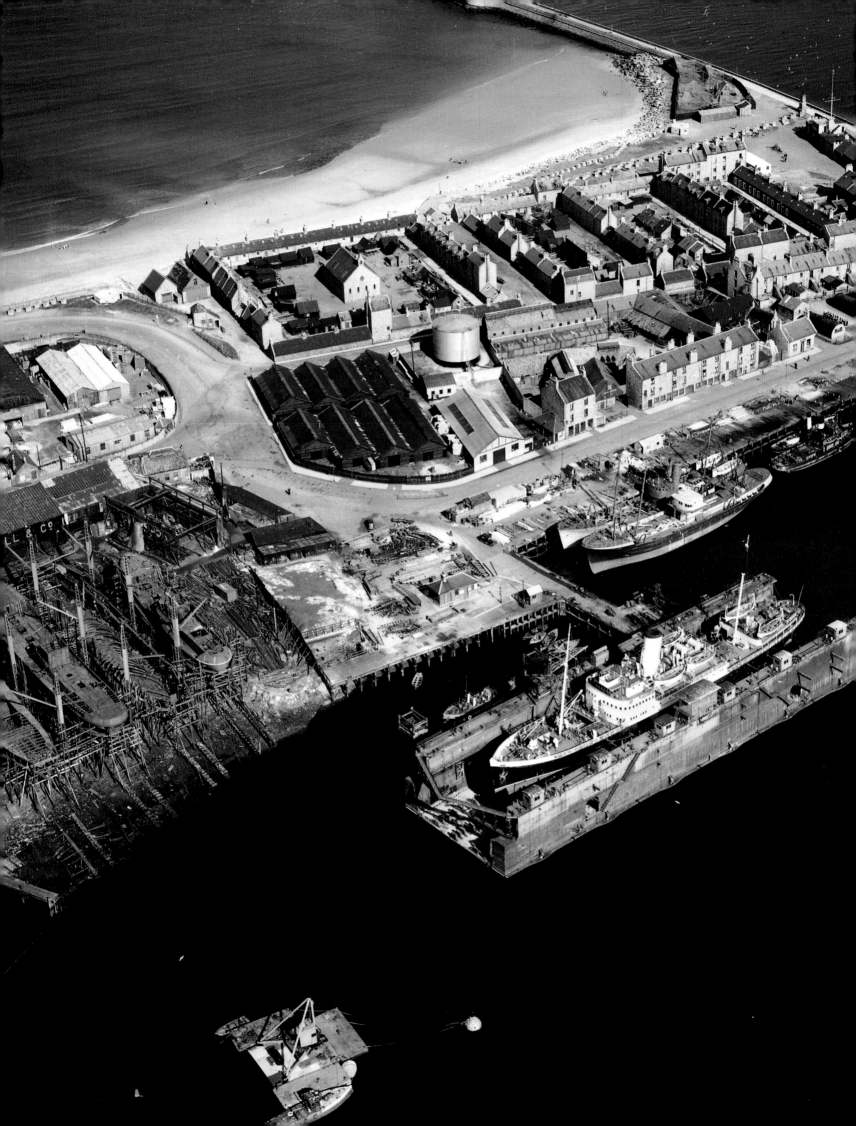

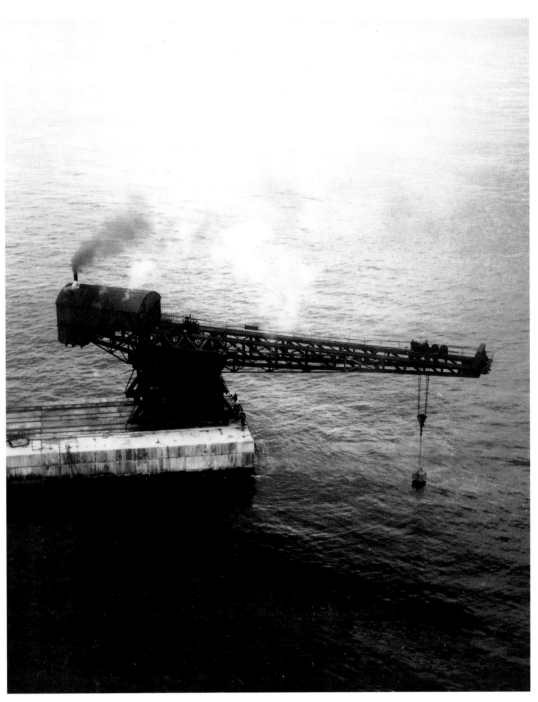

TITAN CRANE, PETERHEAD HARBOUR
1948 HES AEROFILMS SC1269000

POCRA QUAY, ABERDEEN HARBOUR
1949 HES AEROFILMS SC1315009

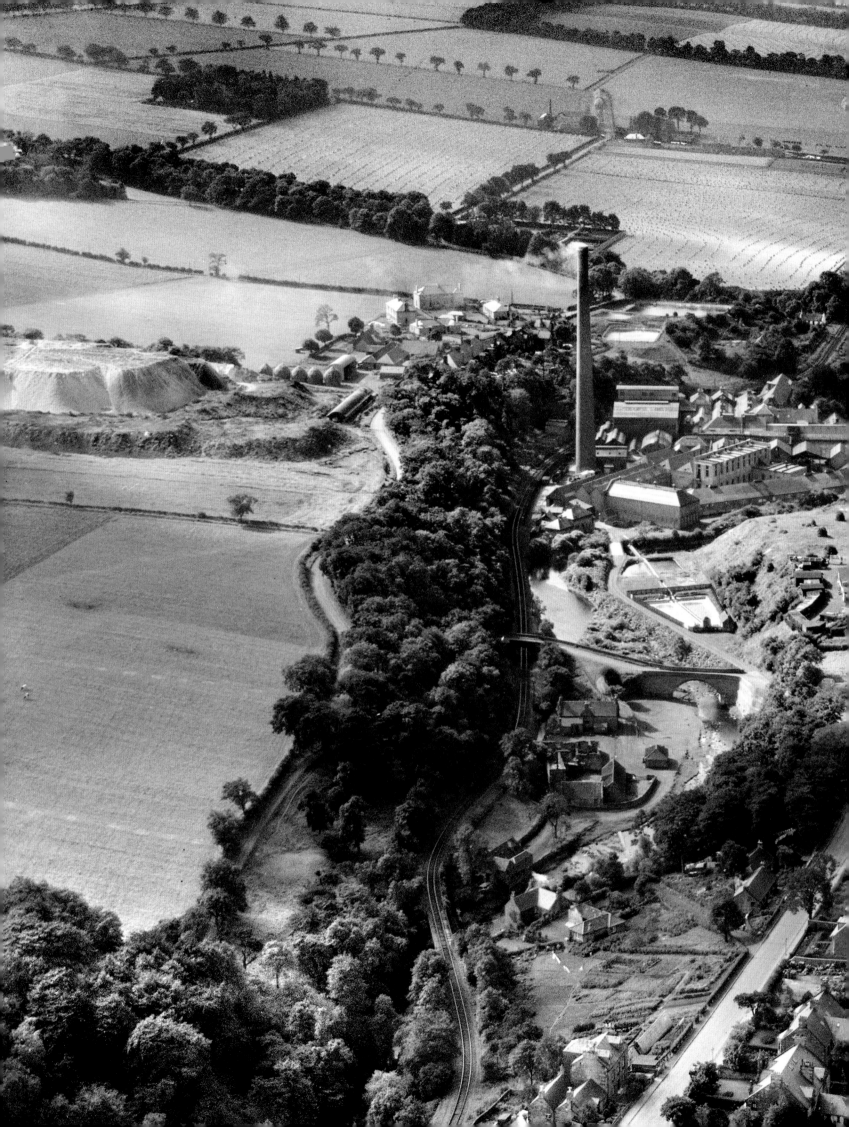

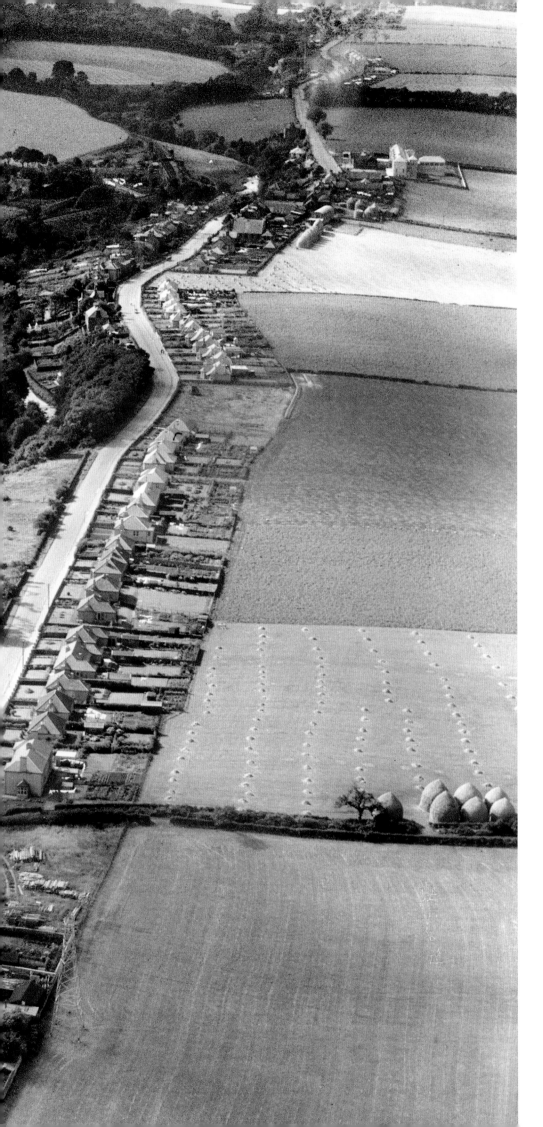

KINLEITH PAPER MILLS, CURRIE

This huge mill, with its towering chimney, squeezes itself into the steep-sided valley of the Water of Leith below Lanark Road. What once dominated the whole area is now gone completely, replaced by a modern housing estate – while the train track that passes alongside the mill has become a popular path for cyclists and walkers.

1932 HES AEROFILMS SC1257268

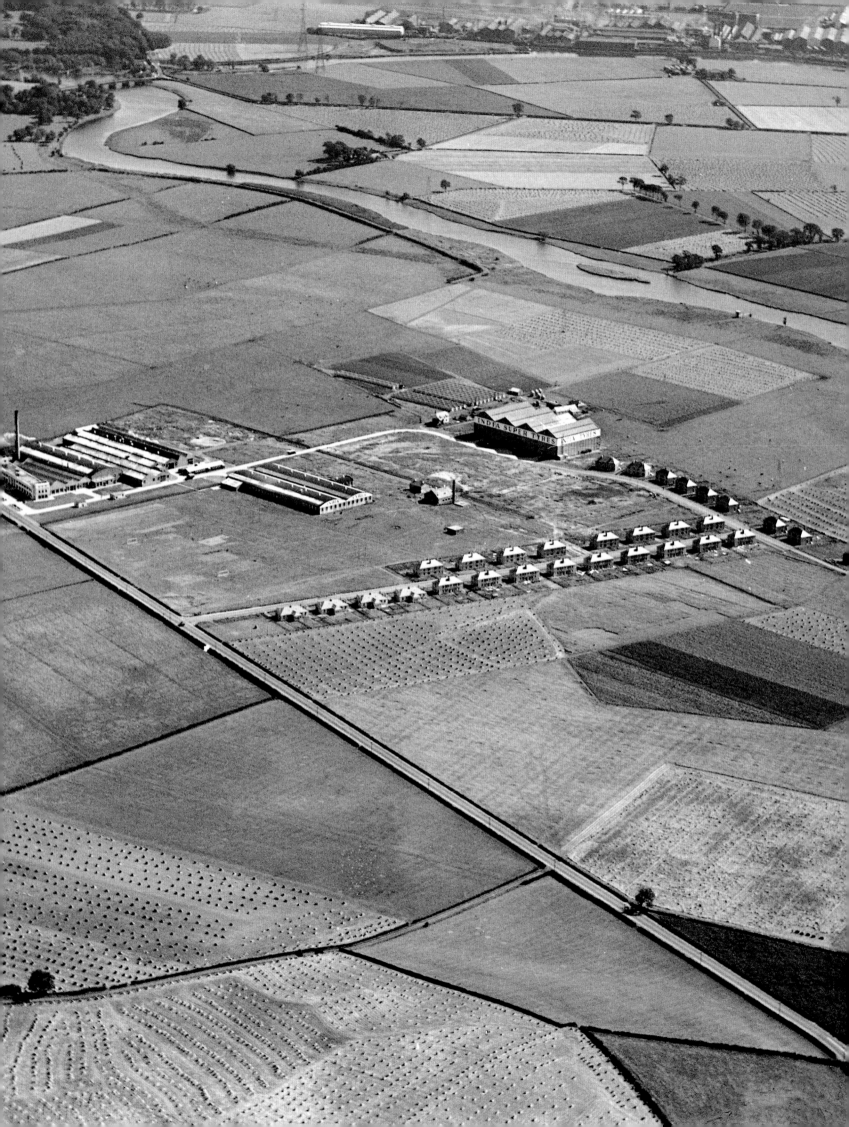

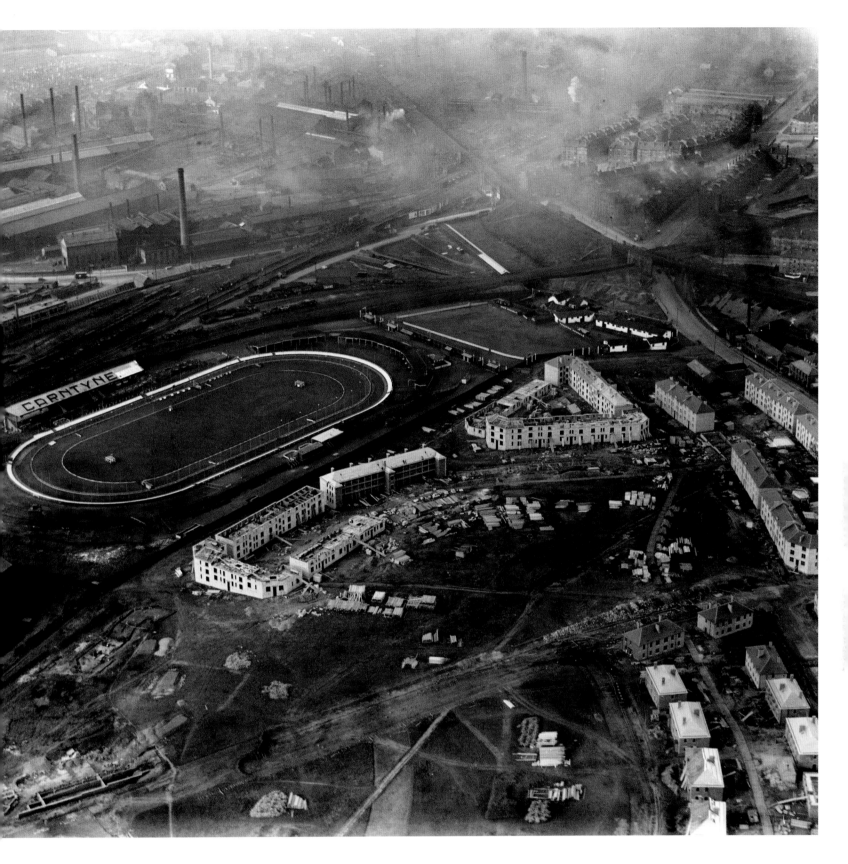

INDIA TYRE FACTORY, INCHINNAN

A whole new community emerges among the fields and hay bales of Renfrewshire. Ordered rows of brand new houses have been built along 'India Drive' for the workers of the India Tyre Company.

1930 HES AEROFILMS SC1452041

CARNTYNE STADIUM, GLASGOW

Sandwiched between railway lines, factories and a housing development construction site, Carntyne Stadium looks remarkably pristine. Not surprising, given that it was only built a few years before this photograph was taken. For half a century it hosted greyhound racing and speedway, until, in 1972, the site was sold on and the stadium demolished by its new owners.

1932 HES AEROFILMS SC1257397

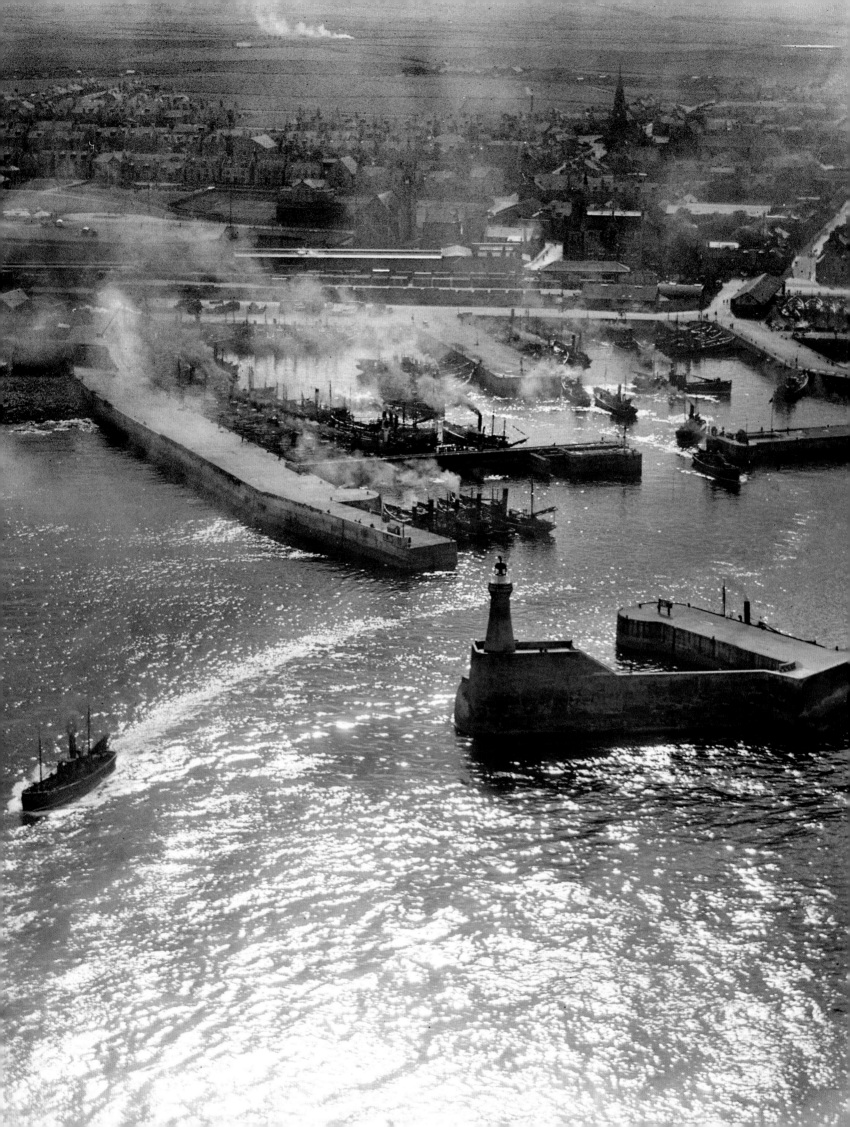

FRASERBURGH, ABERDEENSHIRE

Scotland's industry was not confined to
the great cities of the Central Belt. Here,
the harbour at Fraserburgh is a smoky
stramash of activity. As the boats head out
to the fishing grounds, the Aerofilms pilot
skims the sea to follow one vessel. The
crew appear to appreciate the attention
– look closely and you can see them all
gathered at the stern, with one waving his
hat eagerly up at the aircraft.

1939 HES AEROFILMS SC1258307, SC1258312

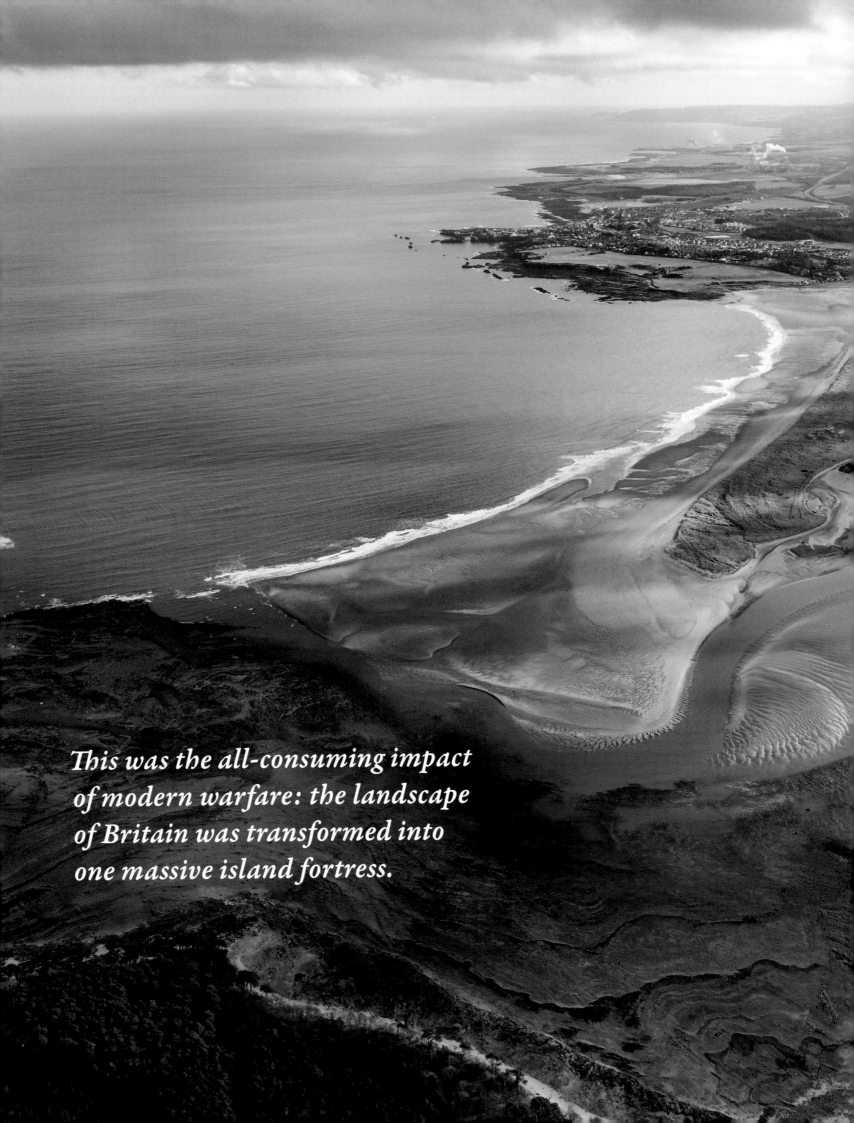

This was the all-consuming impact of modern warfare: the landscape of Britain was transformed into one massive island fortress.

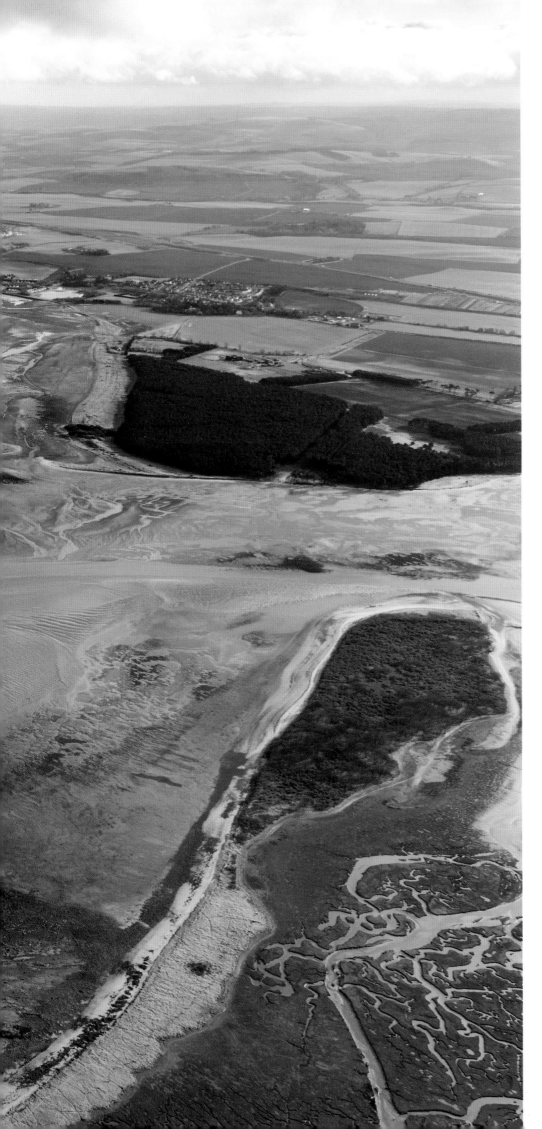

BELHAVEN BAY, DUNBAR, EAST LOTHIAN

Today this expanse of beach, dunes, salt-marsh and grassland is the John Muir Country Park – named after the famous Scottish naturalist, born in nearby Dunbar. A century ago, however, it was Scotland's frontline: the site of a network of trenches bristling with barbed wire and machine gun emplacements – defences against the very real threat of a German invasion. Remarkably, the trenches remain, their distinctive dog-tooth shape running through the long grass beside the forestry plantation on the centre right of this photograph.

2014 HES AERIAL SURVEY DP175892

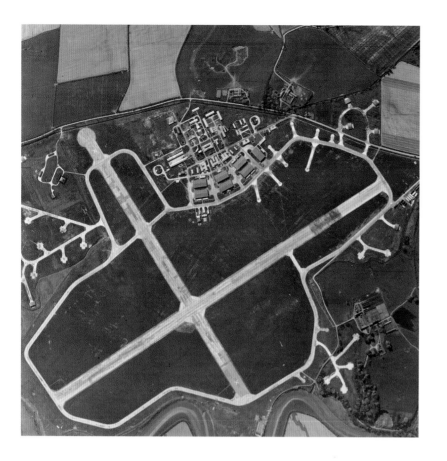

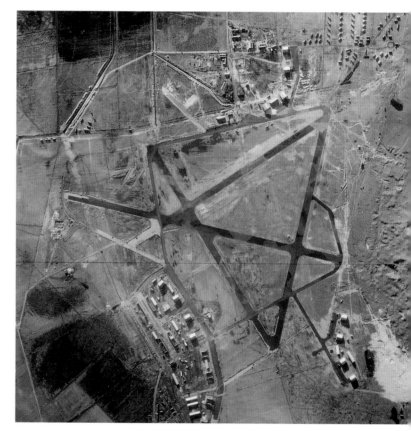

BALDOON AIRFIELD, WIGTOWN top left

During the Second World War, fields all over Scotland were marked with what, from above, appear as strange hieroglyphs. These were airfields, their runways criss-crossing each other in irregular A-frames. They would have been a very familiar sight to the RAF pilots – but also to the Luftwaffe bombers sent to destroy them.

1946 HES RAF COLLECTION SC1135121

FEARN AIRFIELD, BALINTORE bottom left
1943 HES RAF COLLECTION SC458728

MACHRIHANISH AIRFIELD, ARGYLL top right
1941 HES RAF COLLECTION SC1148210

DALLACHY AIRFIELD, SPEY BAY bottom right
1943 HES RAF COLLECTION SC1148209

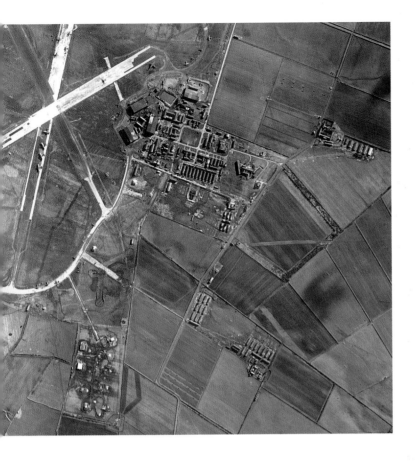

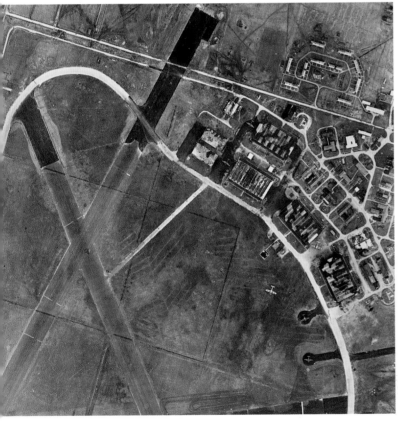

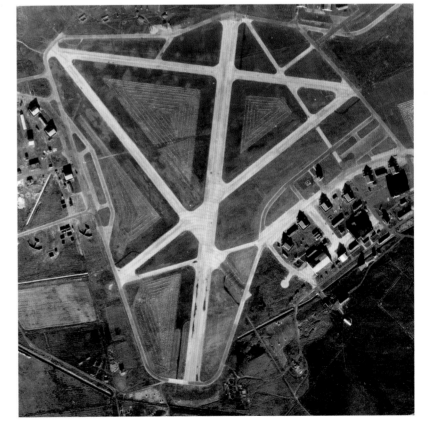

YCE AIRFIELD, ABERDEEN top left

Now Aberdeen International Airport, Dyce Airfield was the wartime home of the No. 8 Operational Training Unit – formed specifically to train pilots in aerial photographic reconnaissance.

1941 HES RAF COLLECTION SC458732

WICK AIRFIELD, CAITHNESS bottom left
1941 HES RAF COLLECTION SC458754

HATSTON AIRFIELD, KIRKWALL, ORKNEY top right
1941 HES RAF COLLECTION SC458768

MACHRIHANISH AIRFIELD, ARGYLL bottom right
1946 HES RAF COLLECTION SC977718

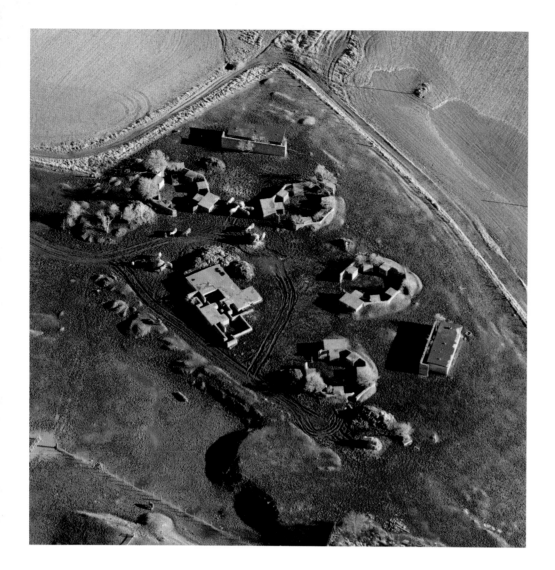

GUN EMPLACEMENTS, LIBERTON, EDINBURGH

The disused shells of four concrete gun emplacements, an ammunition store and a command post have found a new purpose – as feed stores and grazing ground for horses.

2008 HES AERIAL SURVEY DP038484

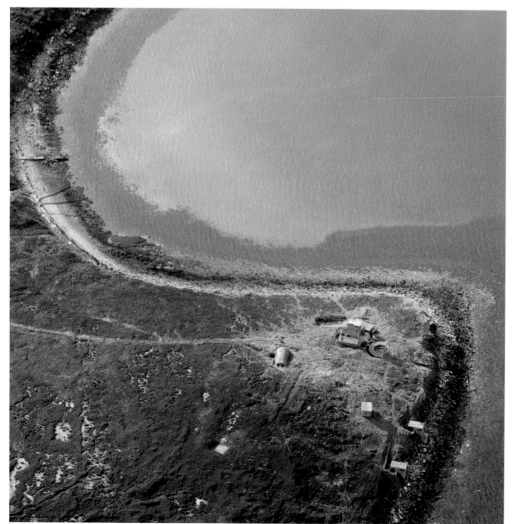

SCAD HEAD COASTAL BATTERY, HOY, ORKNEY

2008 HES AERIAL SURVEY DP053365

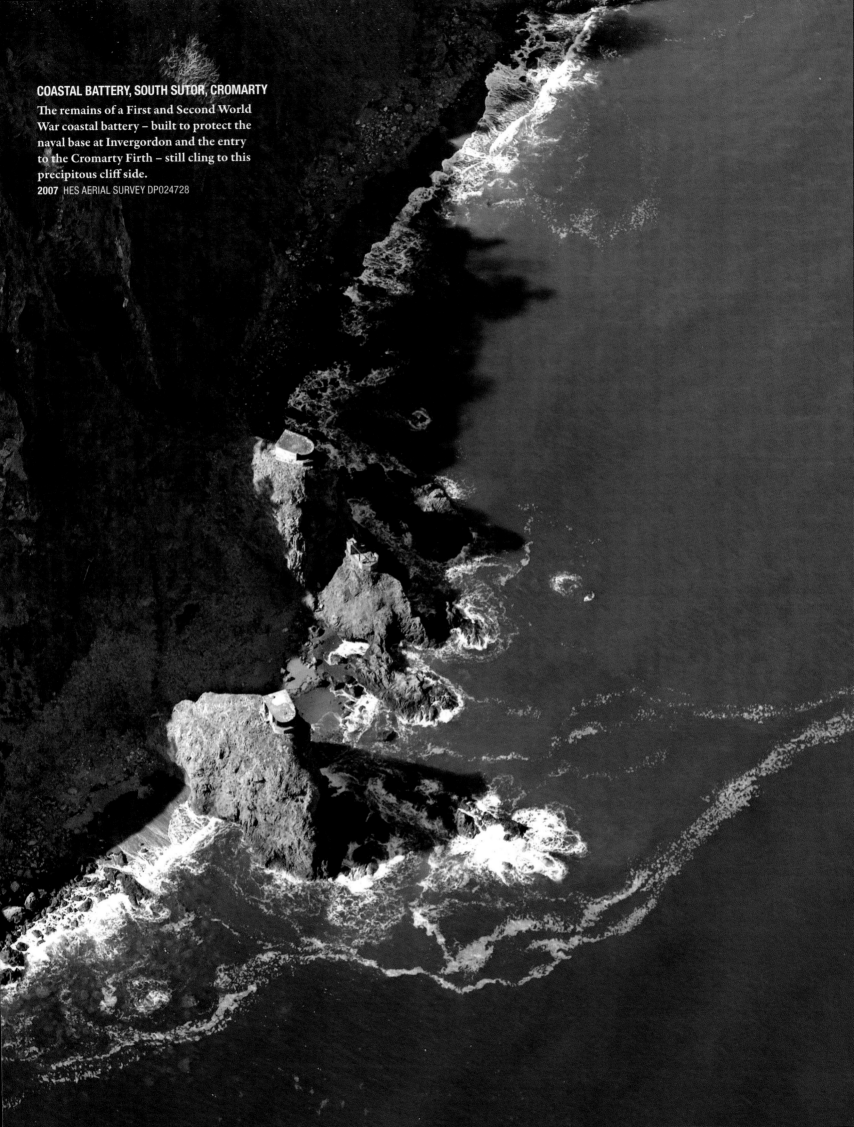

COASTAL BATTERY, SOUTH SUTOR, CROMARTY

The remains of a First and Second World War coastal battery – built to protect the naval base at Invergordon and the entry to the Cromarty Firth – still cling to this precipitous cliff side.

2007 HES AERIAL SURVEY DP024728

ANTI-TANK BLOCKS, WHITELINKS BAY, ABERDEENSHIRE

At hundreds of coastal sites across Scotland, serried rows of reinforced concrete cubes were the first line of defence against a seaborne assault. These anti-tank measures were supplemented by ditches, barbed wire, concrete pillboxes and machine gun emplacements.

1941 HES RAF COLLECTION SC910873

COASTAL DEFENSIVE LINE, FINDHORN BAY, MORAY
1943 HES RAF COLLECTION SC1031163

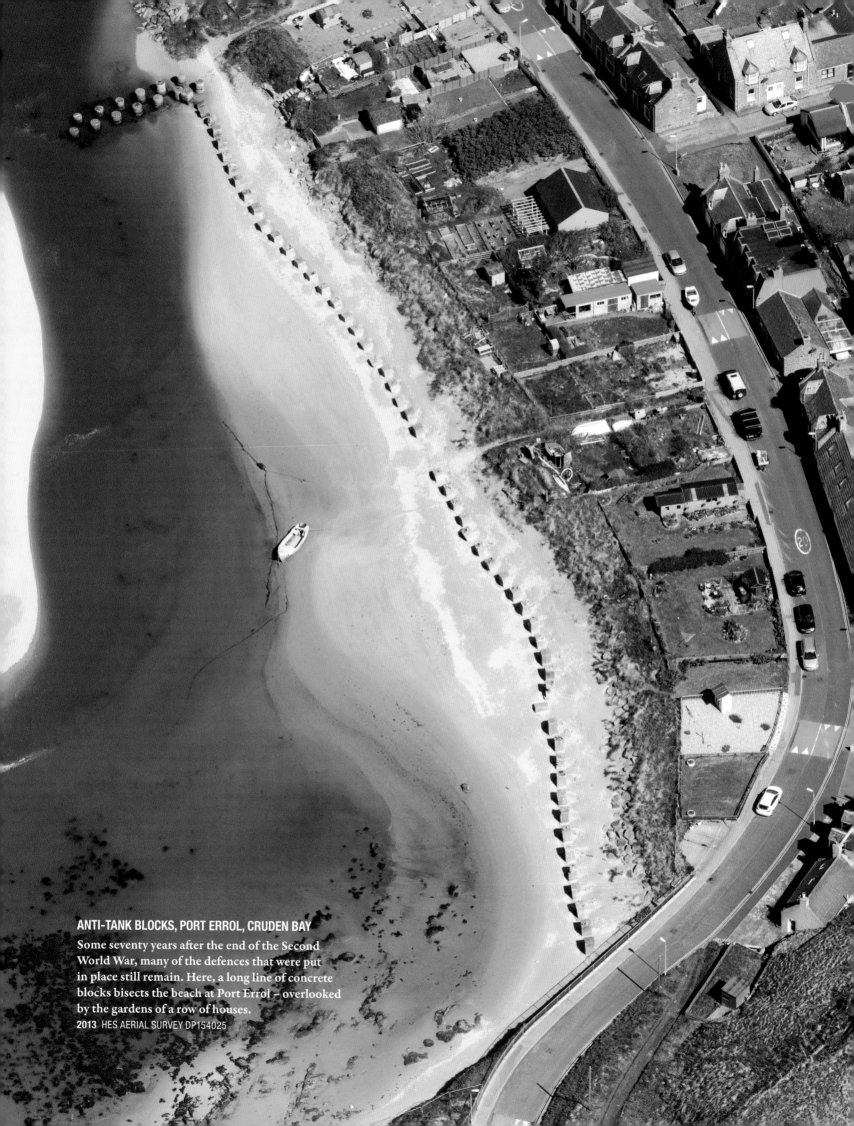

ANTI-TANK BLOCKS, PORT ERROL, CRUDEN BAY

Some seventy years after the end of the Second
World War, many of the defences that were put
in place still remain. Here, a long line of concrete
blocks bisects the beach at Port Errol – overlooked
by the gardens of a row of houses.

2013 HES AERIAL SURVEY DP154025

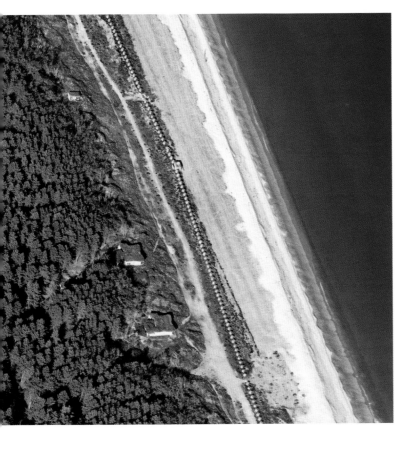

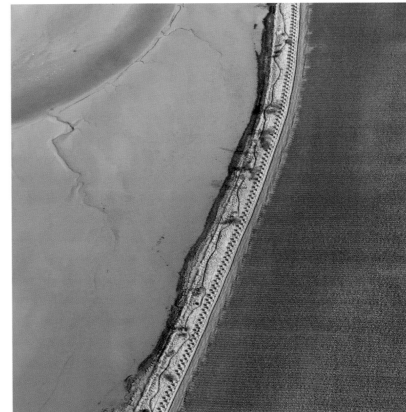

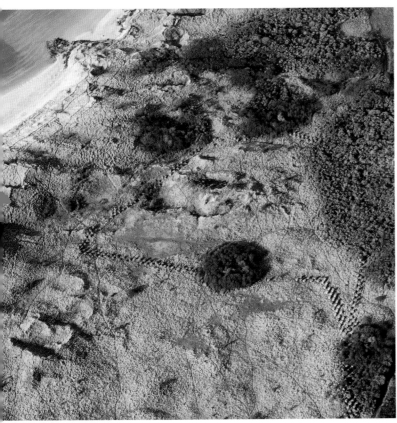

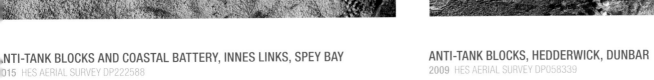

ANTI-TANK BLOCKS AND COASTAL BATTERY, INNES LINKS, SPEY BAY
2015 HES AERIAL SURVEY DP222588

ANTI-TANK BLOCKS, HEDDERWICK, DUNBAR
2009 HES AERIAL SURVEY DP058339

ANTI-TANK BLOCKS, GULLANE SANDS, EAST LOTHIAN
2009 HES AERIAL SURVEY DP054857

ANTI-TANK BLOCKS, GOSFORD SANDS, LONGNIDDRY
2009 HES AERIAL SURVEY DP054831

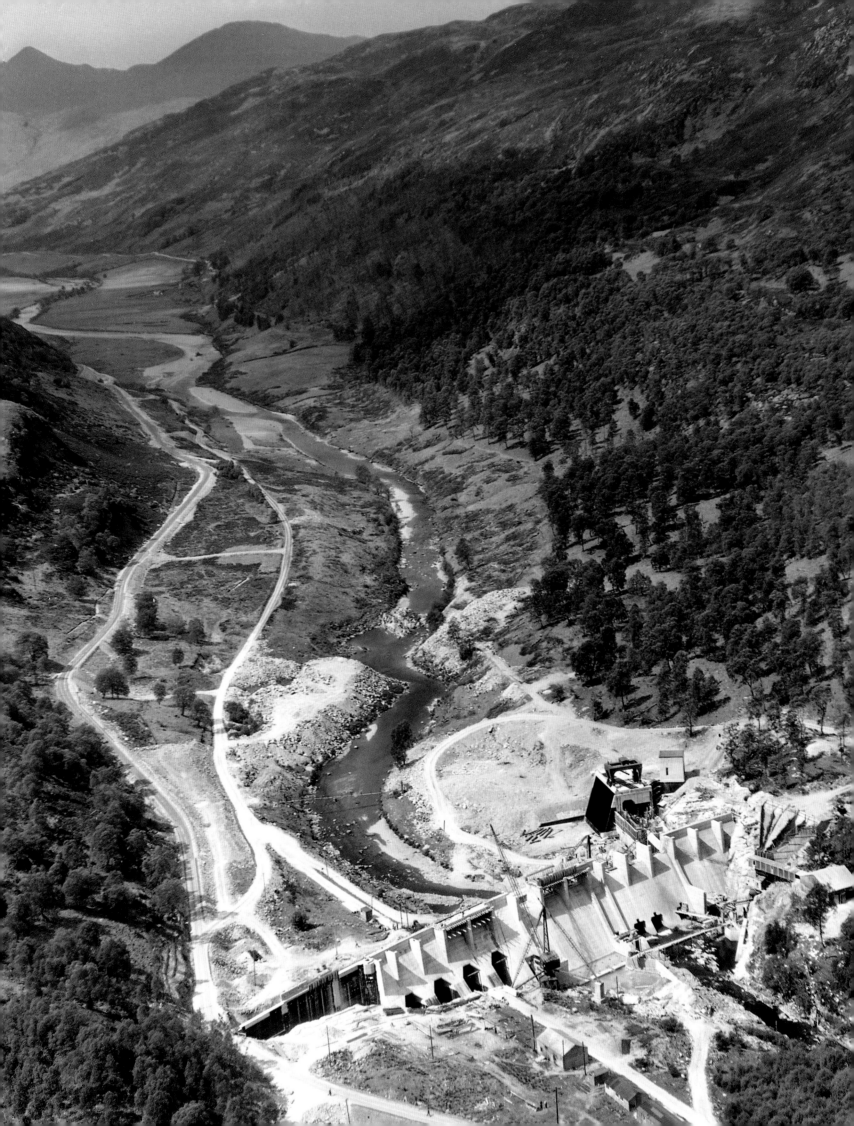

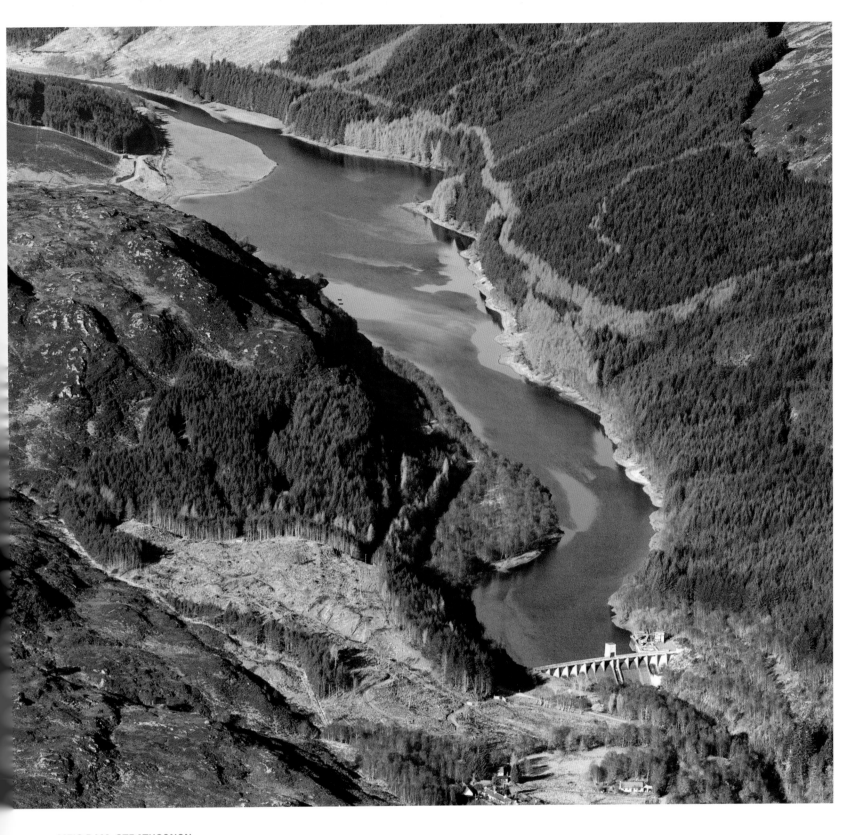

MEIG DAM, STRATHCONON

In the immediate post-war period, the government became obsessed with achieving self-sufficiency: looking to substantially increase tree coverage and farmland, and flooding entire valleys for hydroelectricity – like here in Strathconon, where the construction of a massive concrete dam systematically transformed the River Meig into Loch Meig.

1955 & 2007 HES AEROFILMS & HES AERIAL SURVEY, SC1438411, DP024941

LOCH BEINN A' MHEADHOIN DAM, GLEN AFFRIC
1954 HES AEROFILMS SC1438249

LOCH SLOY DAM, ARROCHAR
1953 HES AEROFILMS SC1438091§

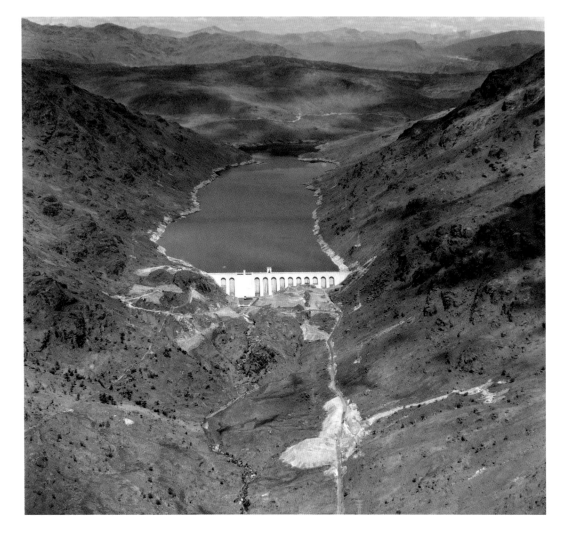

LOCH LUICHART DAM, STRATHCONO
1955 HES AEROFILMS SC143840§

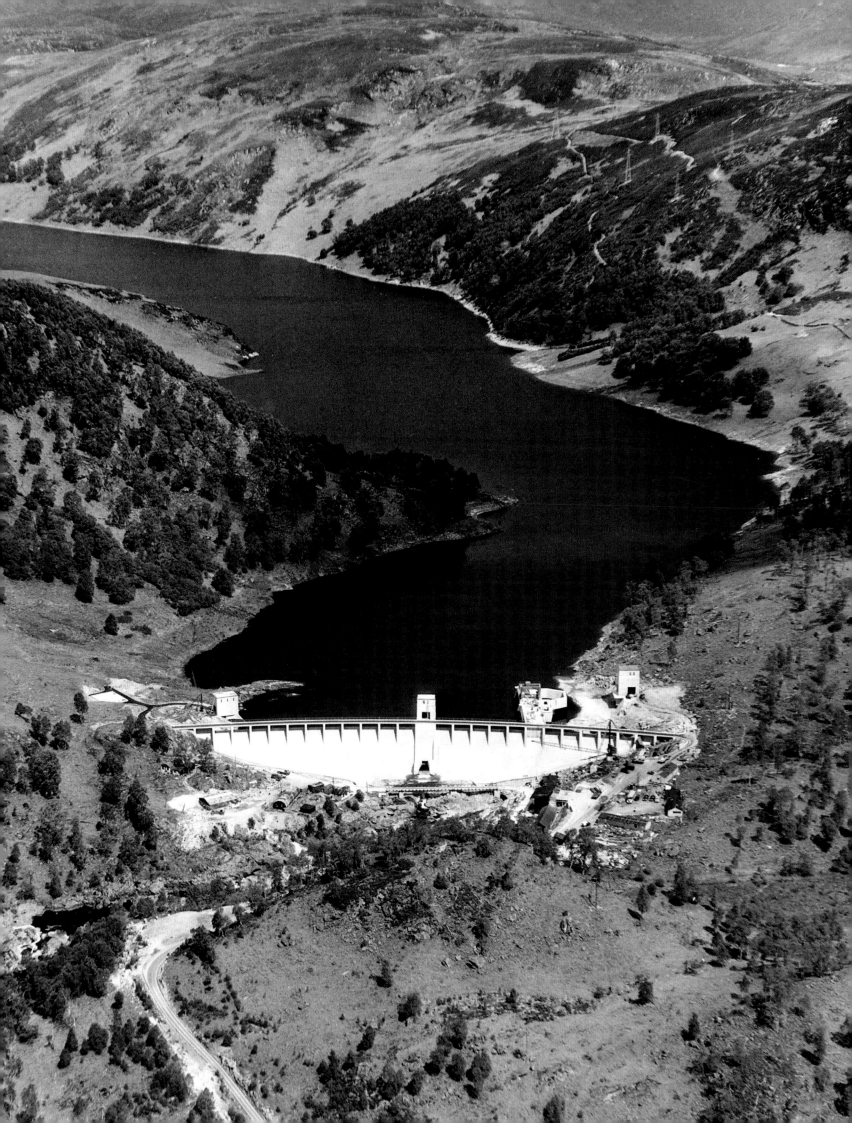

LOCH DUBH DAM, COIGACH
2013 HES AERIAL SURVEY DP156586

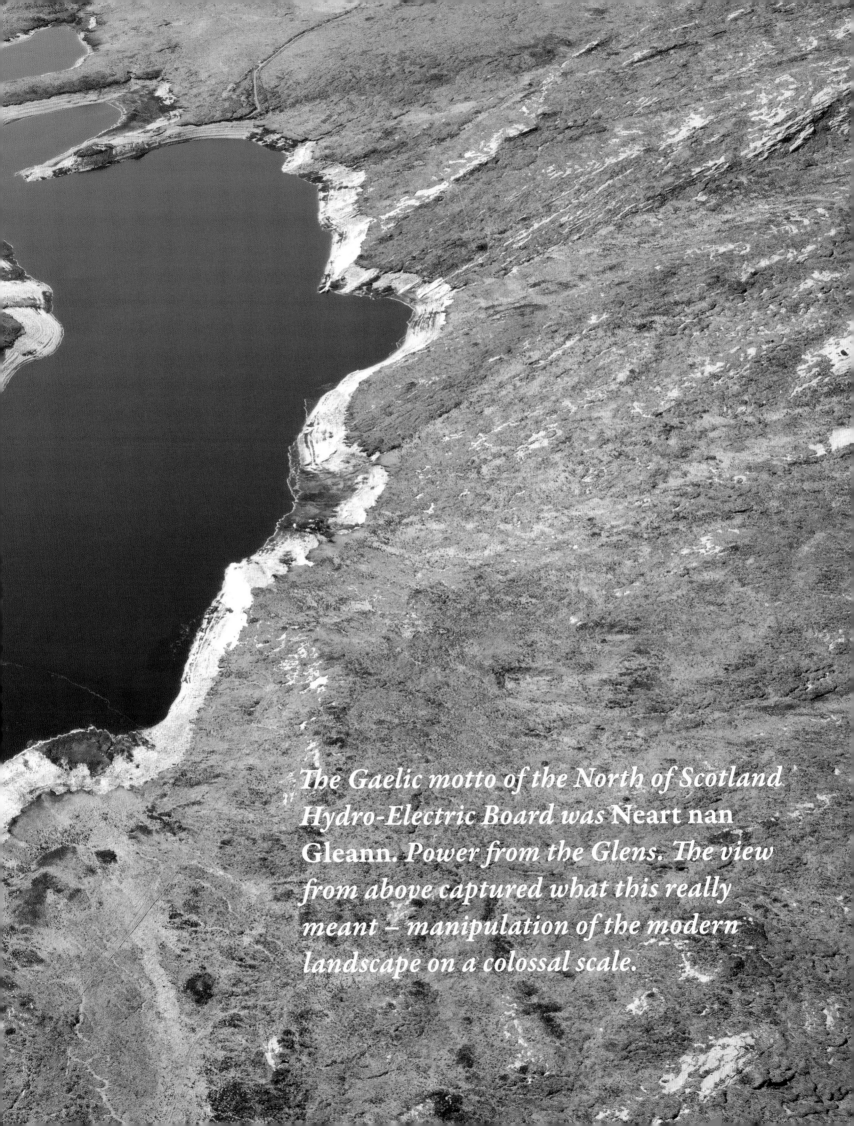

The Gaelic motto of the North of Scotland Hydro-Electric Board was **Neart nan Gleann. Power from the Glens.** The view from above captured what this really meant – manipulation of the modern landscape on a colossal scale.

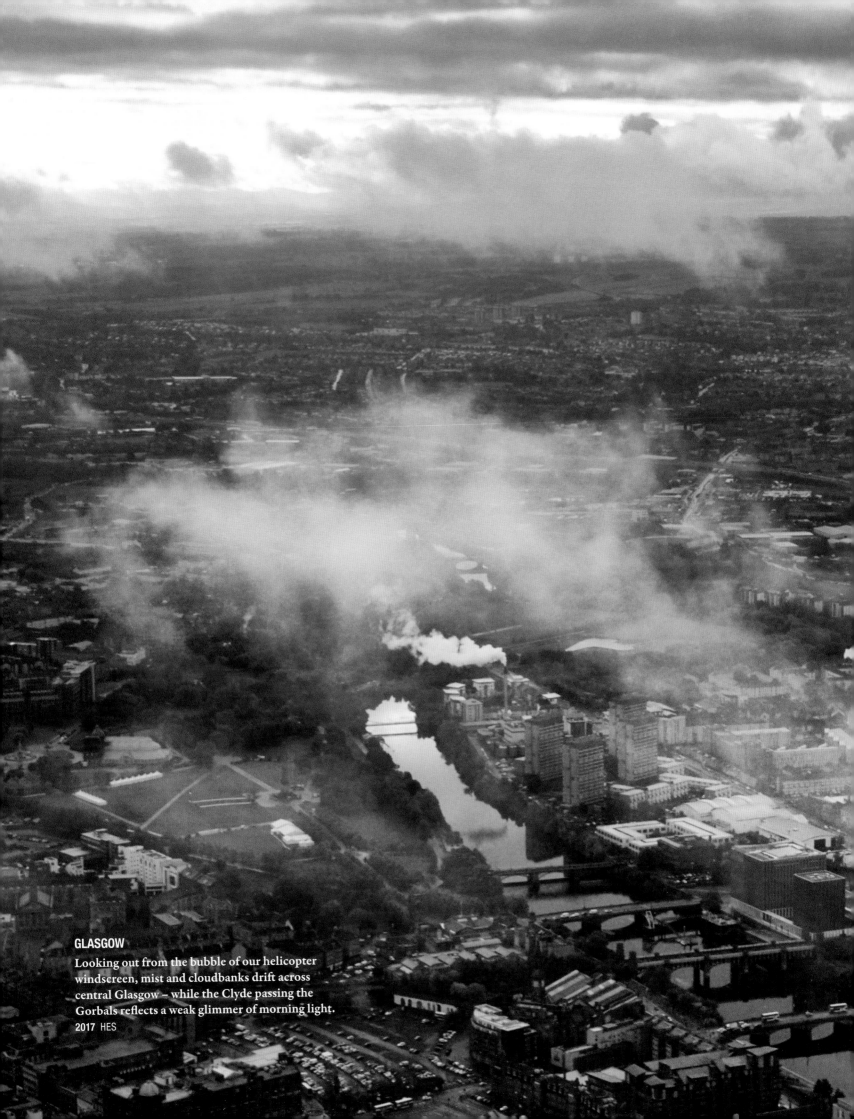

GLASGOW

Looking out from the bubble of our helicopter
windscreen, mist and cloudbanks drift across
central Glasgow – while the Clyde passing the
Gorbals reflects a weak glimmer of morning light.
2017 HES

THE GOD'S-EYE VIEW

The clear skies that had been forecast had still not arrived. Massed cloudbanks were shifting slowly westwards – the landscapes beneath them blurred here and there by columns of rain. It was morning and the sun was rising behind us. Its light fought to break through, causing rainbows to flicker on and off all around us. Water droplets coursed over the helicopter's windscreen. We dodged between the clouds. Drifting beneath us, part obscured and part framed by mist, was the city. Glasgow.

We had followed the course of the motorway in from the east – its thick grey line drawing the eye irresistibly onwards. It was rush hour and the lanes were full of traffic: multicoloured lozenges of cars and lorries stopping and moving haphazardly like debris in a silted river. By the giant Provan gasometers we changed course and banked towards the real river. It curved and kinked off into the distance – towards hills shimmering in light and shadow; towards the solid dark wall of the weather front heading ponderously out to sea.

We passed over the cathedral, once the heart of Glasgow, now a peripheral figure, pressed between a hulking Victorian hospital and a sprawling Victorian graveyard. Then we were above the interlocking square blocks of the modern centre – flying very slowly now, able to look down on the ordered grid of buildings, and peer into the long, dark canyons of George Street, St Vincent Street, Ingram Street and Argyle Street.

When viewed from the sky, cities are transformed. How could they not be? To live and work in a city is to be dominated by its layout and its architecture. From ground level, buildings rise up above you. But when you rise up above buildings, things change. Everything is reduced, becomes almost artificial. It's amazing how much it can feel like you are looking down on a model, a clever replica. You can see how the city has grown within its wider landscape, and you can work out how it all fits together. Your brain is attracted, instinctively, to patterns and order. But often, order is hard to find. Instead it is sometimes the

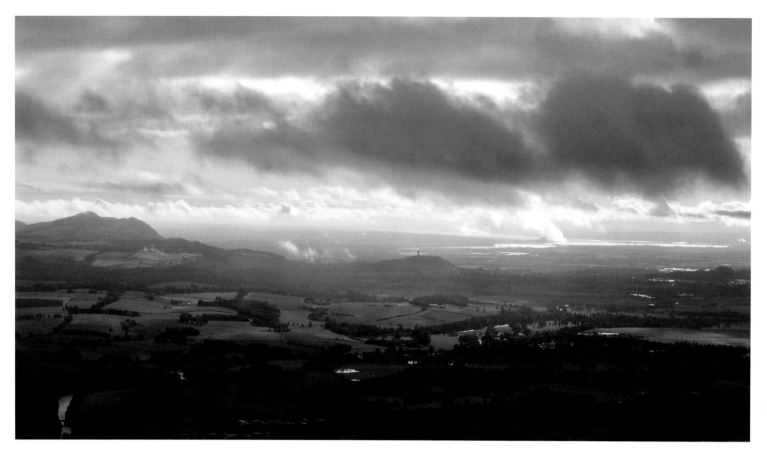

STIRLING AND THE FIRTH OF FORTH
Heading north-east, the glare from the sun striking the Forth Estuary makes silhouettes of Dumyat, the Wallace Monument and Stirling Castle.
2017 HES

anomalies that catch your attention. The jumbles of roads and buildings; the clashes of colours, material, styles and time periods. The city is laid out like a problem, like a complex knot. And it is only human nature that you want to solve the problem, that you're compelled to try to untangle the knot. It all seems so simple from up above. No wonder it's been called the 'God's-eye view'.

The sun emerged, striking the white faces of tower blocks and producing a powerful glare. For an instant they seemed lit up like beacons, signalling to each other from across Glasgow – from Townhead to Maryhill; from Maryhill to Anniesland; from Anniesland south over the river to Cardonald. Then the clouds mustered again, flattening the light and merging the towers back in with the rest of the city. We were tracking the Clyde now, over Finnieston with its collection of futuristic architectural icons – the Hydro, the Armadillo, the Science Centre and the Riverside Museum. Up ahead was the flight path into Glasgow Airport. The pilot's chatter with air traffic control was now incessant. We hovered near Clydebank and then, once we had the all clear, powered quickly northwards, away from the city and up over the Kilpatrick Hills.

A few minutes later and we were at the southern tip of Loch Lomond. Cloud and mist still hung low over the water, fringing the large islands of Inchmurrin and Inchcailloch. The top of the loch was barely visible at all, and the mountains of the Trossachs were hidden entirely. We curved back north-east, over the Lake of Menteith. In this direction visibility was much better. I could see clear across to the Forth Estuary, with the Wallace Monument

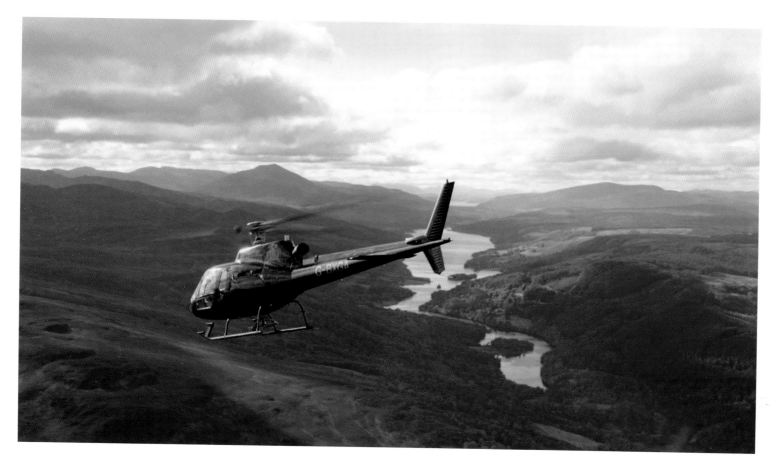

LOCH TUMMEL

Mountains line up on the horizon as our flight takes us on into the Highlands. In the distance, looming over Loch Tummel is the bulky ridge of Schiehallion.
2017 BBC

backlit brilliantly by the rising sun – and looking, I thought, just like one of those Glasgow skyscrapers. By the time we passed Crieff the clouds had rolled away entirely: there was nothing in the skies ahead but blue.

We continued onwards, picking up the line of the A9 at Perth and following it up into the Grampian Mountains. It was late September and the season was on the turn. The heather was no longer purple, but a deep russet. Amid the woods and forests patches of yellows and oranges were emerging. We raced above empty moorlands and skirted over rocky hilltops, at one point scattering a herd of deer, watching them break in arrow formation down through a valley towards the shelter of a geometric block of planted trees.

Just to the right of the pilot's control panel was a screen, not much bigger than a mobile phone. It was a live map, showing exactly where we were and the flight path that we were taking. Much of this map was filled with steep contour lines and the orange-brown shading denoting high ground. In the distance, I could see the mountains growing larger and more pronounced, row after row of them. The little line of the A9 was increasingly hemmed-in by valleys, dominated by the scale of the surrounding landscape. As the helicopter flew on, the map moved with us, scrolling continually to reveal more and more of the terrain ahead. Up in the air it was easy to take for granted: able to see for miles in every direction, with the forms and features below charted on the screen in minute accuracy. Easy to forget that there was a time when none of this existed. No flight, of course – but no maps either. And it wasn't as long ago as you might think.

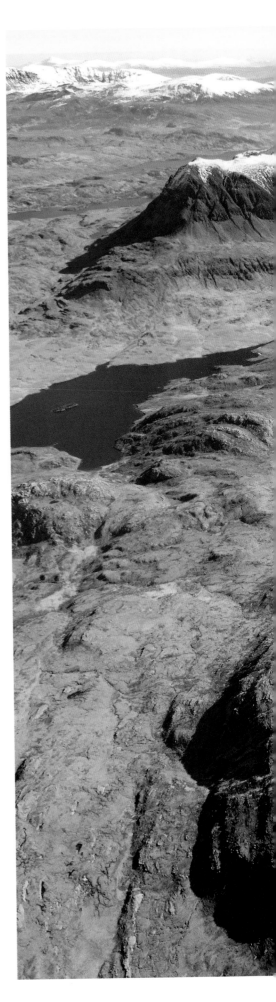

<p style="text-align:center">*</p>

In 1745 the best available map of Scotland consisted of a single sheet of paper. This date is important – the map was published in the same year as the second Jacobite Rebellion. And it was the only resource available to the British government for navigating the Highland landscape. Not surprisingly, at a scale of one inch to thirteen-and-a-half miles, it was woefully inadequate. Over the course of the conflict, the government's military commanders confessed that they were 'greatly embarrassed' by their limited understanding of the terrain. While they succeeded in suppressing the uprising, they failed in their attempts to capture a certain Bonnie Prince – confounded at every turn by what they described as 'rugged, rocky mountains, having a multiplicity of cavities … most adapted to concealment of all kinds'. (What, one wonders, would they have given for a helicopter in their pursuit of the Prince?)

In those days, of course – a century and a half before powered flight – the closest you could get to the view from above was a map. And if the one that existed wasn't good enough, then a new one would have to be produced: more complete, more accurate and more detailed than ever before. 'It fell to my lot', wrote William Roy, the 21-year-old son of an estate factor from Carluke, 'to begin the execution of that map'.

In the summer of 1747 Roy was sent out – by himself – from his post at the military base at Fort Augustus on the south-western tip of Loch Ness. His progress was painfully slow – but also painstakingly methodical. Using surveyors' staffs and metal chains (stretching up to 50 feet in length) he measured the distances between every successive bend in the road. At the same time, he recorded all of the features around him, from farms, fields and houses, to rivers, forests, glens and mountains, filling his notebook with measurements, descriptions and sketch drawings of the landscape. He kept this up all the way to Inverness. And then he continued on, exploring the country, working alone, for over a year. Rather than sacrifice already limited resources, the military used Roy's solo work as a pilot project. But when they saw the initial results, they were delighted: 'the specimens of his progress were so satisfactory' they said, 'that it was determined to extend the survey over the whole of the North of Scotland'.

Soon, Roy was managing six survey teams of six men each, with the greater manpower providing even more scope for detail and accuracy: 'The courses of all the Rivers and numerous streams were followed to the source and measured; and all the Roads and the many Lakes of Salt-water and Fresh were surveyed, as well as such intermediate places and cross lines as were found necessary for filling up the Country.' Fieldwork was carried out in the spring, summer and autumn, and then, at the onset of winter each year, the surveyors returned to their drawing office in Edinburgh so that the results could be translated into the many individual pieces of the final map. Produced in ink and watercolour, these fragments came together to form a beautiful patchwork of Highland Scotland, full of turquoise lochs, green forests, yellow farmlands, buff moorlands, red-

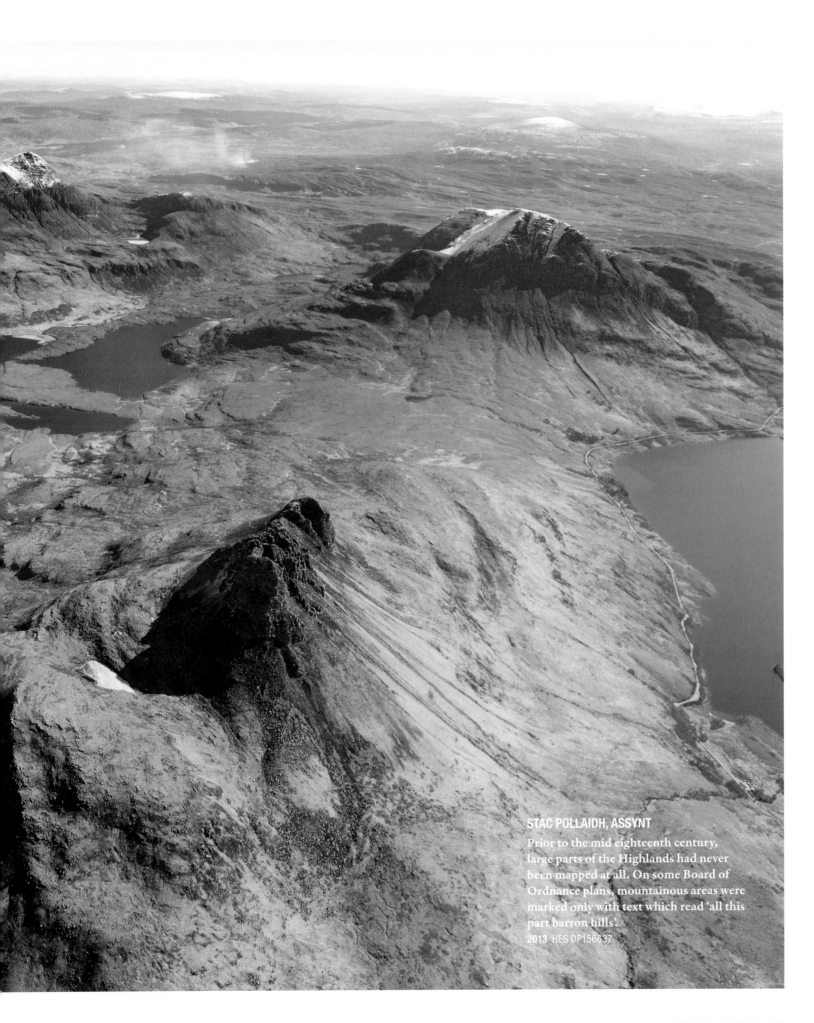

STAC POLLAIDH, ASSYNT

Prior to the mid eighteenth century, large parts of the Highlands had never been mapped at all. On some Board of Ordnance plans, mountainous areas were marked only with text which read 'all this part barron hills'.

2013 HES DP156637

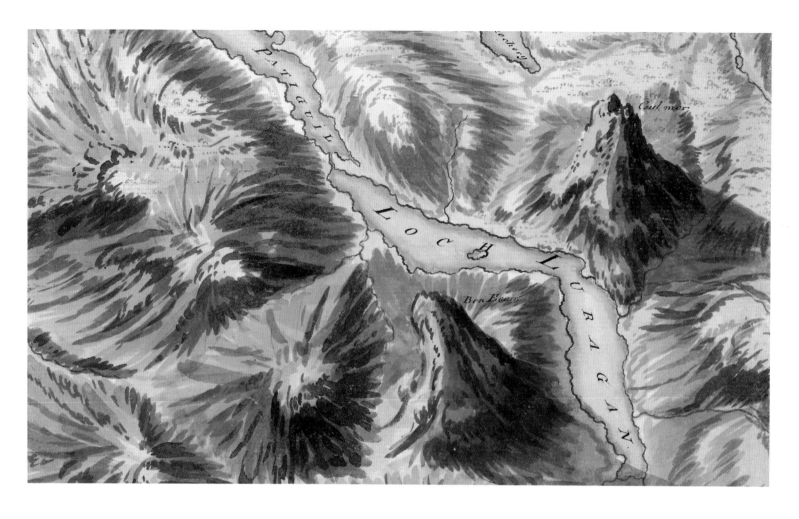

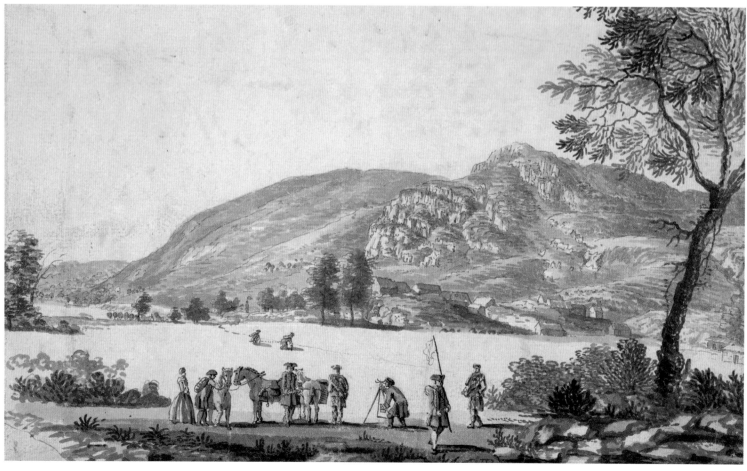

roofed houses and the snaking brown lines of roads. Hills and mountains were depicted in grey wash, with brush strokes showing the direction of the slopes, the tone darkening to indicate steeper gradients. By 1752, this first ever ground measured survey of the Highlands was complete: an astonishing 15,000 square miles had been mapped, down to the scale of 1 inch to every 1,000 yards.

In later years, Roy was self-conscious about the achievement, describing it as 'rather … a magnificent military sketch, than a very accurate map of a country'. This was no false modesty – rather it was the older, more experienced man looking back and lamenting that it could not have been *even more* detailed. His 'Military Survey' – as it was known – was commissioned unequivocally as a political act. It was aimed at subjugating a dissident people by attaining advanced knowledge of the places in which they lived. For Roy himself, however, it was always about a different kind of control: the control that science could exert over nature, the mastery of rational, enlightened man over his environment. No one had ever before produced a systematic survey of this entire landscape at a single point in time. It removed the sense of mystery that had clung to the Highlands like a dense mist. It was a first snapshot – albeit a five-year-long first snapshot – of Scotland from above. And it was an invitation to others, now armed with Roy's 'God's-eye view', to look north, to see challenges, and to seek opportunity.

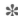

Knowing a landscape is just a first step. The next, invariably, is to manipulate it and to exploit it. It did not take long for the government to begin making plans to change and – in their words – 'improve' northern Scotland. Roads, bridges, jobs and industry: all were on the drawing board. The objective was to pacify the whole territory through *integration*: opening up transport and travel across the unforgiving terrain, forging new communities, and fostering economic growth. Engineering a future for the Highlands.

I was back on solid ground now, having left the helicopter behind in order to follow the route of a road built over two hundred years ago as part of this 'taming' of the landscape. Its construction linked Inverness on the east coast to Loch Broom on the west coast, and was intended to allow valuable produce to be brought overland to market. In the mid eighteenth century, the only route between these two parts of the country had been 'reckoned amongst the worst in the Highlands of Scotland, being mountainous, rocky and full of stones, and no bridges upon the rivers, so that nothing but necessity makes strangers resort here and for the great part of the year it is almost inaccessible'. Yet by 1794, reports commended the 'excellent road … now nearly finished, where … carts and carriages can now travel with the greatest of ease'. Its construction was commissioned by the British Fisheries Society (an organisation founded in 1786 for the sole purpose of 'Extending the Fisheries and Improving the Sea Coasts of the Kingdom') and it was known, unsurprisingly, as the 'Fish Road'.

The afternoon was tipping into evening as I drove out of Inverness. Traffic was slow over the Kessock Bridge, but soon cleared as I turned off the A9 onto the A835 towards Conon and Maryburgh. Beyond the bridge at Contin the modern road came to follow almost exactly the same path as the 'Fish Road', sometimes running parallel to it, other times sitting directly on top of it. The landscape was growing notably wilder, and I soon passed through the steep forest valley at Strathgarve, overlooked by the distinctive whaleback ridge of Ben Wyvis. Alongside was the Alltan Dubh – the Black Water – and then the Glascarnoch River. In the distance, the great grey wall of a dam was strung across the valley. The old road ran right up to its concrete base. Welled up on the other side was the long thin expanse of Loch Glascarnoch, a river valley flooded for hydroelectricity in 1957. I drove up its 7km length, parked in a lay-by at its western end, and made my way down the grassy verge onto the boggy, boulder-strewn ground leading to the water.

It wasn't hard to pick up the line of the old road again – it ran arrow-straight out of the loch, its tarmac still solid and intact. I paced along it, down to the waterside, then turned back and followed it as far as I could in the other direction. It disappeared this way too – subsumed once again beneath the A835 where it bent round the side of the loch. I climbed back into my car and continued north-west.

A muggy, overcast day had turned into a beautiful evening. The skies had cleared and the low sunlight was suffusing the sparse, rocky hills with a soft pinky-red glow. I was alongside Loch Broom now, and could look ahead to where its dark waters opened out to the sea. Minutes later, through the trees, I caught a first glimpse of pods of white yachts and colourful fishing boats; and behind them a long row of white-washed houses facing back down the loch. This was what the Fish Road was built to reach – the village and port of Ullapool. Two centuries ago, Ullapool was also brand new. The British Fisheries Society didn't just build roads. They built whole villages and towns too: settlements conceived, designed and constructed from scratch. In Ullapool's case, the aim was to use its natural setting – a fan of flat, low-lying land offering sheltered waters near the mouth of Loch Broom – as the base for a deep-sea fishing station. Boats could easily access the Minch and the Atlantic to plunder the great shoals of herring that gathered off the north-west coast. As the MP for the Burgh of Perth put it at the time, 'the seas abound with fish; the Highlands with industrious and good people. It will be the business of the legislature to bring these two to meet.'

The Chief Engineer for the British Fisheries Society was Thomas Telford – the son of an Eskdale shepherd, who would, of course, become one of the most famous names in the history of Scottish engineering. Telford had already approved or devised designs for new fishing ports at Tobermory, Stein and Ullapool when, in the summer of 1801, he was commissioned by the government 'first, to find the most commodious and productive stations for the Fishery both of Herrings and White Fish. Secondly to discover the means of establishing a safe and convenient intercourse between the Mainland of

LOCH GLASCARNOCH

The monumental Glascarnoch Dam sits at the head of a vast accumulation of water. A whole valley has been lost beneath its surface – although some traces still remain. As the modern A835 bends around the loch on its way to Ullapool, you can still see the remains of the old eighteenth century 'Fish Road' approaching the face of the dam. This route was resurfaced in the early nineteenth century by Thomas Telford and remained in use until the construction of the dam in the 1950s forced the road to divert.
2007 HES AERIAL SURVEY DP024798

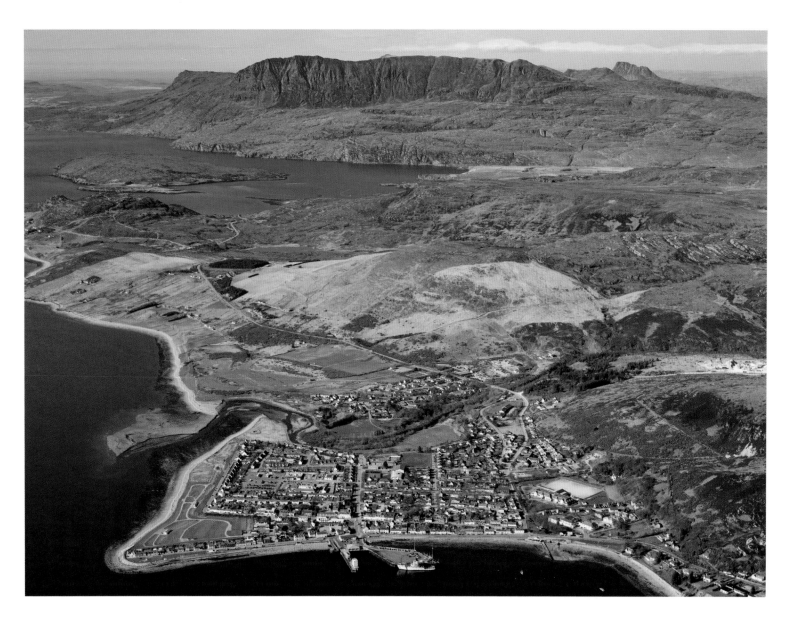

ULLAPOOL
2007 HES AERIAL SURVEY DP024758

Scotland and the Islands, and thirdly to ascertain the practicability of forming a complete inland navigation from the Eastern to the Western Coast.'

By October of that same year, Telford's inspection was complete. 'I have carried regular surveys along the Rainy West through the middle of the tempestuous wilds of Lochaber, on each side of the habitation of the far-famed Johnny Groats, around the shores of Cromarty, Inverness and Fort George, and likewise the Coast of Murray', he wrote. 'The apprehension of the weather changing for the worse has prompted me to incessant and hard labour, so that I am now almost lame and blind; I have, however, I trust, now nearly accomplished all the main objects of my mission, and shall be able to make out a plan and surveys of one of the noblest projects that ever was laid before a Nation.' His ambitious plans were approved and, over the succeeding decades, he was responsible for creating a thousand new bridges and over a thousand miles of new roads; forty new or improved fishing ports; some thirty new churches (new communities, of course, needed new places to worship); and – not least – the colossal undertaking of driving one long canal right through the heart of the Great Glen.

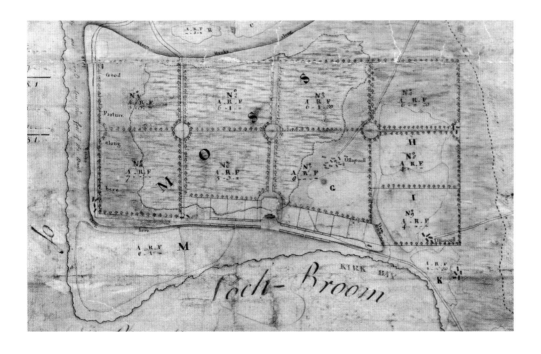

ORIGINAL DESIGN FOR ULLAPOOL

This first plan for Ullapool was drawn up by the land surveyor Peter May in 1756. 'I have designed and marked upon the plan a village just opposite to that part of the Firth called Kirk Bay' wrote May, 'with one street and rows of houses on each hand and in the middle a kirk, tollbooth or court house with an avenue northwards which divides the fields ... I have also marked out gardens behind the said houses'. While it would be another three decades before the British Fisheries Society began work on the construction of Ullapool, their new town retained the simple, geometric elegance of May's original design.

In Telford's hands, mapping had turned into large scale social engineering. 'The Lairds have transferred their affections from the people to flocks of sheep' he wrote, 'and the people have lost their veneration of the Lairds. It is the natural progress of Society, but it is not a pleasant change. There was great happiness in the patriarchal state of Clanship – they are now hastening into the opposite extreme. It is quite wrong.' He wanted to build a better world, to use science and technology to reinvigorate an environment traumatised by conflict and economic hardship. But sometimes even the best laid – and best intentioned – plans can still meet with failure. Take Ullapool. Within just a few decades, the herring stocks had vanished, either from natural migration, or from overfishing, and the local economy collapsed for the best part of a century.

I drove into Ullapool and parked my car on Shore Street, directly overlooking the waters of Loch Broom. Originally this street was reserved for public buildings and storehouses for the fish. The workers' houses were placed behind, going east to west, part of a simple grid system. When you look at Ullapool in aerial photographs, it stands out as an unmistakably human intervention in the landscape – a tiny little stamp of ordered lines amid an unruly, muscular mix of lochs and mountains. Yet somehow what this creates is rather beautiful, opposites that attract to tell a story that is both poignant and hopeful. Ullapool failed at first as a fishing port, but it thrives today, boosted by the arrival of a new industry: tourism.

I walked out to the end of the headland, beyond the long row of houses, so that I was able to look in one direction down to the cluster of hills at the head of Loch Broom; and in the other out past the distinctive saddle of Beinn Ghobhlach to the sea. The air was warm, there was barely any breeze, the sun was dipping towards the western horizon – and the views were heart-stopping. It's remarkable how, in just a few hundred years, the way we see a place can change entirely. Roy mapped the Highlands to help conquer them. Telford engineered them to exploit them for industry and 'improvement'. Yet today we walk through them, cycle over them, climb them, explore them – and photograph them, over and over again. This landscape no longer repels people with its harsh, unknowable obscurity. Instead it attracts them in their millions from all over the world. They come with their guidebooks and their maps – maps that can trace their ancestry all the way back to William Roy's map. Today's visitors don't see a place that has been cowed and defeated. Instead they see an expanse of wilderness characterised by unfettered freedom.

In the Highlands, the 'God's-eye view' was used to imprint order and progress onto a previously blank canvas. Planners could join the dots between isolated and remote communities. They were, by and large, adding infrastructure where little had previously existed. But lying behind all of this was the need to make a clear, deliberate statement: this landscape was now part of the British Empire and it was being prepared to contribute to the imperial cause – through its resources and through its manpower.

Fast forward another century and 170 acres of one of Glasgow's best-loved green spaces were being used for the very same purpose. Aerial photographers captured the open fields and hillsides of Bellahouston Park as they were transformed into a whole new city – built from scratch, in just fourteen months. Between May and October of 1938, it was the site of a bold, bombastic display of British imperial might. It was called the Empire Exhibition and over six months it invited a staggering twelve and a half million people through its gates. What they experienced was a celebration of the present wrapped up as a startling vision of the future. Bellahouston was covered with walkways, ornamental lakes, fountains, cafes, restaurants, bandstands, pavilions – and huge palaces. Not palaces for kings or queens though, but palaces of industry, engineering and art. Huge exhibits were dedicated to all aspects of manufacturing: displays of everything from ships, steam engines and cranes to sewing machines, carpets, furniture, fabrics, knitwear and pottery.

All of this was nothing new. But the setting? Well, that was a different story. Most visitors had never seen anything like the Exhibition's buildings. They were big, blocky and sharp-edged, uniform in style and largely free of any ornament. And they were all fitted in place as part of one grand plan, linked together by wide curving avenues tailored exactly to the needs of the crowds – as the exhibition brochure put it, 'a city of light, colour, spaciousness, spectacle and gaiety'.

The astonishing centrepiece of the exhibition, visible from almost anywhere in the city, was a 300-foot-tall, pencil thin, all-metal tower – dubbed the 'Tower of Empire', it was Glasgow's first skyscraper. The three balconies at its summit were capable of taking up to six hundred visitors at any one time, and from the top views stretched out some eighty miles in every direction. Here was a startling symbol of a new Scotland, raised up to look down on the old one – from above.

The creation of the exhibition was overseen by the architect Thomas Tait. He designed the central tower himself, but brought in a team of bright young things to work on the rest of the buildings – a new generation of architects such as Basil Spence and Jack Coia. The Lord Provost declared that the exhibition showed 'a finer and more colourful way of living' for Glasgow and Scotland, a future 'without drabness and greyness'. And then, when the gates finally closed at midnight on 29 October 1938, almost all of the exhibition was dismantled. Tait's tower *had* been built to last, designed as a new icon of a modern Glasgow skyline. But within a year, it too was demolished – out of fear that its great

THE TOWER OF EMPIRE

Thomas Tait's design for the tower used a steel framework clad in metal sheeting pre-painted with aluminium. The result was a blindingly modern addition to the Glasgow skyline, a soaring structure whose reflective surfaces glittered in the sunlight and were lit up with powerful spotlights at night. Over a million people travelled to the top of the tower using its two express elevators. This building confidently announced itself as the future. A short-lived future as it turned out – within a year it had been demolished.

1938 HES AEROFILMS SC1258228

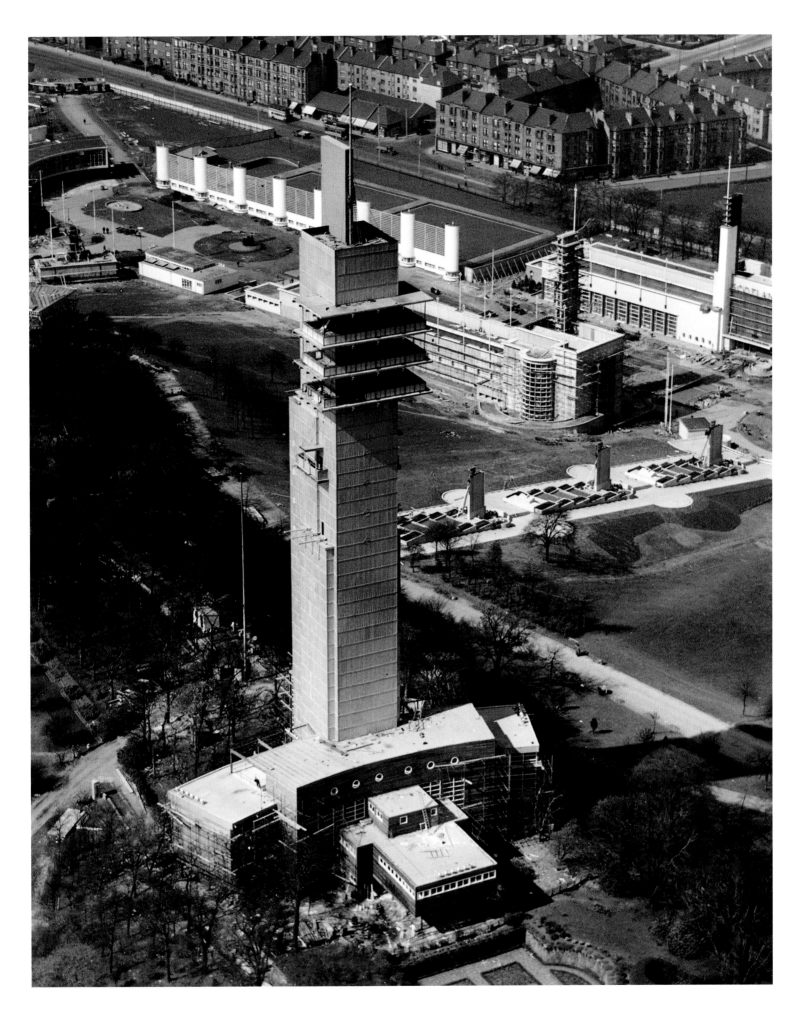

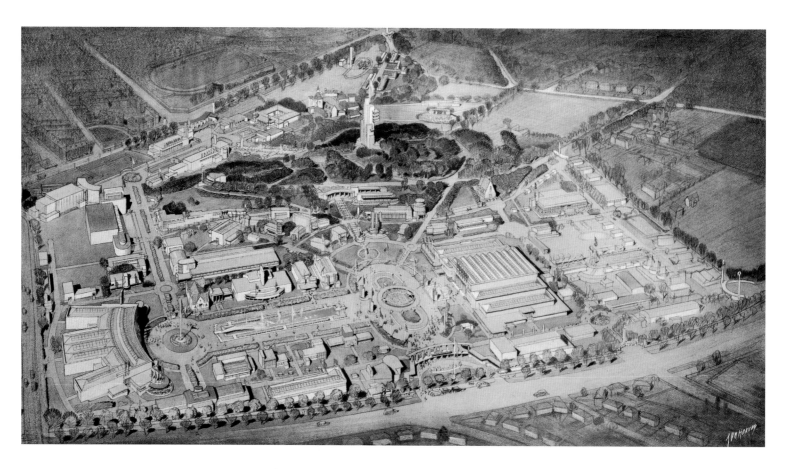

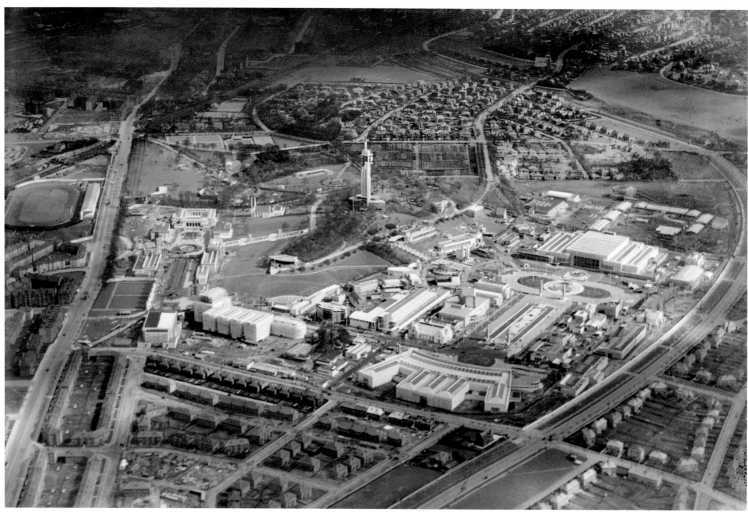

Both this artist's impression and the Aerofilms aerial photograph below use the view from above to demonstrate the incredible scale and ambition that lay behind the transformation of Bellahouston Park. In no time at all an empty green space became the site of a brand new, miniature city.

1938 HES & HES AEROFILMS COLLECTION SC1259498, SC1063411

height could attract German bombers. Today, even its foundations are overgrown by the trees on top of Ibrox Hill.

The city of the future was gone. But not forgotten, and not for good. This park was, in part, a testing ground for a new kind of world – the world of the modernist, a world which wanted to leave the past behind, take a scalpel to the old fabric of our towns and cities and replace them with what they called 'architecture by the people, for the people'. They wanted buildings that would meet pressing social needs, not aggrandise wealthy elites.

At Bellahouston Park, Scotland's early modernists worked under the guise of Empire – but Empire was never really their style; in fact, it was the exact opposite, a relic of Queen Victoria, the aristocracy and rampant industrial capitalism. The Second World War had begun. The Empire would not really survive it. But the modernists would. And they had a plan for Scotland – a plan bigger than anyone had ever had before – a plan to build the nation of the future.

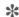

In the aftermath of the war, of course, the world was in desperate need of planners. The human cost of the conflict was immense, unparalleled. But so too was the architectural cost. Large tracts of Europe, and in particular France and Germany, had been devastated. People needed places to live, work, shop, worship. Many of these had to be built from scratch. Two World Wars in half a century had seemingly shown the ultimate failure of the old ways. And now the slate was wiped clean for new ideas, new thinking – and new buildings – to move in.

While Scotland had avoided the brunt of the destruction, it emerged far from unscathed. Luftwaffe attacks on Clydebank had smashed the fabric of the town. There, the only option was to rebuild. But the war had also exposed the unsuitability of living conditions across the country, and in particular in the big cities. Overcrowding, squalor, poor amenities and inadequate infrastructure were the norm. Scotland's cities were seen as things of the past, ill-equipped to deal with the demands of the present, let alone the future.

As the architect John Wilson put it, 'Scotland must plan or disintegrate.' There was an urgent need to look at the country in its entirety, assess every inch of land. The best way to do it was from the air. In 1944, even before the war had ended, a handful of RAF squadrons were tasked with making a complete photographic map of all of Scotland.

The same planes, pilots and photographers who had helped plan and carry out the bombing of Europe were now instrumental in rebuilding on the home front. It was a job of the utmost importance. And also mind-numbing boredom. As one crew member of a co-opted Lancaster Bomber explained, 'On each trip we would be allocated a block of land forty miles long by thirty miles wide. This was divided into ten runs, each three miles apart. When reaching the designated block, success depended upon the ability of the pilot to maintain a

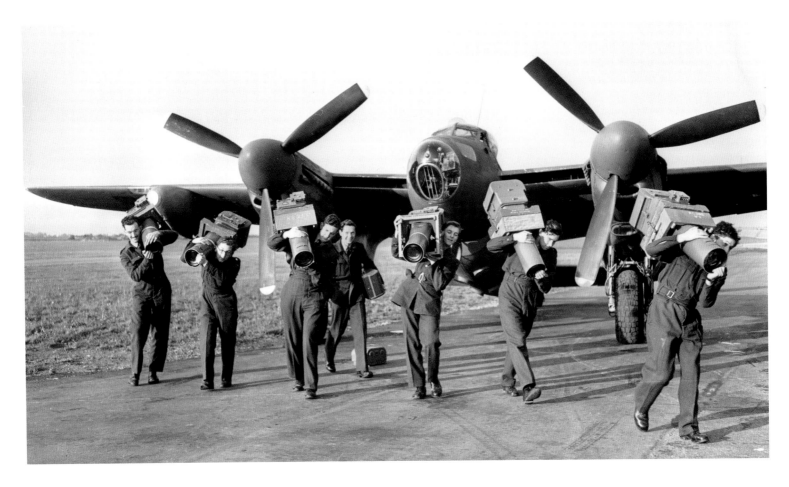

RAF PHOTOGRAPHERS
Airmen of the Photographic
Reconnaissance branch of the RAF
unload their giant cameras from a
Mosquito aircraft –a wartime bomber
co-opted to carry out a systematic aerial
survey of Britain's landscapes.
1950 CENTRAL PRESS / GETTY IMAGES

steady course, altitude, and speed, and upon the navigator's map-reading and
dexterity with the camera which was set into the floor of the nose-compartment
of the aircraft.' What this ultimately meant was 'four hundred miles of staring
at the flying control panel or peering at the ground through a bomb-sight. For
the other five members of the crew, these photographic sorties were tedious in
the extreme.'

They carried on for six years – over five hundred flights taking nearly
three hundred thousand photographs of Scotland. Their work effectively
took planners into the sky. Mosaic maps were made from stitched together
photographs – each one-metre-square mosaic corresponding to twenty-five
square kilometres of real land. What could be laid on top was the blueprint
for a post-war nation. The vision for a new Scotland was rising up out of these
photographs. But there was still the question of what it would actually look like.

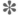

It was the view from above that pointed the way to the future. Back in October
1909, one of the earliest pioneers of powered flight – the Frenchman Count
Charles de Lambert – flew over Paris and circled the Eiffel Tower. This was
the first time an aircraft had ever flown over a city. Watching the spectacle
was another Charles – Charles-Édouard Jeanneret – a young art student and
son of a watchmaker who would become the cultish father-figure of modern
architecture: 'Le Corbusier'.

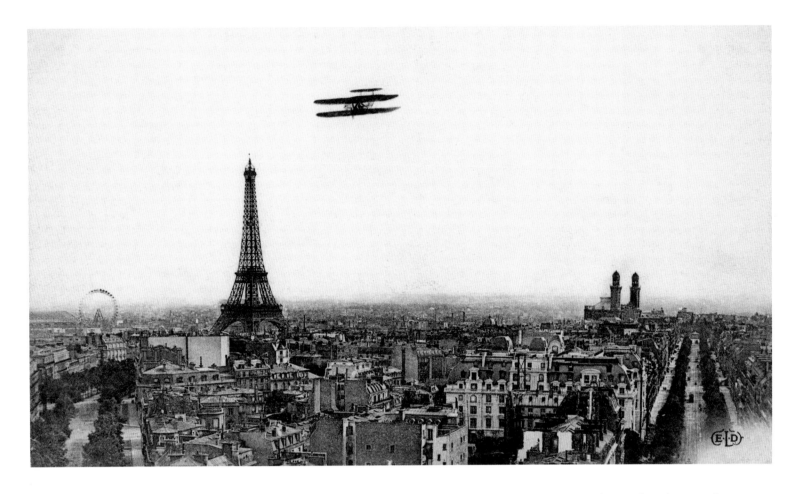

PARIS FLIGHT

This souvenir postcard captured Count
Charles de Lambert approaching the Eiffel
Tower on his pioneering flight above Paris
in October 1909. It was the first time an
aircraft had ever flown over a city.

1909 EVERETT COLLECTION HISTORICAL
/ ALAMY STOCK PHOTO

From that moment on, Le Corbusier became obsessed with aircraft, saw
them as a perfect symbol of the technological future. When he finally took to
the skies himself, he described the experience as 'ecstasy'. At the same time, the
view from above opened his eyes to what he believed was a terrible truth. 'Fly
over our nineteenth century cities' he said, 'over those immense sites encrusted
with row after row of houses without hearts, furrowed with their canyons of
soulless streets. Look down and judge for yourself … The architects of the past
did not build for men; they built for money.'

'We now have proof' he went on, 'recorded on the photographic plate, of
the rightness of our desire to alter methods of architecture and city planning.
The airplane instills the *modern* conscience. Cities with their misery must be
torn down. They must be largely destroyed and fresh cities built.'

This was powerful stuff. And it was a message that was embraced
wholeheartedly by many of Scotland's post-war planners and architects. They'd
build a brave new world: socialist, scientific and rational; driven by the real
needs of real people – not by class, or capitalism, or industry. What could
possibly go wrong?

Glasgow was Scotland's biggest city, and also its most poverty stricken, full
of slums, faltering heavy industry, and a creaking Victorian infrastructure. The
immediate and massive task of addressing the situation was known simply as
'the Glasgow Problem'. A 1945 public information film, which deliberately used
footage of the city shot from an aircraft, summed it up: '1,000 feet in the air,
looking down on a city of congested and narrow roads, drenched with railway

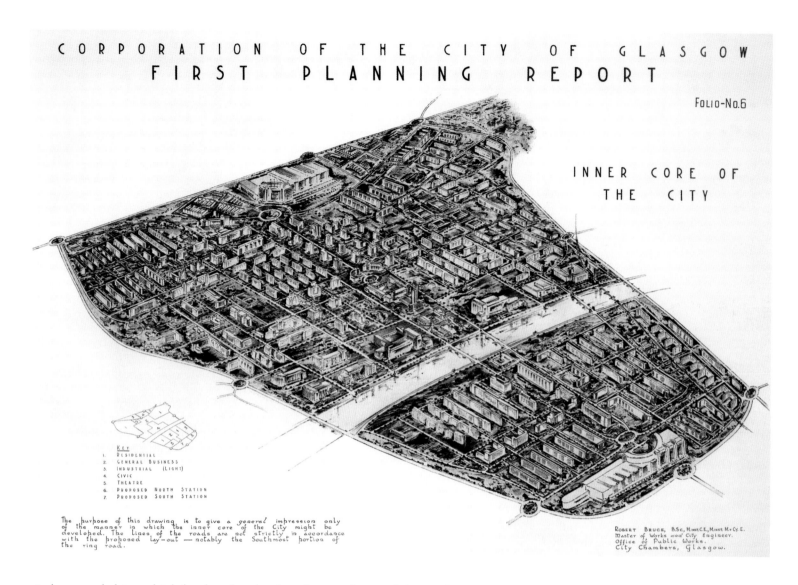

viaducts and ships which load and unload at the very heart of the city's gates.
Down there a great population living under outmoded conditions which give
rise to much confusion as well as discomfort.' Architects needed to think fast,
and they needed to think big. And they certainly did think big.

First to propose a solution was the city's Chief Engineer, Robert Bruce. In
1945, he recommended levelling the old centre of Glasgow almost in its entirety
and starting again. Buildings like Central Station, the City Chambers – even
the Charles Rennie Mackintosh School of Art – were all marked for demolition.
Bruce called it 'surgical' planning. By implication, anything old was like a
tumour to be cut away. The plan was approved in 1947, but then promptly
shelved – not due to any reservations about its content, but rather because of the
vast costs involved.

And so it did not go away completely. In the 1950s, twenty-nine areas
across the city were earmarked for 'comprehensive redevelopment'. This was
just another way of saying 'tear down and rebuild from scratch'. The areas took
in over 2,700 acres, home to some 300,000 people. In place of the traditional
tenement came its modernist equivalent, the tower block – huge concrete
slabs were shooting up all over Glasgow, at a pace and on a scale unmatched
anywhere across Europe.

THE BRUCE REPORT

This is Glasgow as it could have been.
Robert Bruce was proposing a new city
of skyscrapers and high-rises, with zoned
spaces separating out housing, industry,
commerce, transport and recreation. His
aim, he said, was to create a 'healthy and
beautiful' Glasgow. But, to achieve it, he
would have to demolish all trace of the old
city, and start again from scratch.

1945 GLASGOW CITY COUNCIL, GLASGOW MUSEUMS

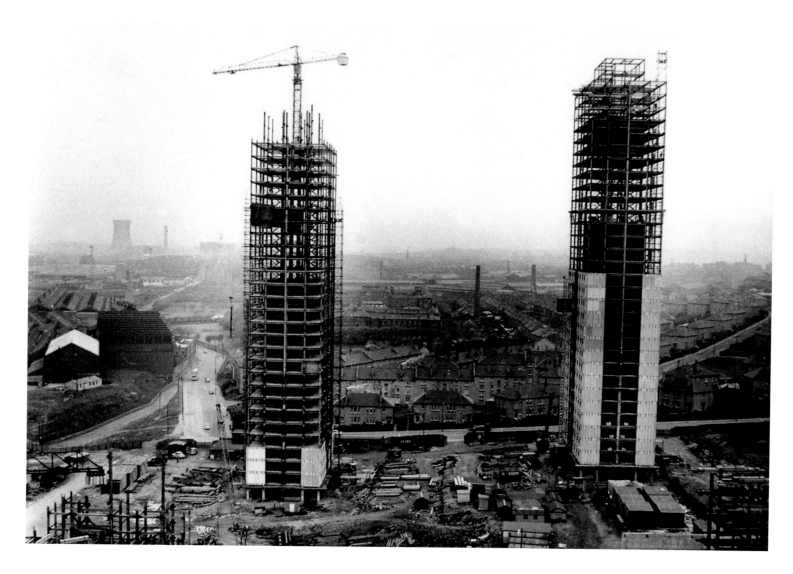

RED ROAD FLATS UNDER CONSTRUCTION
Although a lack of funds led to the
scrapping of Robert Bruce's vision,
Glasgow's planners were still quick to
embrace the utility of high-rise living.
Everywhere tenements were demolished to
be replaced with monolithic tower blocks.
1965 HERALD AND TIMES GROUP

In the Gorbals, prestigious architects such as Basil Spence and Robert
Matthew brought sky-scraping modernism to the blank slate of flattened
neighbourhoods. For Spence, his twenty-storey Hutchesontown C towers were
like 'hanging gardens' and 'great ships in full sail': tenements and streets in the
sky. Le Corbusier's aerial vision was becoming a Glasgow reality. As the planners
looked down from above, they saw that the comprehensive redevelopment
areas surrounded the old city centre: Glasgow Cross, Townhead, Cowcaddens,
Anderston, Shields Road and the Gorbals. Here was the perfect opportunity to
introduce that other modernist favourite: the motorcar. The 1965 *Highway Plan*
demonstrated how the areas could be linked up by one massive, elevated inner-
city ring road – Britain's first-ever urban motorway.

Aerial photography from the time shows how the road carved straight
through the fabric of the old city, entering from the east and then powering
south, up and over the Clyde via the ramp of the Kingston Bridge. Construction
began in 1965, and kept going up till 1981. But the full ring road was never
completed, just the first two sides – a line that divided the city in two, rather
than turning the centre into a motorway island. By the late 1970s the 'White
Heat' of progress had died to a flicker. Enthusiasm for the road turned to mass
protest – in particular from the residents of Glasgow's West End to the idea

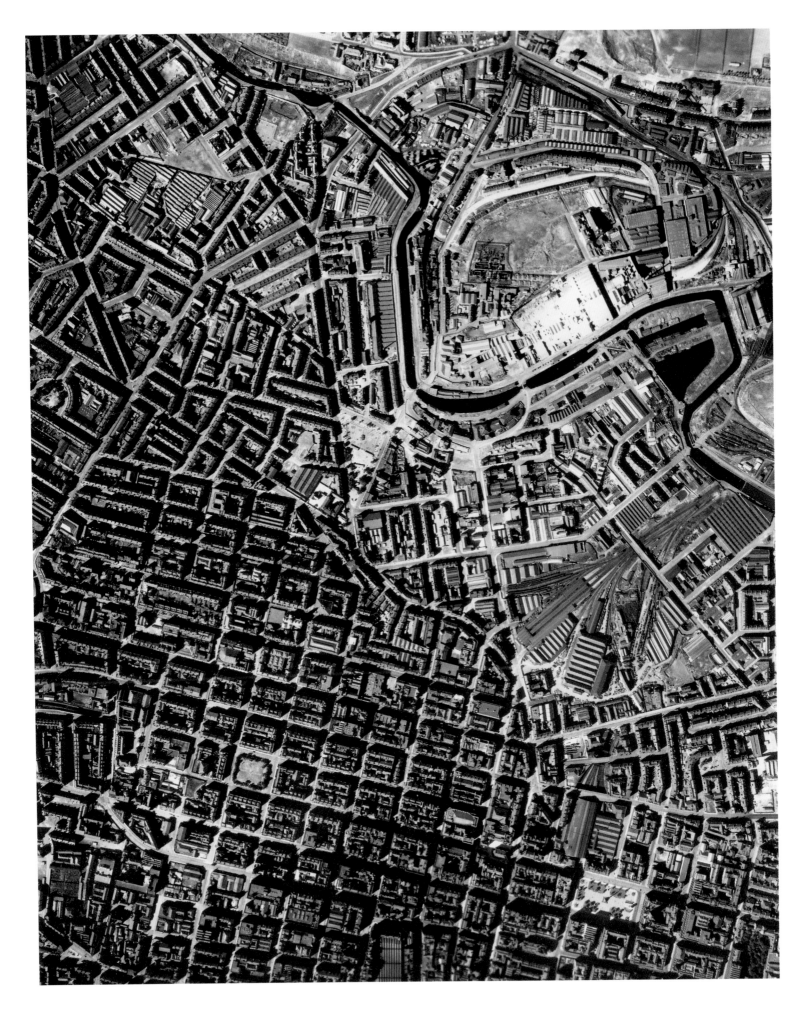

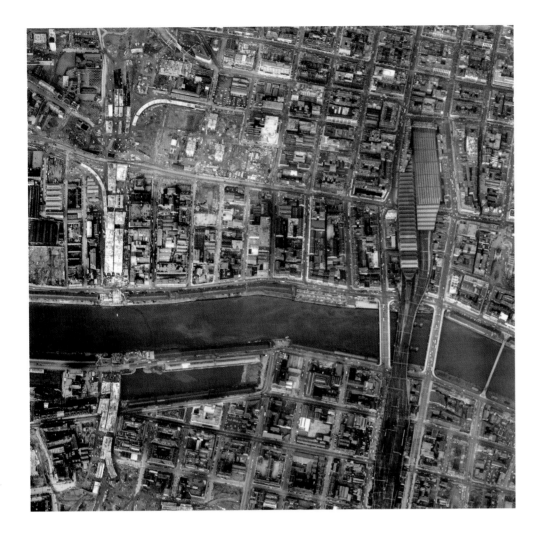

THE M8 AND KINGSTON BRIDGE UNDER CONSTRUCTION, 1968 above

The bare concrete slabs of the M8 slot together like a jigsaw puzzle as they prepare to cross the River Clyde.

1968 HES NCAP 000-000-082-081

GLASGOW CITY CENTRE, 1947 left

Twenty years earlier this was Glasgow before the arrival of high-rises and the motorway – a tight-knit block system that was home to the most densely packed population of any city in Europe.

1947 HES RAF COLLECTION SC802946

of an M82 motorway: a branch of the ring road that was designed to surge north-west in a three-lane, sixty-mile-an-hour expressway to Loch Lomond and the Trossachs. This route would have cut through Maryhill and kissed the corner of Mackintosh's Queen's Cross Church and the Botanic Gardens. The protestors won, and the road was abandoned. By this point, the shock of the new was just too shocking.

In Scotland's post-war cities, old and new came crashing together. Just as they have always done, as each new generation looks to change or adapt what has been left by the one before. Modernist ambition increasingly met opposition – from residents weary of all the concrete, from vocal communities and groups campaigning to protect old buildings. Construction was scrapped or left half complete: illustrated perfectly by the infamous 'bridge to nowhere' at Charing Cross, or the 'ski jump' at Tradeston.

Today, plans are being drawn up to remove stretches of Glasgow's urban motorway from sight altogether. At Charing Cross, the intention is to hide the road beneath a public space – a onetime vision of the future, consigned to the past. People will sit there, walk across an urban garden, children will play. Apart from the faint rumble of underground traffic, they won't notice the motorway beneath them. And from the air? Well, it will simply have just disappeared …

Glasgow's post-war experience of grand urban master plans has been a very mixed one. Take high-rise living. Many of the tower blocks that were heralded as smart solutions to inner-city congestion quickly became symbols of social decay and deprivation. Some barely lasted two decades. Since the early 1980s, lives lived high in the city's sky have been brought crashing back down to earth in – almost ceremonial – public demolitions. These buildings have shared the same fate as Tait's original, iconic tower, leaving little trace behind of their once monolithic presences. The natural reaction is to apportion blame and to brand these visionary schemes as failures. Yet this ignores a broader truth: that our cities are hard-wired for change. They need to continually regenerate and rewrite themselves. They are, in that sense, like living things: always growing, changing, striving, suffering or thriving. And one thing is for certain. The cities that we know today will not be the cities we know tomorrow.

Dawn was breaking as the speedboat pulled slowly away from the old stone harbour at Broughty Ferry. We passed beneath the shadow cast by the little port's squat, fifteenth century castle and then arced out into the Tay Estuary. Off to the east, the river met the North Sea. The sky over the horizon offered a delicate palette of pinks and oranges, the morning sun muffled behind thin tendrils of cloud. Then the boat turned sharply away to the west, powering upriver through remarkably still waters. We were on our way to look at the new face of Dundee – a city that is currently changing faster than any other in Scotland.

Off to our left, shingle beaches soon gave way to a long line of wharves and warehouses. Barges and ships were moored up against the backdrop of stacked shipping containers. In one harbour, an oil platform was under construction. Next the road bridge was looming up ahead, solid with traffic. We raced between its concrete struts and then slowed abruptly as our destination came into view. Time and again in the history of cities, you will find new architectural icons rising up, each one hoping to define the character of their urban landscapes. In twenty-first century Dundee, it is the turn of the £80 million V&A Museum of Design.

We brought the rib in as close as we could to the building. What was immediately clear was how the appearance of the structure constantly shifted as our viewpoint changed – it was all lines, angles, edges and corners. Formed out of an irregular series of giant, concrete walls – hung with some 2,500 pre-cast

THE TAY ESTUARY
Racing upriver on our way to see the new face of Dundee's waterfront.
2017 BBC

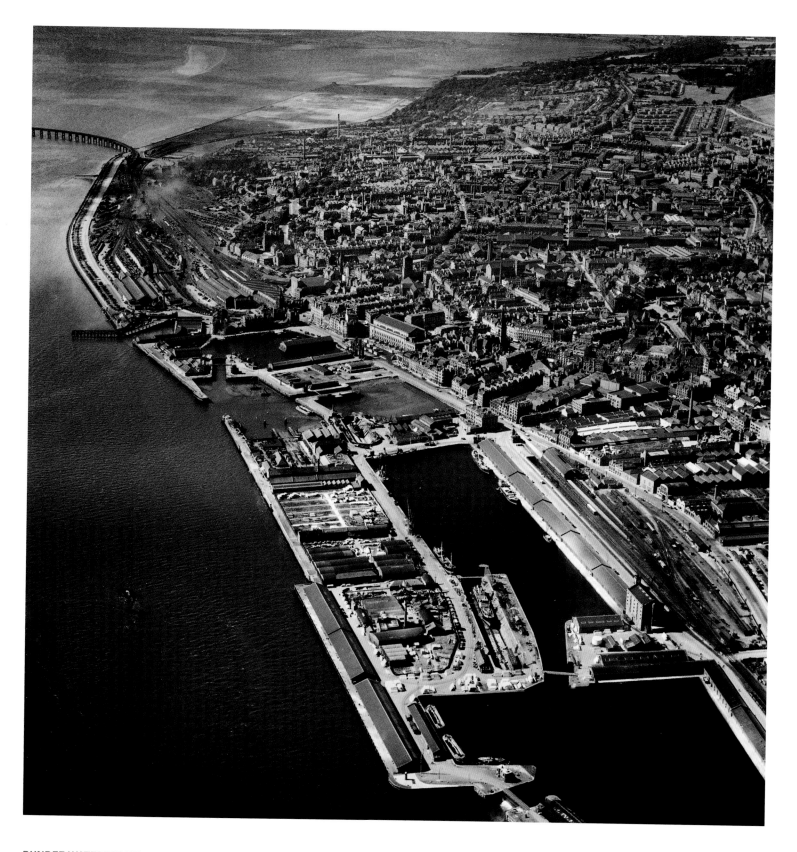

DUNDEE WATERFRONT, 1947

Dundee is a city that has always been defined by its relationship to the sea. It is no wonder
then that its waterfront has experienced so much upheaval over the centuries – seeming
to change almost as often as the tides. Here it is photographed in the immediate post-war
period. While the Victoria Dock in the foreground still remains today, the King William IV
and Earl Grey Docks beyond were soon to be filled in – and would disappear entirely under
concrete with the arrival of the Tay Road Bridge in the 1960s.

1947 HES AEROFILMS SC1268649

THE V&A MUSEUM OF DESIGN, DUNDEE
2017 BBC

stone panels – the intention, according to the building's Japanese architect Kengo Kuma, was to recreate the distinctive texture and appearance of a Scottish coastal cliff. Looking up from the water, I'd say that he has succeeded. This is a building that is quite literally aiming to reassert Dundee's connection with the sea – appearing to almost defy gravity as it juts out over the Tay. As Kuma explained, he wanted 'to create a new type of harmony between nature and landscape. In a sense, the building is like a bridge between the River Tay and the city.'

Although modest in scale, in ambition it is huge. The V&A is the centrepiece of a £1 billion, three-decade-long redevelopment of the entire Dundee waterfront – a grand experiment in *cityscaping* that is unparalleled in modern Scotland. I was looking out at a structure that wants to transform a whole city through force of will. Even in its unfinished state, I could sense its power, its self-confidence. Perhaps crucially, what it recognises is that the harbour has always been key to the story of Dundee, a continual source of both riches and ruin.

It was time for us to go – the tide was heading out, and if we weren't back at Broughty Ferry soon, the water would be too low for us to moor up. We motored east: back under the bridge, back along the dockfronts, busy now with morning activity. Maybe it was just the time of day and the particular quality of the light – the sun rising and bathing the waterfront in a warm yellow glow – but there was a palpable sense of life and vibrancy. The aura of renewal. Something which Dundee knows very well.

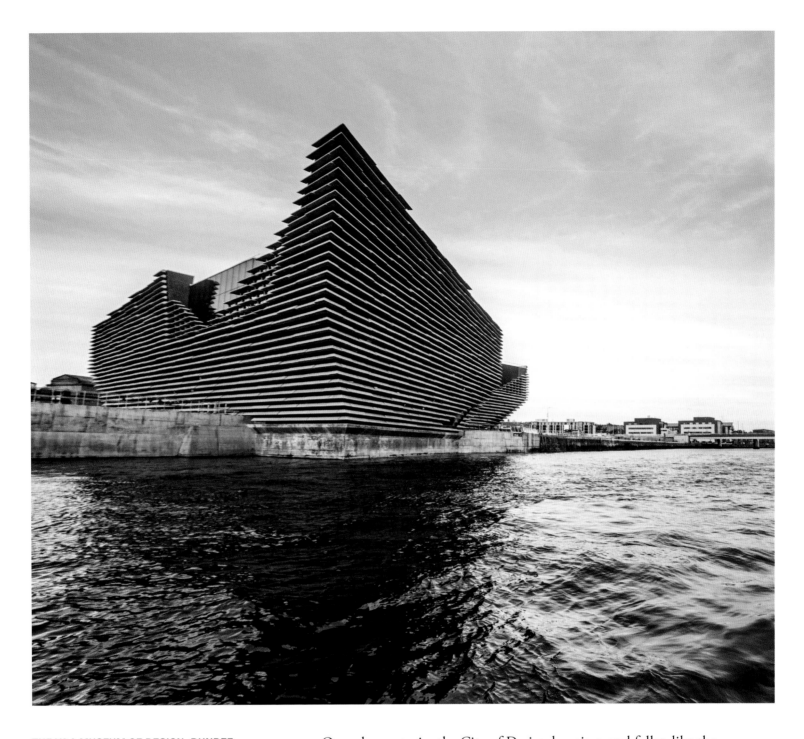

THE V&A MUSEUM OF DESIGN, DUNDEE
2017 V&A DUNDEE / ROSS FRASER MCLEAN

Over the centuries the City of Design has risen and fallen like the tides – perhaps because each new generation has felt the need to *redesign* it in their own image. Three hundred years ago, Dundee was Scotland's most cosmopolitan port, a city of grand merchant palaces forming curved streets specifically intended to keep the biting wind away from the town centre. It was Copenhagen on the Tay, its architecture shaped by the fashions and influences of trading partner sea towns across Scandinavia and northern Europe. By the start of the nineteenth century, it was bursting at the seams with mercantile traffic. So much so that the city turned to none other than Thomas Telford to oversee a massive harbour redevelopment. It thrust Dundee further out into the Tay, creating a brand new shoreline for the old port. This harbour would

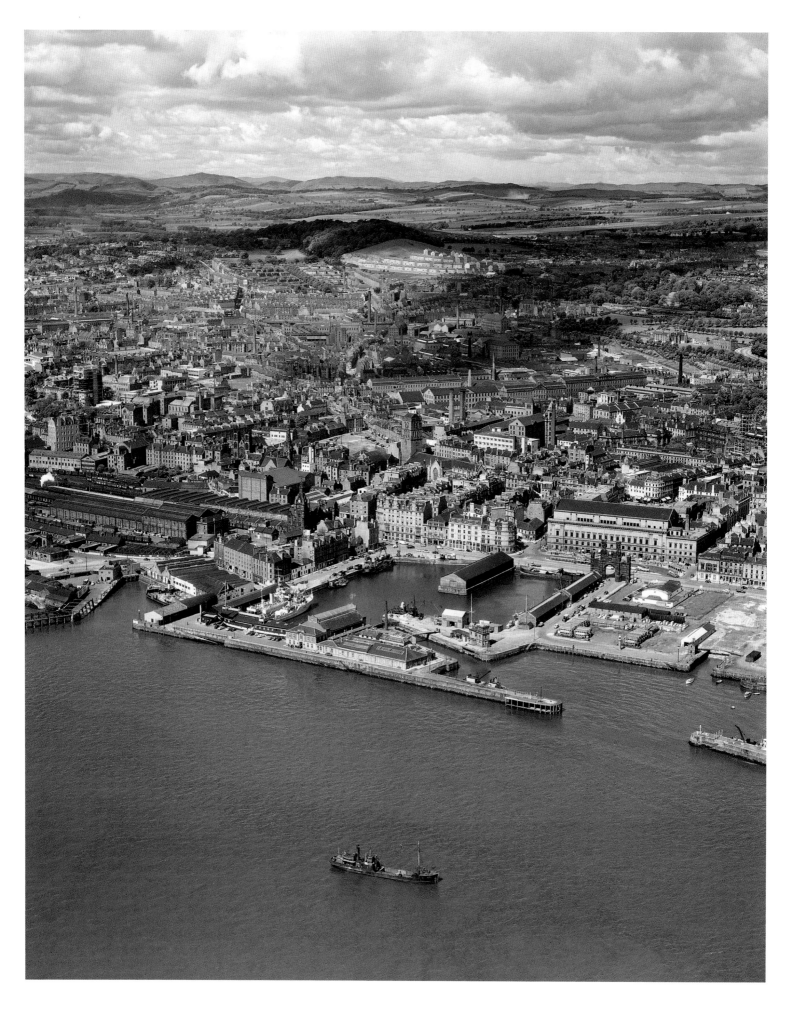

Dundee is one of the most photographed cities in Historic Environment Scotland's aerial collections. As a result, you can put a century of images together and see its urban landscape morphing before your very eyes. It is a graphic – and sometimes shocking – illustration of how our cities can never stay still, whether we plan or not. It is in their restless nature to continually rewrite themselves.

1960 HES NCAP-000-000-085-030

come to occupy 119 acres of land reclaimed from the river, with three and half miles of quayside linked by ten miles of railway.

By the latter half of the nineteenth century, the vast majority of the 800,000 tonnes of trade being handled by the city each year was in one product: jute. The city became known as 'Juteopolis'. It was dense, steepled and smoky – an industrial powerhouse but also, increasingly, an insanitary slum. So, in 1871, Dundee's Victorian City Fathers took radical action: achieving what Glasgow's Chief Engineer Robert Bruce could not a century later. Fired-up by Jute fortunes, they agreed and enacted a plan to tear down the old renaissance city centre, building an entirely new one in its place, a redesigned core modelled on the grand boulevards of Milan and Paris.

Another half century on however, and the jute industry was in terminal decline, undercut by cheaper labour costs in India. The tide of prosperity was slipping away. As the industry disappeared, many of the harbour buildings were abandoned, left without a purpose. In the 1960s, a new road bridge thrust the motorcar into the heart of Dundee. Just like in Glasgow, it was now the turn of the designers of modernism: devotees of the high-rise, the fly-over and the shopping centre. The port, once the city's lifeblood, fell into decay or was buried underneath a great expanse of car parks – as if Dundee had suddenly turned itself away from the sea.

There are, perhaps, few better examples of the speed at which our cities can change. Take a map of Dundee from the late eighteenth century and compare it with one from the late nineteenth and you will find very little overlap. It is as if you are looking at two different places. Even the shape of the landscape itself has altered, due to the large tracts reclaimed from the river to develop the harbour. By the 1920s, you can begin to track this shifting city through aerial photographs. You can even spot how, year by year, the great chimneys of the jute factories disappeared, one by one, until there were barely a handful left. You can see how the road bridge materialised across the Tay, high-rises pushed up into the skyline and concrete colonised the crumbling docklands. And you can watch it happening all over again, right now: the latest version of Dundee emerging, old and new fitting together like a jigsaw puzzle of the city's history.

It all seems so easy from up high. Countryside and cityscapes stretching off in every direction: the *God's-eye view*. Look down and the answers appear obvious – transform a landscape here, move a whole population and reshape an entire city there. Knock all that down. Build all this up. It can be seductive and compelling. The reality, of course, is never quite that simple. All the same, from above you *can* see, in an instant, the true transience of our world, the restlessness of our built environment. Yes, you can pick out the traces of the past set amid the sprawl of the present. But you can also spot – and imagine – the future: always coming towards you, just over the horizon. And always approaching fast.

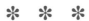

THE CUILLIN, SKYE
2015 HES AERIAL SURVEY DP221667

2

THE GOD'S-EYE VIEW
IMAGERY FROM THE HISTORIC ENVIRONMENT SCOTLAND COLLECTIONS

These images have been selected to offer you your own 'God's-eye view' of Scotland. Starting with the – seemingly – wild, untouched and 'unknowable' Highland landscapes of the eighteenth century, you will gradually see the intervention of man – roads winding along coastlines or through glens, settlements emerging, bridges spanning rivers and lochs. As the imagery continues, the focus will shift from the rural to the urban, mixing old and modern photography together to show how the view from above has been used time and again to rewrite our cityscapes.

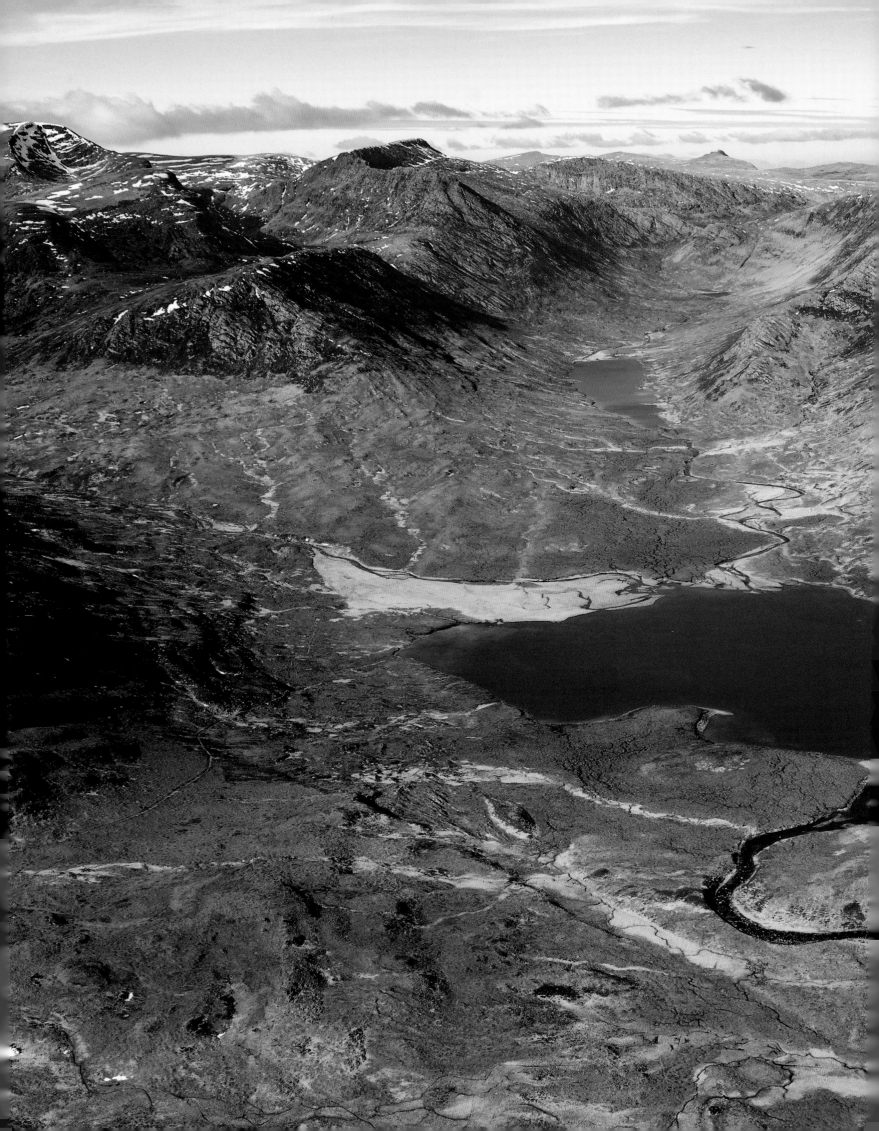

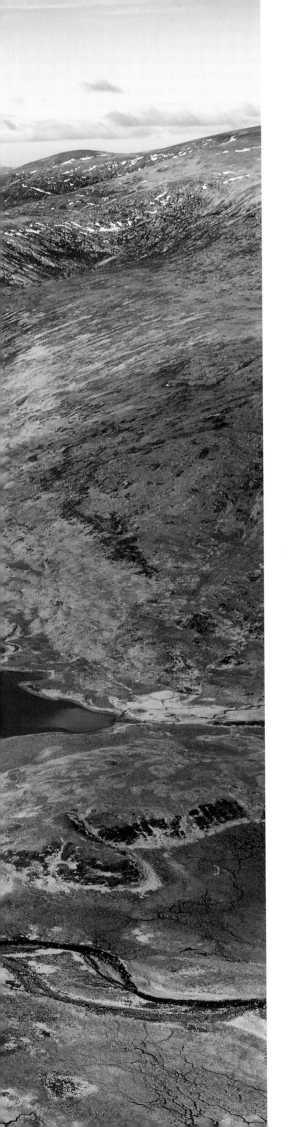

Over the course of the second Jacobite Rebellion, the government's military commanders confessed that they were 'greatly embarrassed' by their limited understanding of the Highland terrain. While they succeeded in suppressing the uprising, they failed in their attempts to capture a certain Bonnie Prince – confounded at every turn by what they described as 'rugged, rocky mountains, having a multiplicity of cavities ... most adapted to concealment of all kinds'.

LOCH A' GHARBHRAIN AND LOCH COIRE
LAIR, WESTER ROSS
2007 HES AERIAL SURVEY DP024792

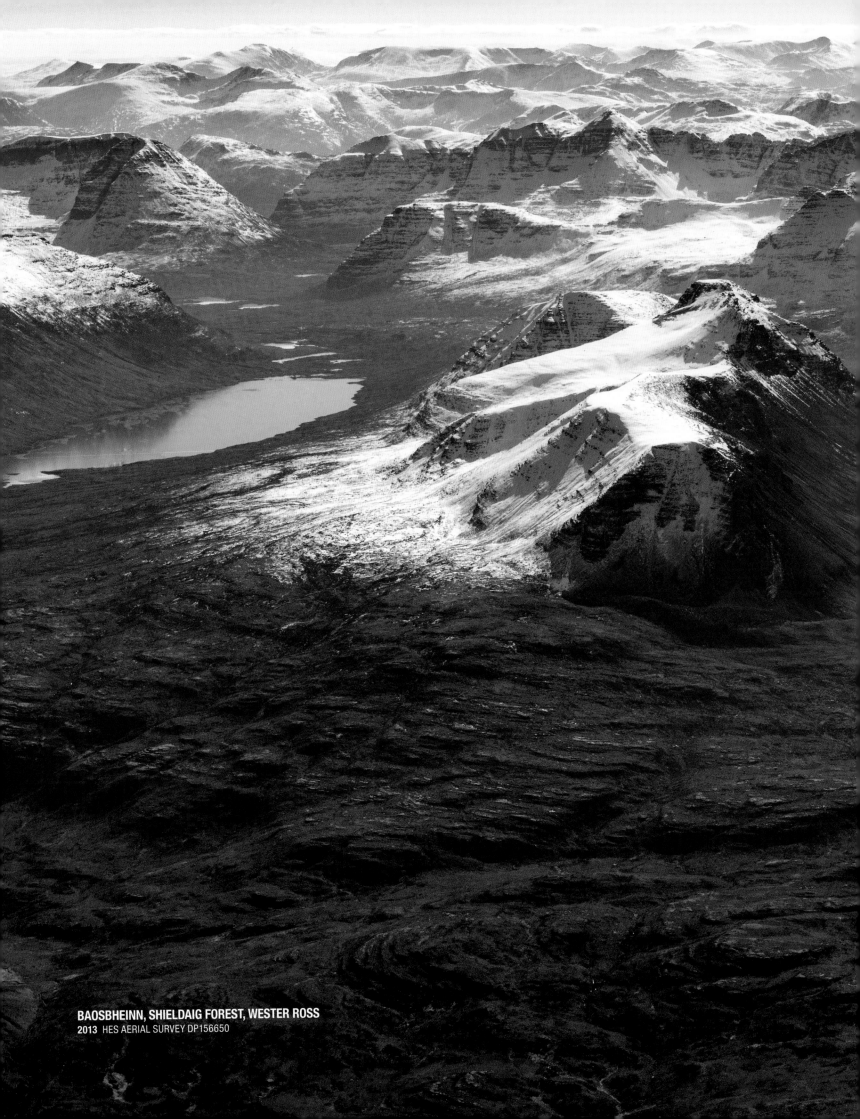

BAOSBHEINN, SHIELDAIG FOREST, WESTER ROSS
2013 HES AERIAL SURVEY DP156650

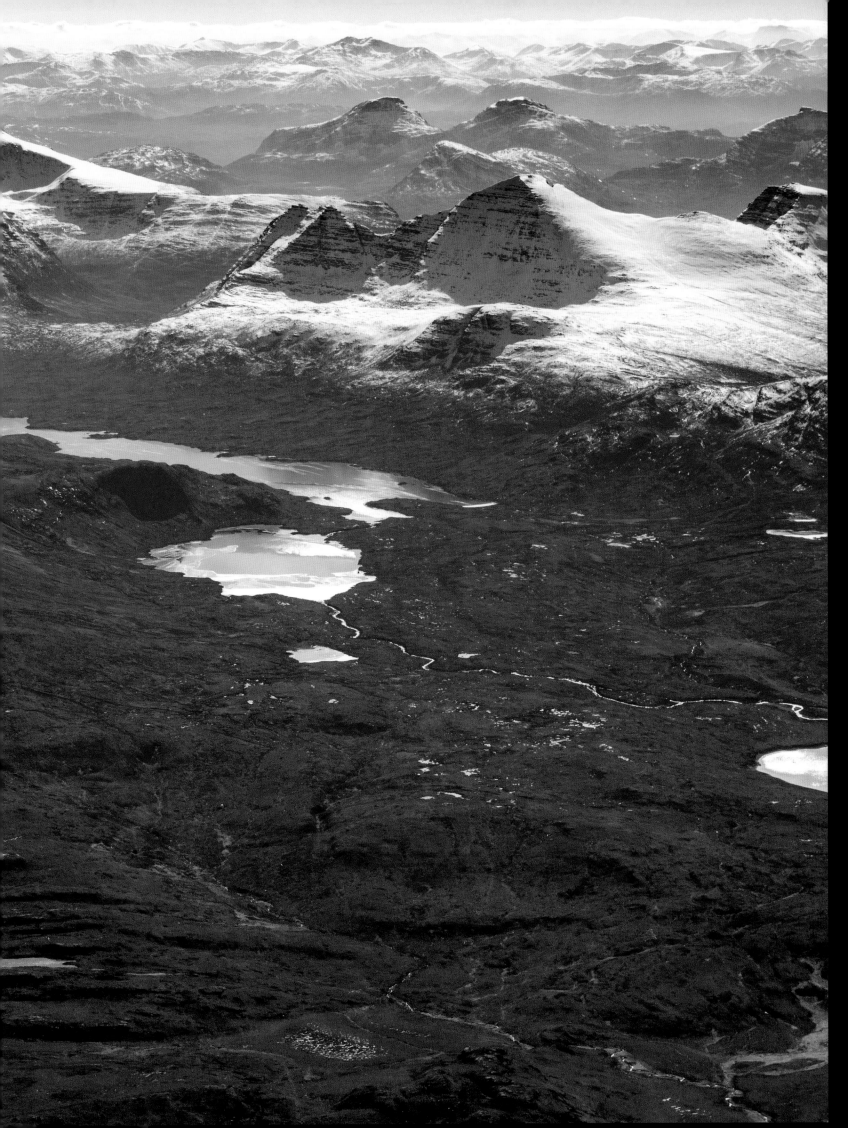

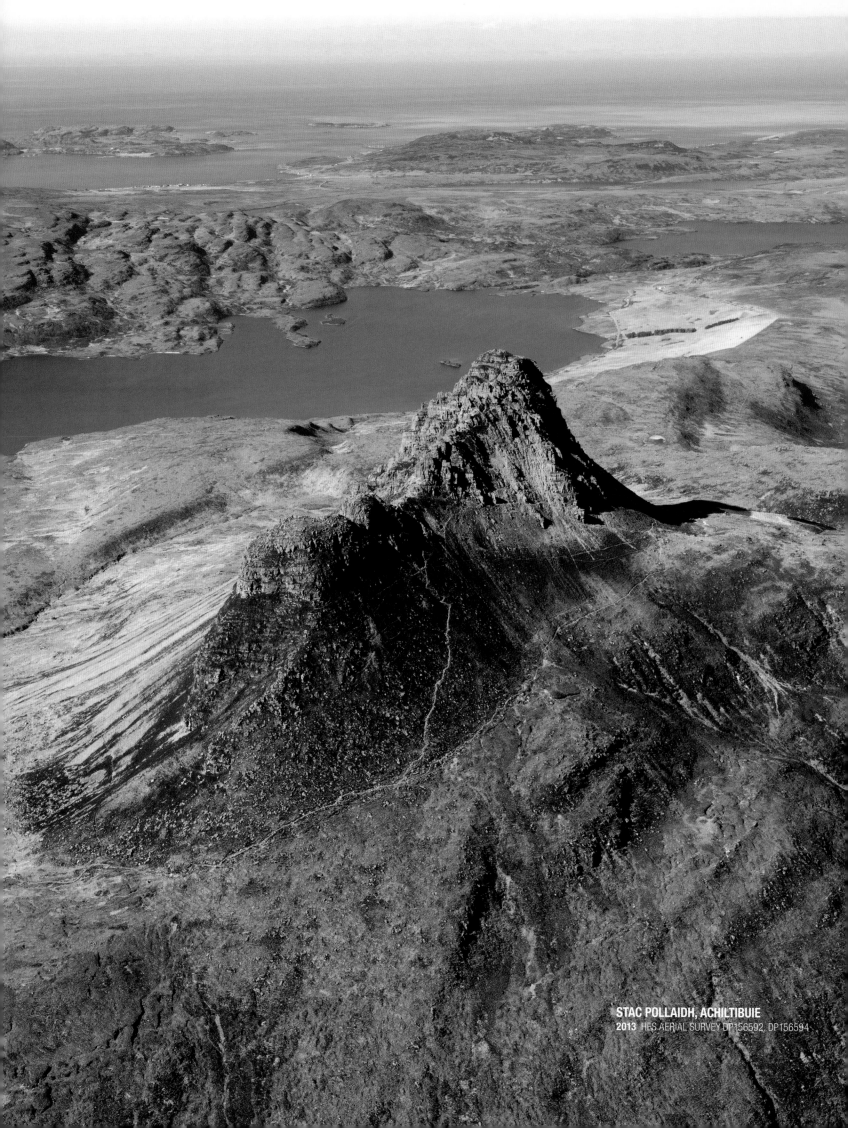

STAC POLLAIDH, ACHILTIBUIE
2013 HES AERIAL SURVEY DP156592, DP156594

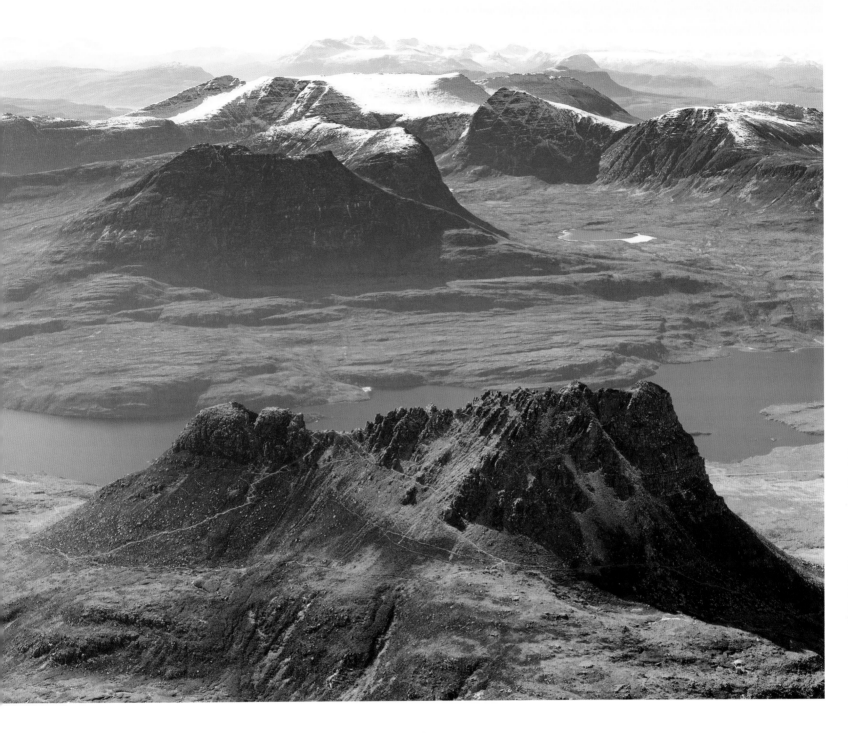

'The courses of all the Rivers and numerous streams were followed to the source and measured; and all the Roads and the many Lakes of Salt-water and Fresh were surveyed, as well as such intermediate places and cross lines as were found necessary for filling up the Country'

ACCOUNT OF WILLIAM ROY'S 'MILITARY SURVEY' OF THE HIGHLANDS

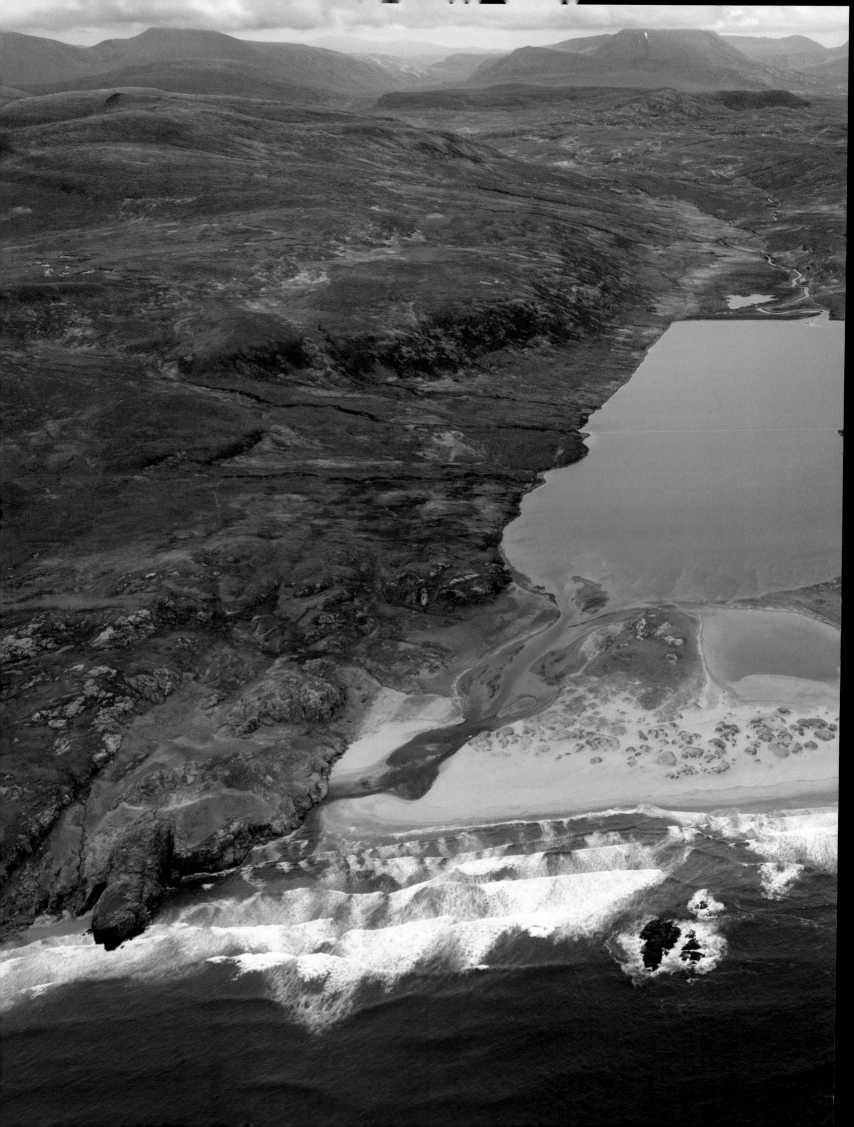

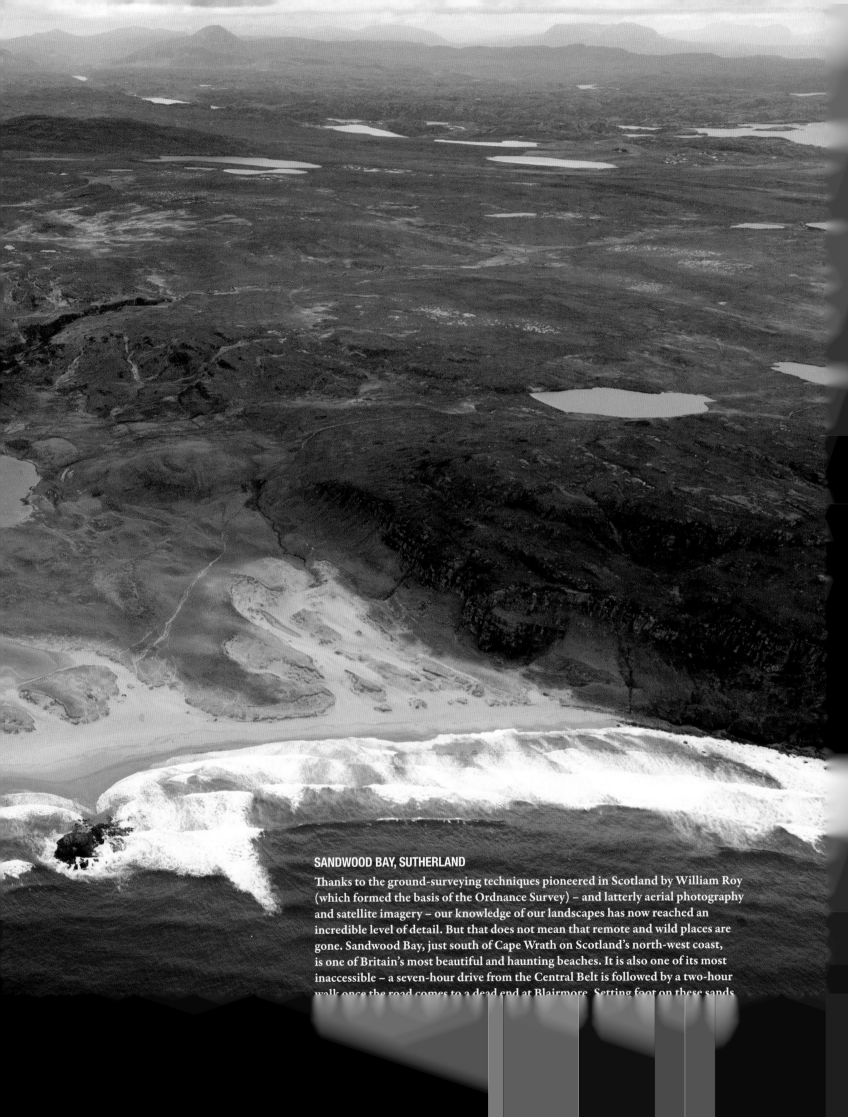

SANDWOOD BAY, SUTHERLAND

Thanks to the ground-surveying techniques pioneered in Scotland by William Roy (which formed the basis of the Ordnance Survey) – and latterly aerial photography and satellite imagery – our knowledge of our landscapes has now reached an incredible level of detail. But that does not mean that remote and wild places are gone. Sandwood Bay, just south of Cape Wrath on Scotland's north-west coast, is one of Britain's most beautiful and haunting beaches. It is also one of its most inaccessible – a seven-hour drive from the Central Belt is followed by a two-hour walk once the road comes to a dead end at Blairmore. Setting foot on these sands

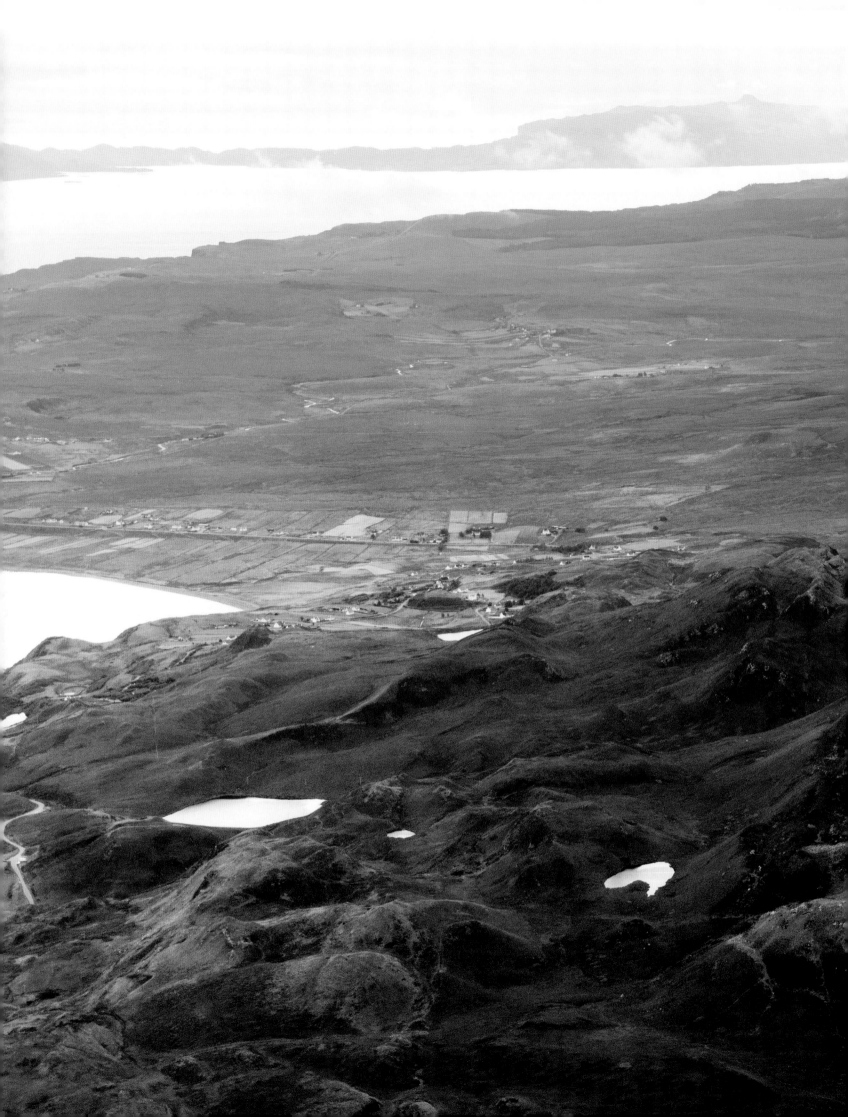

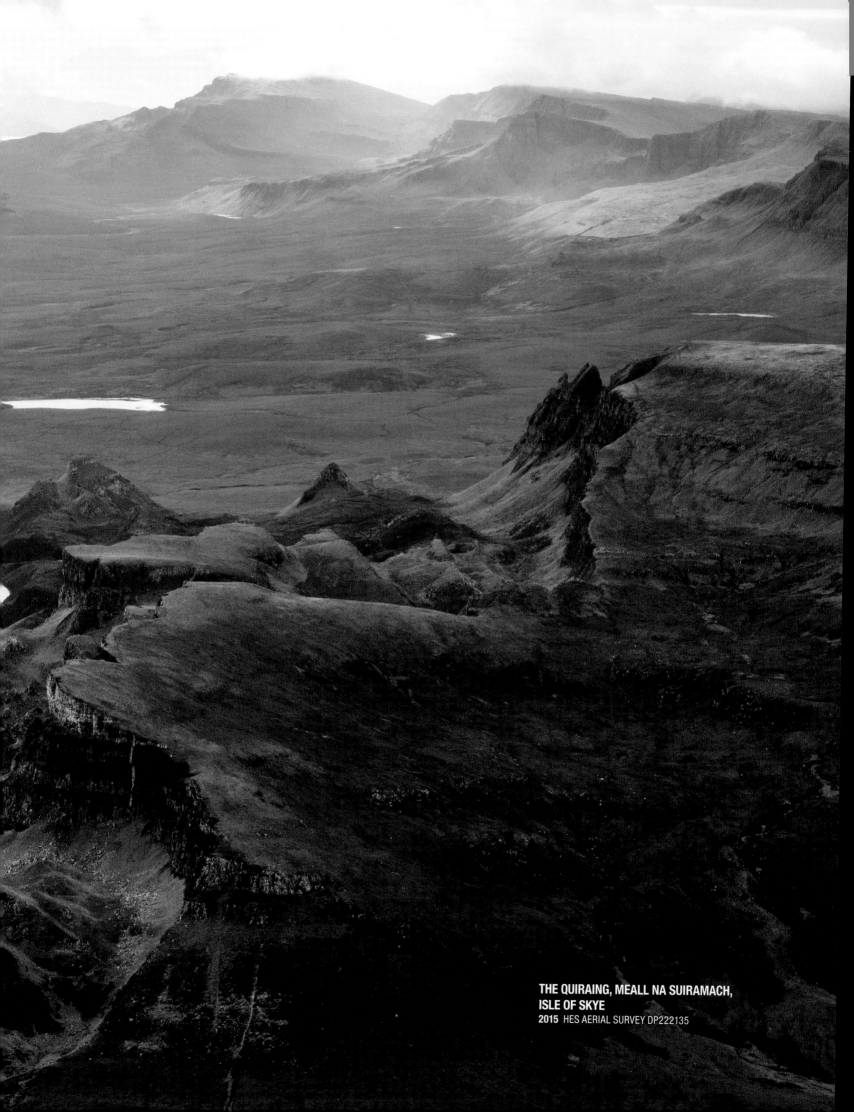

**THE QUIRAING, MEALL NA SUIRAMACH,
ISLE OF SKYE**
2015 HES AERIAL SURVEY DP222135

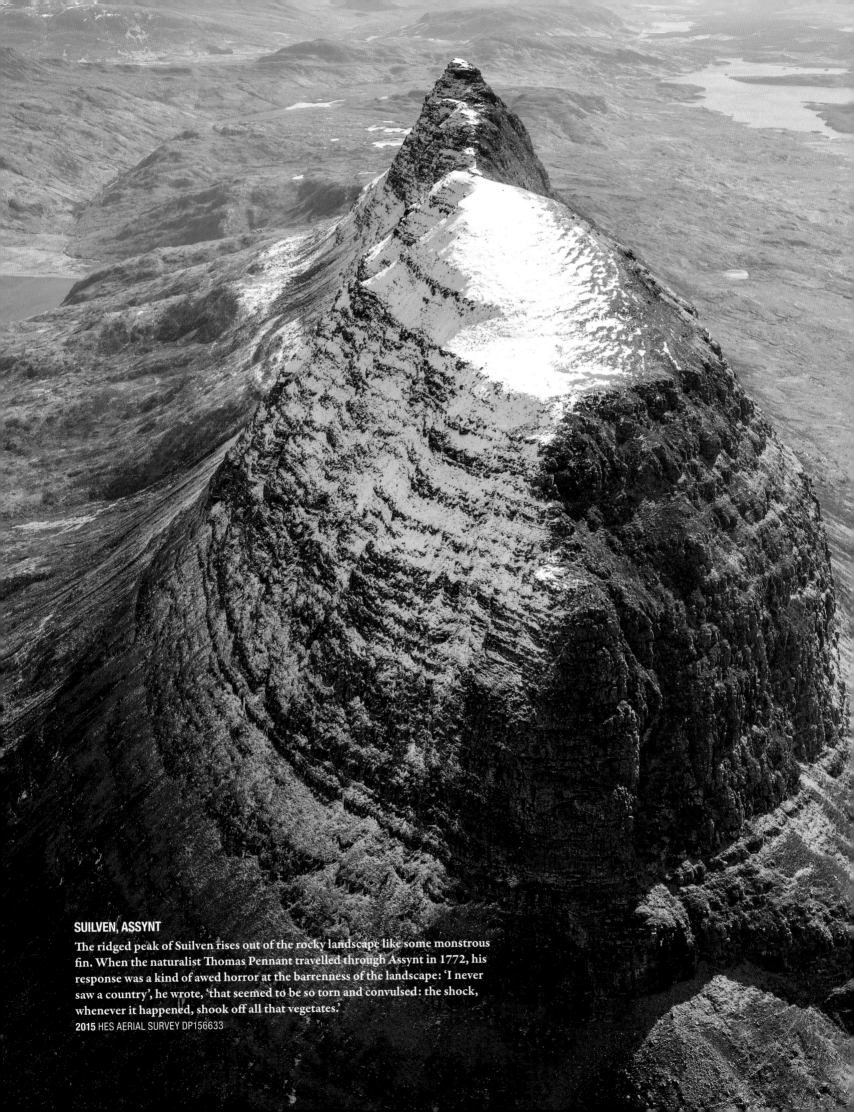

SUILVEN, ASSYNT

The ridged peak of Suilven rises out of the rocky landscape like some monstrous fin. When the naturalist Thomas Pennant travelled through Assynt in 1772, his response was a kind of awed horror at the barrenness of the landscape: 'I never saw a country', he wrote, 'that seemed to be so torn and convulsed: the shock, whenever it happened, shook off all that vegetates.'

2015 HES AERIAL SURVEY DP156633

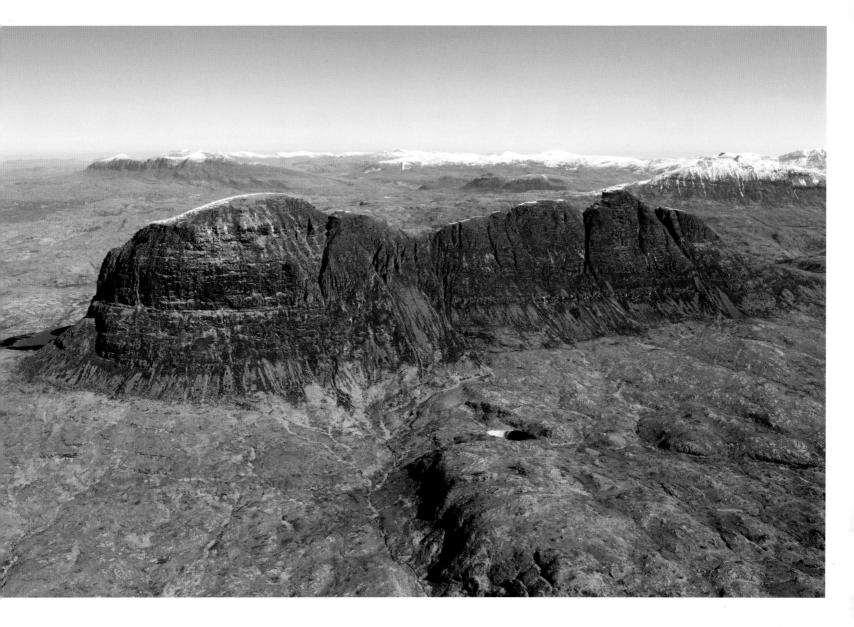

SUILVEN, ASSYNT

While the survey of the Highlands was commissioned as a military and political act, for William Roy it always had a more universal goal – to demonstrate the power of rational science over wild, 'unknowable' nature. As Roy traversed the country he became increasingly curious about the processes that had led to the creation of the strange and unusual landscapes he encountered. 'This', Roy wrote of Assynt, 'though appertaining to the mountainous region of the country, is very different from the adjoining Highland districts; for without being so remarkably high, it is infinitely more rugged and broken than any other part of Britain. In order to convey any tolerable idea of a country so very extraordinary in its nature we may suppose some hundreds of the highest mountains split into many thousands of pieces, and the fragments were scattered about.'

2015 HES AERIAL SURVEY DP156625

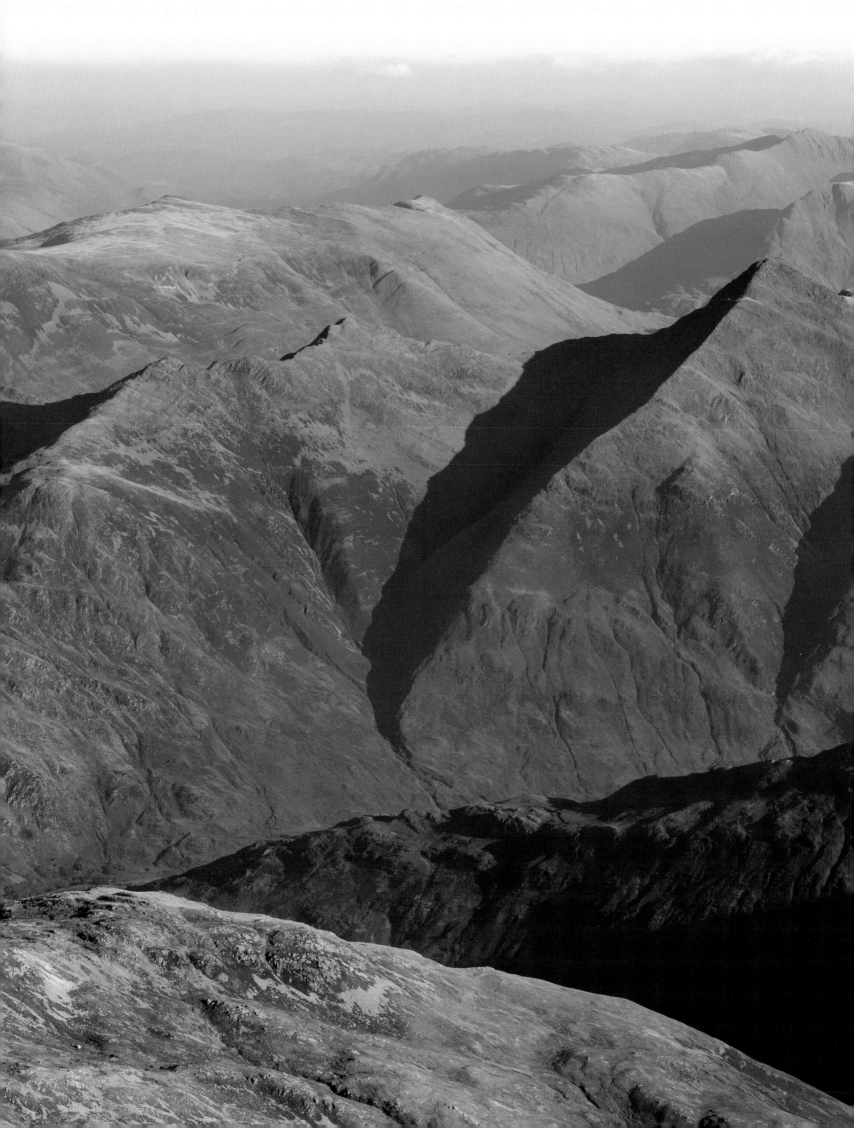

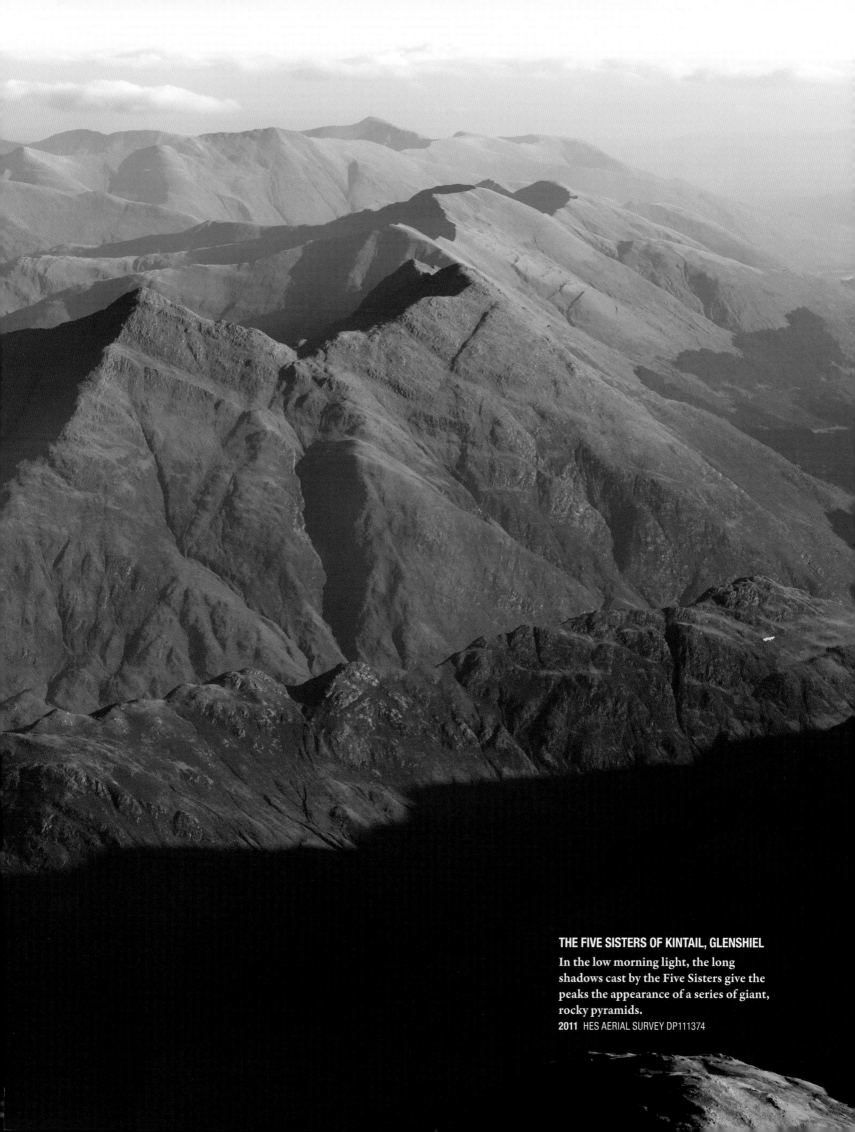

THE FIVE SISTERS OF KINTAIL, GLENSHIEL

In the low morning light, the long shadows cast by the Five Sisters give the peaks the appearance of a series of giant, rocky pyramids.

2011 HES AERIAL SURVEY DP111374

KYLESTROME, NORTH-WEST SUTHERLAND

This stretch of the A894 overlooking the waters of Loch a' Chairn Bhain only dates from the 1980s, when the construction of the Kylesku Bridge removed the need for a ferry crossing of the Caolas Cumhann channel.

2015 HES AERIAL SURVEY DP162728

GLEN BEAG AND THE SPITTAL OF GLENSHEE, PERTHSHIRE

The A93 hugs the valley floor as it descends southwards from its high point of over 2,000 feet at the Cairnwell Pass – making it the highest public road in Britain. The modern road runs alongside – and on top of – a military road built by Major William Caulfield in the immediate aftermath of the second Jacobite Rebellion. The road was constructed to provide a link from the lowlands to the government's new Highland military base of Fort George.

2015 HES AERIAL SURVEY DP226335

'I have, however, I trust, now nearly accomplished all the main objects of my mission, and shall be able to make out a plan and surveys of one of the noblest projects that ever was laid before a Nation'

THOMAS TELFORD ON HIS PROGRAMME OF HIGHLAND 'IMPROVEMENTS'

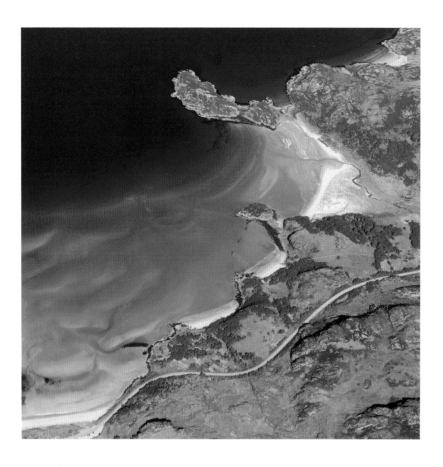

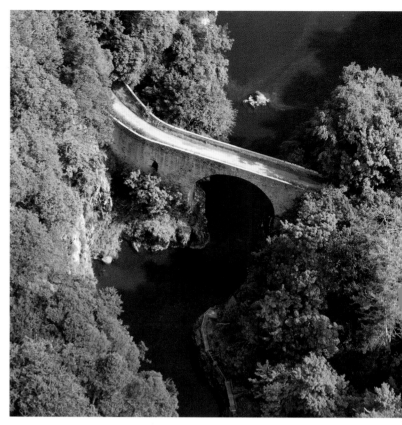

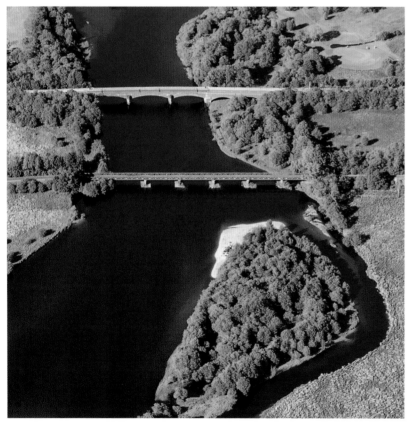

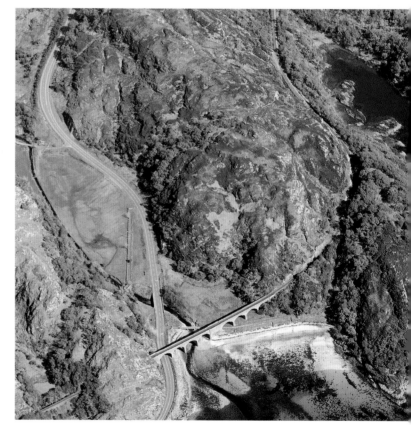

GRUINARD BAY, WESTER ROSS top left

This lonely stretch of the A832 – a coast-to-coast route linking Gairloch in the west to Cromarty in the east – was one of Scotland's 'Destitution Roads', built during the Potato Famine of 1846–7 to provide crofters with work in exchange for oatmeal rations. For centuries now, work has been ongoing to open up access across all of Scotland's more remote landscapes.

2011 HES AERIAL SURVEY DP110038

BRIDGE OF ALVAH, RIVER DEVERON, BANFF top right
2015 HES AERIAL SURVEY DP217786

LOCH AWE ROAD BRIDGE AND RAILWAY VIADUCT, RIVER ORCHY, ARGYLL bottom left
2006 HES AERIAL SURVEY DP017808

LOCH NAN UAMH RAILWAY VIADUCT, ARISAIG bottom right
2007 HES AERIAL SURVEY DP031331

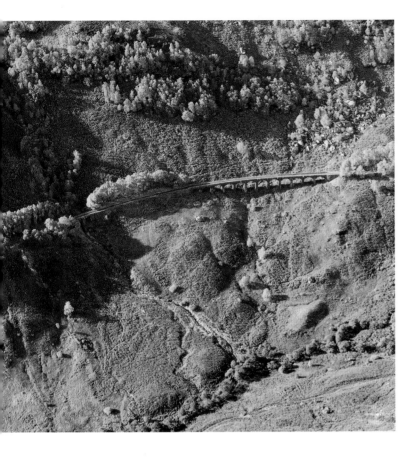

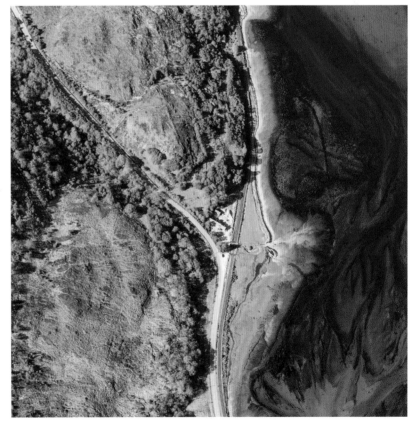

GLEN OGLE RAILWAY VIADUCT, THE TROSSACHS top left

This twelve-arch railway viaduct, completed in 1866, carried the track of the former Callander and Oban railway over the rocky eastern slopes of Meall Reamhar. While the structure still stands, the route itself was closed down in the 1960s. Further down the slope lie the grassed-over tracks of another older route: the eighteenth century Stirling to Fort William military road.

2008 HES AERIAL SURVEY DP110038

ACHADH RUIGH LUIRG, LOCH FANNICH, WESTER ROSS bottom left
2009 HES AERIAL SURVEY DP074568

THE BLACK WATER, STRATH BRORA, SUTHERLAND top right
2009 HES AERIAL SURVEY DP080204

PORT NAM FAOCHAG, LOCH CARRON, WESTER ROSS bottom right
2011 HES AERIAL SURVEY DP109913

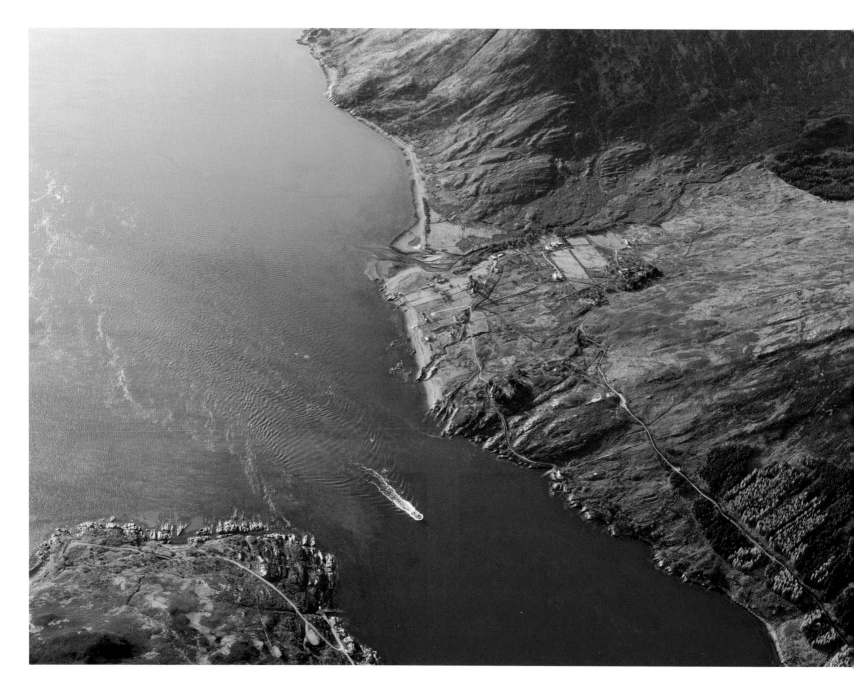

KYLERHEA FERRY, ISLE OF SKYE

A solitary boat powers through the channel between the slipways of Glenelg on the mainland and Kylerhea on the Isle of Skye. This ferry crossing still runs every summer – although its importance has been rather lessened by the construction of the Skye Bridge. When first completed two hundred years ago, however – as part of Thomas Telford's work for the Highland Road Commission – these roads and slipways were an essential part of the main route linking Skye to Edinburgh.

2011 HES AERIAL SURVEY DP110078

ACHNAHAIRD BAY, COIGACH

The end of the line. A single track road opens out to a small parking area which then gives way to an abandoned boathouse and a rocky Atlantic coastline.

2012 HES AERIAL SURVEY DP139356

LAXFORD BAY, NORTH-WEST SUTHERLAND

As the A838 makes its way towards the most north-western point on the British mainland, it passes the narrow, rocky inlet of Loch Laxford. On the right hand side of the image you can just make out a small, coursed rubble pier, built in the mid nineteenth century. Beyond the mouth of the loch is nothing but the Atlantic Ocean.

2015 HES AERIAL SURVEY DP211890

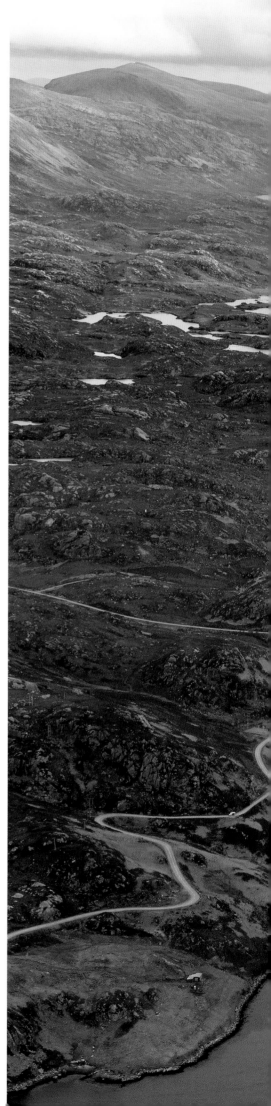

LOCH INCHARD, NORTH-WEST SUTHERLAND

A few miles further on the road passes over the Rhiconich River as it empties into Loch Inchard. The crossing itself is by a beautiful, single-arched stone bridge, built in the 1830s.

2015 HES AERIAL SURVEY DP211926

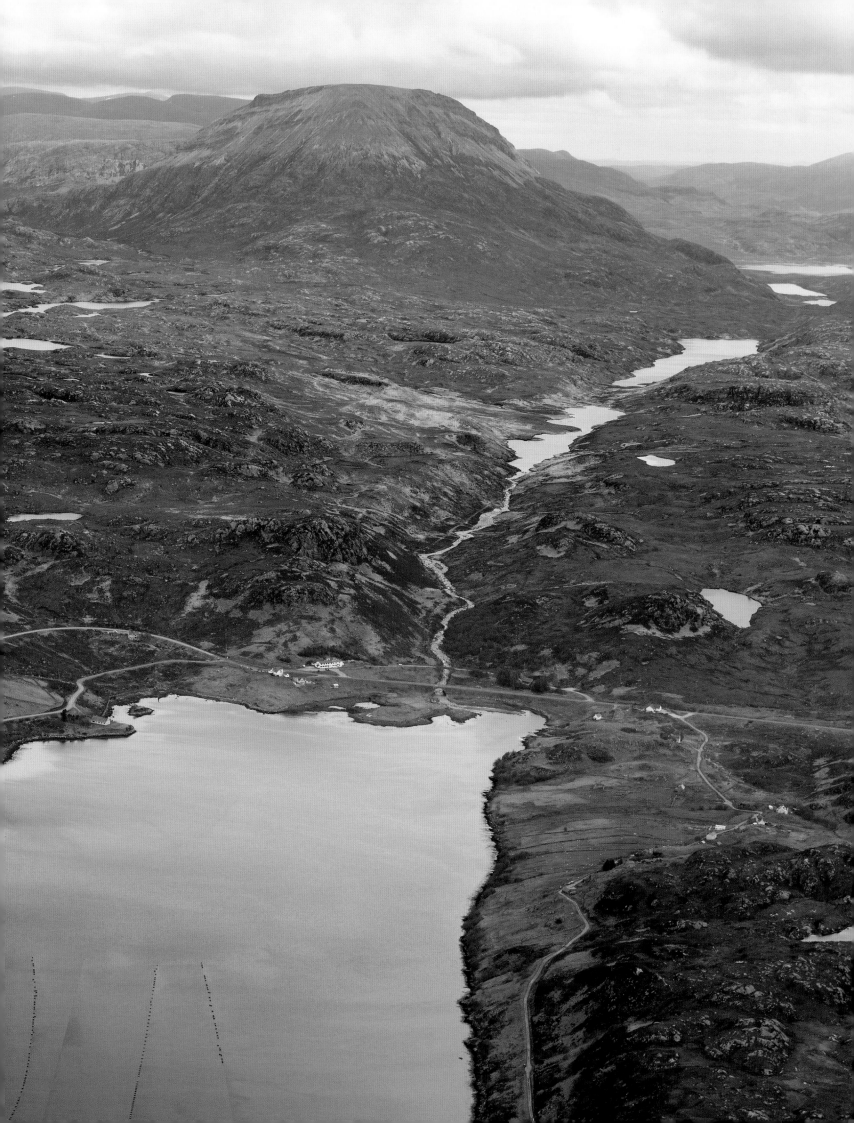

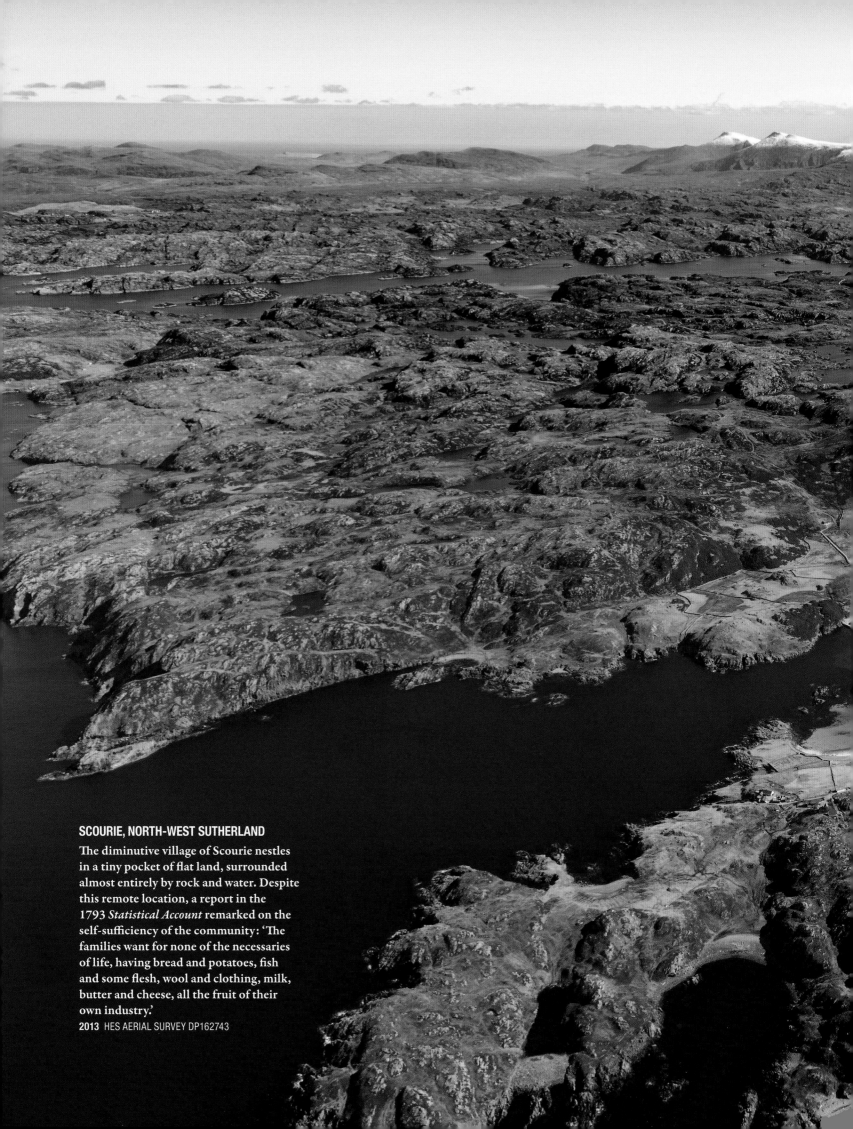

SCOURIE, NORTH-WEST SUTHERLAND

The diminutive village of Scourie nestles in a tiny pocket of flat land, surrounded almost entirely by rock and water. Despite this remote location, a report in the 1793 *Statistical Account* remarked on the self-sufficiency of the community: 'The families want for none of the necessaries of life, having bread and potatoes, fish and some flesh, wool and clothing, milk, butter and cheese, all the fruit of their own industry.'

2013 HES AERIAL SURVEY DP162743

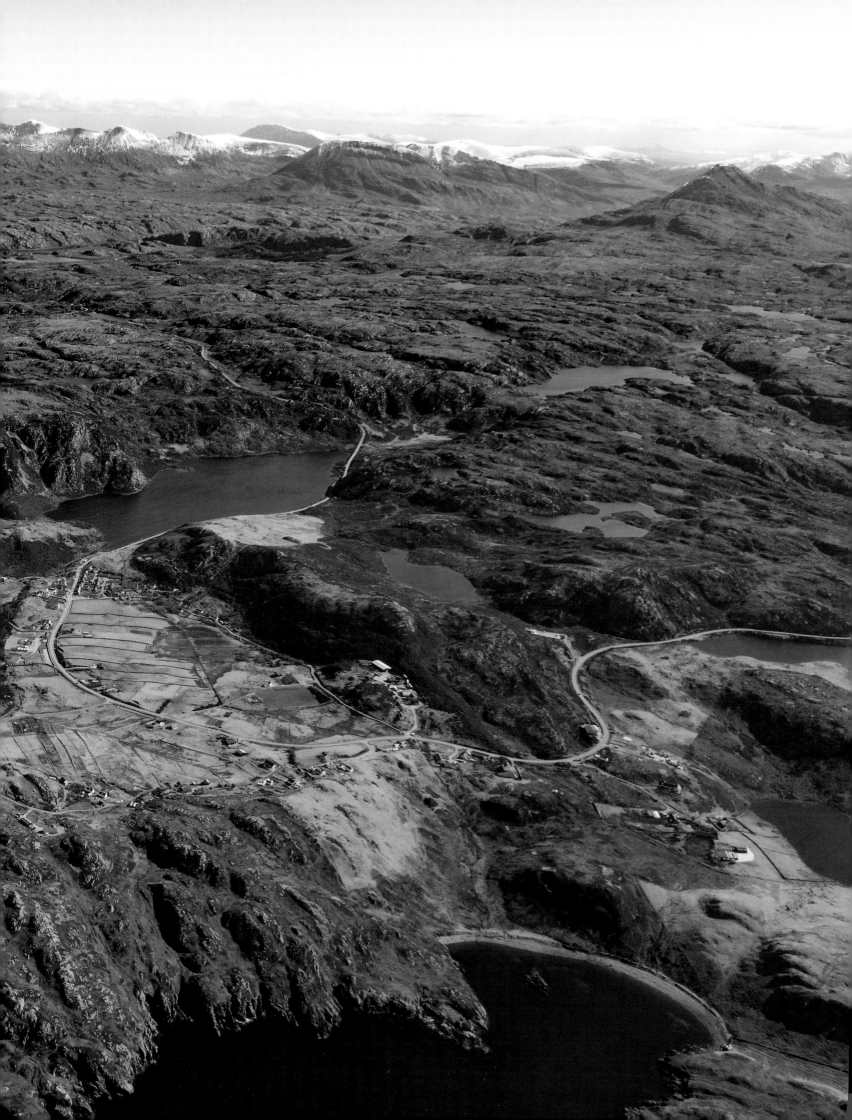

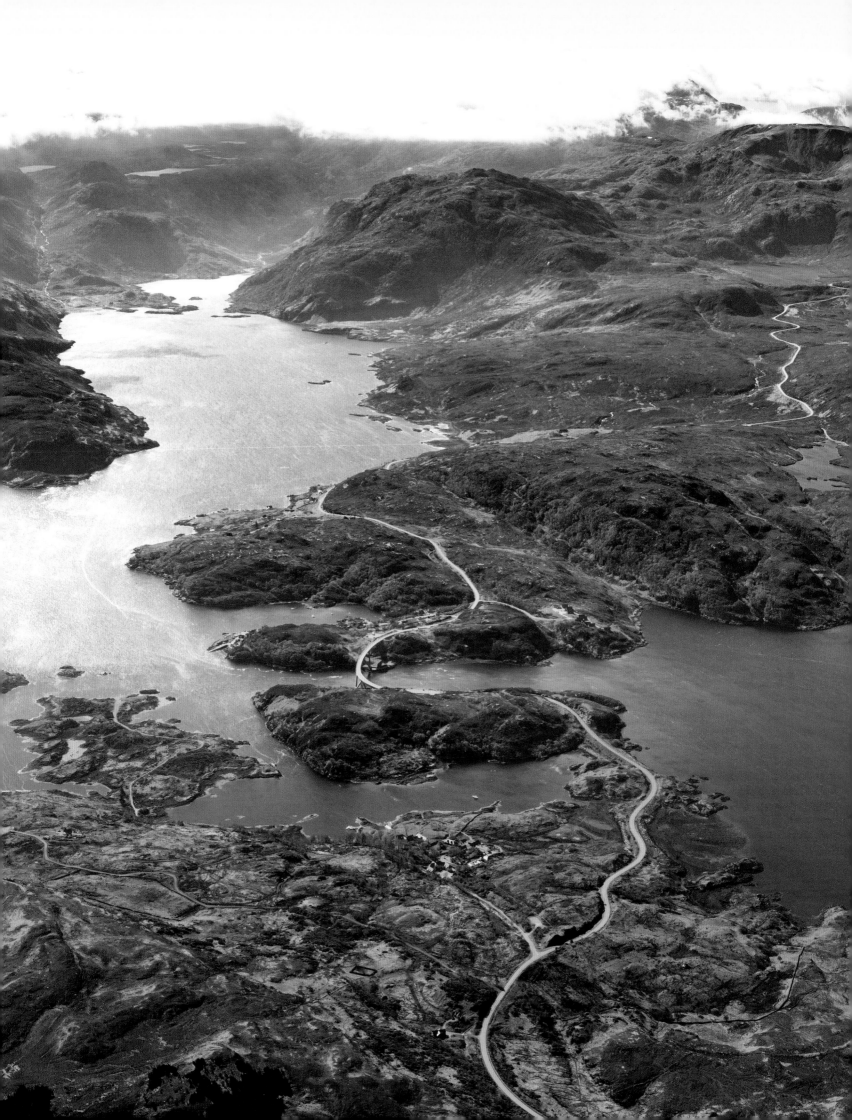

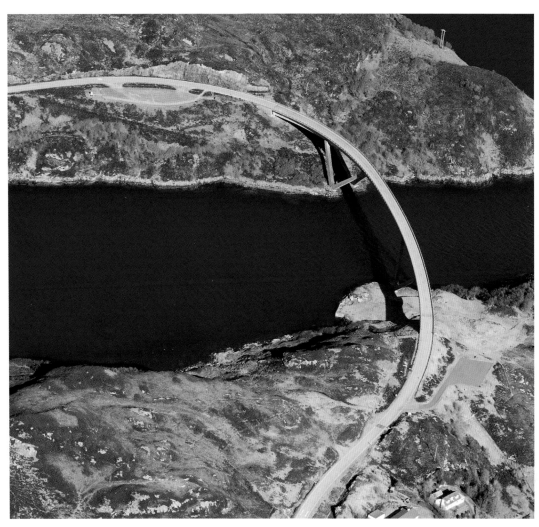

KYLESKU BRIDGE, 'NORTH COAST 500', NORTH-WEST SUTHERLAND

Routes that first emerged out of the eighteenth and nineteenth century explosion in Highland road building have undergone a twenty-first century rebranding – as the 'North Coast 500', a 500-mile loop around the whole northern tip of the country – Scotland's answer to the US 'Route 66'.

2015 & 2013 HES AERIAL SURVEY DP212194, DP162720

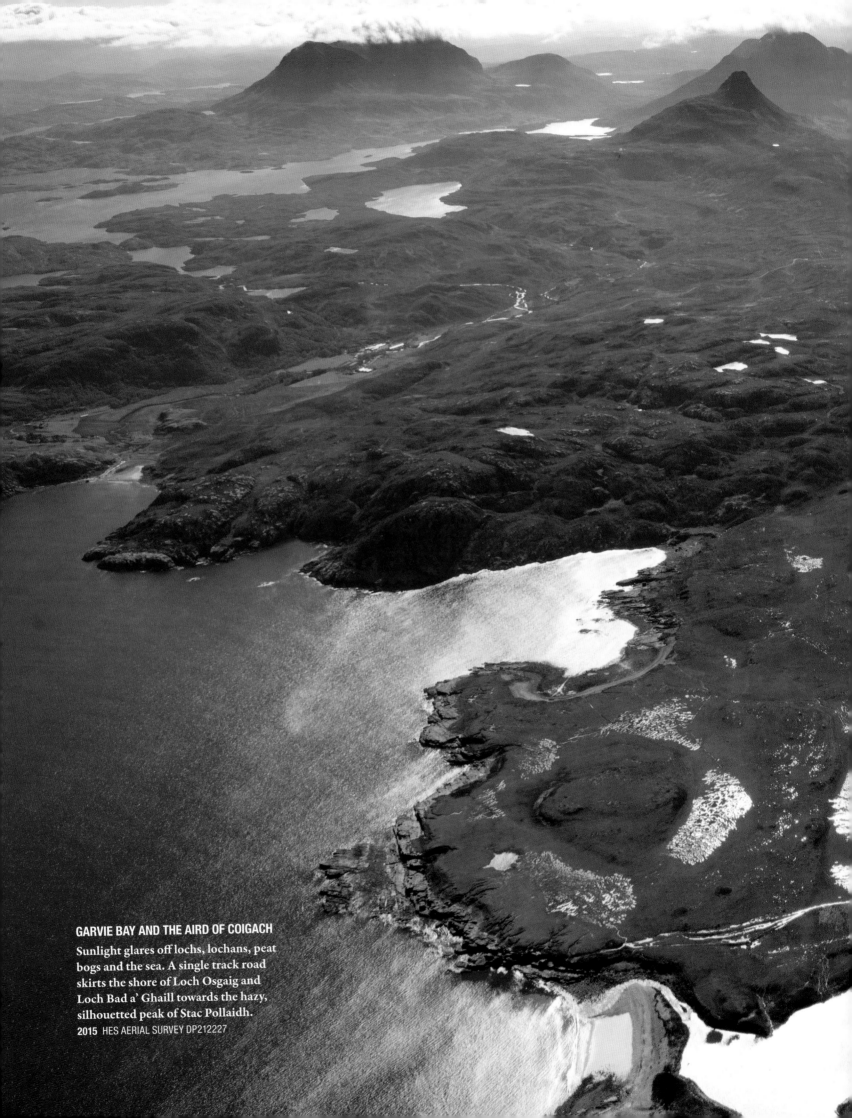

GARVIE BAY AND THE AIRD OF COIGACH

Sunlight glares off lochs, lochans, peat
bogs and the sea. A single track road
skirts the shore of Loch Osgaig and
Loch Bad a' Ghaill towards the hazy,
silhouetted peak of Stac Pollaidh.

2015 HES AERIAL SURVEY DP212227

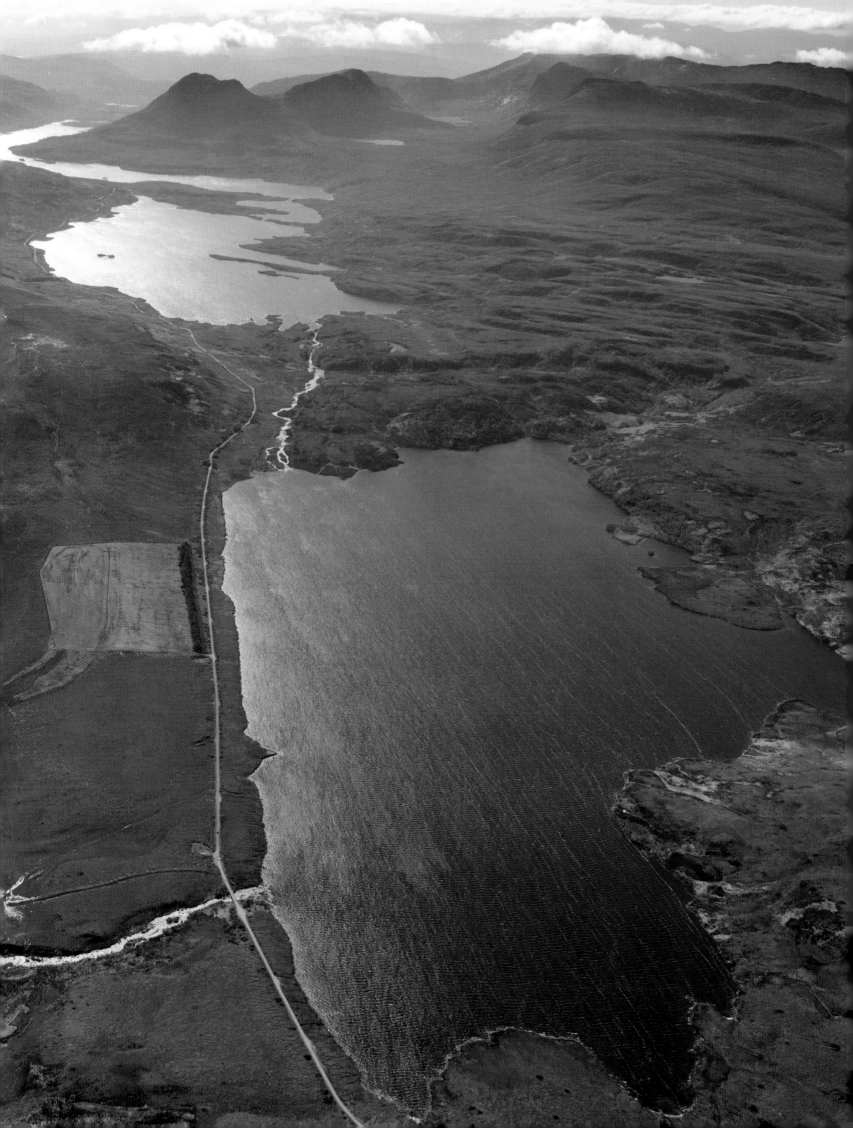

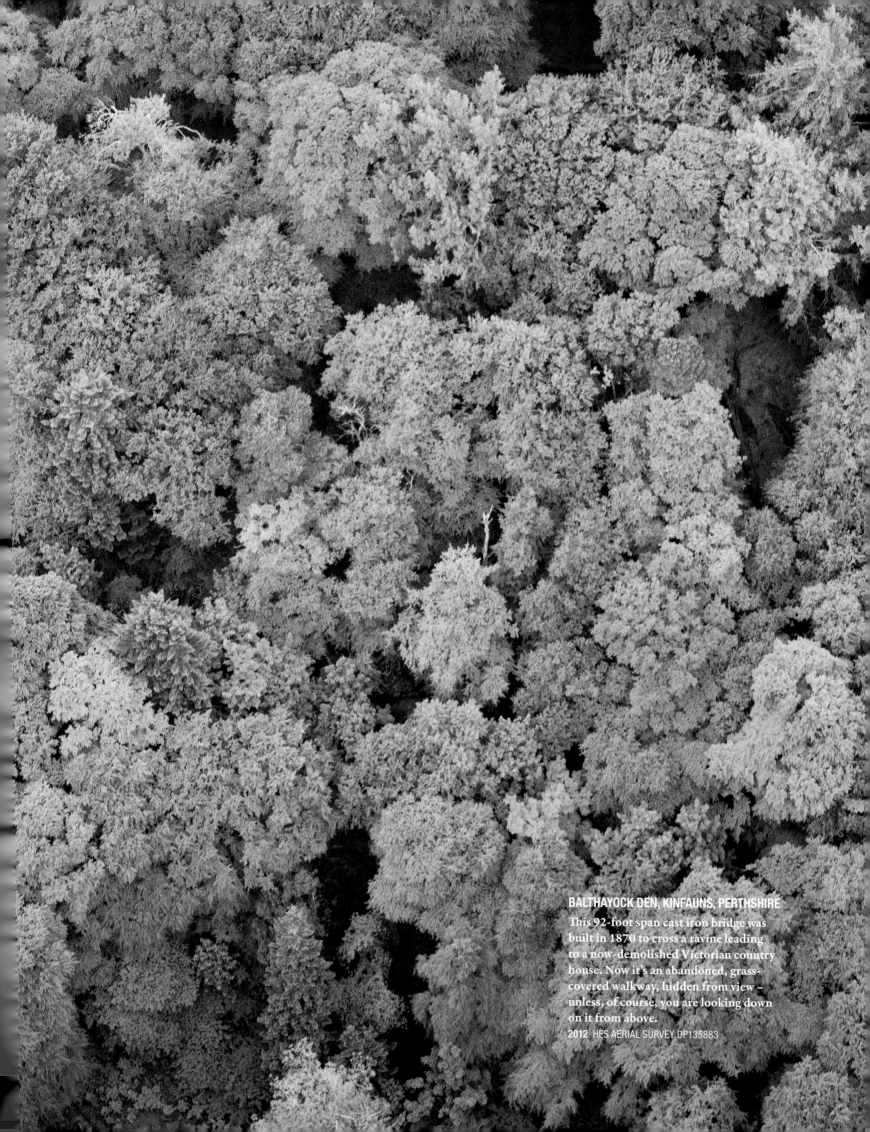

BALTHAYOCK DEN, KINFAUNS, PERTHSHIRE

This 92-foot span cast iron bridge was built in 1870 to cross a ravine leading to a now-demolished Victorian country house. Now it's an abandoned, grass-covered walkway, hidden from view – unless, of course, you are looking down on it from above.

2012 HES AERIAL SURVEY DP135883

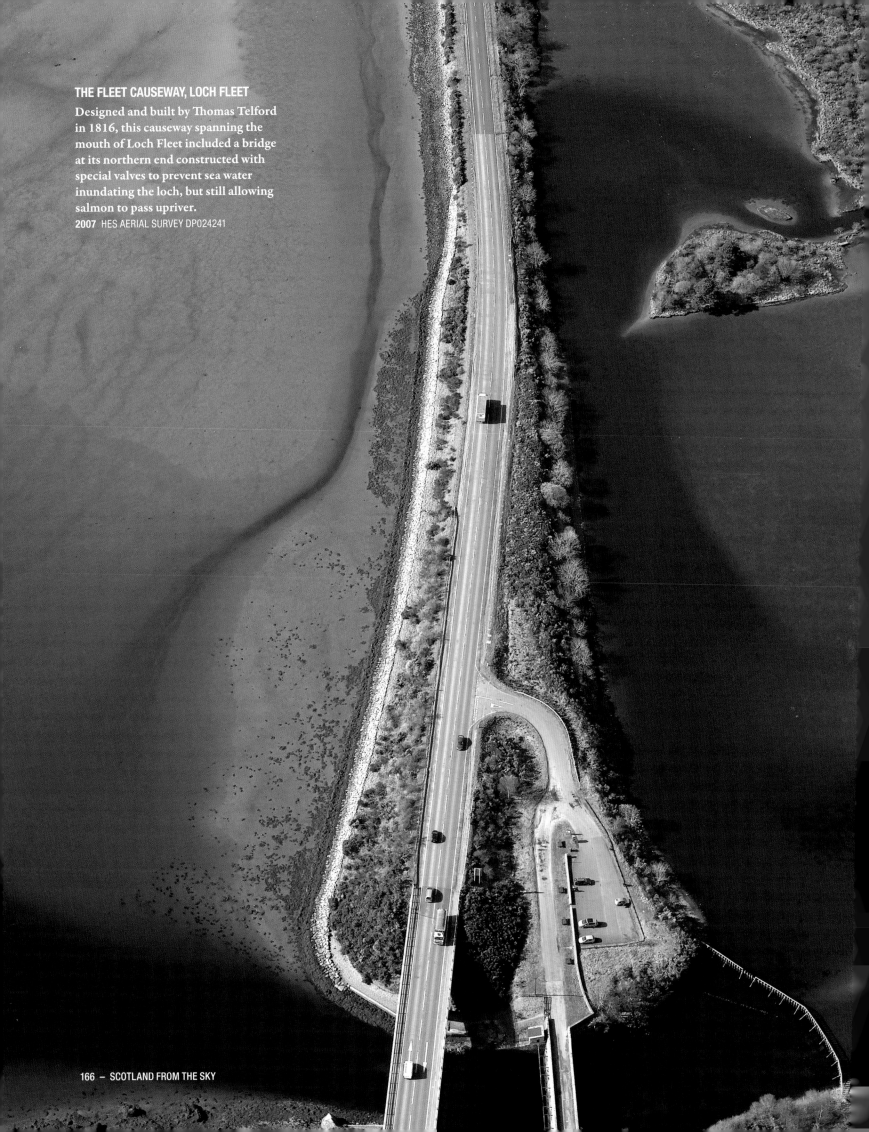

THE FLEET CAUSEWAY, LOCH FLEET

Designed and built by Thomas Telford in 1816, this causeway spanning the mouth of Loch Fleet included a bridge at its northern end constructed with special valves to prevent sea water inundating the loch, but still allowing salmon to pass upriver.

2007 HES AERIAL SURVEY DP024241

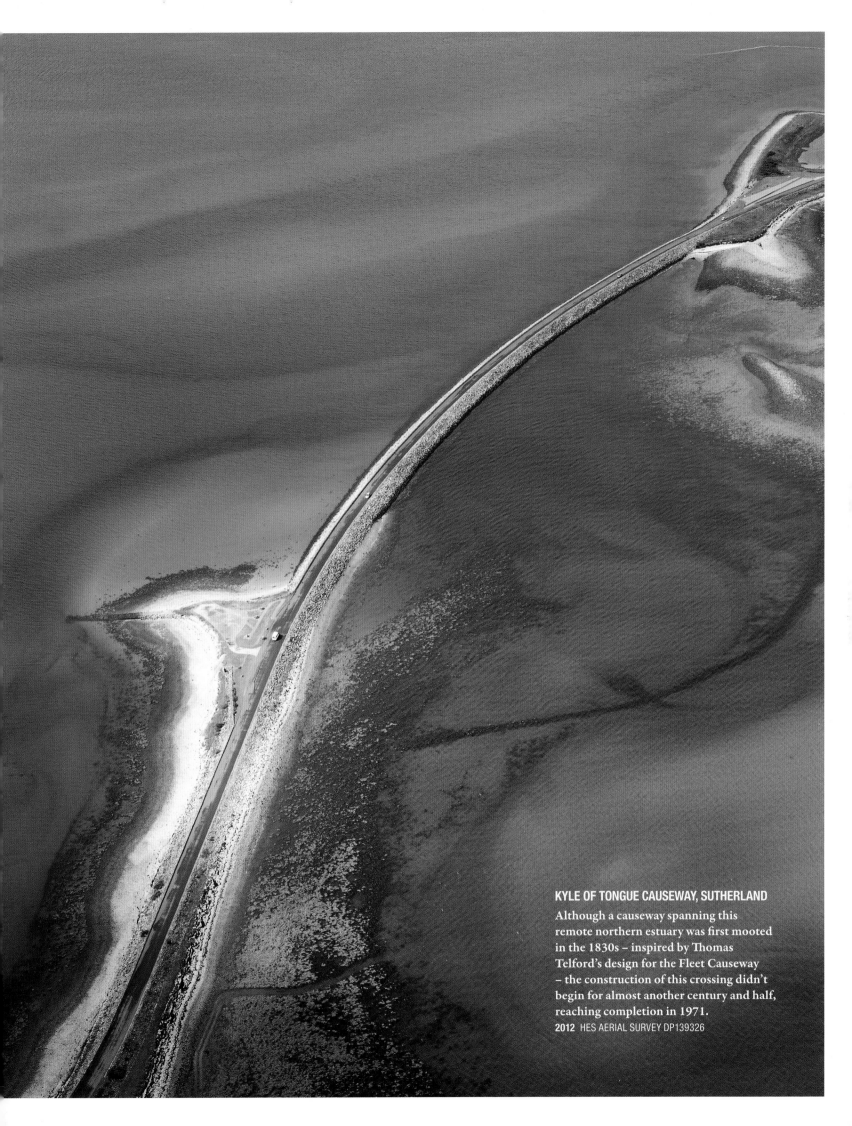

KYLE OF TONGUE CAUSEWAY, SUTHERLAND

Although a causeway spanning this
remote northern estuary was first mooted
in the 1830s – inspired by Thomas
Telford's design for the Fleet Causeway
– the construction of this crossing didn't
begin for almost another century and half,
reaching completion in 1971.

2012 HES AERIAL SURVEY DP139326

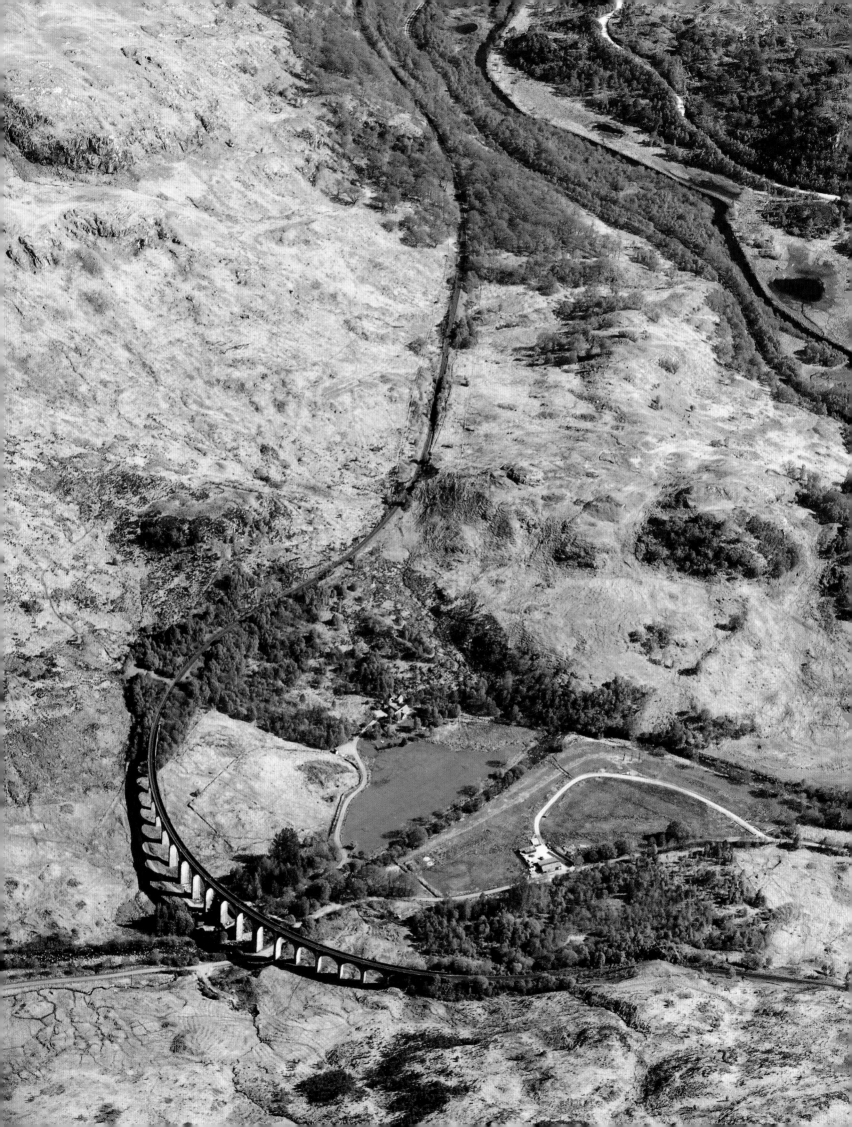

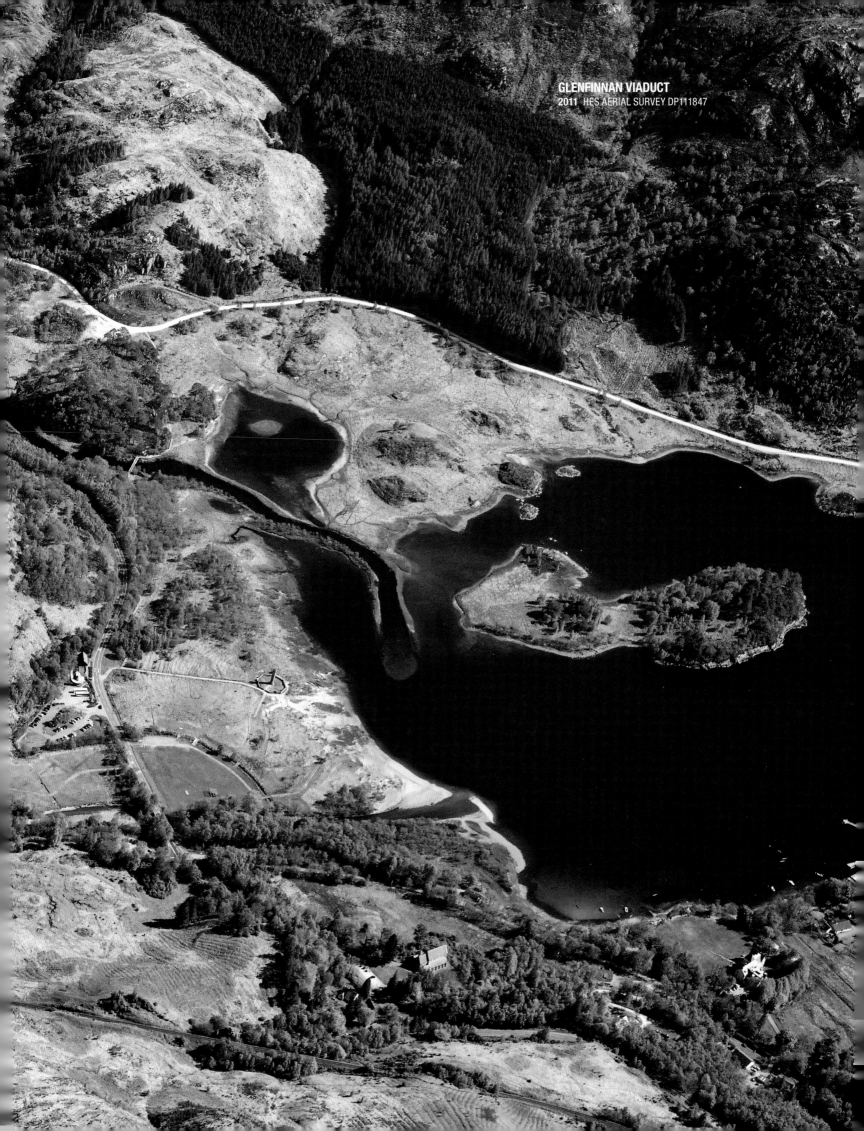

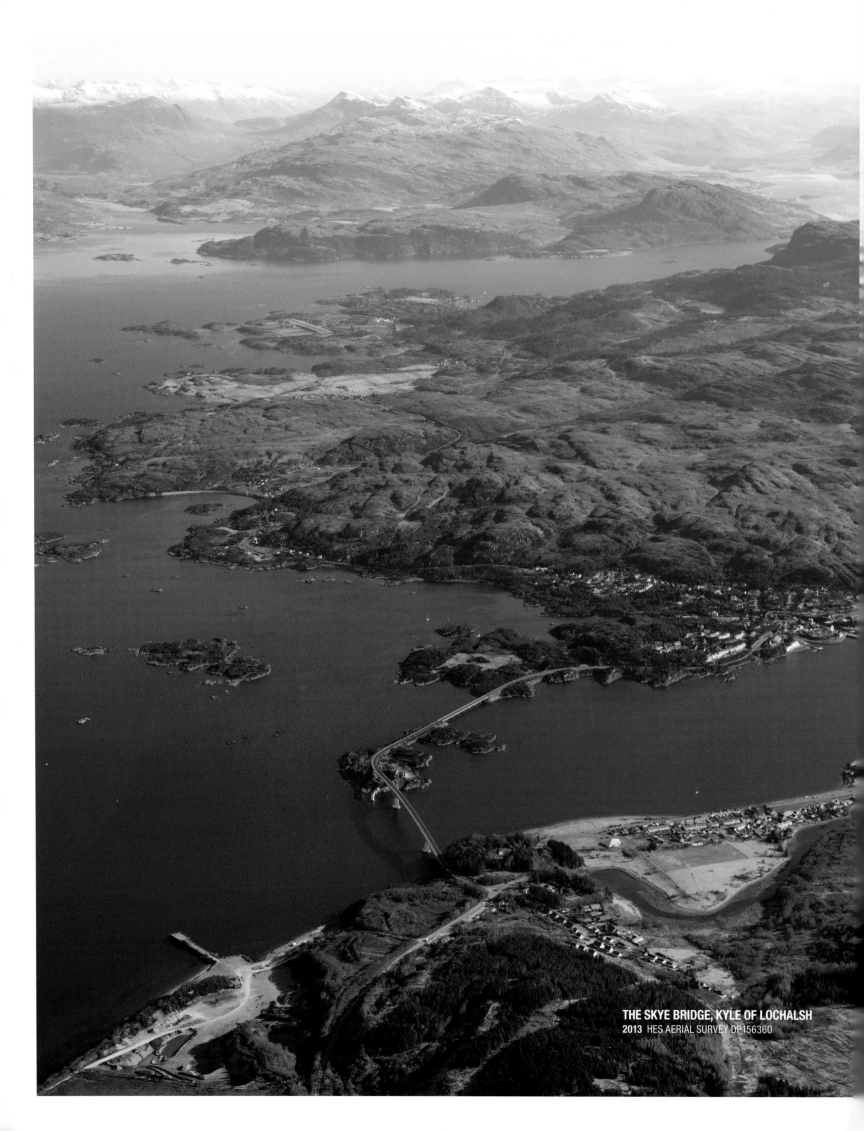

THE SKYE BRIDGE, KYLE OF LOCHALSH
2013 HES AERIAL SURVEY DP156360

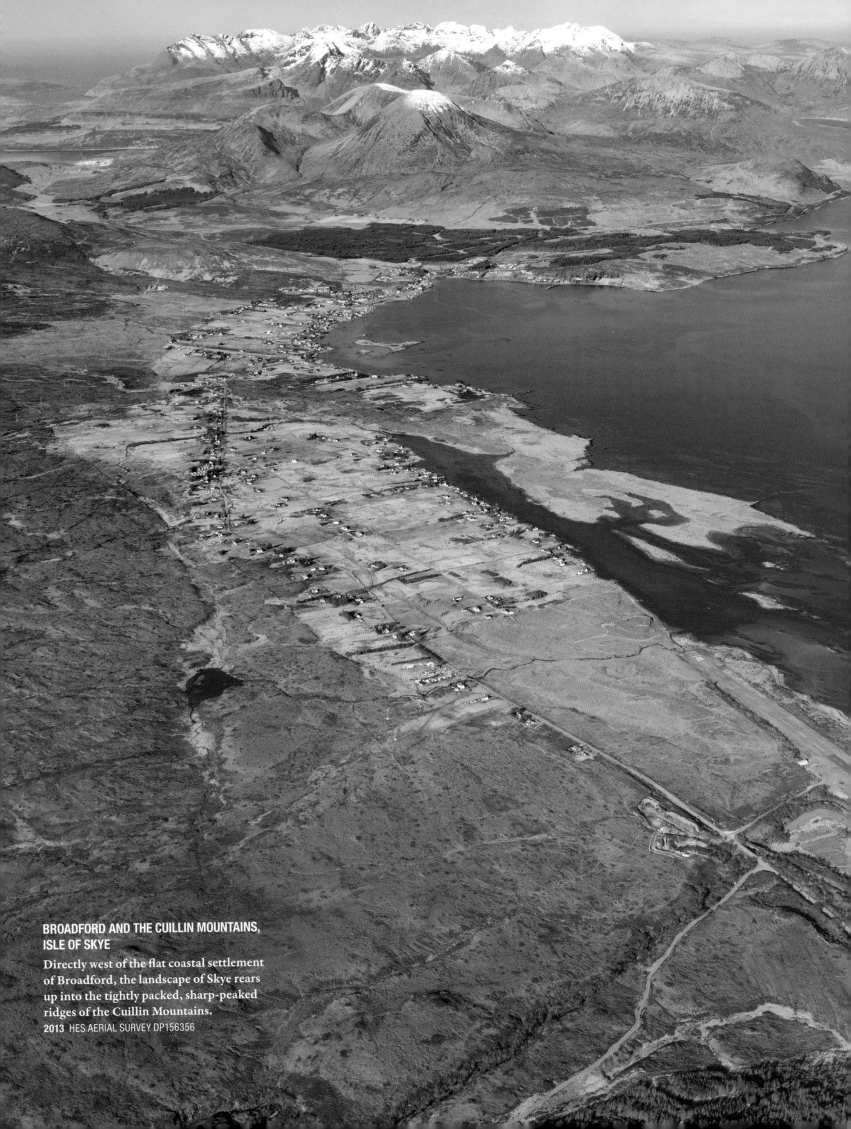

BROADFORD AND THE CUILLIN MOUNTAINS, ISLE OF SKYE

Directly west of the flat coastal settlement of Broadford, the landscape of Skye rears up into the tightly packed, sharp-peaked ridges of the Cuillin Mountains.

2013 HES AERIAL SURVEY DP156356

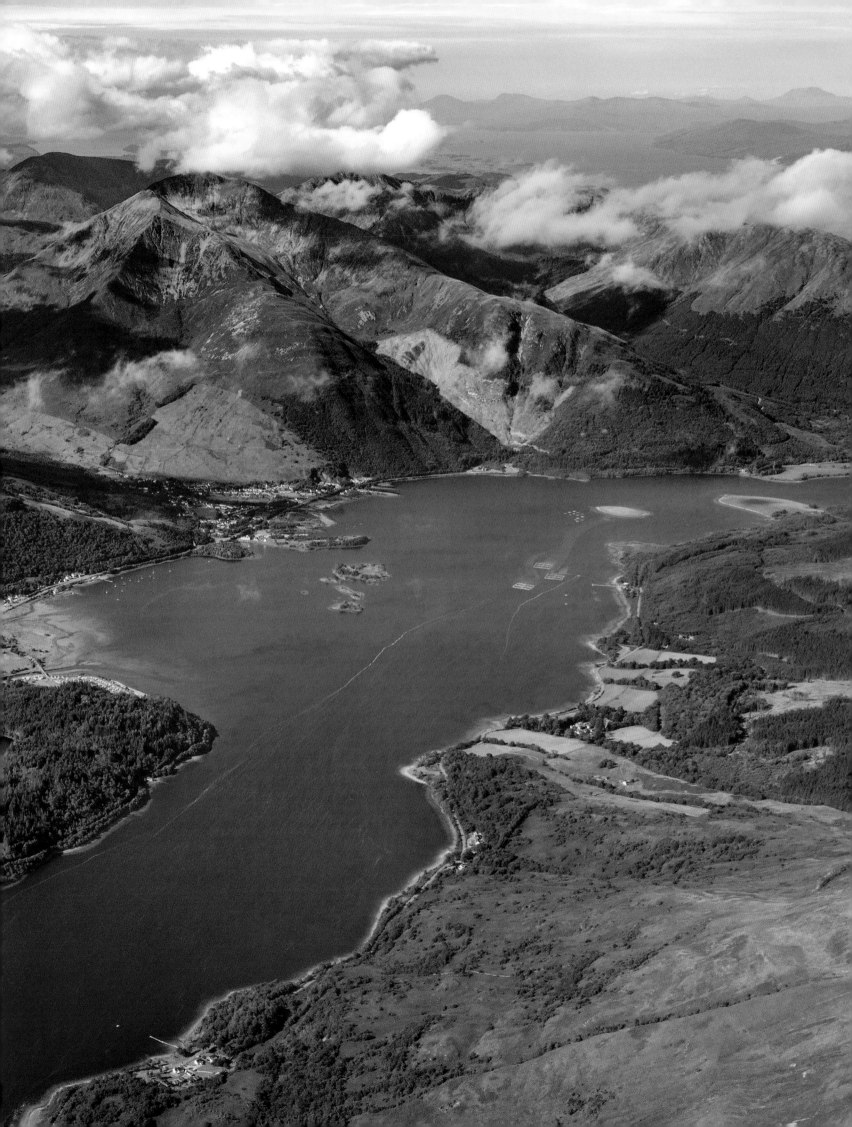

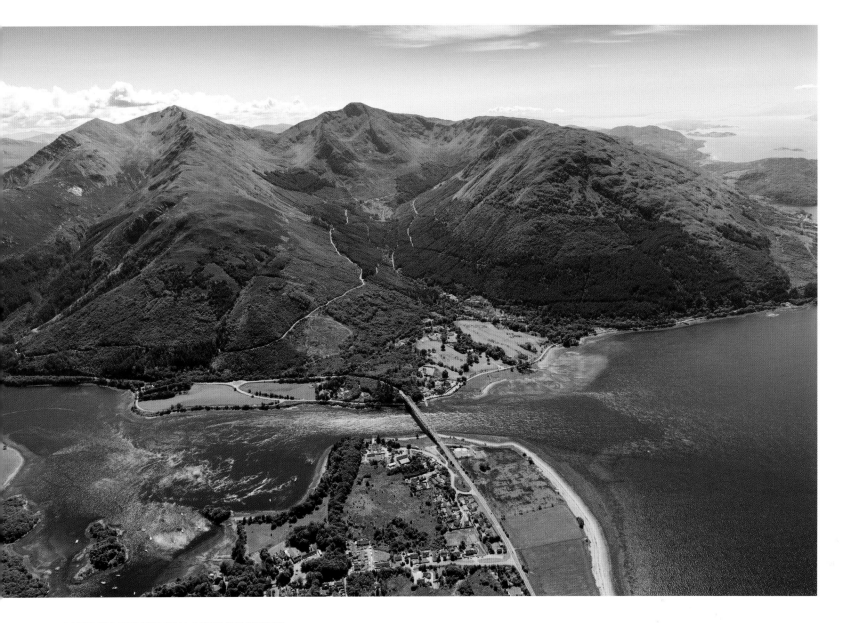

BALLACHULISH AND THE BALLACHULISH BRIDGE

The modern A82 – passing through the high plateau of Rannoch Moor and then dropping down through Glencoe to sea level, here at Ballachulish – follows almost exactly the route laid down by Thomas Telford at the beginning of the nineteenth century. Telford, in turn, had used portions of the old military roads built by George Wade and William Caulfield in the mid eighteenth century. The bridge at Ballachulish is a relatively recent addition, however, completed in 1975 to replace the ferry crossing of the perilous Loch Leven narrows. You can still see the old slipways, dipping down into the water either side of the road bridge.

2016 & 2014 HES AERIAL SURVEY DP239792, DP193658

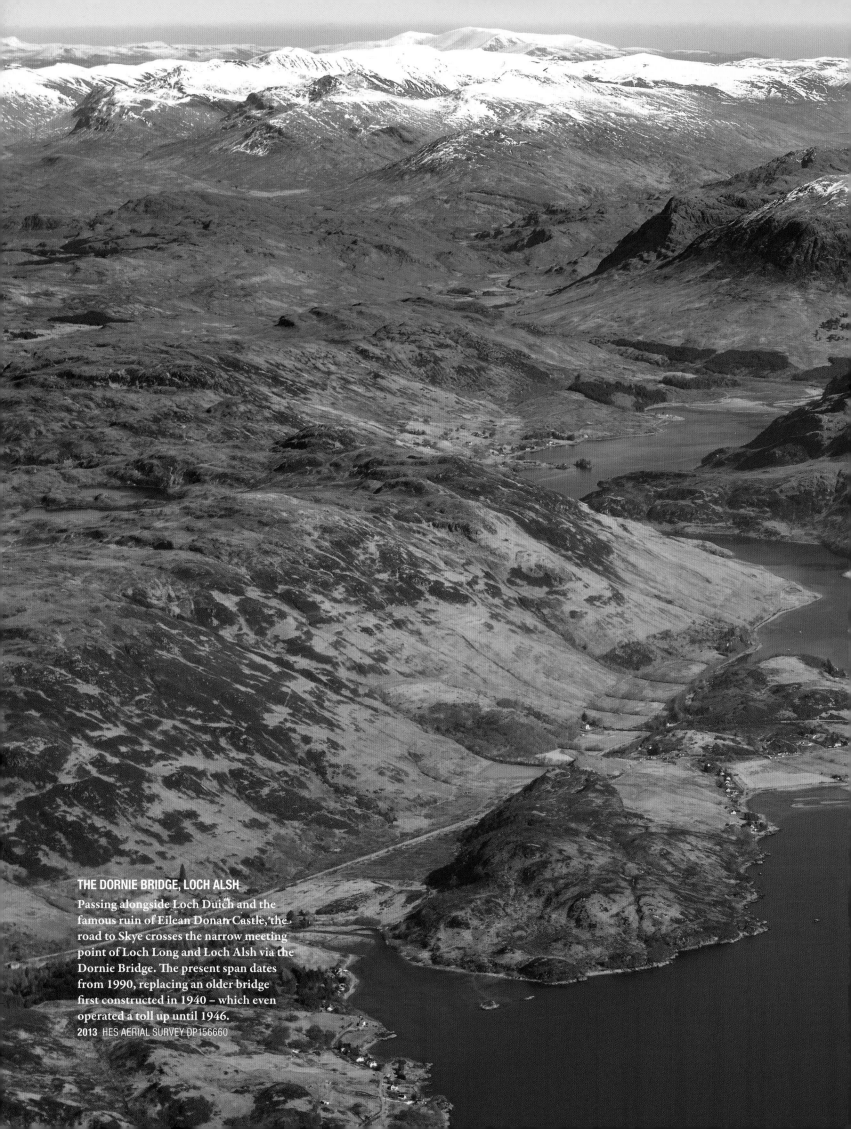

THE DORNIE BRIDGE, LOCH ALSH

Passing alongside Loch Duich and the famous ruin of Eilean Donan Castle, the road to Skye crosses the narrow meeting point of Loch Long and Loch Alsh via the Dornie Bridge. The present span dates from 1990, replacing an older bridge first constructed in 1940 – which even operated a toll up until 1946.

2013 HES AERIAL SURVEY DP156660

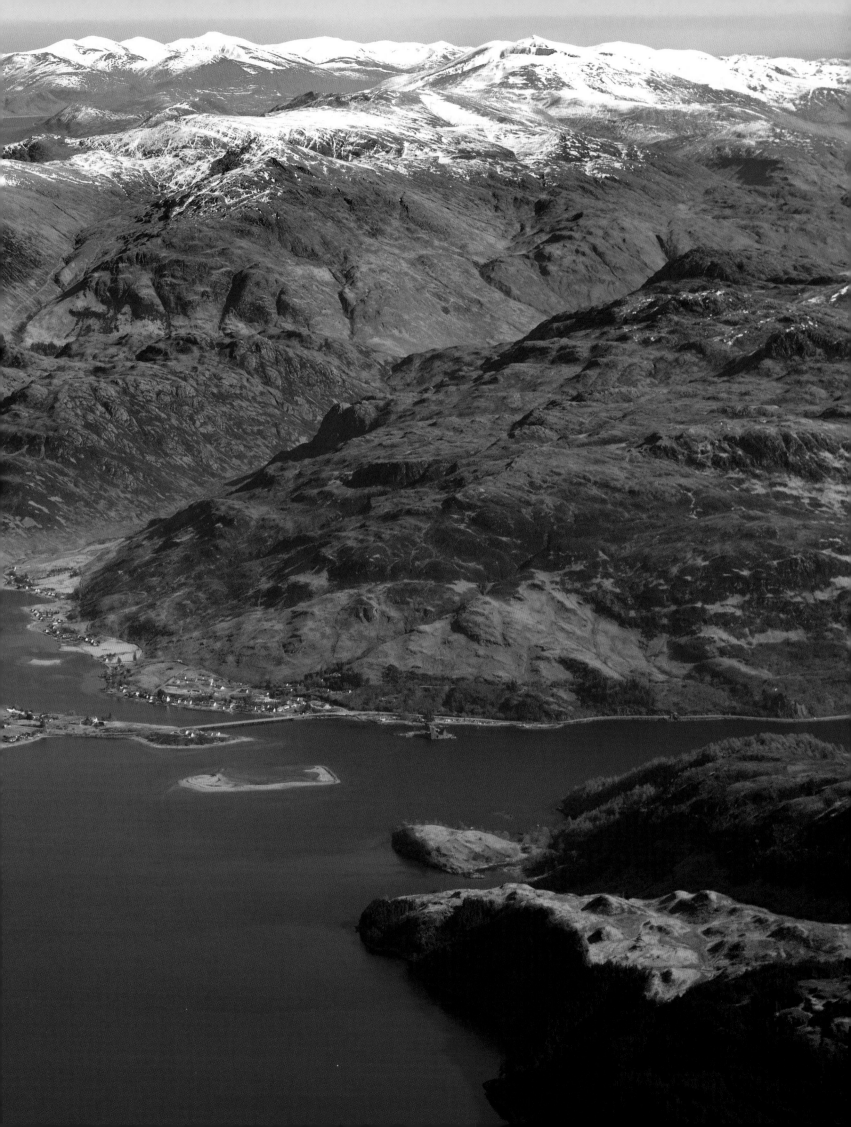

There was an urgent need to look at the country in its entirety, assess every inch of land. The best way to do it was from the air. In 1944, even before the war had ended, a handful of RAF squadrons were tasked with making a complete photographic map of all of Scotland.

THE CALDERA, ARDNAMURCHAN PENINSULA

Two hundred years after William Roy's Military Survey, the government had a new tool for mapping Scotland's landscapes: aerial photography. Between 1944 and 1950, the RAF took some 300,000 photographs from the skies, creating an incredibly detailed, top-down mosaic map of the whole country. In this 1944 image of Ardnamurchan – as well as roads and settlements – you can see the spectacular geological history of the peninsula. The concentric rocky rings spreading out from the centre of this photograph are the remnants of a giant, collapsed volcano.

1944 HES RAF COLLECTION SC1013335

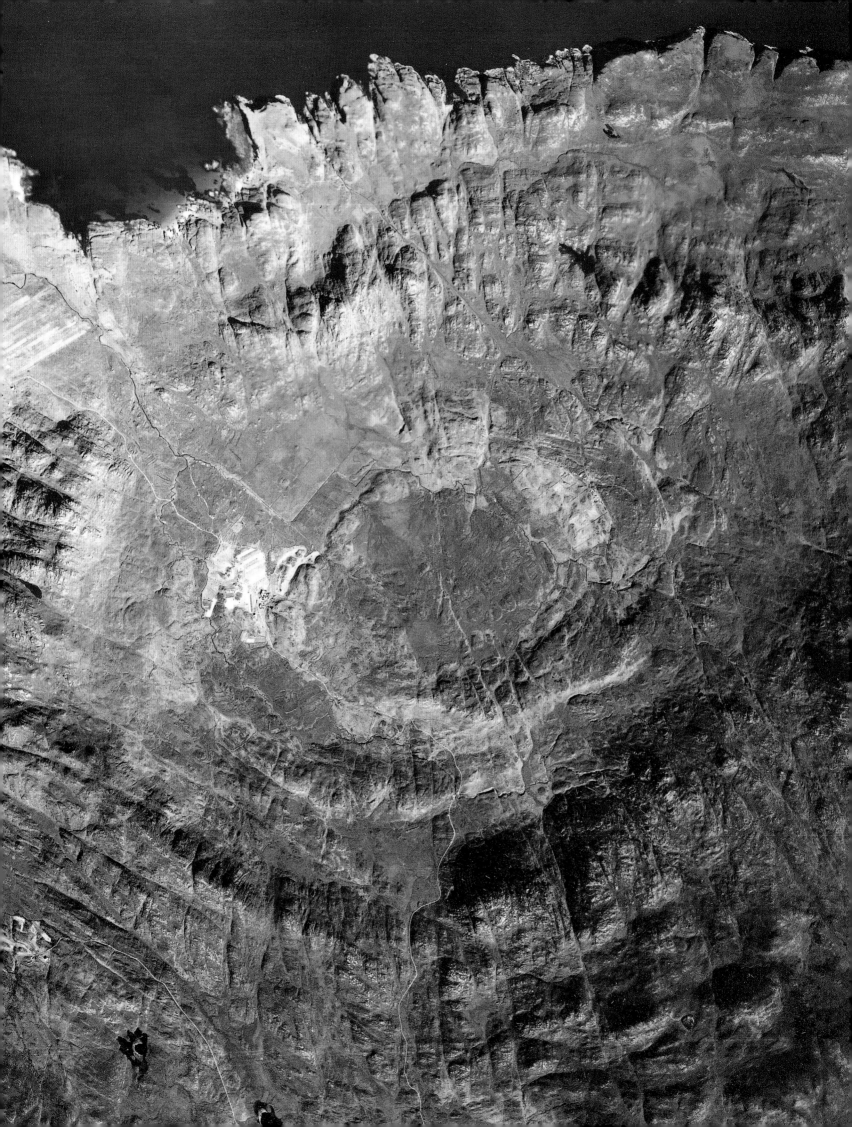

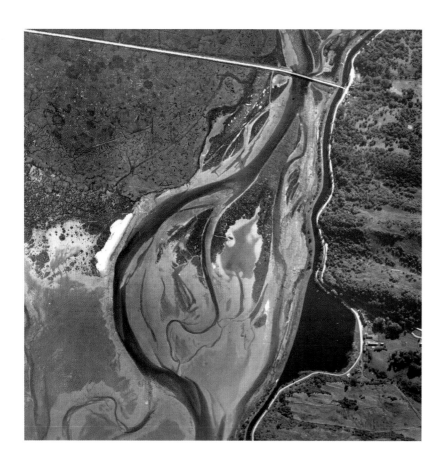

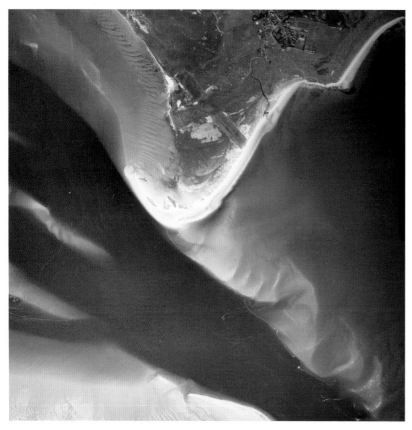

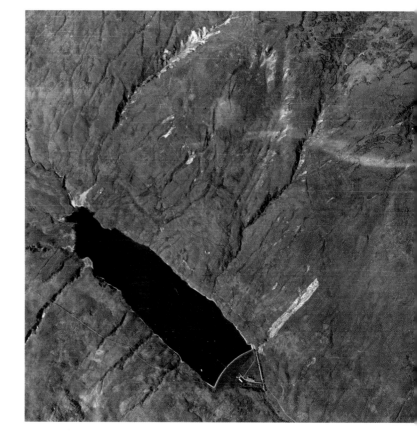

CRINAN CANAL
1947 HES RAF COLLECTION SC1021718

ABERFOYLE
1948 HES RAF COLLECTION SC1061038

DORNOCH FIRTH
1944 HES RAF COLLECTION SC1073718

LOCH FINLAS
1946 HES RAF COLLECTION SC1060310

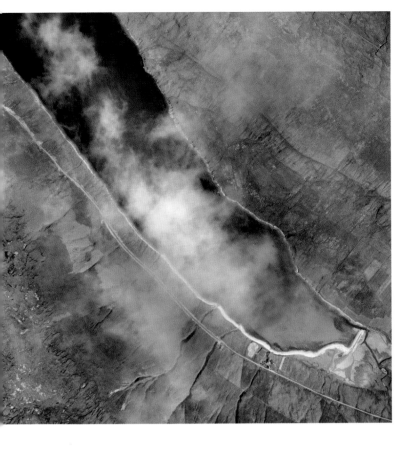

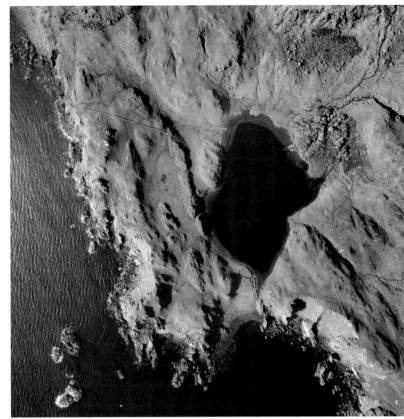

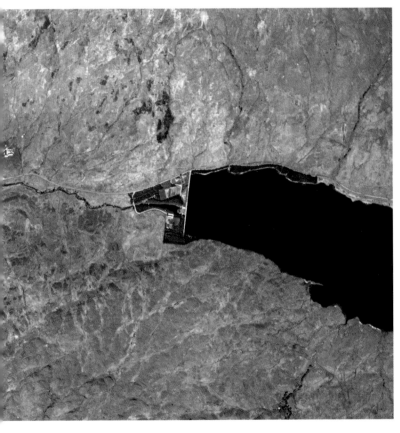

ALES VOE, SHETLAND
1967 HES ORDNANCE SURVEY OS/67/0297_8225

LOCH ARKLET
1948 HES RAF COLLECTION SC1060831

PAPADIL, RUM
1967 MERIDIAN AIRMAPS LTD MAL/0048/67_0035

UNKNOWN LOCATION
1980 CLYDE SURVEYS LTD CLY/8004_1091

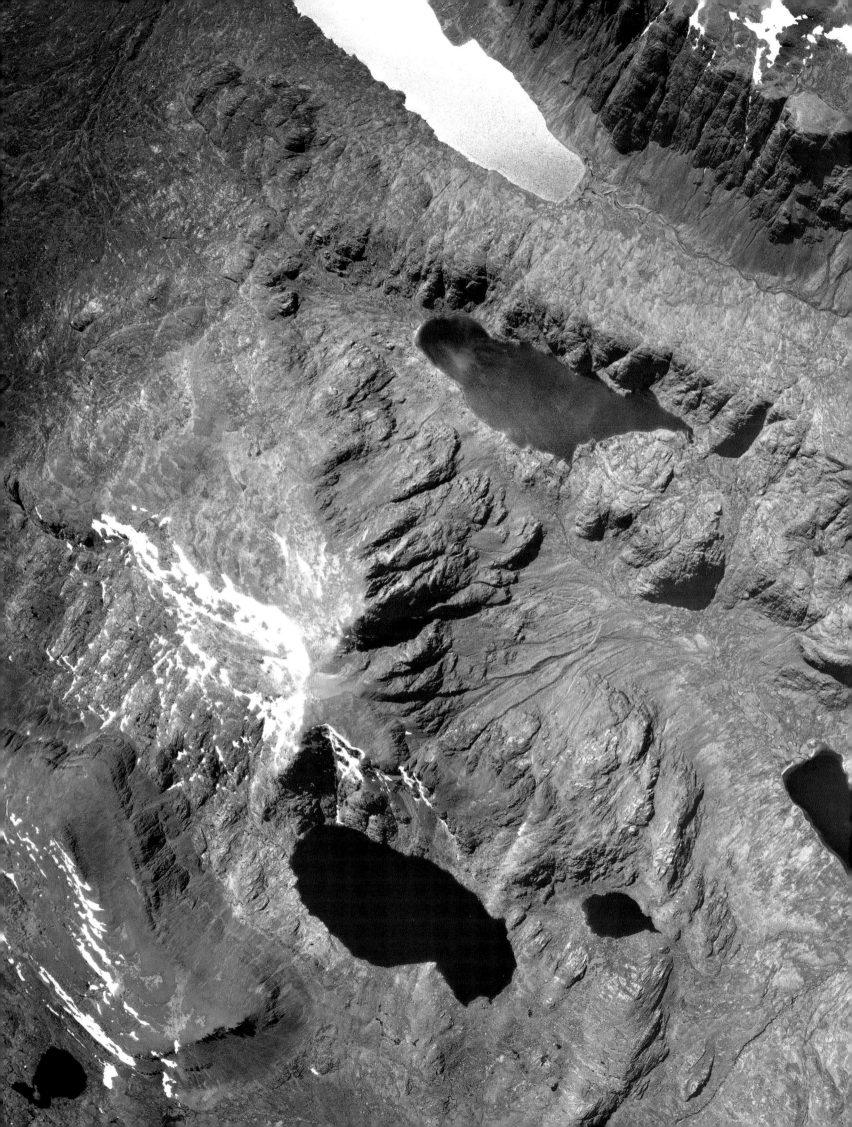

They carried on for six years – over five hundred flights taking nearly three hundred thousand photographs of Scotland. Their work effectively took planners into the sky. Mosaic maps were made from stitched together photographs – each one-metre-square mosaic corresponding to twenty-five square kilometres of real land. What could be laid on top was the blueprint for a post-war nation. The vision for a new Scotland was rising up out of these photographs. But there was still the question of what it would actually look like.

ST ANDREWS, FIFE
1944 HES AERIAL SURVEY SC1123414

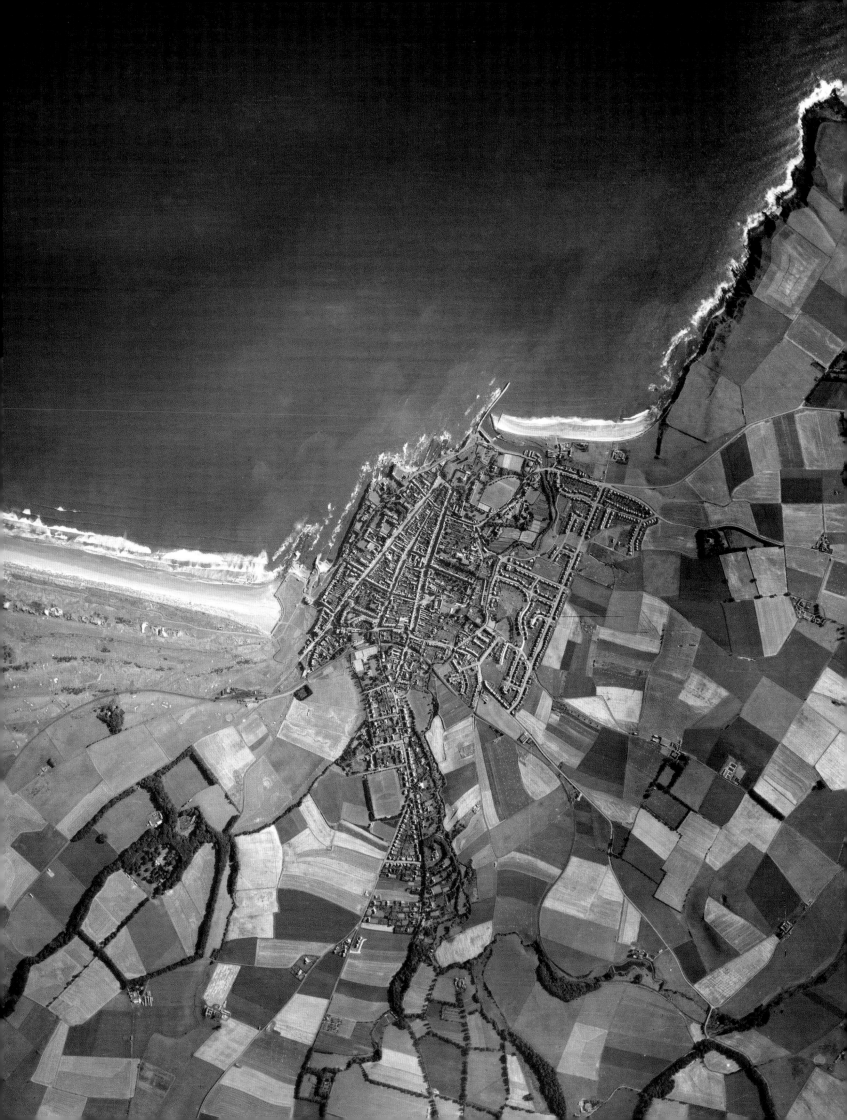

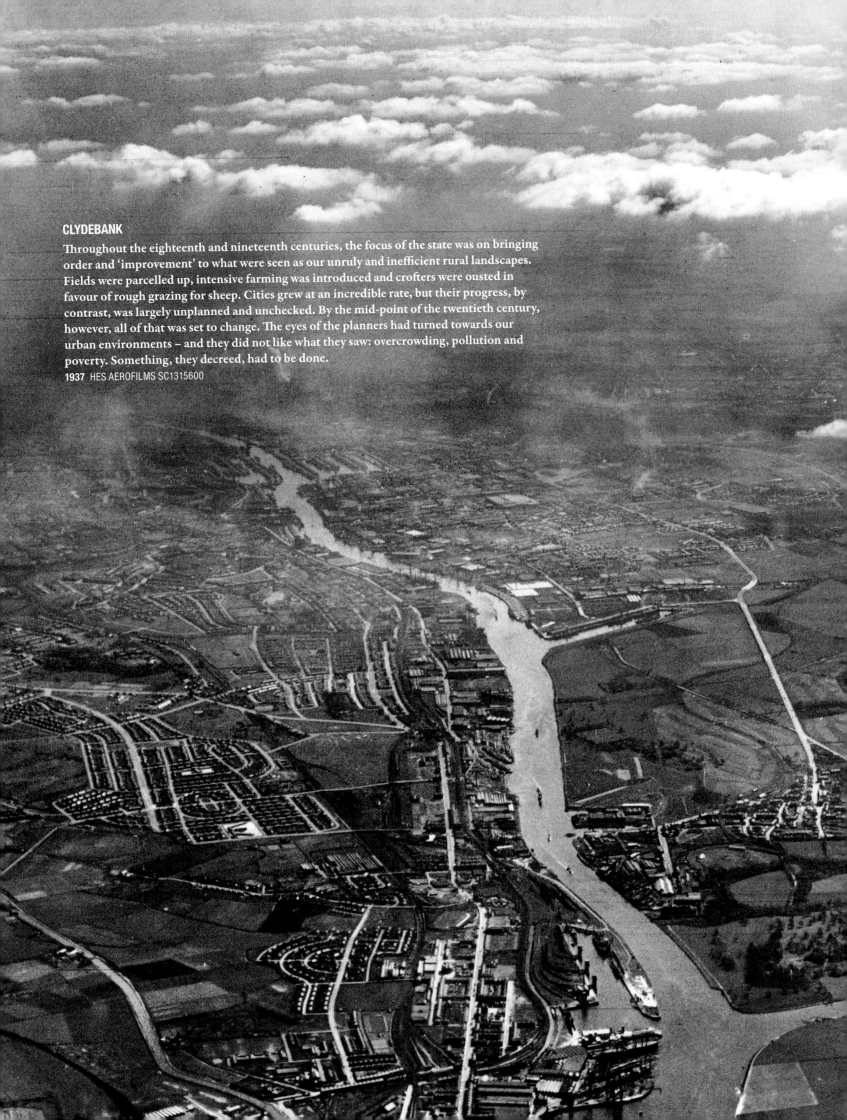

CLYDEBANK

Throughout the eighteenth and nineteenth centuries, the focus of the state was on bringing order and 'improvement' to what were seen as our unruly and inefficient rural landscapes. Fields were parcelled up, intensive farming was introduced and crofters were ousted in favour of rough grazing for sheep. Cities grew at an incredible rate, but their progress, by contrast, was largely unplanned and unchecked. By the mid-point of the twentieth century, however, all of that was set to change. The eyes of the planners had turned towards our urban environments – and they did not like what they saw: overcrowding, pollution and poverty. Something, they decreed, had to be done.

1937 HES AEROFILMS SC1315600

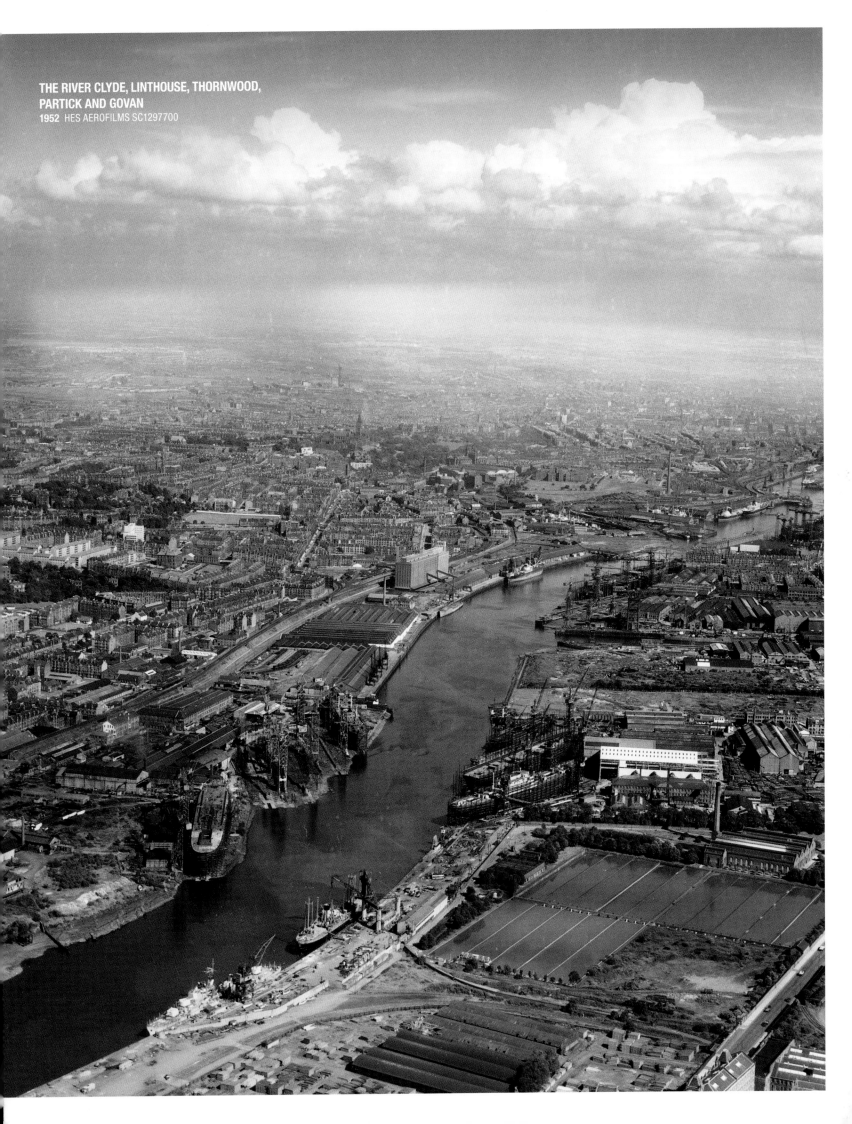

GLASGOW UNIVERSITY, THE KELVIN HALL
AND KELVINGROVE MUSEUM
1947 & 1927 HES AEROFILMS SC1437771, SC1246261

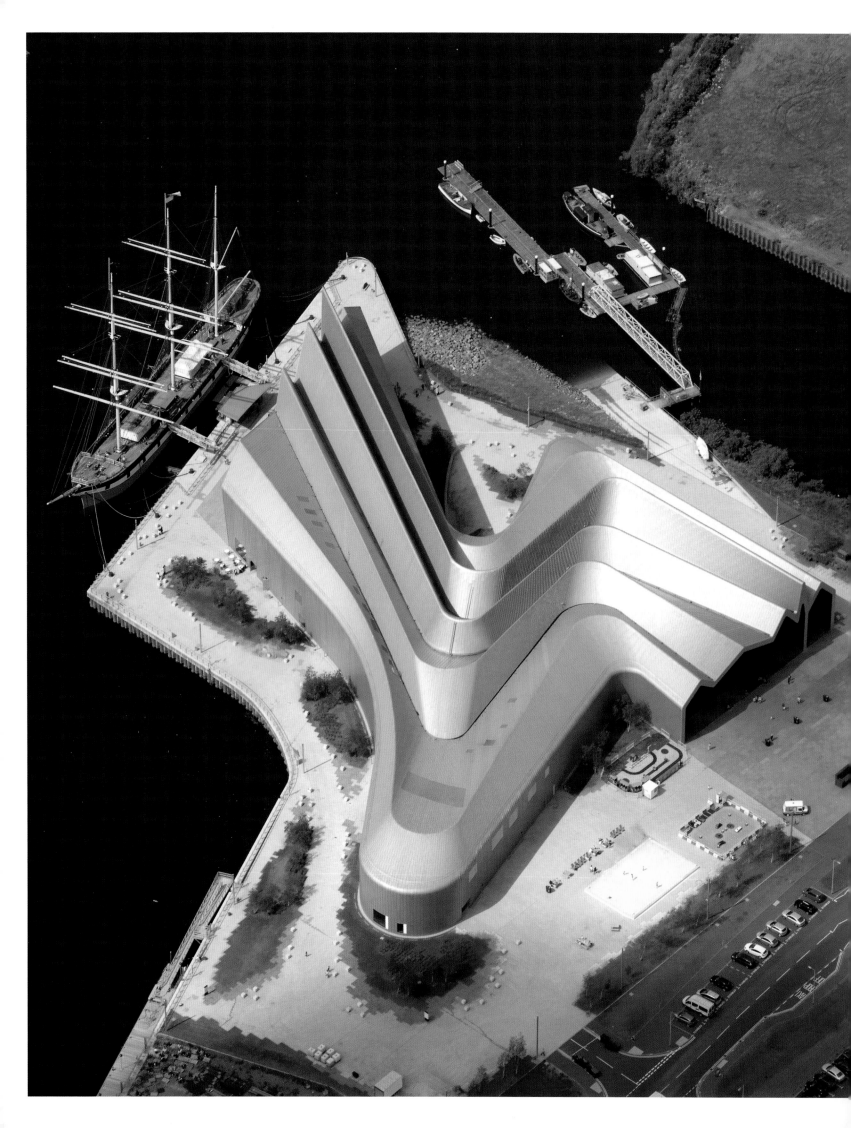

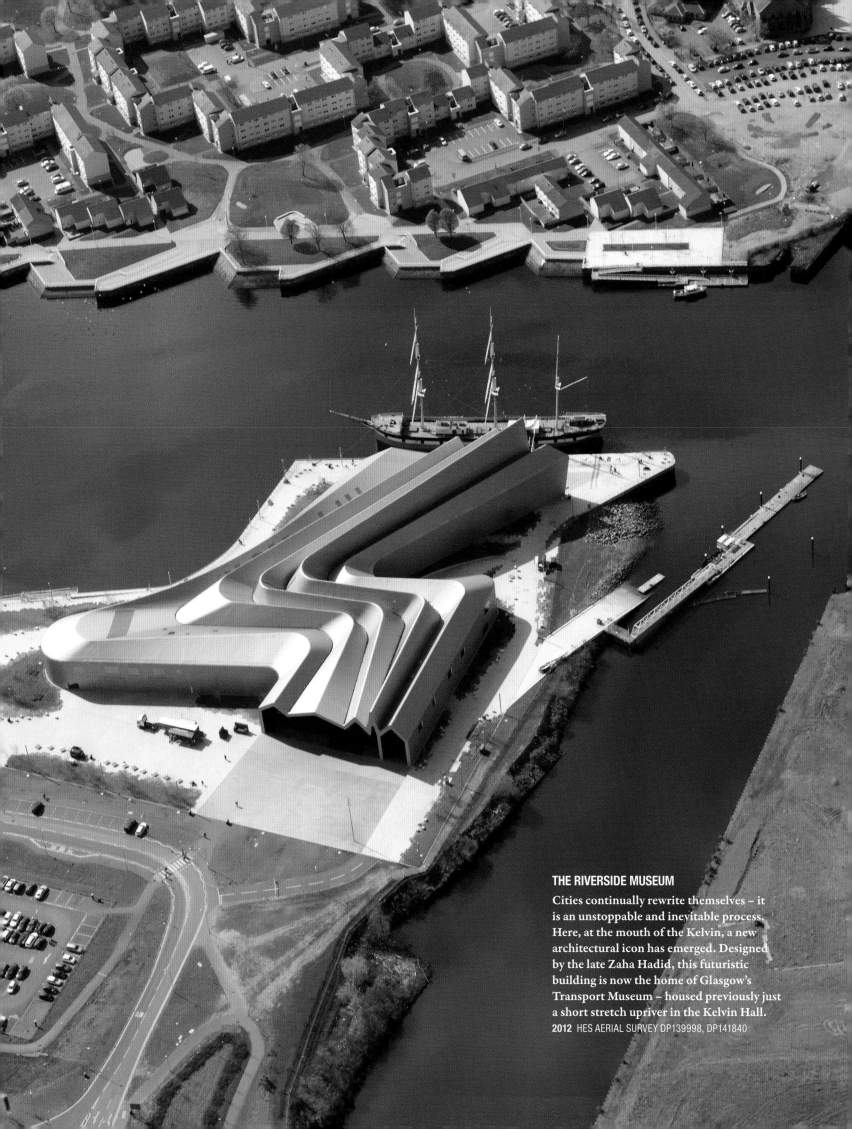

THE RIVERSIDE MUSEUM

Cities continually rewrite themselves – it is an unstoppable and inevitable process. Here, at the mouth of the Kelvin, a new architectural icon has emerged. Designed by the late Zaha Hadid, this futuristic building is now the home of Glasgow's Transport Museum – housed previously just a short stretch upriver in the Kelvin Hall.

2012 HES AERIAL SURVEY DP139998, DP141840

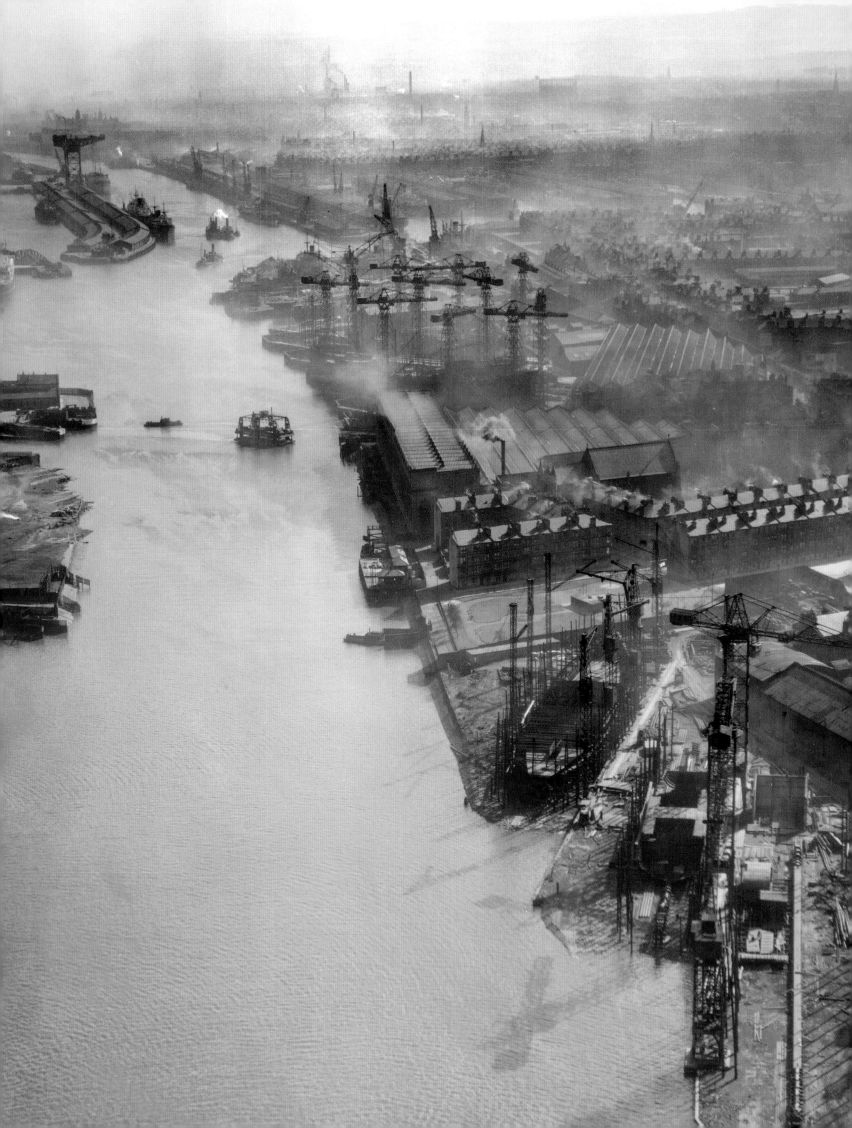

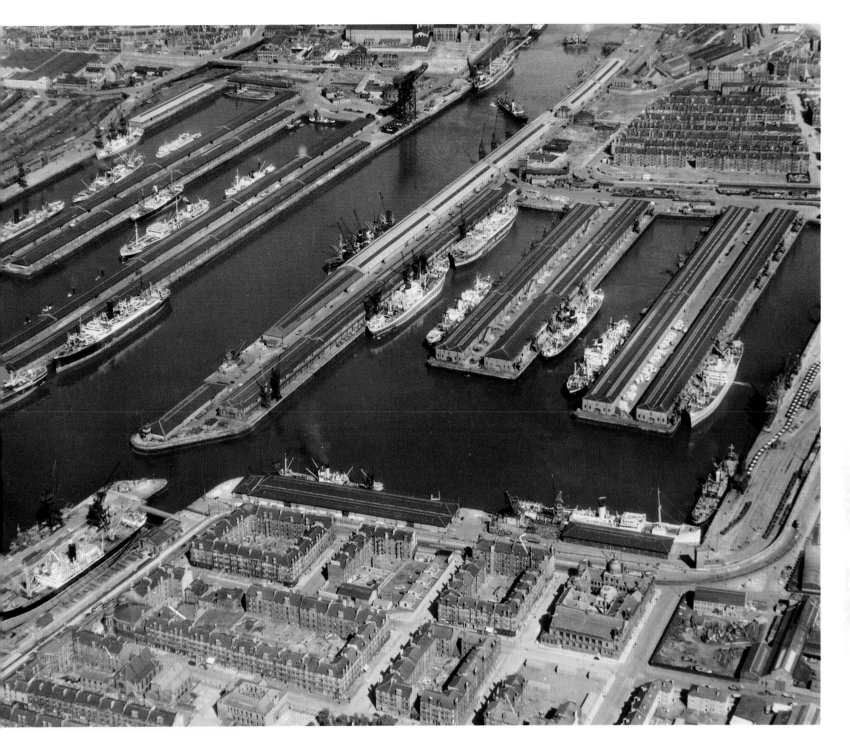

QUEEN'S DOCKS AND PRINCE'S DOCKS, FINNIESTON, GLASGOW

A forest of cranes rises up above the canopy of smog, while boats throng the quaysides. These are bustling, muscular scenes of a city hard at work. Almost nothing you can see here remains today. Only the stalwart silhouette of the Finnieston Crane, first built in 1926 and visible at the top of both images, has remained a fixture of the Glasgow skyline – a monument to vanished industry.

1950 & 1951 HES RAF COLLECTION & HES AEROFILMS
SC1096029, SC1437904

THE HYDRO, FINNIESTON, GLASGOW

From above, you could be forgiven for mistaking the Hydro's massive 1,400-tonne latticed-steel dome for a crash-landed UFO. In the image on the right, the long shadow of the Finnieston Crane reaches out to touch this latest addition to the Clyde Waterfront. As the crane enters its ninth decade, it has witnessed the incredible transformation of its surroundings – from mid twentieth century industrial powerhouse to 1970s and 80s dereliction, to today's design-led, cultural and architectural renewal.

2012 & 2013 HES AERIAL SURVEY DP141850, DP141855, DP140007, DP164490

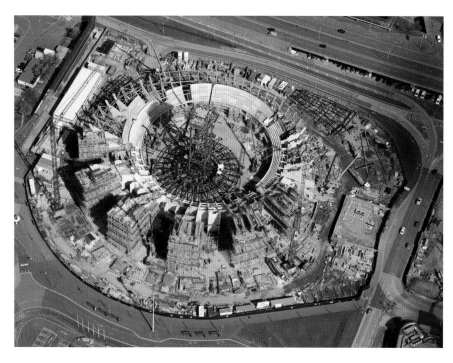

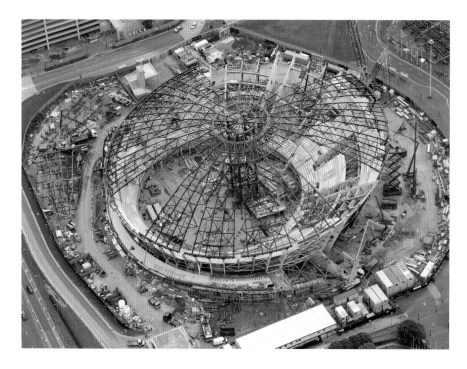

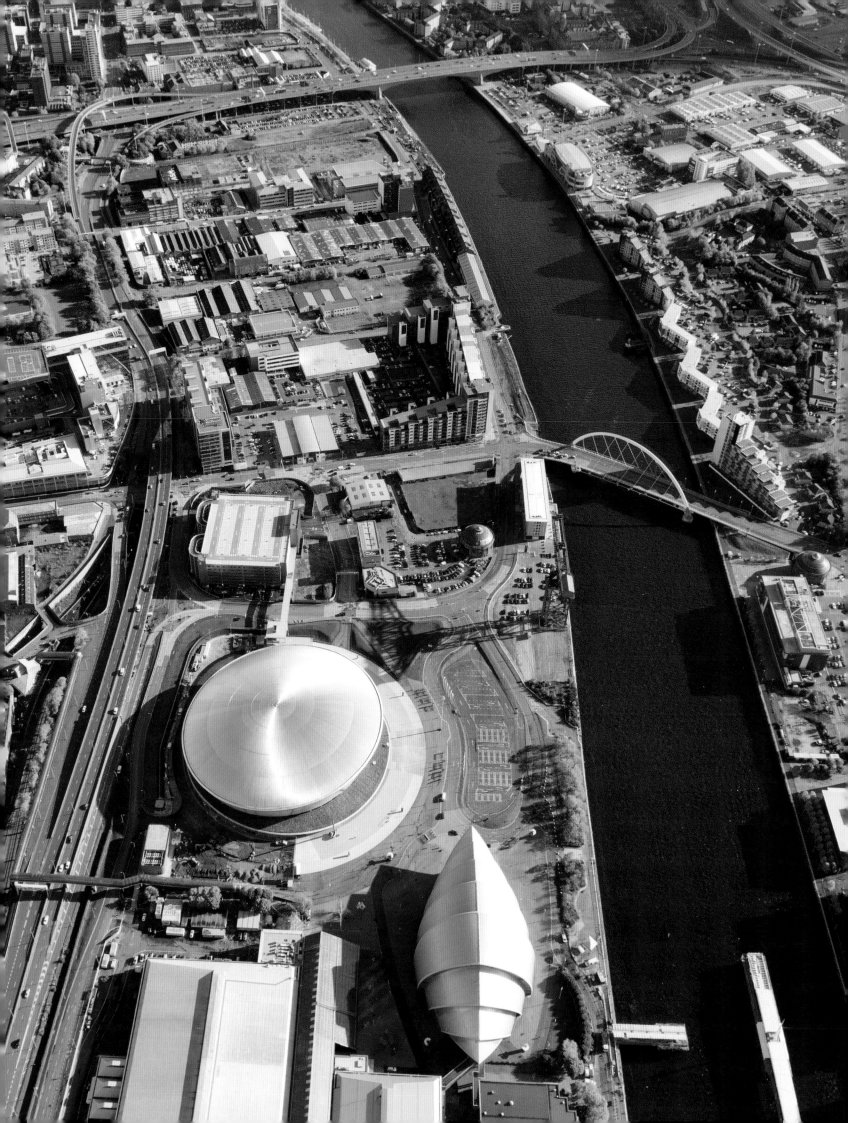

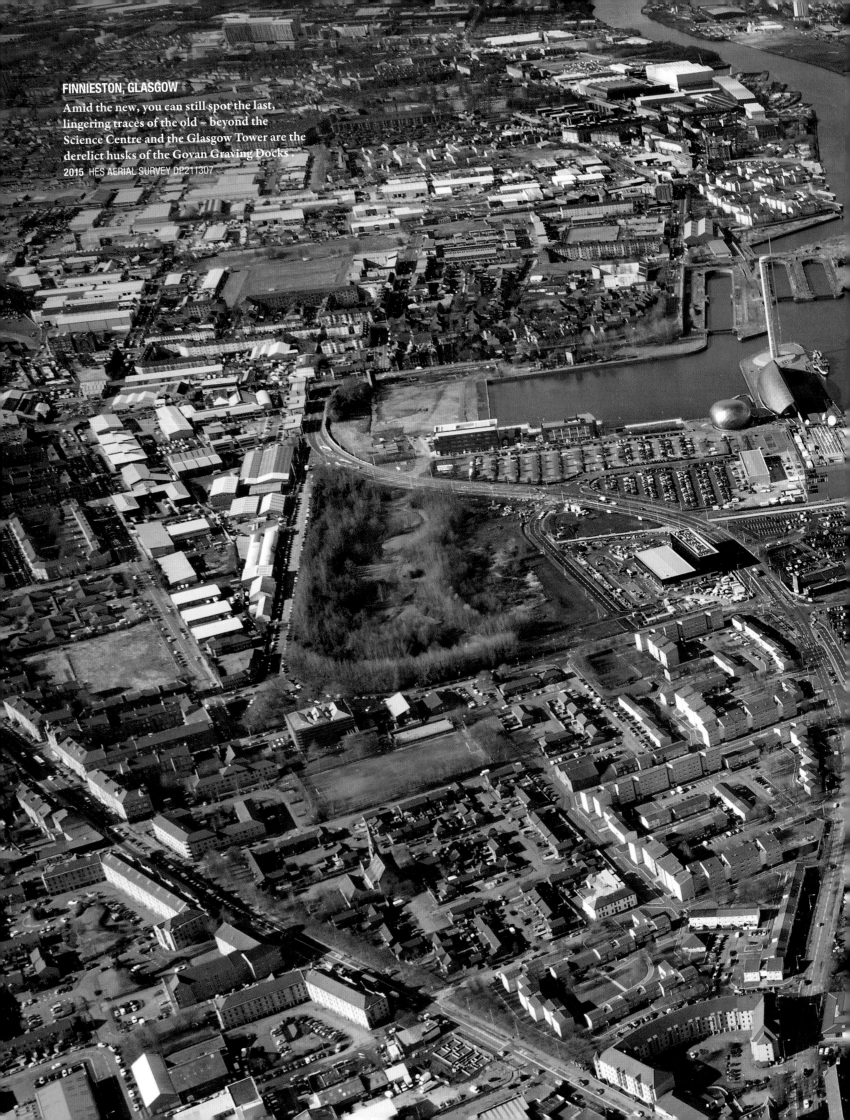

FINNIESTON, GLASGOW
Amid the new, you can still spot the last, lingering traces of the old – beyond the Science Centre and the Glasgow Tower are the derelict husks of the Govan Graving Docks.
2015 HES AERIAL SURVEY DP211307

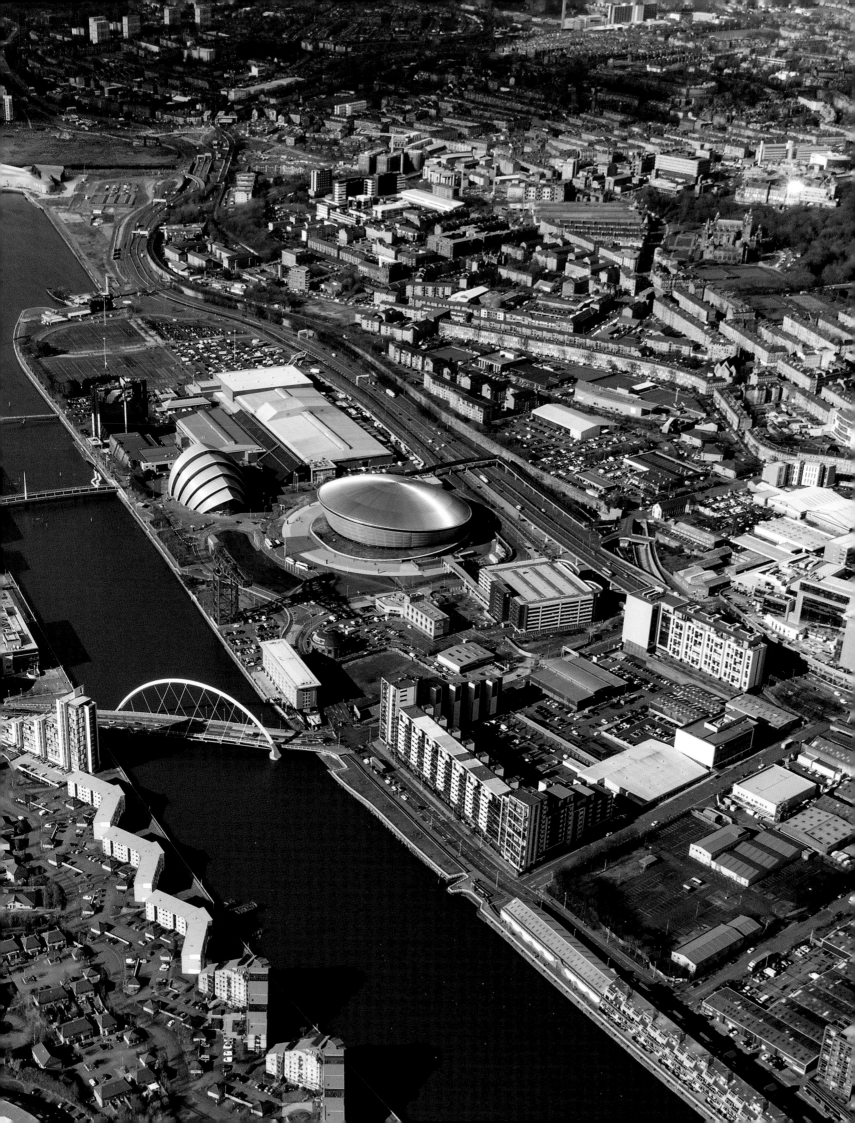

GLASGOW CITY CENTRE
1947 HES AEROFILMS SC1437739, SC1437744

'1,000 feet in the air, looking down on a city of congested and narrow roads, drenched with railway viaducts and ships which load and unload at the very heart of the city's gates. Down there a great population living under outmoded conditions which give rise to much confusion as well as discomfort.'

1945 GLASGOW PUBLIC INFORMATION FILM

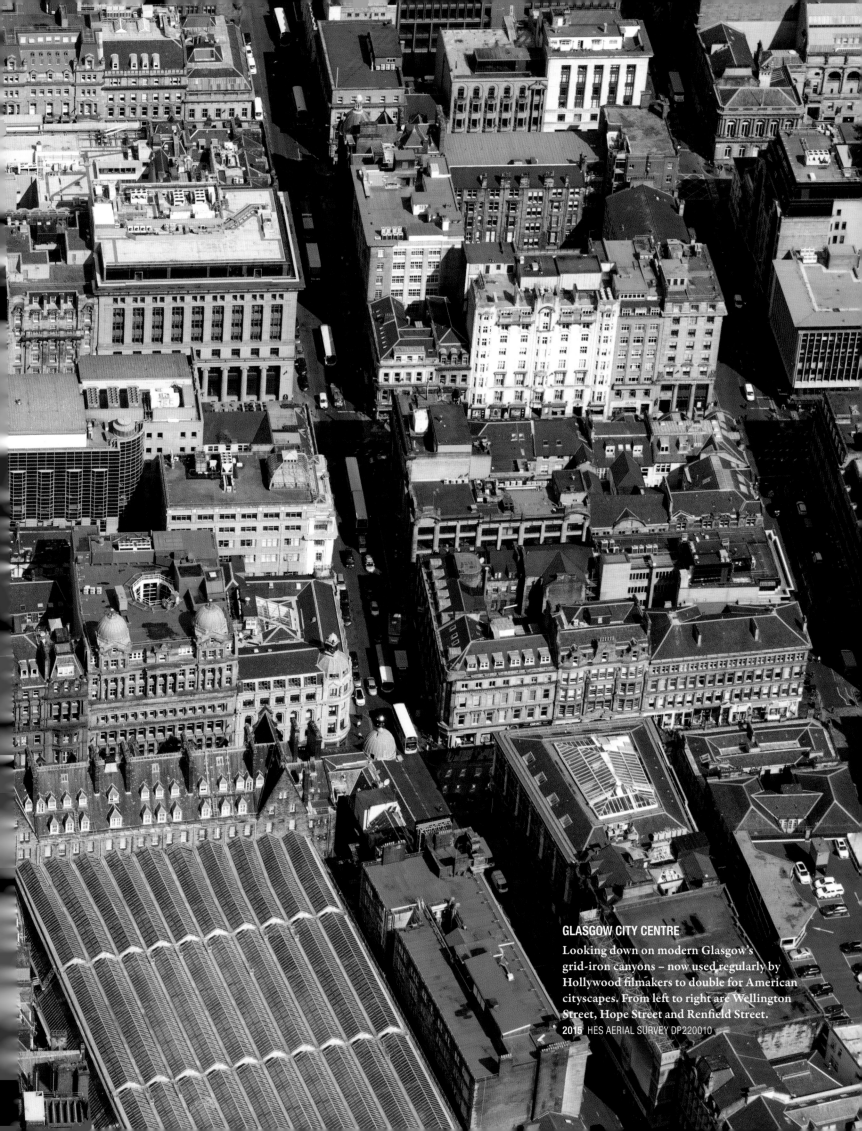

GLASGOW CITY CENTRE

Looking down on modern Glasgow's grid-iron canyons – now used regularly by Hollywood filmmakers to double for American cityscapes. From left to right are Wellington Street, Hope Street and Renfield Street.

2015 HES AERIAL SURVEY DP220010

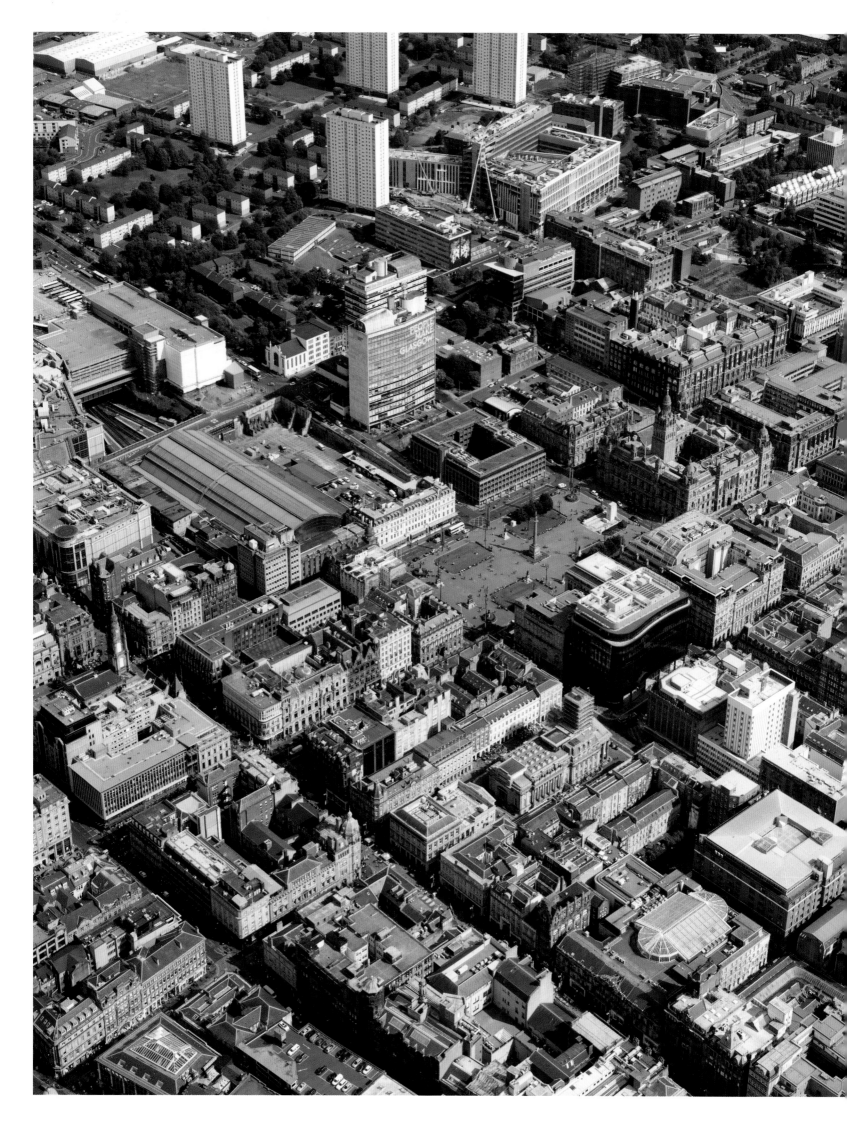

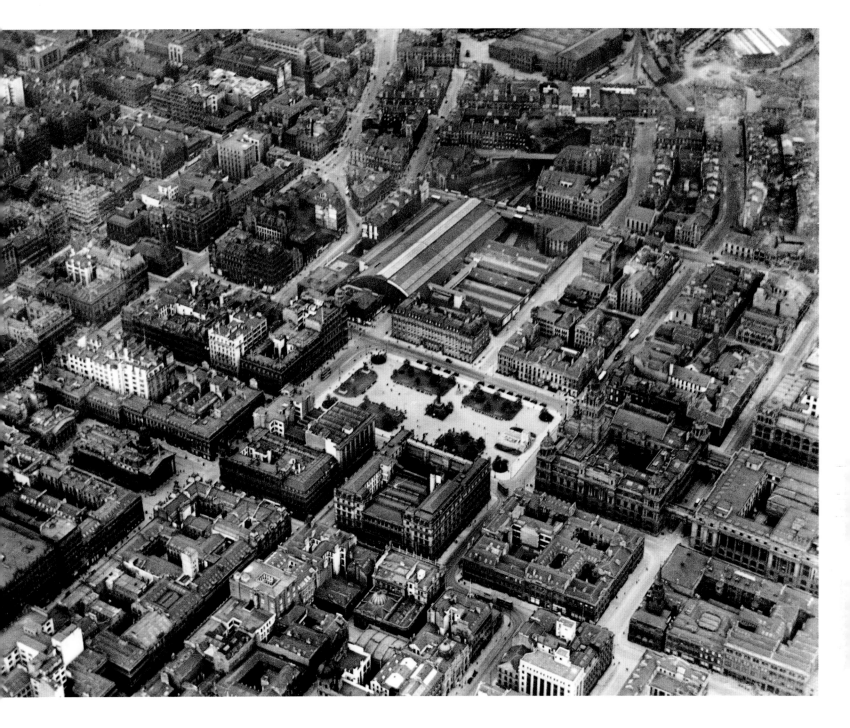

GEORGE SQUARE, GLASGOW
2015 & 1927 HES AERIAL SURVEY &
HES AEROFILMS DP220095, SC1257241

In 1945 the city's Chief Engineer Robert Bruce recommended levelling the old centre of Glasgow almost in its entirety and starting again. Buildings like Central Station, the City Chambers – even the Charles Rennie Mackintosh School of Art – were all marked for demolition. Bruce called it 'surgical' planning.

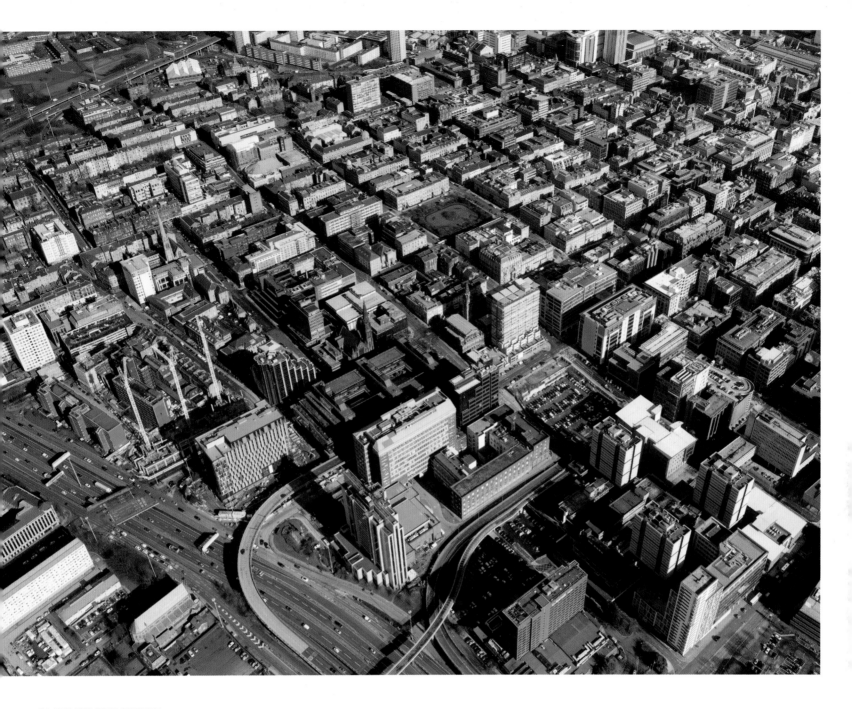

GLASGOW CITY CENTRE

A decade after the image on the left was
taken, work would begin on Britain's first
urban motorway, a great concrete expanse
that would slice right through the heart
of Charing Cross and Anderston, cutting
Glasgow's city centre in two.

1955 & 2015 HES AEROFILMS & HES AERIAL SURVEY
SC1438371, DP211281

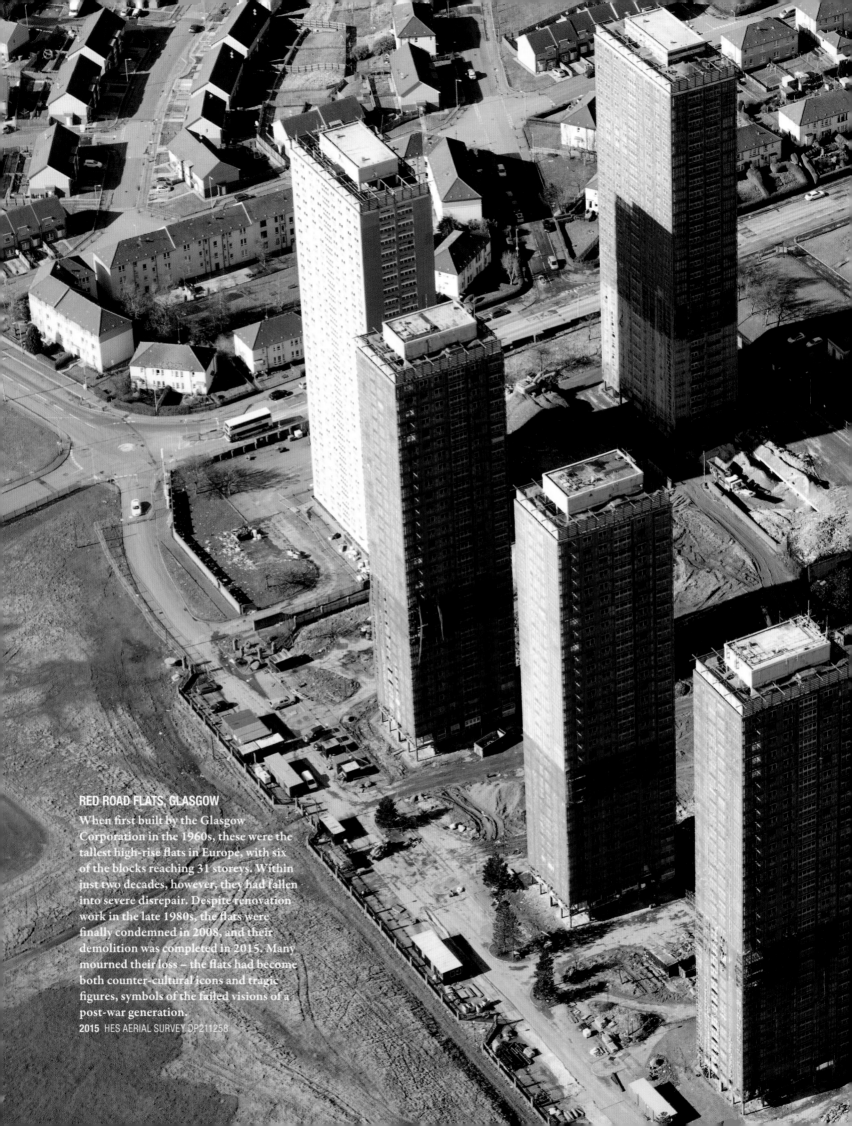

RED ROAD FLATS, GLASGOW

When first built by the Glasgow
Corporation in the 1960s, these were the
tallest high-rise flats in Europe, with six
of the blocks reaching 31 storeys. Within
just two decades, however, they had fallen
into severe disrepair. Despite renovation
work in the late 1980s, the flats were
finally condemned in 2008, and their
demolition was completed in 2015. Many
mourned their loss – the flats had become
both counter-cultural icons and tragic
figures, symbols of the failed visions of a
post-war generation.

2015 HES AERIAL SURVEY DP211258

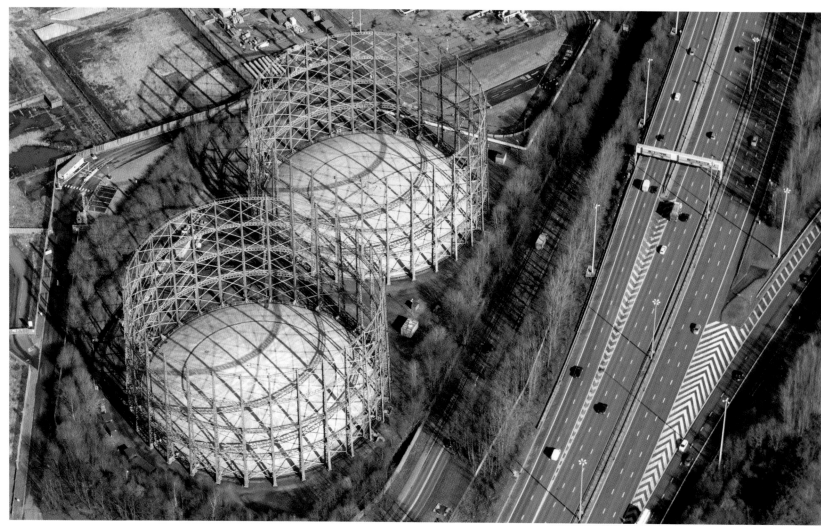

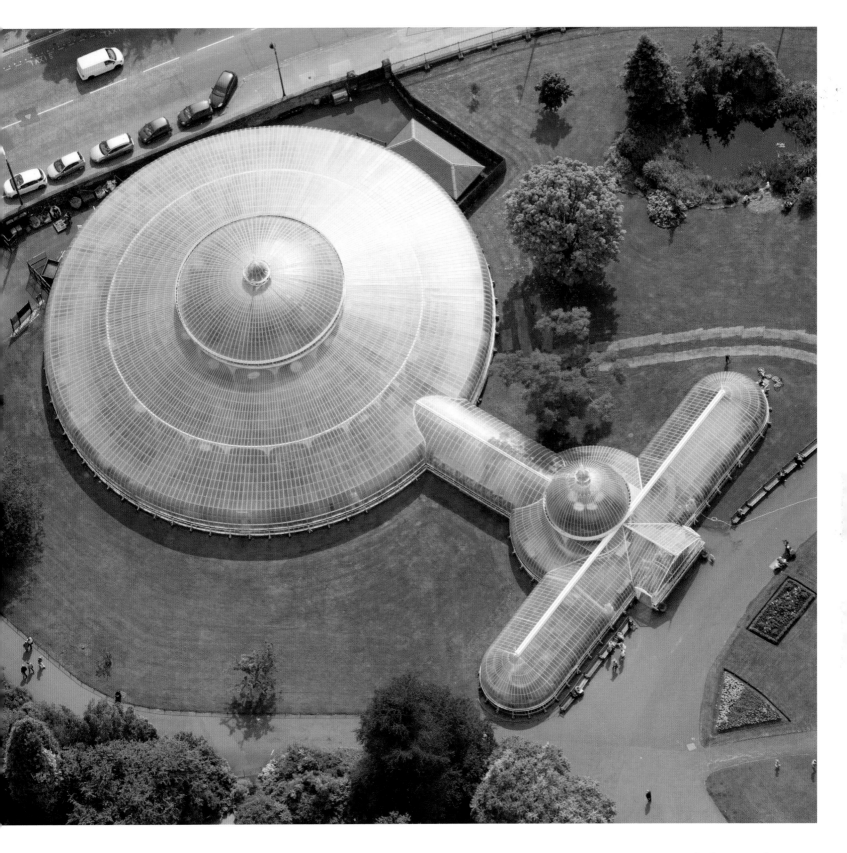

**COMMONWEALTH GAMES ATHLETES'
VILLAGE, GLASGOW**
2015 HES AERIAL SURVEY DP211216

PROVAN GASOMETERS, GLASGOW
2015 HES AERIAL SURVEY DP211242

**KIBBLE PALACE, BOTANIC GARDENS,
GLASGOW**
2015 HES AERIAL SURVEY DP219254

*In Scotland's post-war cities, old and
new came crashing together. Just as
they have always done, as each new
generation looks to change or adapt
what has been left by the one before.*

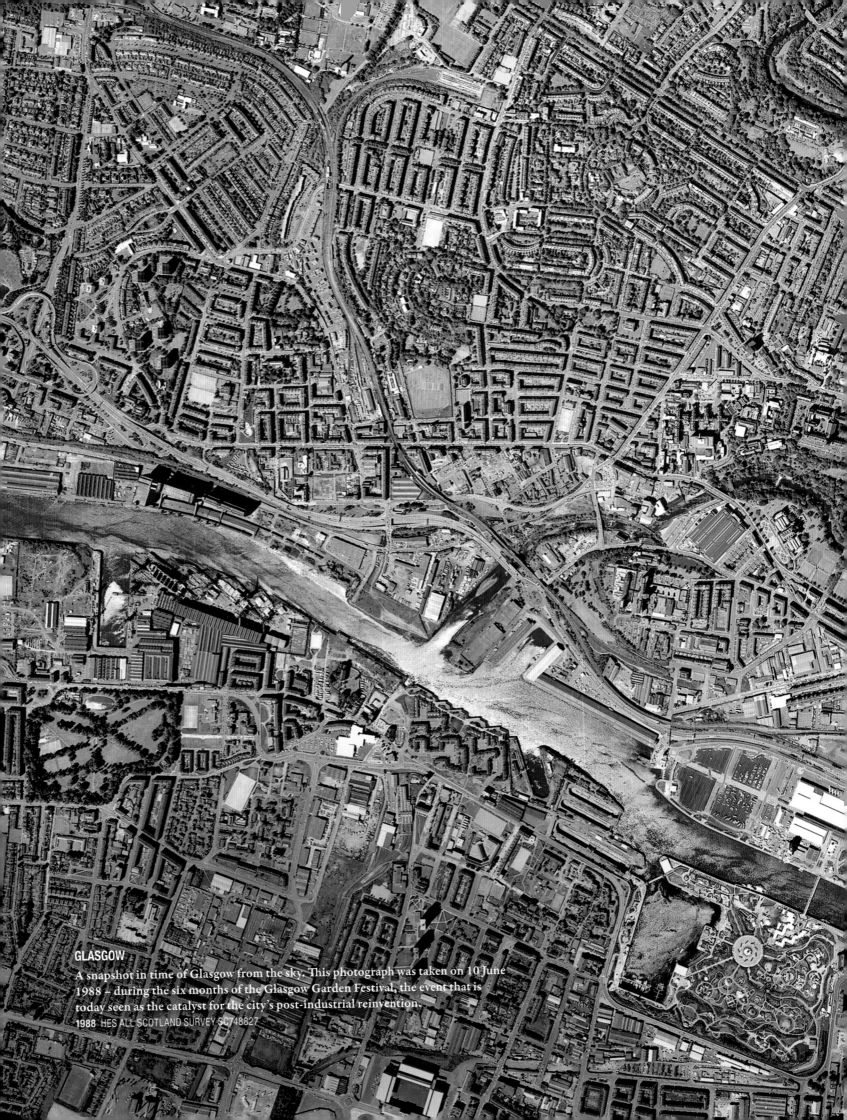

GLASGOW

A snapshot in time of Glasgow from the sky. This photograph was taken on 10 June 1988 – during the six months of the Glasgow Garden Festival, the event that is today seen as the catalyst for the city's post-industrial reinvention.

1988 HES ALL SCOTLAND SURVEY SC748827

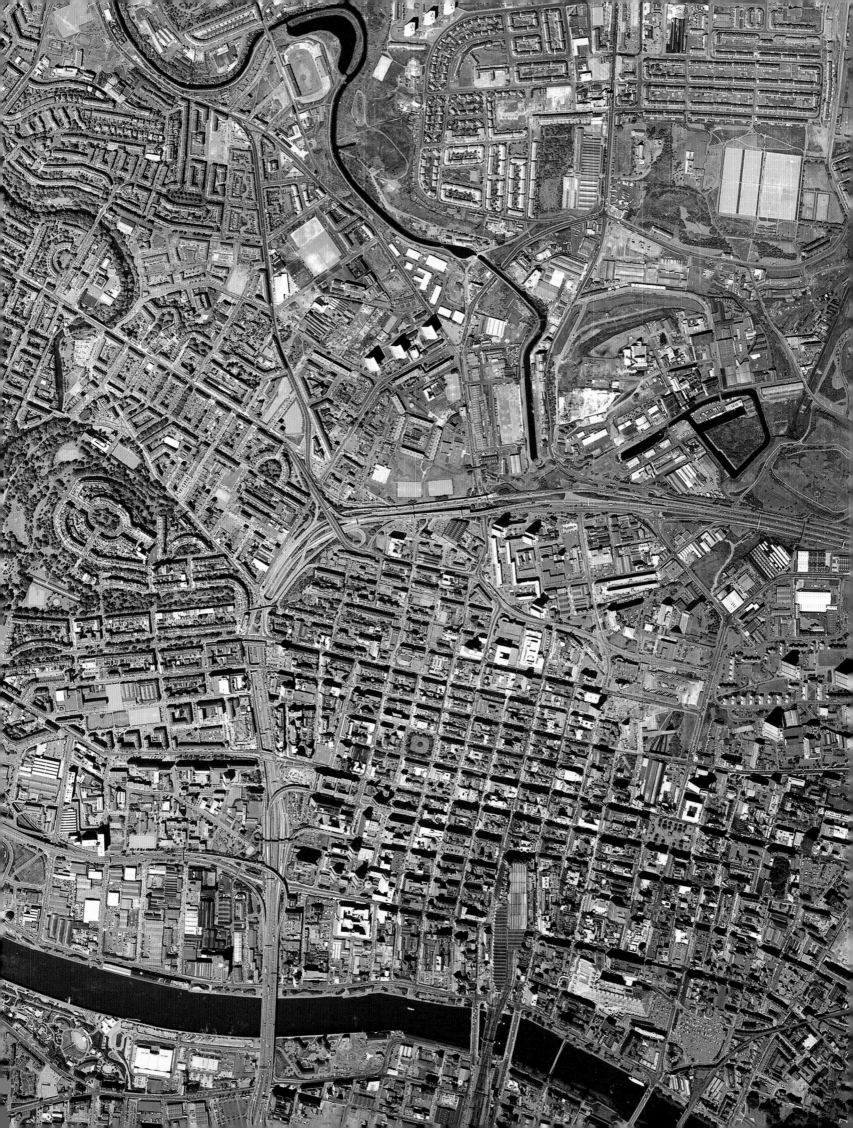

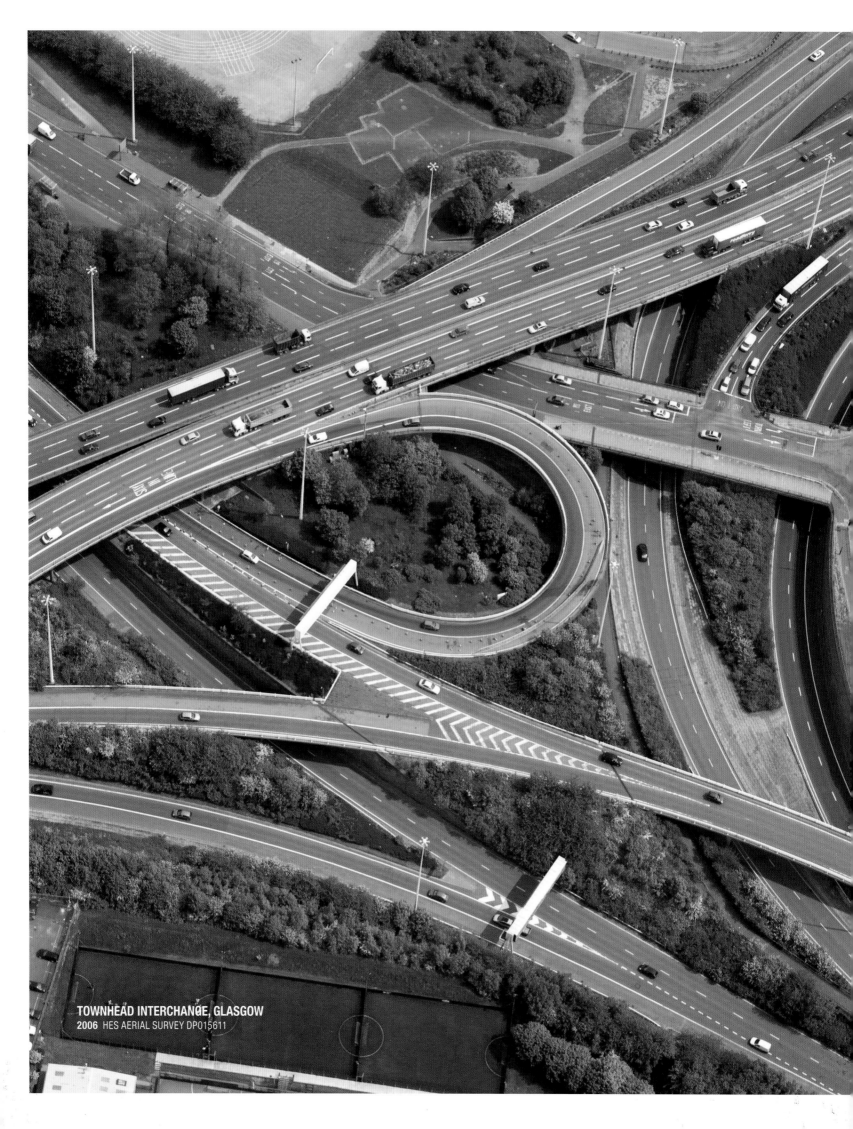

TOWNHEAD INTERCHANGE, GLASGOW
2006 HES AERIAL SURVEY DP015611

THE A8, CARNBROE, COATBRIDGE
1930 HES AEROFILMS SC1256946

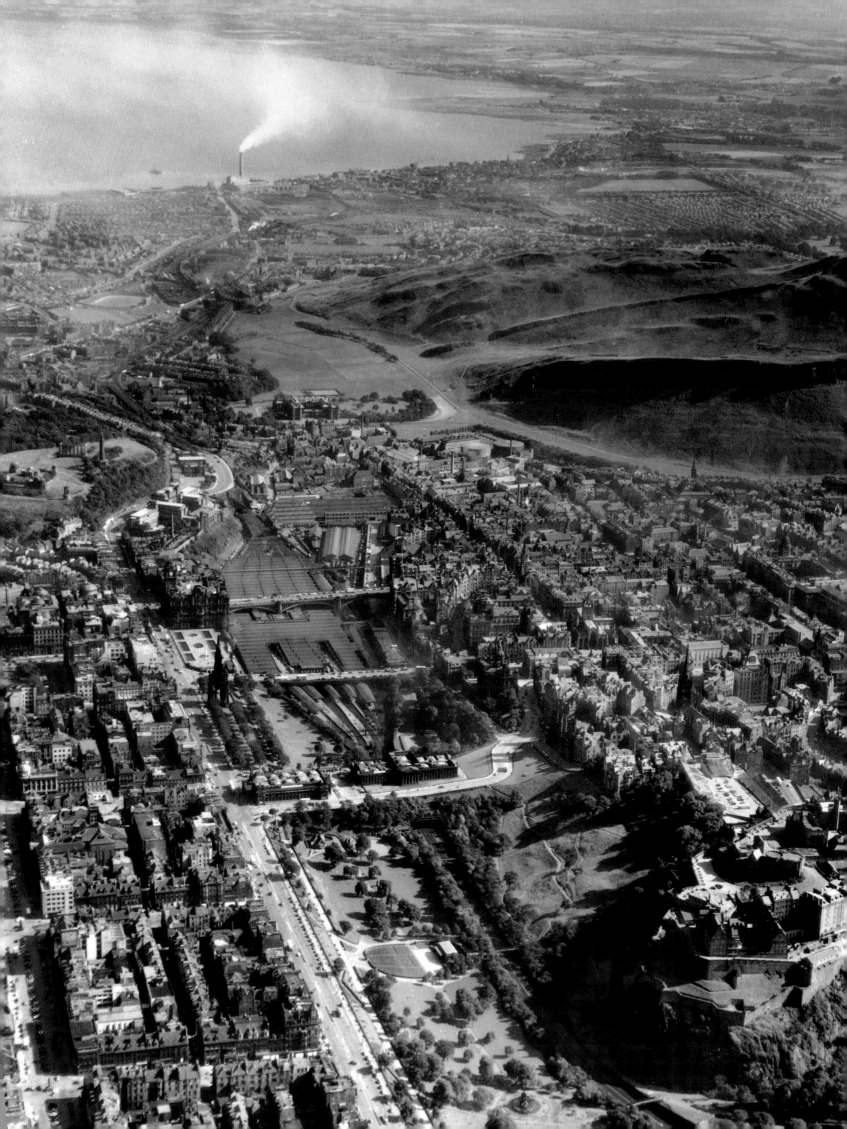

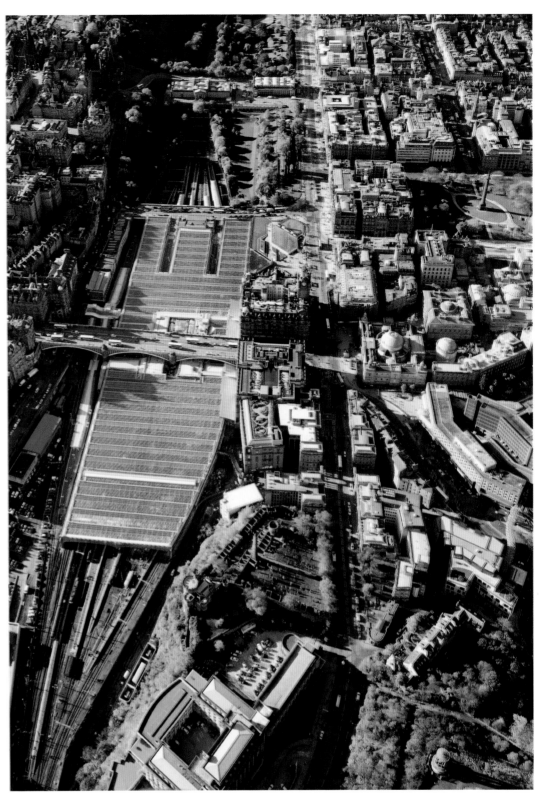

EDINBURGH OLD AND NEW TOWNS

Edinburgh is very unusual in that its medieval core – the spine leading from the Palace of Holyrood up the steep-sided glacial hill to the Castle Rock – escaped the destruction experienced by so many historic cities in the nineteenth and twentieth centuries. Instead, the Old Town was largely abandoned as an insanitary slum, with wealthy residents moving north across the valley (once the Nor Loch, now occupied by railway lines and Waverley Station) to the brand new city they built for themselves. From the sky, the stark contrast between the chaotic anthill of the Old Town and the ordered, geometric streets of the New, is graphically clear.

1958 & 2013 HES AEROFILMS & HES AERIAL SURVEY SC1269665, DP164424

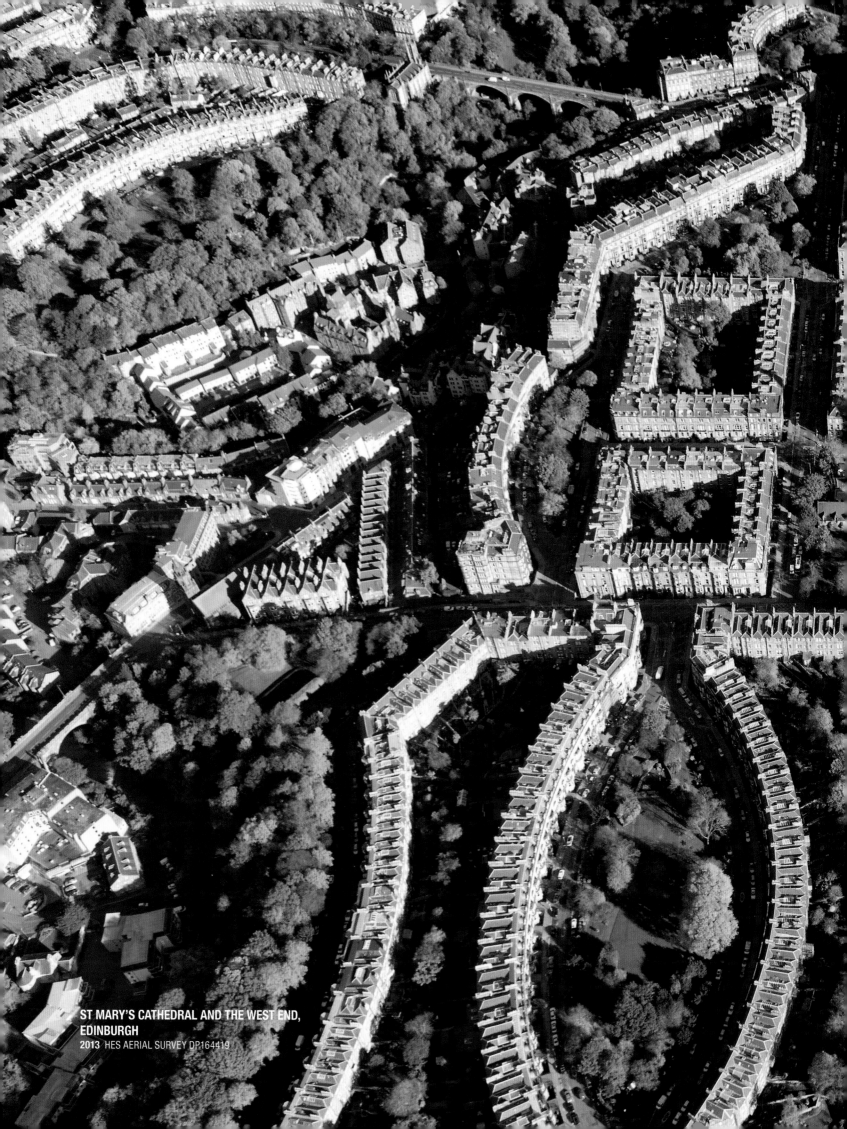

ST MARY'S CATHEDRAL AND THE WEST END,
EDINBURGH
2013 HES AERIAL SURVEY DP.164419

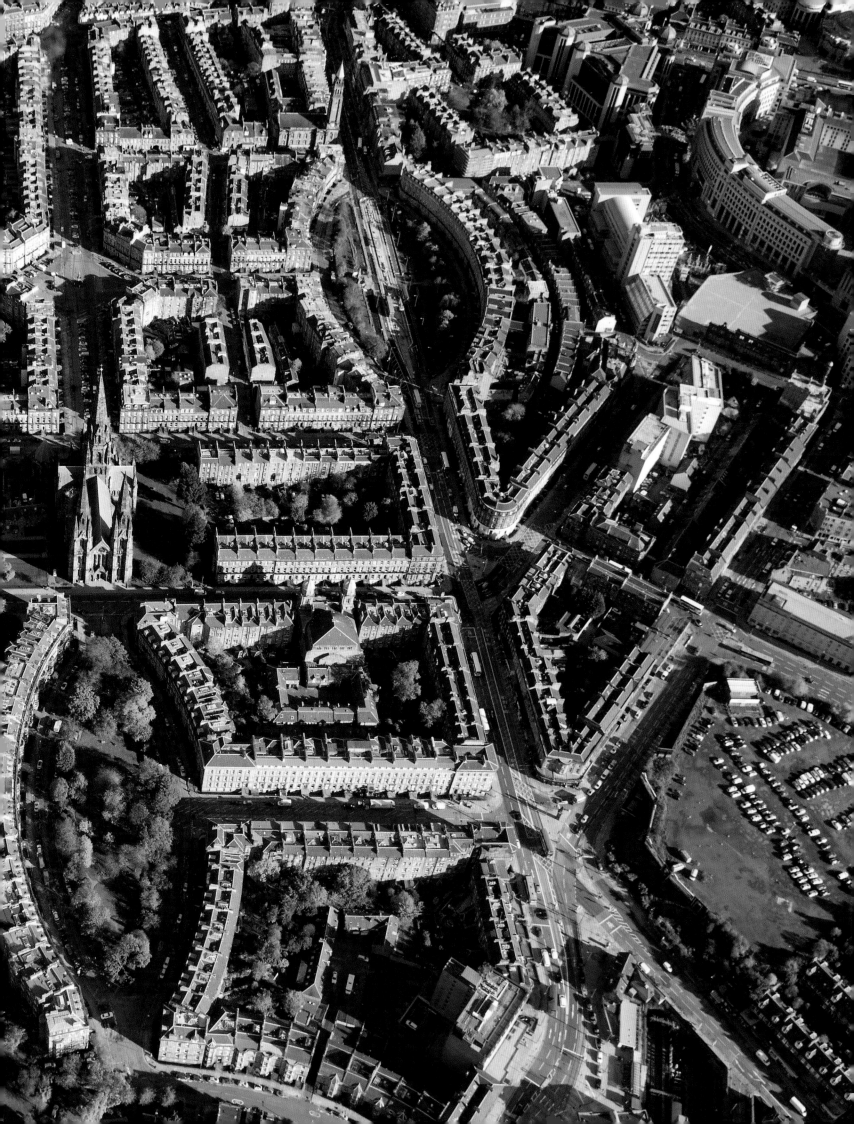

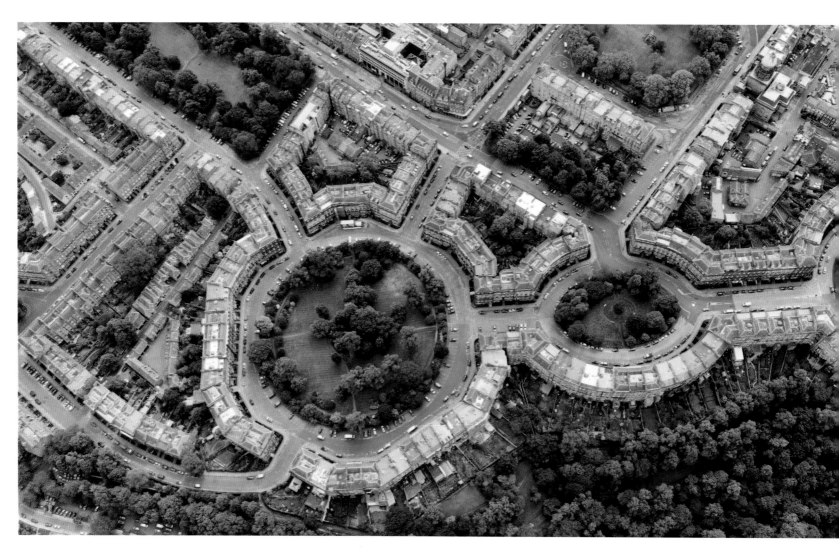
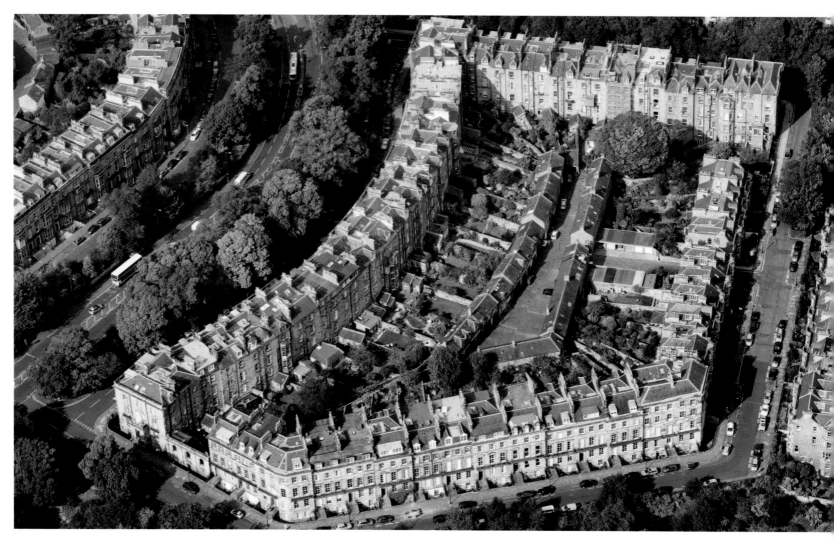

MORAY PLACE AND AINSLIE PLACE,
EDINBURGH NEW TOWN left
2015 HES AERIAL SURVEY DP216932

CLARENDON CRESCENT AND ETON TERRACE,
EDINBURGH NEW TOWN below left
2015 HES AERIAL SURVEY DP221225

CHARLOTTE SQUARE, EDINBURGH
NEW TOWN right
2015 HES AERIAL SURVEY DP216935

CALTON HILL AND ROYAL TERRACE,
EDINBURGH NEW TOWN below
2015 HES AERIAL SURVEY DP216994

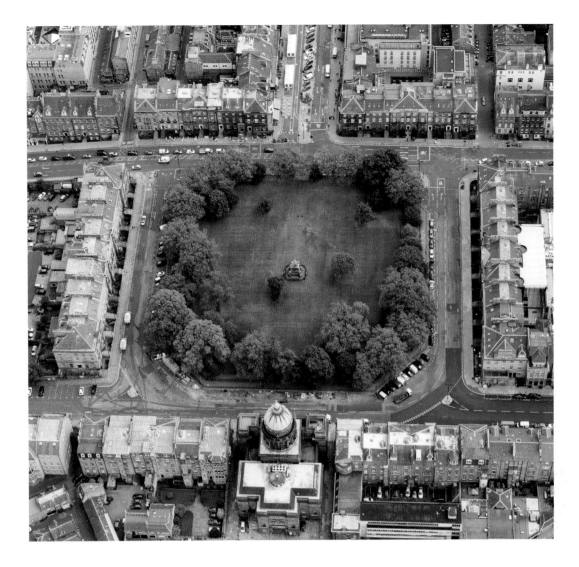

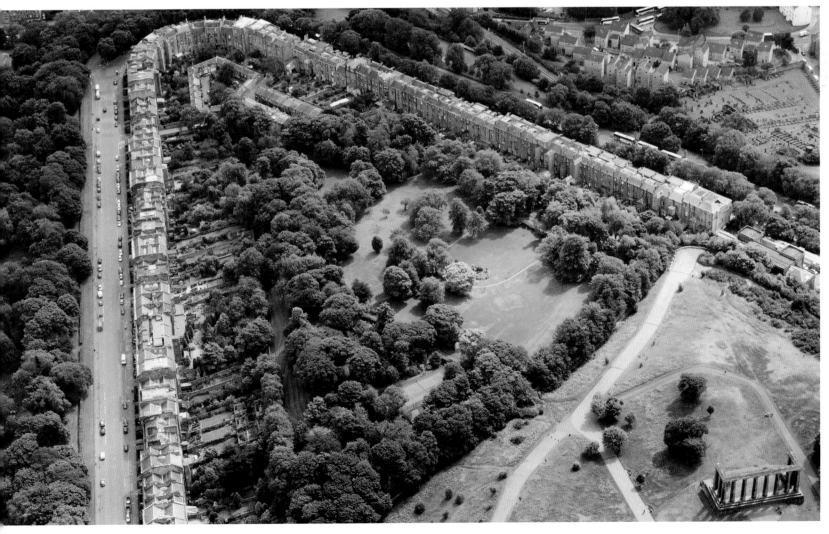

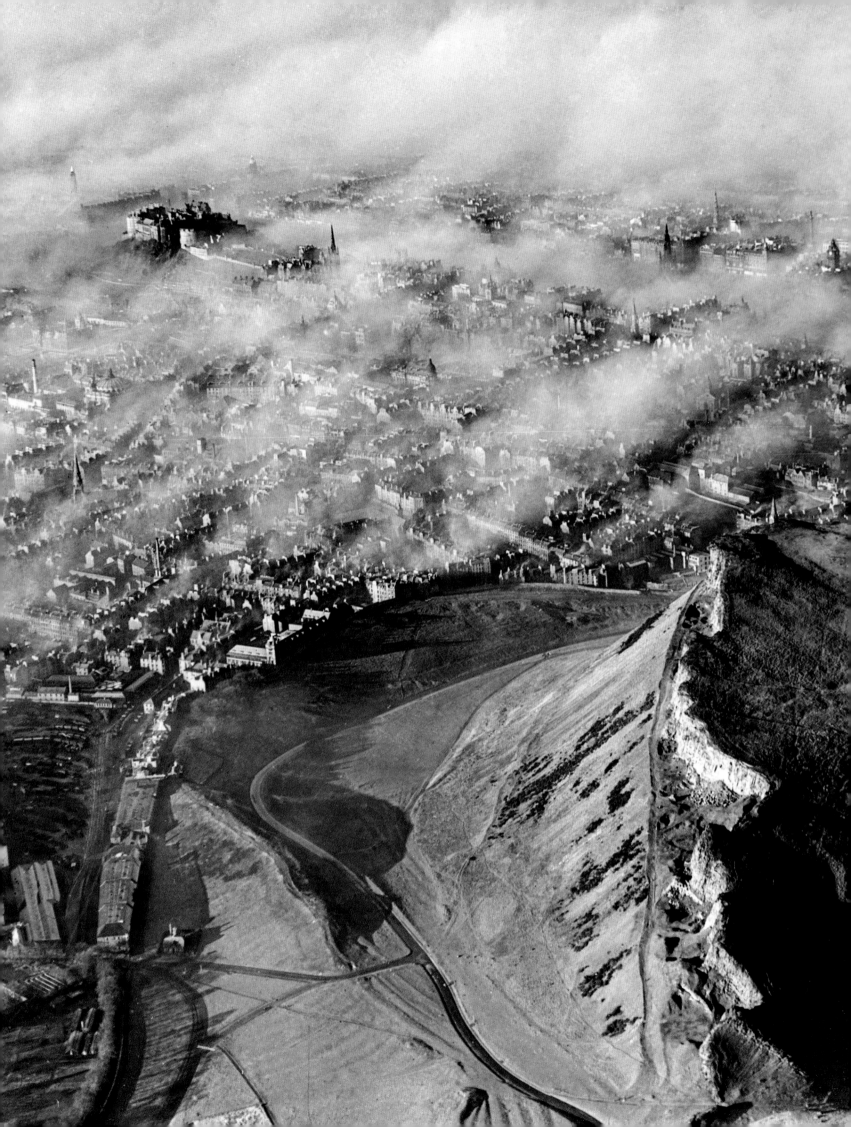

SALISBURY CRAGS AND ARTHUR'S SEAT, EDINBURGH
1949 & 2014 HES AEROFILMS & HES AERIAL SURVEY SC1256946, DP193161, DP193164

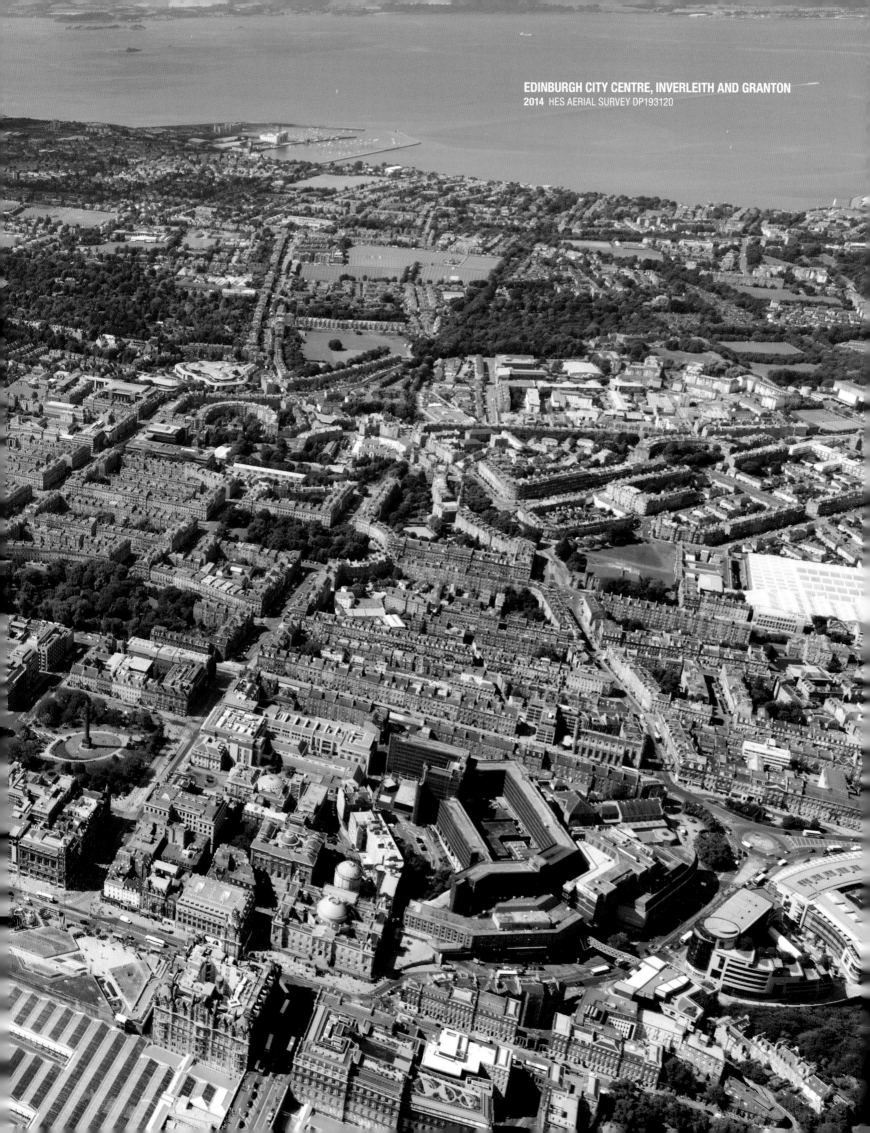

HOLYROOD HOUSE AND THE SCOTTISH PARLIAMENT, EDINBURGH

This site at the foot of the Old Town is a study in both preservation and change. Today, the ruins of a thirteenth century abbey still cling to a sixteenth century royal residence. On the other side of Queen's Drive and Horse Wynd, however, the breweries, gasworks and tenements of the early twentieth century have been replaced by the Scottish Parliament, a grand post-modern statement in steel, oak and granite.

1947 & 2014 HES AEROFILMS & HES AERIAL SURVEY SC1437762, DP193137

Cities are, in a sense, like living things: always growing, changing, striving, suffering or thriving. And one thing is for certain. The cities that we know today will not be the cities we know tomorrow.

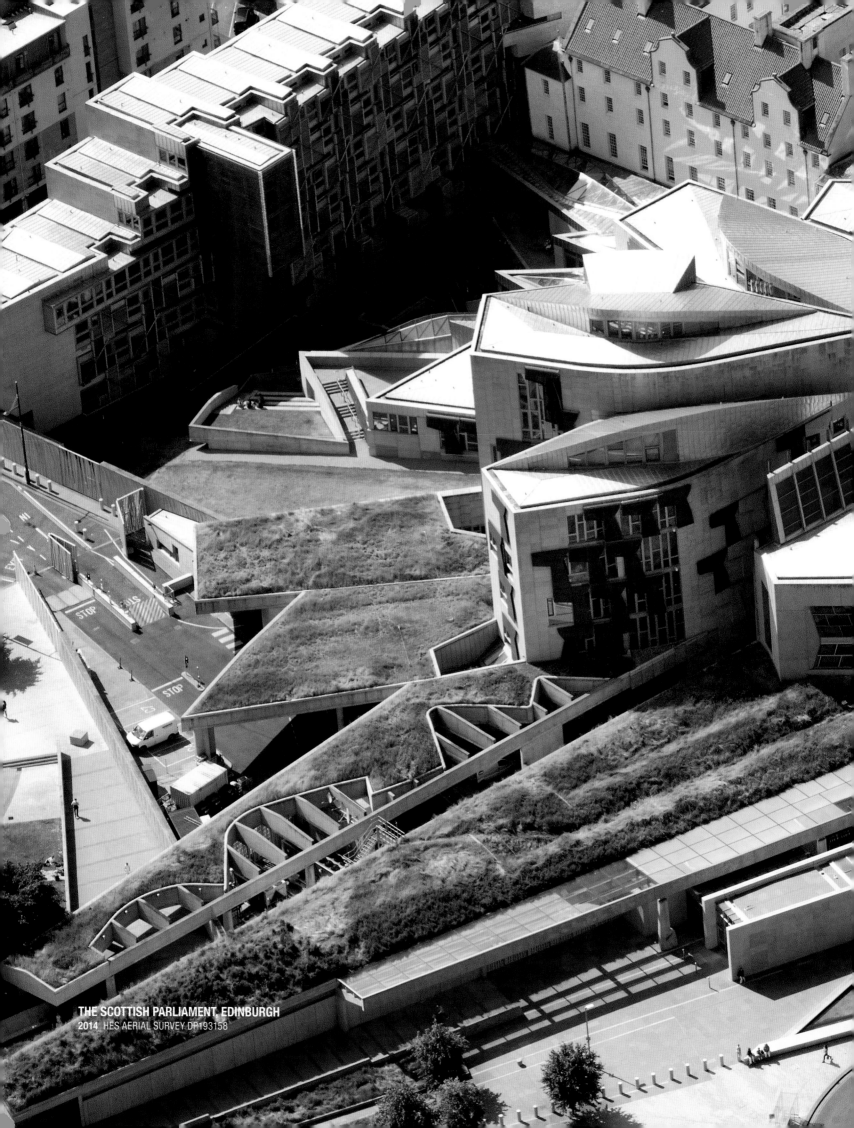

THE SCOTTISH PARLIAMENT, EDINBURGH
2014 HES AERIAL SURVEY DP193158

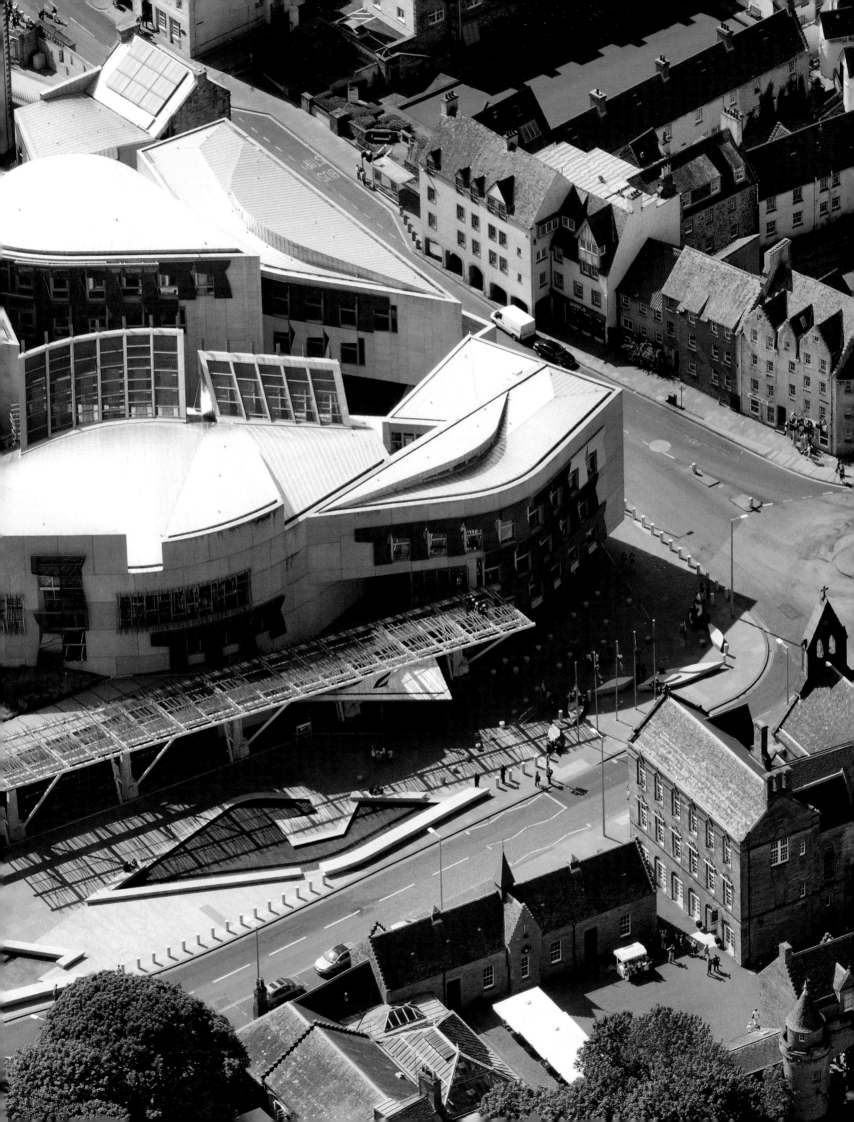

THE FORTH BRIDGE
1953 HES AEROFILMS SC1315348

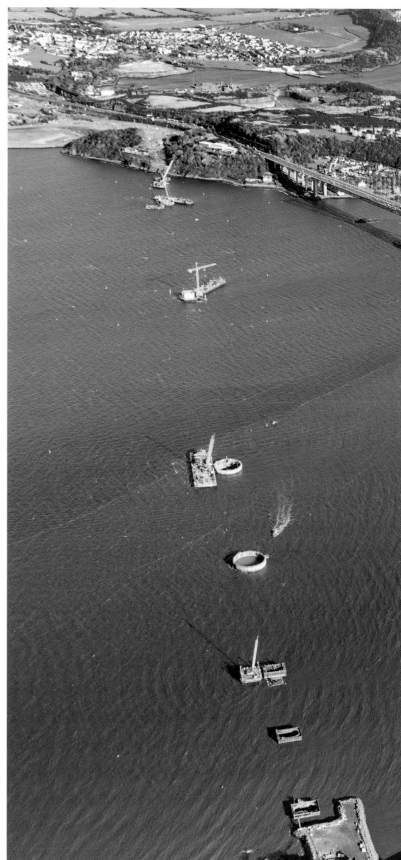

THE QUEENSFERRY CROSSING

The HES aerial survey team photographed every stage in the construction of the new bridge. Above left, photographed in the summer of 2008, a drilling rig probes the seabed as part of the initial feasibility study. Another five years on and – above right – the bases of the bridge supports are strung out in a line across the Firth. By March 2015 (opposite page) the crossing's three 160m-high towers have risen from the waters, still waiting for the spans that will link them all together.

2008, 2013 & 2015 HES AERIAL SURVEY DP049584, DP164384, DP211155, DP220946

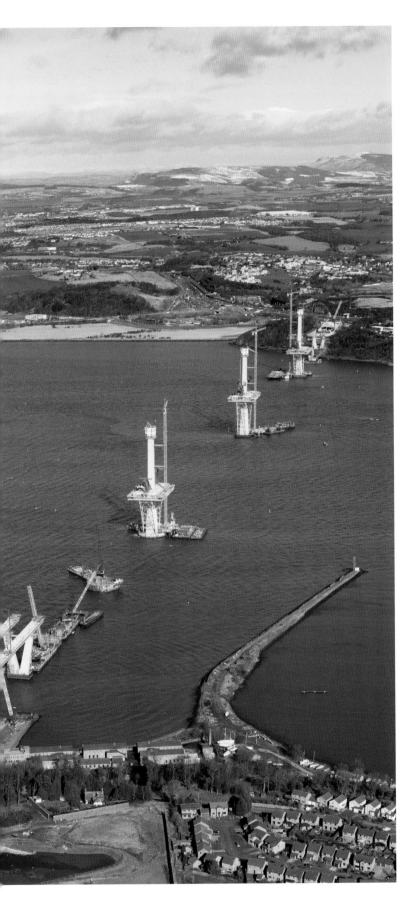
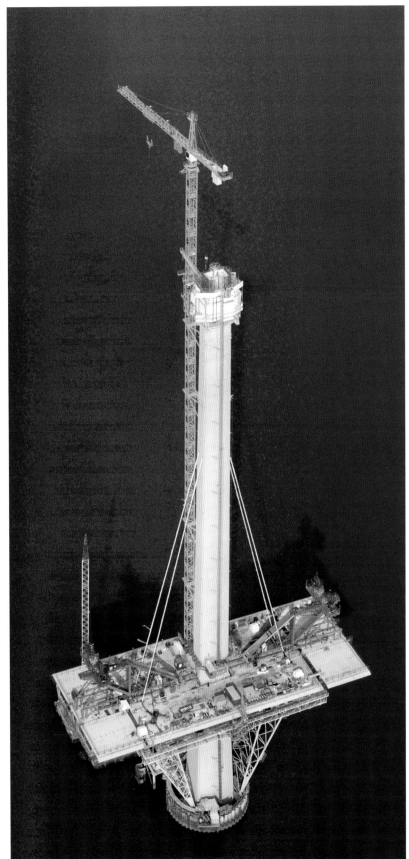

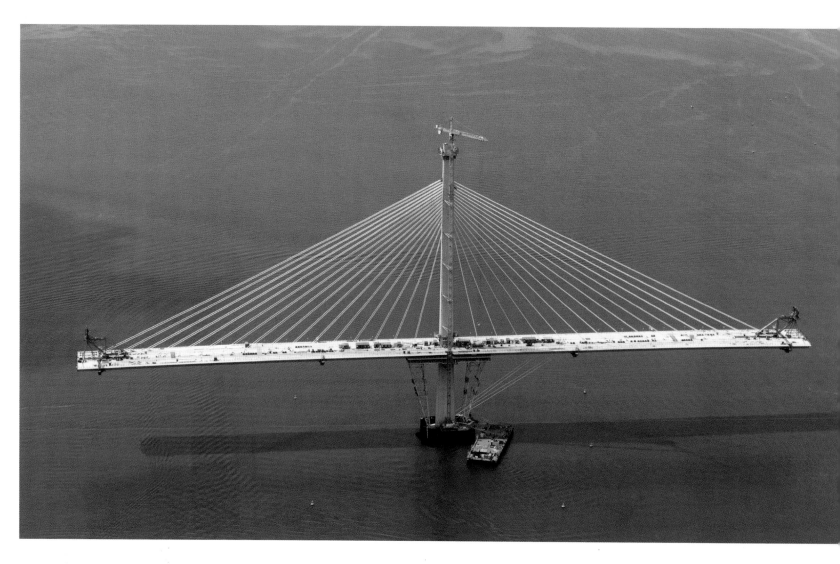
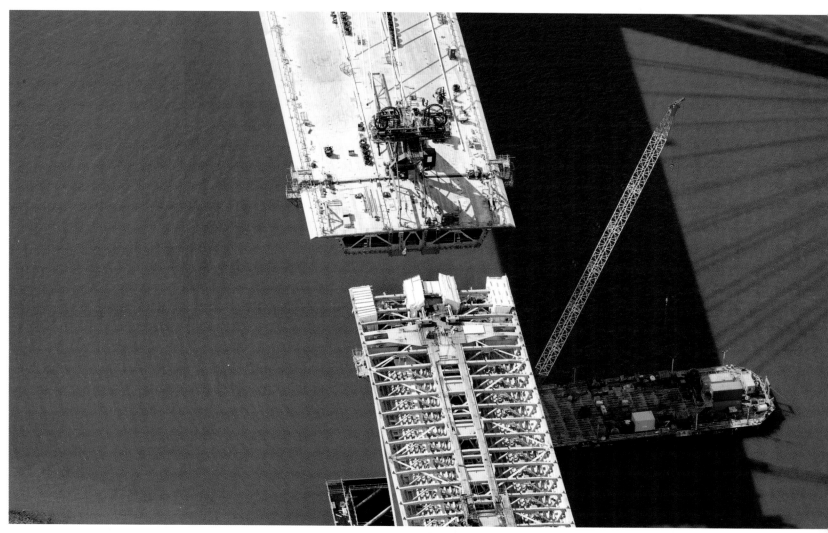

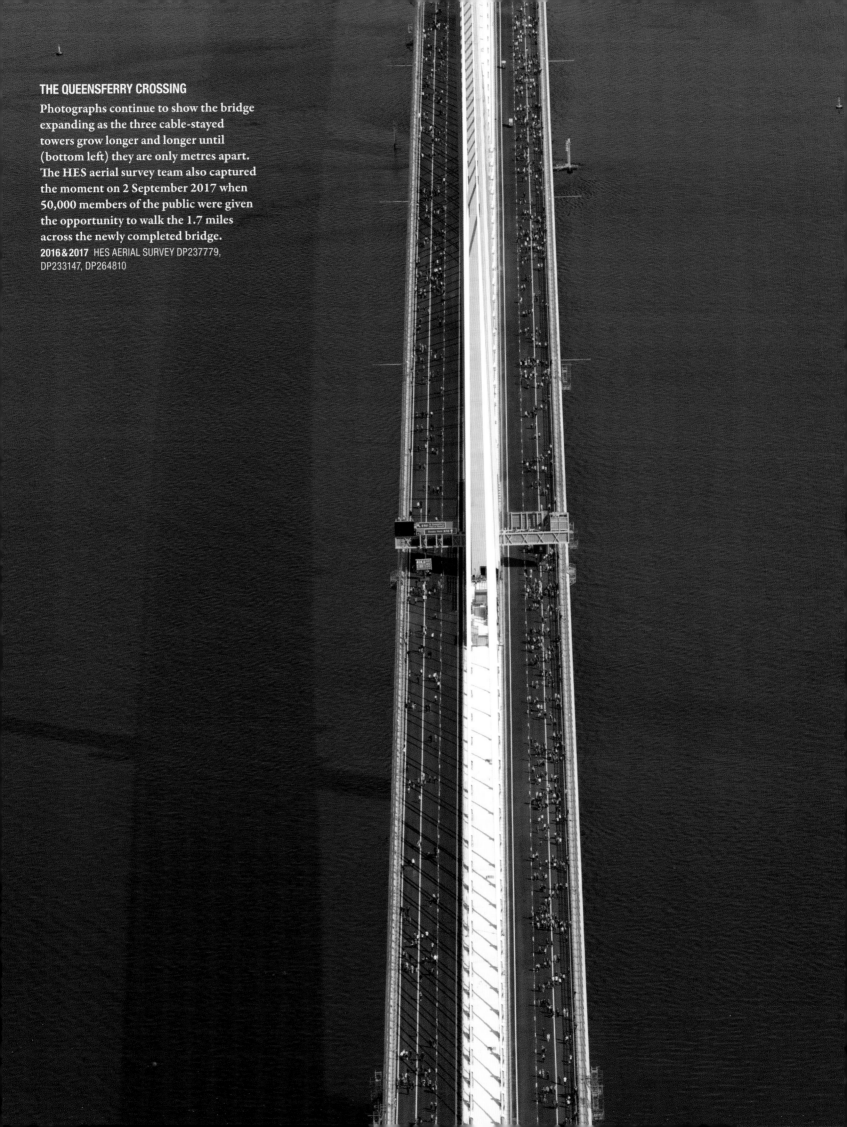

THE QUEENSFERRY CROSSING

Photographs continue to show the bridge expanding as the three cable-stayed towers grow longer and longer until (bottom left) they are only metres apart. The HES aerial survey team also captured the moment on 2 September 2017 when 50,000 members of the public were given the opportunity to walk the 1.7 miles across the newly completed bridge.

2016 & 2017 HES AERIAL SURVEY DP237779, DP233147, DP264810

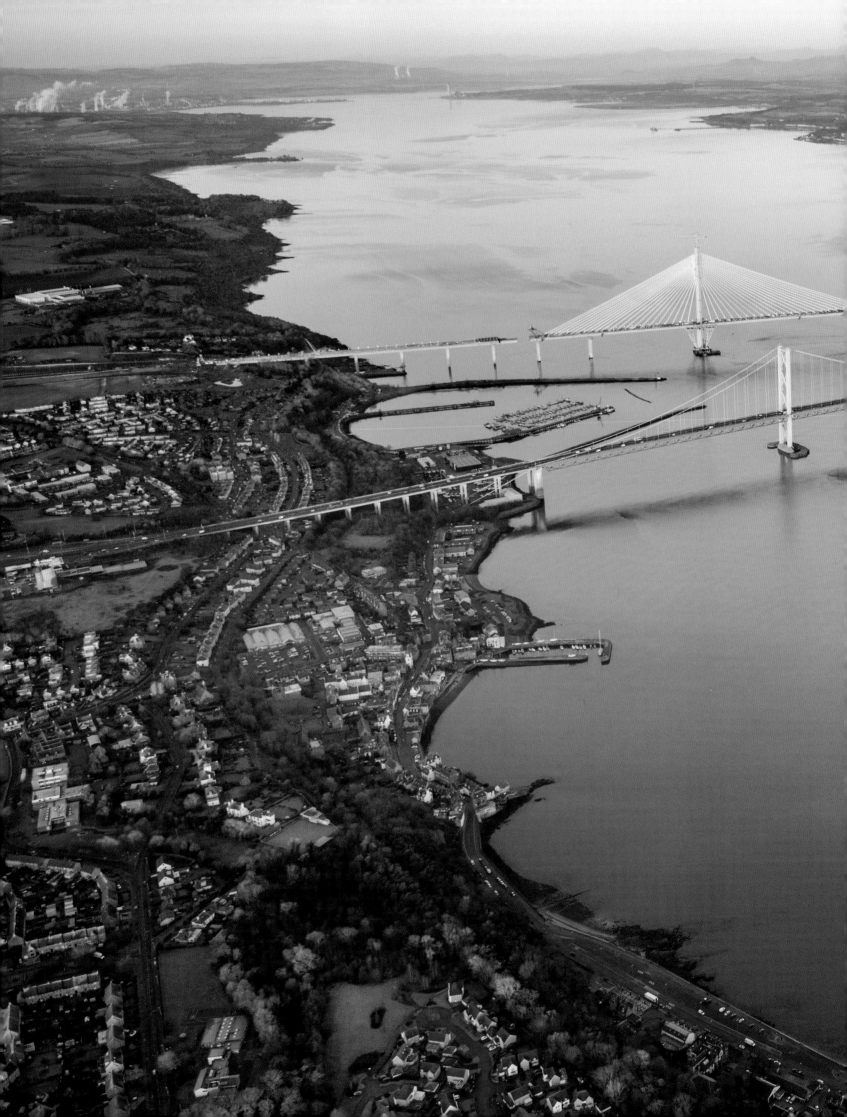

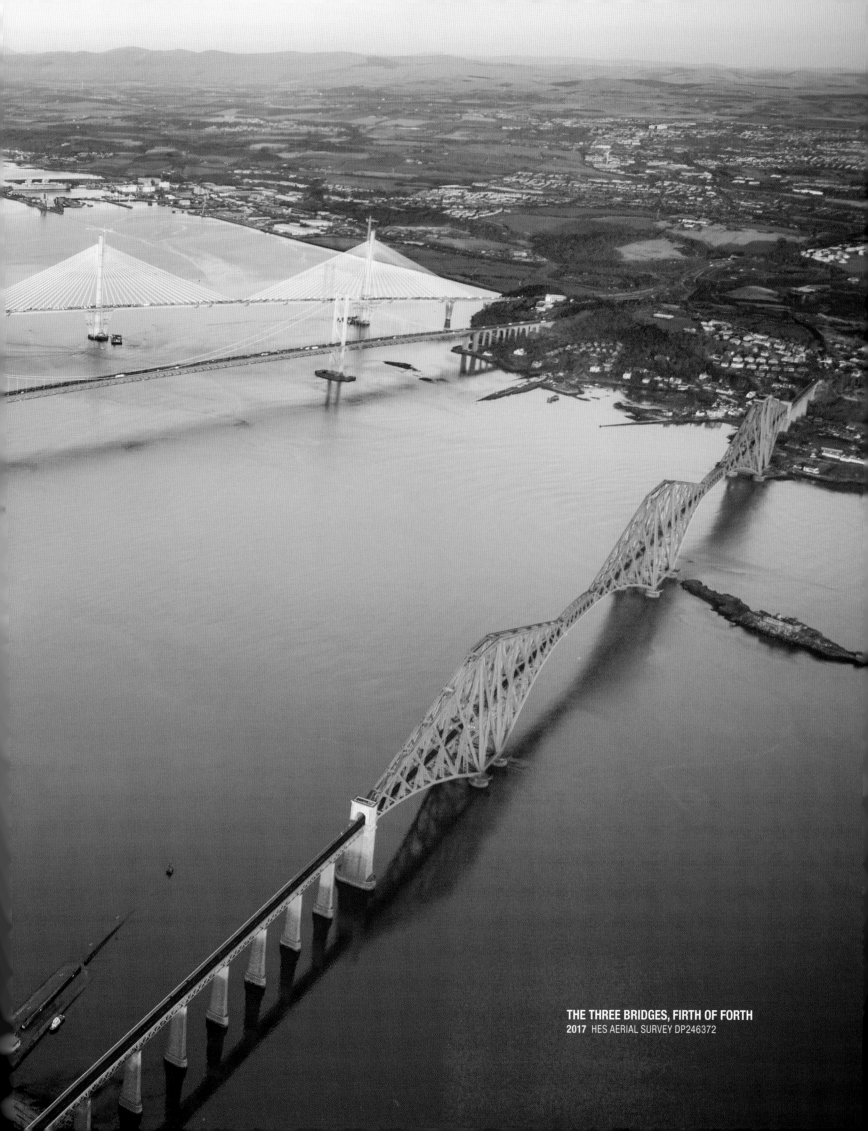

THE THREE BRIDGES, FIRTH OF FORTH
2017 HES AERIAL SURVEY DP246372

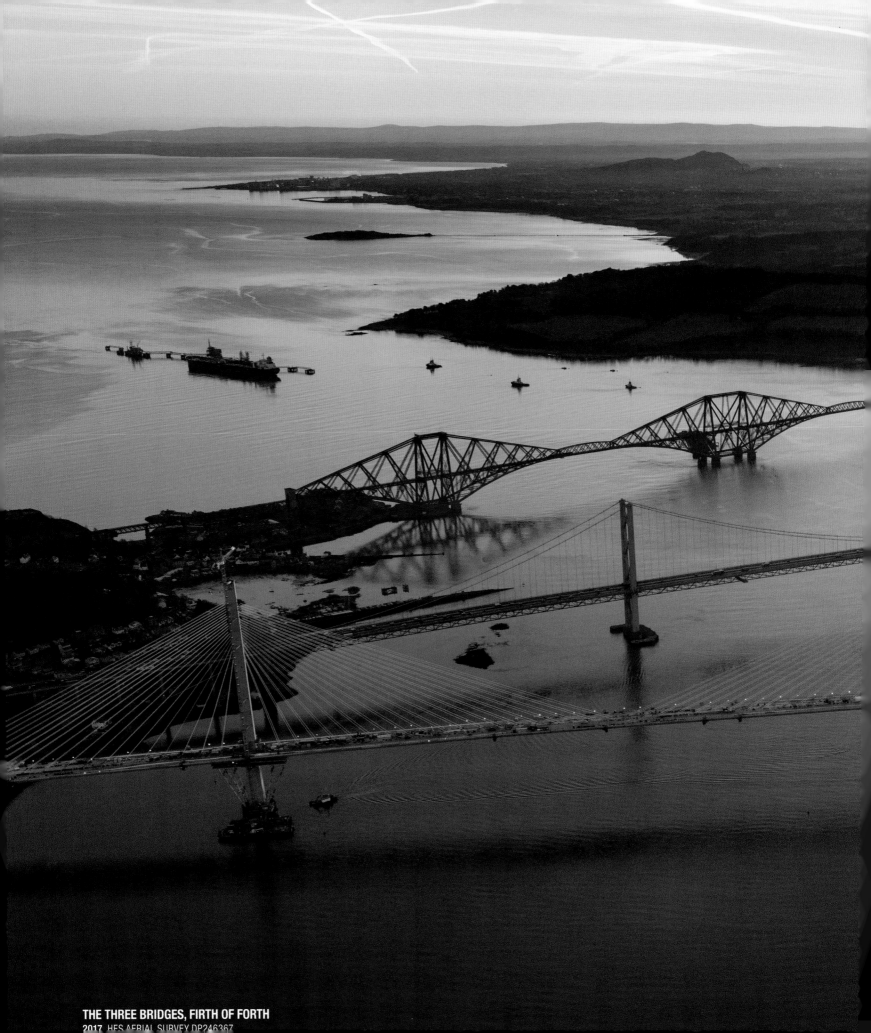

THE THREE BRIDGES, FIRTH OF FORTH
2017 HES AERIAL SURVEY DP246367

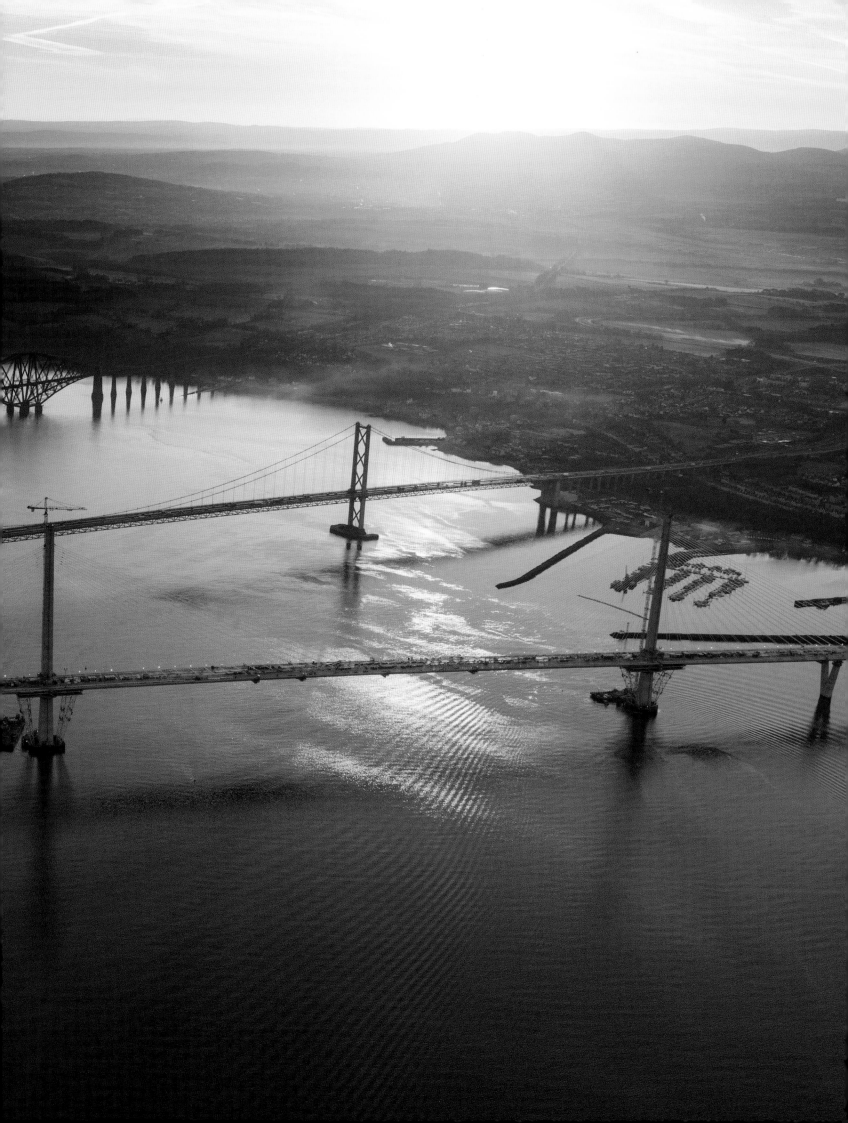

ABOVE SCOTLAND IN A TIGER MOTH
2017 SAM FINCH

THE TIME MACHINE

It's not very often that you get the chance to travel back in time. Through the doors of the aircraft hangar, waiting on the grass beside an apron of runway, was a 1942 DH82a de Havilland Tiger Moth – an open-cockpit tandem biplane made of steel tubing, thin plywood and stretched fabric. This was going to be my time machine.

I walked out from the hangar and across the runway with my pilot, William Mackaness. Together, we were aiming to recreate a pioneering flight made from this same Perthshire aerodrome in the summer of 1939. Back then the pilot was a man called Geoffrey Alington, who operated a company called Air Touring. And his passenger was Osbert Guy Stanhope Crawford – now dubbed the 'father of aerial archaeology'. Crawford's flight was about travelling back in time too.

The air was almost perfectly still – the aerodrome's windsock was hanging listlessly from its pole. Beyond, to the north, you could see a wide expanse of farmland and the solid outline of the Cairngorms. The late summer sun was dropping, catching the distant mountains half in light and half in shadow. Set against the flatness of the surrounding land they looked somehow artificial, like the backdrop to a theatre set. This sense of unreality was appropriate. On top of my olive-green flight-suit I was wearing a leather and fur-lined Irvin jacket that had once belonged to a Second World War pilot.

'Right now you'll feel really hot', William said. 'But once you're in the air you'll be grateful for it'.

William had already begun his starting sequence. 'There's something almost magical about it' he said. 'It's a checklist you learn off by heart – a ritual that puts you in a different mind set, that marks the start of your journey.' First came the 'walk round' – feeling the tension in the flying wires, looking at the fuselage for any signs of damage, making sure the wheels were at the right pressure and were free rolling, inspecting the fuel tank above the cockpit

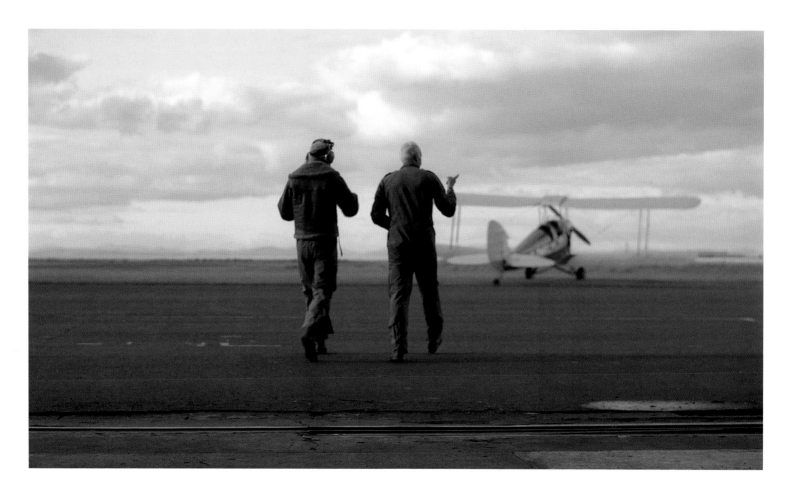

PERTH AERODROME
Preparing for take-off with Tiger Moth pilot William Mackaness.
2017 BBC

– capable of holding 19 imperial gallons; 'enough for about two and a half hours of flying' as William explained. Next he checked the oil in the Tiger Moth's 130hp Gipsy Major Engine. 'It's nicknamed the "Dripsy"', he said, 'because it's notorious for leaking oil.' A detail that, I confess, I did not want to hear immediately before take-off.

William compared this process to a kind of dance – I could see what he meant. Even climbing into the aircraft had a sequence of set steps: right foot here, left foot there, twist your body this way, grip just that part of the wing – not below or above – left leg over, then lower yourself down to your seat. Why? Because, very simply, if you step in the wrong place there's a good chance you might put your foot straight through something important …

As I fastened the seatbelt straps over my shoulders and around my waist, William began to, as he put it, 'tickle' the engine – first allowing the fuel to flow down to the intake manifold, then drawing it into the engine itself by turning the large single propeller on the nose. The propeller was a startling piece of craftsmanship. And very clearly of another time – a single piece of wood, carved exquisitely into a sort of curved figure-of-eight and lacquered to a smooth liquid shine, with gold-metal trim for the edges that sliced through the air. It brought to mind the fluid, streamlined hull of some vintage speedboat.

'Magnetos off, fuel is on, throttle closed, four blades', William recited. 'Four blades' referred to turning the propeller four times, to ensure that each cylinder takes in the fuel–air mixture. Then it was 'magnetos on' – creating

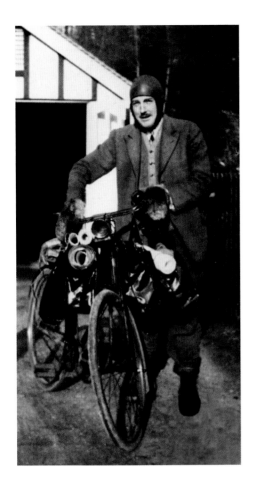

the electric spark that ignites the engine. With a guttural roar, the propeller in front of me spun to a blur. We sat for a few minutes, letting the engine and the oil warm up, before nimbly taxiing over the grass and on to the runway.

The take-off was remarkably quick. William ramped the engine up to 1600rpm with the breaks still on. Then he gently released the breaks and fed in the throttle, which he controlled with his feet. 'You need soft shoes for it' he told me, 'you have to feel the aircraft, and the power, right in the soles of your feet.' Within seconds we were racing over the tarmac. I pulled the goggles down from my canvas flying helmet as the rush of air tore at my eyes. Another few seconds later, we were up. And we were going back in time.

Osbert Guy Stanhope Crawford – OGS for short – was born in Bombay in 1886, but he grew up in Hampshire. As a schoolboy he roamed the many ancient monuments littering the chalkways of the Marlborough Downs, cultivating a lifelong passion for archaeology. The grandson of a Fife clergyman, at the age of 28 he donned a kilt to fight for the London Scottish regiment in World War One. After several months in the trenches he was offered a job as a Maps Officer, walking the Western Front to take panoramic photographs of the landscape. But as more and more aerial imagery came across his desk for map-making, he was determined to take his camera into the skies, and volunteered as an Observer for the Royal Flying Corps.

It did not begin well – he was shot in the foot on his first reconnaissance flight, and was later captured and held as a prisoner of war when his plane crashed behind enemy lines. But his excitement at the view from above never left him. Even as the battles were raging in the trenches below, he saw something else. Not the bloody present, but the past. When he flew over the Somme and described it as a 'wonderful sight', he wasn't talking about the spectacle of war. He was talking about the traces he could see of fields worked by prehistoric farmers; of roads and settlements built by the Romans – messages in the landscape, left behind thousands of years before.

After the war, it was almost inevitable that he would combine his two great passions of flight and archaeology. He corresponded with the Ordnance Survey so incessantly about the inaccuracies – and absences – of ancient sites on their maps that they created the new position of Archaeology Officer especially for him. His superiors assumed that the work would be desk-based. Crawford was having none of that. He was a brilliant reader of landscapes, able to recognise things others could not – and he was unswerving in his insistence that he had to be out in the field.

To begin with, though, he was more of a cycling archaeologist than an aerial one. He was based in Southampton, but his work took him all over the country. And throughout the 1930s he travelled to Scotland, urging his bicycle up and down back-roads and country lanes – bags hanging from the handlebars, maps wrapped around the crossbar, raincoat strapped to the carrier

behind his seat. His standard outfit was a suit and waistcoat (with trousers rolled up), and his old wartime flying helmet and furry mittens.

He would ride from site to site, sometimes on the road for a month or more at a time. He brought the same urgency to this job as he had to his wartime intelligence work – he saw it as equally important. He once boasted of cycling 72 miles from Stonehaven to Blairgowrie in a single day. This was all about putting himself within the landscape, being alive to its endless, ever-changing subtleties. But he always wanted more – to see more, to explore more, to look harder and look further. So in the summer of 1939 he requested permission to track down possible new Roman sites in Scotland … *from the sky*.

His bosses refused: they thought he was asking on a whim and suggested he take a taxi instead. But Crawford was stubborn. He took leave and paid for the aircraft himself. The trip above the Scottish lowlands cost him £27 – equivalent to several thousands pounds in today's money. Crawford thought it wasn't much really, as it was 'the world in general which reaped the profit'. Over five days in June 1939, he flew across Scotland, from Annandale to Aberdeenshire. The aerodrome at Scone – now Perth Airport – was just one of his stop-off points.

What made the aerial perspective so revolutionary when it came to the study of the past? From the air, Crawford said, the tracery of the ancient world showed up like 'the bony skeleton of an old horse'. The landscape emerged as a 'document that has been written on and erased, over and over again'.

And, crucially, it was a document that no one had ever read before. Crawford was creating a new language by deciphering the mysterious lines, colours, shapes and symbols that became visible from above. Of course, height is crucial. But so too are other factors – in particular the quality of the light and the patterns of the weather.

There were three key components to this vocabulary. First were what Crawford called 'shadow sites' – sites that are visible only in the early morning or late evening when a low sun picks out unnatural, manmade humps and bumps in the earth. They can be seen just for a few instants, then they are gone again. As Crawford put it, quoting from William Wordsworth's poem 'Intimations of Immortality', these sites very quickly 'fade into the light of common day'.

Next were 'crop sites': so-called because the intervention of man – even from many thousands of years ago – can still influence crop growth today. Where there are ancient ditches, crops grow higher because of deeper soil and appear darker than the rest of their field; where there are ancient buildings, they grow shorter, and appear paler. The same is true even when there are no crops – Crawford's third category, 'soil sites', worked in exactly the same way. But both required ideal conditions – a drought to suck the moisture from the earth. And even then, at ground level, this phenomenon is all but invisible, hidden in plain sight. You need elevation. You need an aircraft.

When Crawford made his tour in the summer of 1939, the conditions could not have been better. 'A long drought had burnt up the grass' he reported. And as a result, the traces of the past were inscribed in the landscape of Scotland with startling vibrancy: 'as if', he wrote, 'they had been painted in vivid green on a

DH82A DE HAVILLAND TIGER MOTH 'VICTOR TANGO'

Our 'time machine' awaits on the grass verge alongside the runway of Perth Airport. Crawford flew through here during his pioneering trip above Scotland in the summer of 1939.

2017 SAM FINCH

brown canvas'. Yet these signs too were merely fleeting. 'We were fortunate in catching the last week of this drought' Crawford said. 'The weather broke on the day that we flew south.' The rains came, and washed the glimpses away.

But, for that one blissful week, it was thrilling stuff. Cutting edge. It felt like the future to Crawford – technology revealing, with almost shocking suddenness, how the living share the land with the dead. How ghosts are, in a sense, all around us all the time. He believed that the view from above had the power to alter almost everything we knew about our history. 'The moral is obvious' he wrote. 'The young archaeologist who wants to make discoveries must learn to fly. Not until then will the harvest be reaped.' Our past was still an 'unexplored country'. Aerial photography, he pronounced, was to the archaeologist what the telescope was to the astronomer. Before it, they had been squinting into the dark. Now they could really see.

For Crawford, it was obvious that the new generation of archaeologists must operate among the clouds. So much of the ancient world was just waiting to be uncovered. 'The exploration of Scotland from the air has only just begun' he wrote. 'It is one of the most promising fields of research anywhere in the world.' But war was on the horizon once again – and, in a fight for the future, there was little time to think about the search for the past. Three months after Crawford's flight, Britain declared war on Germany. This lost world would just have to wait.

'You have the controls' William's garbled voice announced through the headset. 'I have the controls' I said back – not entirely convinced. When we had discussed the possibility of me flying the Tiger Moth back on the ground, William had advised finding a spot on the horizon, a mountain top for instance, and aiming for it. I spotted a peak off to our right, and – very gingerly – moved the stick. The Tiger Moth began to bank, the mountains and the low sun rolling round so my target was suddenly over the nose. Not so hard, I thought. Levelling out proved rather more difficult. I pulled back a little too abruptly, and filled our view with sky. I overcorrected the other way and – this time rather more alarmingly – aimed us towards the ground. There was only one thing for it. 'You have the controls!' I shouted. I could just make out William in reply, but, even had I not heard him, the near instant recovery of equilibrium was confirmation enough that the message had been received. And in any case, I wasn't up there to fly. I was up there to *look*.

It was past seven o'clock in the evening. We had entered into what photographers call 'golden hour' – the period before sunset when the light has to travel through more of the earth's atmosphere, becoming warmer and more diffuse as a result. We were flying south-west, above the farmlands parcelling up almost every inch of land in the river valleys of Strathearn and Strathallan. Off to my left were the Ochil Hills, and to my right the Grampian Mountains. This is the same course taken by the modern A9, and I could see

FLYING ABOVE STRATHEARN

From the open cockpit at the front of the Tiger Moth, the views across Strathearn and Strathallan were spectacular. In the low, raking light of sunset, the fields below were transformed – traces of the past casting their long shadows out over the landscape.
2017 BBC

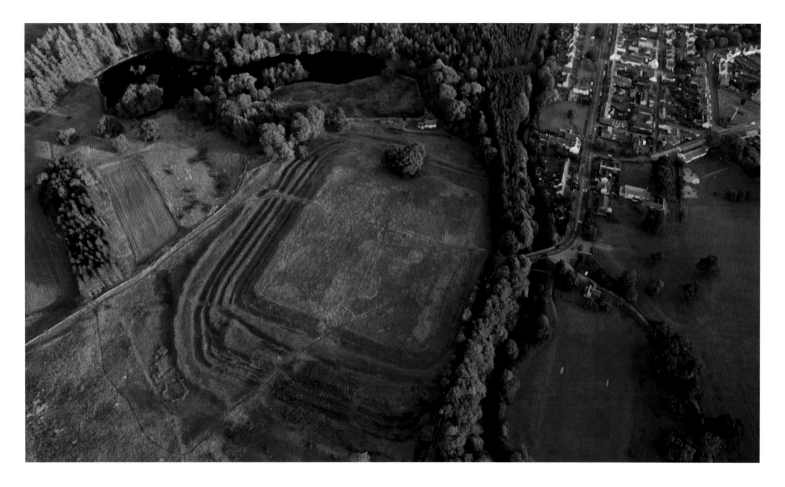

ARDOCH ROMAN FORT, BRACO

We followed the course of the old Roman road down through Perthshire, where it meets the earthwork remains of Ardoch Fort. Originally constructed in the late first century AD, it is remarkable that, nearly two thousand years later, its massive floorplan is still inscribed so deeply into the earth.

2017 BBC

its dual carriageways skirting the lower slopes of the Ochils, sun-flashes from windscreens signalling to us from the steady flow of traffic. But we were hunting a much older route. Some two millennia ago, the Romans built a road that runs exactly parallel to the A9. We picked it up around the tiny hamlet of Findo Gask, tracked it as it ran between the towns of Muthill and Auchterarder and followed it on to Braco.

It wasn't hard to imagine how captivating this must have been for pioneers like Crawford. For this brief, precious period of the day, the landscape below us was transformed. Shadows had grown very long now, the sun a spotlight sitting just above the horizon. Colours were startlingly vivid – the ochre of the sunset mixing into the greens, browns and yellows of the fields. And it reduced the patchwork of farms to a patina, a thin layer barely able to contain the fragments of the past straining beneath its surface. Crawford's shadow sites were everywhere – mounds, lines and sinews of ancient structures announcing their presence in those last instants before dusk. It's hard to think of a better way of *really* seeing history brought to life: the closest we could ever come to time travel.

At Braco we circled the great Roman fort of Ardoch. What is left today is a raised square plateau, surrounded by a series of ramparts and ditches – like a great weight has been dropped down to send deep ripples out into the landscape. We flew on, over the Ochils and into the valley of the Forth, cutting between the Wallace Monument and Stirling Castle. At Falkirk, we picked up the trail of what was once one of the great walls of the world. Named after

the Emperor Antoninus Pius, it was built by the Romans in the mid second century AD as the boundary of civilisation. It is still here today. Sort of. Now the Antonine Wall is a fractured line of humps and ditches, running around tower blocks and through back gardens, alongside canals and under busy A-roads: 35 miles from Bo'ness on the Forth to Old Kirkintilloch on the Clyde.

The wall was a statement of Roman *exhaustion*. Two hundred years after Julius Caesar landed on a beach in Kent in 55 BC, they'd had enough. They'd swept through the southern half of the country, conquering all-comers, but had – it was believed – ventured only briefly into the dark, wet, hostile north, before deciding to call it a day. Apart from a few roads and a handful of impressive forts, it was thought that the Romans had left little impression on Scotland beyond the Forth and Clyde valleys. But Crawford's flights marked the beginning of a period of discovery that would completely transform this history.

Over the past 70 years, the aerial view has revealed the true extent and ambition of the Empire's attempts to conquer Scotland. Look from above and the giant boot-prints of a brutal ancient war still scar our landscape. It has been said that the 'Roman army owed as much to the spade as to the sword'. Time and again, the shovels of Roman soldiers bit the dirt to dig ditches and foundations for wooden walls and gates. Those defences are, of course, long gone. But the marks left by the spades are not.

Running from Perthshire, through Angus to Aberdeenshire and Moray, a series of startling lines and geometric shapes have been spotted from the air in field after field of wheat, corn and barley. These are Crawford's 'crop sites' – and what they reveal is the back-breaking toil of Roman soldiers two millennia ago.

They weren't building forts, but something much more basic: temporary camps, simple accommodation for an army of thousands on the move. More of these camps have been found in Scotland than in any other country in Europe. 260 of them in all, and they are still being discovered all the time from the air. Some are vast, the size of over 60 football pitches. Some would only have been occupied for weeks, even days – yet remarkably, their ancient floorplans are still visible.

You need the ideal conditions of course. Dry summers where crops grow tall or stunted to reveal the secrets beneath them. But if the timing and weather are just right, you can follow the Roman advance north-eastwards with the ripening harvest – all the way to the northernmost camp, Auchinhove on the Moray coast.

It was a man called John Kenneth Sinclair St Joseph – 'Holy Joe' to his friends – who, following Crawford's lead, set out doggedly on the trail of the imperial army. St Joseph served in the RAF and had, just like Crawford, interpreted aerial imagery as part of military intelligence. He was said to be one of the best in the business, with hawk-like eyes and an uncanny ability to understand, almost instantly, what was going on in any given image.

In 1948, he became the first ever curator of aerial photography at Cambridge University. Working with de-mobbed RAF planes and pilots – St Joseph's 'bus drivers' as they called themselves – he flew all over Britain with his F24 hand-held camera. That first summer alone, he was in the air for some 140

JOHN KENNETH SINCLAIR ST JOSEPH
JKS St Joseph was quick to follow Crawford into the skies above Scotland. Even before the war ended, he recalled how he was 'by chance, able to undertake a few hours flying over south Perthshire in the late summer of 1944, while working at Scone airfield. The experience was memorable, both for the impression gained of the wide extent of arable land which should surely be productive of crop marks ... and for a view of Ardoch, where the earthworks, without compare in Scotland, convey such a striking impression of upstanding defences of a Roman fort.'
c1939 MASTER AND FELLOWS OF SELWYN COLLEGE, CAMBRIDGE

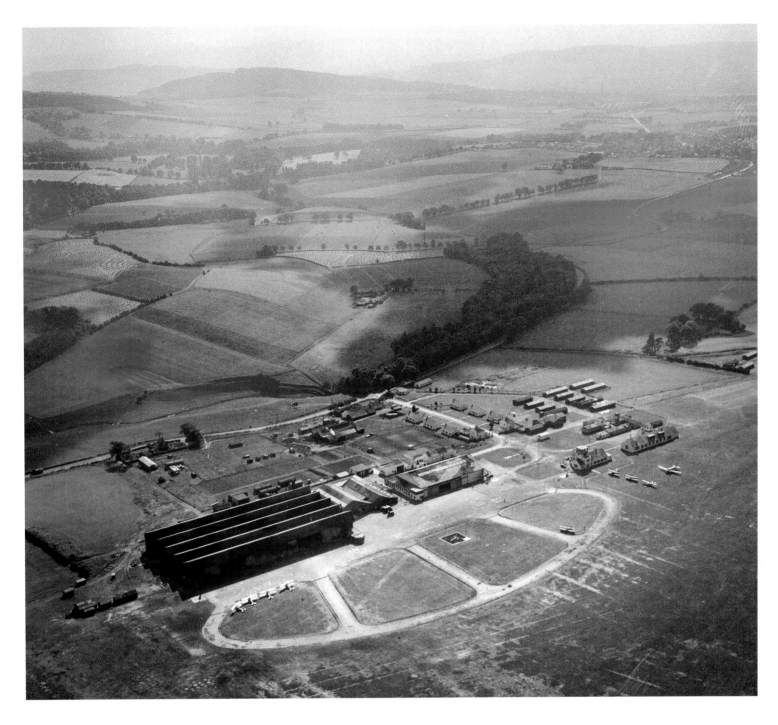

SCONE AERODROME, 1947

For many years St Joseph used this aerodrome – now Perth Airport – as a base for flying all over Scotland, hunting the fleeting traces of Roman marching camps in the landscape. 'The most careful scrutiny may be needed', he wrote, 'for crop marks are by no means easy to see, and observation often has to be repeated over the years ... Aerial reconnaissance is apt to yield surprises, and the price of success is thus constant vigilance.'

1947 HES AEROFILMS SC1268712

hours – from Kent in the south to Angus in the north – taking over 13,000 photographs.

He was often based at the RAF training school at Perth Aerodrome. And from there he mounted his own one-man campaign to solve the mysteries of Roman Scotland. Up in the air, he chased the crop marks of military camps further and further northwards in search of a Brigadoon-like battlefield known as 'Mons Graupius'. This was the fabled site, according to the Roman historian Tacitus, of a titanic victory over the great unwashed Caledonians. But then the Romans would say that, wouldn't they? The battlefield remains undiscovered to this day – some wonder if it even existed at all. But, thanks to St Joseph, whose flights led to the discovery of almost half of the Roman camps now known in Scotland, what we *can* be certain of is the true, massive scale of the invasion.

Take a site like Kintore. Today it is a small town of around 4,500 people: a quiet, peaceful place set on the main road between Aberdeen and Inverness and overlooking the banks of the River Don. If you'd been there 2,000 years ago, however, it wouldn't have been quiet at all. Thousands upon thousands of men were stationed there, filling to the brim a military camp that was some 44 hectares in area.

For the Romans, it was a sort of Caledonian Camp Bastion, a little city of wood barriers and tents set out on the plains, away from trees and mountains and marauding Picts. It was surrounded by ditches 3.5m wide and 1.5m deep. The A96 runs right over the top of it now. A school playing field today forms a tiny part of the camp's bottom corner, and there's a new housing estate plonked right in the middle. In St Joseph's photographs you can see its outline, a huge square etched around the town of Kintore in crop marks.

This camp was finally excavated when the new houses were built. And the discoveries were astonishing. The archaeologists didn't really expect to find much, but time and again fragments of two things kept coming out of the ground: ovens and latrines. It stands to reason of course – an army marches on its stomach and … well, think of the number of portable toilets you need at a big music festival and you get the idea. And when the Romans left, they filled their latrine pits with shoes, tent pegs, pottery and anything they thought the locals might use against them, in particular axes, wheels and nails. It's the glamour of archaeology that sometimes the greatest finds appear in a 2,000-year-old toilet.

When it came to the ovens, the sheer number discovered was remarkable – long long lines of them, over 250 in total, more than have been found in any other Roman site in the world. They were clay, wood-fired and used for baking bread: what we'd think of today as pizza. If you were in Aberdeenshire on a Friday night around AD 100 and looking for a takeaway, then this was the place to come.

The ovens tell us another thing too. Through carbon dating, we know that this site wasn't used just once, but on at least two other occasions. A generation or more after their first incursion into Scotland, the Romans came back, they tried again, they fired up the ovens once more, and dug out their long drops. And then finally, they really did give up.

It's a tantalising thought, but there must have been one Roman who pulled the gate shut on this camp one last time, trudging wearily back down through the chain of sites, over the Antonine Wall and finally retreating back behind the stone line of Hadrian's Wall. Some camps may have been set alight as the soldiers left, but others – most likely including Kintore – were just abandoned and left untouched for centuries. Perhaps this was because the locals considered the ground as 'tainted', or perhaps because they feared yet another return.

But there was no coming back this time – or at least not until Crawford and St Joseph took to the skies. And if you wanted to order a pizza in Kintore you'd have a long wait. About 1,800 years to be exact …

Above Grangemouth we altered course to follow the Antonine Wall westwards, turning away from the gleaming stainless steel sculptures of the Kelpies and navigating by the line of the Forth & Clyde Canal as it runs alongside the ancient Roman frontier. Light flashed from the water in the aqueduct and the big round basin of the Falkirk Wheel. And then we were passing over the remains left behind by one of the wall's main forts at Rough Castle. In the ever-dipping light, the groove left by the wall's earthworks was a solid black line of shadow. From my seat up in the Tiger Moth, I could see it running off into the distance, imprinted as heavily into the landscape as the canal, railway and motorway alongside. Yes, it has been subsumed and surrounded by the sprawl of the twenty-first century world. But life clearly still clings to it, thousands of years after it was built. It is the same story all across our modern landscape.

As the decades passed following Crawford and St Joseph's pioneering flights, thousands of new sites – and not just Roman ones – were discovered from the air. In 1976, the archaeologists of the Royal Commission on the Ancient and Historical Monuments of Scotland – now part of Historic Environment Scotland – first took to the skies. They couldn't have picked a better year to start flying. Britain was baking in a long, stifling heat wave – the driest summer since 1910, with 15 consecutive days of temperatures above 32 degrees, and one of the most severe droughts ever recorded.

But what was torture for office workers was ideal for aerial archaeologists. Under the relentless sun, the landscape became like a litmus paper for the past.

FOLLOWING THE ANTONINE WALL

There are few better illustrations of how the ancient and modern can still collide in our landscape today. Here, the 1,800-year-old remains of the Antonine Wall appear as a deep groove in the landscape, running exactly parallel to a railway line, and passing beneath two rows of electricity pylons.

2017 BBC

With soils sapped of moisture, the crops were giving up secrets that were buried deep and were long hidden, secrets that only such extreme conditions could reveal.

On one of their earliest flights, the aerial survey team circled above a field just to the east of Banchory in Aberdeenshire, overlooked by Crathes Castle. Like all good detective stories, it begins with a mystery. Or rather, two mysteries. When they analysed the photograph, the team focused on a pronounced geometric pattern in the middle of the field. It turned out to be an absolutely stunning discovery – the floorplan of a great hall built with large oak timbers nearly 6,000 years ago. Containing traces of crops like wheat and barley, it could conceivably be Scotland's oldest farm building.

But if this wasn't remarkable enough, there was more to come. At the top of the field, the photograph revealed a series of dark, regularly spaced dots running in a straight line. You can barely spot them – and in the field itself, on the ground, you've no chance. There's nothing at all, not a trace.

The marks appeared in this one photograph and never again. But it offered a crucial glimpse, a place to look. When archaeologists came to excavate the site years later, they found something that defied explanation. Twelve circular pits, all of different sizes, had been dug in a line going north-east to south-west, running for some 50m. They were filled with traces of burnt flint, nuts and bone, and at least two of them were used to keep wooden stakes standing upright. Radiocarbon dating then revealed some staggering information – they were first dug out some 10,000 years ago, and they were re-dug, maintained and kept in constant use for at least the next 4,000 years.

Here was evidence of some of Scotland's earliest people, hunter-gatherers – who were generally thought to have left little or no traces behind – maintaining an elaborate landscape monument for some four millennia. It's mind-boggling. For what possible reason? Well, we still don't know – and, of course, we never truly will. But one theory presents a tantalising possibility – that here, in what is now a featureless field of wheat in Aberdeenshire, the very concept of time was invented. A team of archaeologists has been exploring the idea that these pits were a primitive calendar, the first anywhere in the world. The hunters may have used them to work out when it was time to chase the migrating deer, or when the salmon would return upstream in the nearby River Dee. Because of their specific alignment, the pits may have offered a way of tracking the movements of the sun and moon, and the changing of the seasons, for generation, after generation, after generation.

It is a dizzying thought – and a humbling one. Today it may seem like there is nothing there, nothing to see. But this is a site that has known people for as long as there have been people to know. It must have held some unique significance, been a place of special pilgrimage. Undeniably it is about the enduring and intimate connections between humans and the land – where life, time, nature and the seasons intersect. From the world's oldest calendar to Scotland's first farmhouse, to a line of dots on a grainy black and white photo. Thanks to that drought of 1976 – and a camera poking out of a aircraft window – we were briefly, fleetingly, able to see further back than we'd ever seen before.

THE CRATHES CASTLE PITS

This was the photograph that led archaeologists to excavate a seemingly featureless field in Aberdeenshire. Running across the top of the image you can see a regular pattern of dark spots – evidence, as it turned out, of a series of pits first dug out of the ground nearly 10,000 years ago. For what purpose, we can never truly know. One theory suggests that they were a primitive calendar or timekeeper – which would make this the earliest site of its kind ever discovered.

1976 HES AERIAL SURVEY SC1071719

For decades, Scotland's archaeologists had relied on analysing other people's photographs. But now *they* were the ones in the air, holding or directing the cameras and pilots. They could follow their own hunches and pursue their own leads, look further and wider than ever before. It was the first leap into a whole new world of understanding. And it meant that entirely new aspects of the history of Scotland could appear in the most unexpected of places.

In the summer of 1984, for instance, archaeologist Marilyn Brown was flying above the picturesque ruins of Castle Kennedy in Dumfries and Galloway. In the flat, empty terraces in front of the old castle she spotted a series of distinctive patterns and lines in the grass – like an old plan etched into the modern landscape. It was a discovery that would come to dominate her work over the next thirty years, and would take her above castles, stately homes and country houses all across Scotland.

What Marilyn was trying to find were traces of one of the most enduring, but fragile, examples of human creativity in the landscape. She was looking for gardens. It may seem a slightly strange quest, when set against the hunt for Romans or our prehistoric ancestors. But in actual fact, gardens have a huge amount to tell us about our history. They've always been a way of turning the landscape itself into a piece of art – and, like any art-form, as they change over time they provide remarkable insights into society, politics, fashion, economics and philosophy across hundreds and even thousands of years.

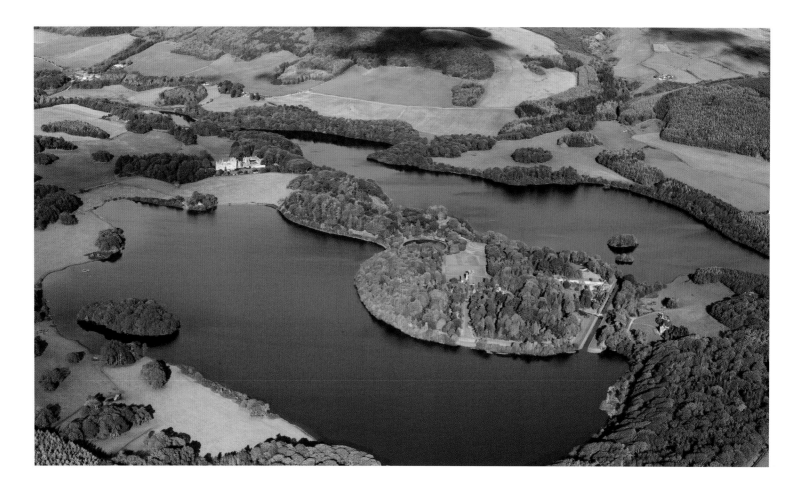

If you had come to this spot at Castle Kennedy some three centuries ago, you would have been standing at the centre of a masterpiece. Forget staring at a painting hanging on a wall – here you could step inside the picture, walk though it, listen to it and smell it. You could see it change with the seasons, grow and mature and evolve. What other art form can say the same?

The marks that Marilyn saw from the air were evidence of centuries-old digging and spadework. Just like Crawford's crop sites, the soil and grass were giving up patterns thanks to a dry, parched summer. And what they showed was a formal garden laid out in the late seventeenth century for Sir John Dalrymple, the second Earl of Stair. This garden was Dalrymple's pride and joy. But then he did something rather unexpected. He ripped it up.

The reason for this decision can be found in the crumbling ruins of Castle Kennedy. Back in 1716, when Dalrymple returned from Paris where he was the British Ambassador to the court of King Louis XV, he found a smouldering shell. One of his maids had set the building alight trying to dry bedding too close to an open hearth – and the fire had gutted the place.

Dalrymple's response is itself a study of the different mind-set of the aristocrat. He didn't see disaster in the ruin, but *opportunity*. He would make the burnt-out castle the centrepiece of 70 acres of new gardens – a complex array of woodland avenues, hedges, exotic plants, flowers and fruit trees filling the space between two bodies of water, the White Loch and the Black Loch. The two lochs were joined together by digging out a canal, and land was reclaimed on one side to create a perfectly circular pond.

CASTLE KENNEDY

Today, the crumbling ruins of Castle Kennedy remain the centrepiece of a remarkable designed landscape. What is even more remarkable, however, is that you can still see the blueprints of the old designs if you look down from above: the gardens that came before, but were over-written as times – and tastes – inevitably changed.

2008 HES AERIAL SURVEY DP052061

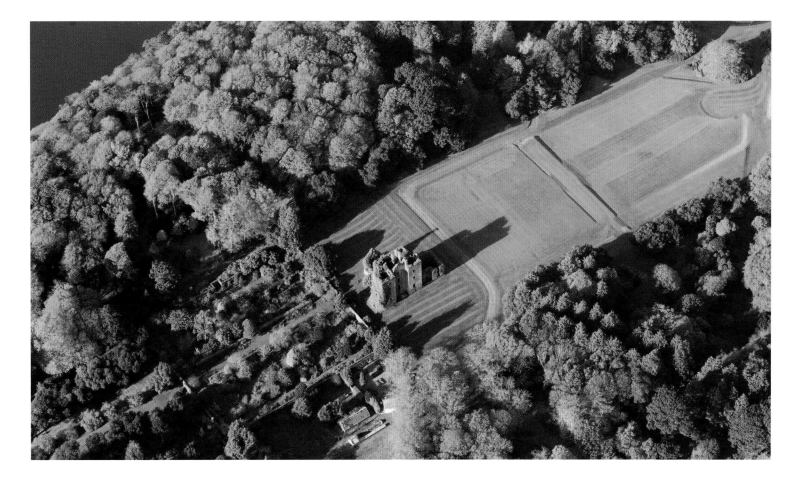

CASTLE KENNEDY

It was on this stretch of open lawn, below the ruins of the castle, that Marilyn Brown spotted the traces of garden features – avenues, hedges and even stairways – dating back as far as the seventeenth century.

2008 HES AERIAL SURVEY DP052053

The work took around fifteen years, and involved the substantial movement of large amounts of earth to create banks and terraces. Dalrymple even roped in the services of the soldiers of his own regiment, although his head gardener complained that they didn't work long or hard enough. The end result was, however, seen as a triumph. As the poet Samuel Boyse put it in 1734, 'sweetly bewildered the spectator roves / midst hills and moss-grown rocks and hanging groves / with care the eye examines every part / Too form'd for nature – yet too wild for art'.

But in the process, of course, his older gardens were lost – until Marilyn's survey flight. What she had spotted at Castle Kennedy wasn't just the fading imprint of a beautiful place – now all but vanished. It was the blueprint of a cultural revolution. During the seventeenth and eighteenth centuries, the Scottish landscape underwent a vast transformation. Landowners like Dalrymple sought to tame nature, laying out their gardens along rigid lines, applying strict geometric principles. It was all about imposing order. Soon, all of Scotland followed. The regular pattern of enclosed fields, the vast patchwork grid that dominates our landscape today, was born in these gardens.

Ironically, however, once the unruly countryside was tamed and devoted to mass agricultural production, country estates grew nostalgic for wilderness. Tastes changed and the lairds began transforming their formal gardens back into wilder idylls – refuges from the soulless, ordinary matrix of fields that now stretched as far as the eye could see. Chaos became order, and order became chaos. And it is only from above, if we are lucky, that we can still see, here and there, the ghosts of gardens past.

<p style="text-align:center">*</p>

The light was beginning to fade, the sun sinking visibly through thin tendrils of clouds sitting over the mountains to the west. We were still following the line of the Antonine Wall – very conveniently, because it took us right to our final destination, the runway at Cumbernauld Airport. Remarkably, the wall's remains run just a few metres to the north of the landing strip. I watched it for as long as I could as we dropped lower and lower, only losing it in the last few metres before the Tiger Moth touched down.

Back on solid ground. And back to the present. But the experience remained unforgettable. To be in an open cockpit, flying over a landscape lit with the most perfect light you could ask for, was to experience a near-electric jolt of connectivity to history; to see in glorious Technicolor just how much of the past remains in the present. It was a startling demonstration of one of the simplest lessons of archaeology – that the more you look, the more you find.

Crawford and St Joseph knew this, when they first climbed into their aircraft. So too did Marilyn Brown, as she set off in search of lost gardens. And Dave Cowley, Historic Environment Scotland's Aerial Survey Manager, knows it today, as he continues to criss-cross Scotland's skies. But it's not just about looking, it's also about *how* you look. And on the small island of Arran, state-of-the-art technology is now looking at the landscape in much greater detail than ever before.

By firing some 100,000 lasers beams a second straight down at the earth and capturing the echoes – a technique known as airborne laser scanning – a picture has been built up that is accurate almost to the centimetre. Computer algorithms process the data to find the true surface, the 'naked' earth. In the process, a real island becomes a virtual one. A 3D Arran, a digital clone, now lives in the 'cloud', an exact replica. If the earth ever swallowed Arran up, we'd have all the data now to recreate it just as it was. And it is at this point that archaeologists like Dave can start to play God. Remember Crawford's 'shadow sites' – the humps and bumps of ancient landscapes that only appeared under the light of a low sun? Well in the 3D world, the sun can come from any direction at any time. Arran can be flipped and twisted and studied as if it was permanently dawn or dusk. The sun can rise in the south and set in the north if you want it to.

What emerges is astonishing. Shadows reach out from a lost landscape: traces of the lives of our prehistoric ancestors – Arran's first farmers – and the buildings, fieldworks and burial grounds they left behind. As Dave says, 'this technology is an absolute game-changer in terms of being able to cover something like the whole landmass of Scotland, in my life time'. This is the next frontier of aerial archaeology, and it promises a new revolution in our understanding of the past.

Stand on Arran – even in one of its remotest parts – and the chances are that you can't move for tripping over some trace, however faint, of human

3D MODEL OF ARRAN
Airborne laser scanning has allowed archaeologists to create a 3D 'copy' of Arran that can help reveal previously undiscovered sites. From a comprehensive model of the entire island to a detailed view of the low footings of prehistoric round houses (above), the captured data provides a unique and powerful opportunity to explore landscape in ways that were unimaginable even a few years ago.

2018 HES

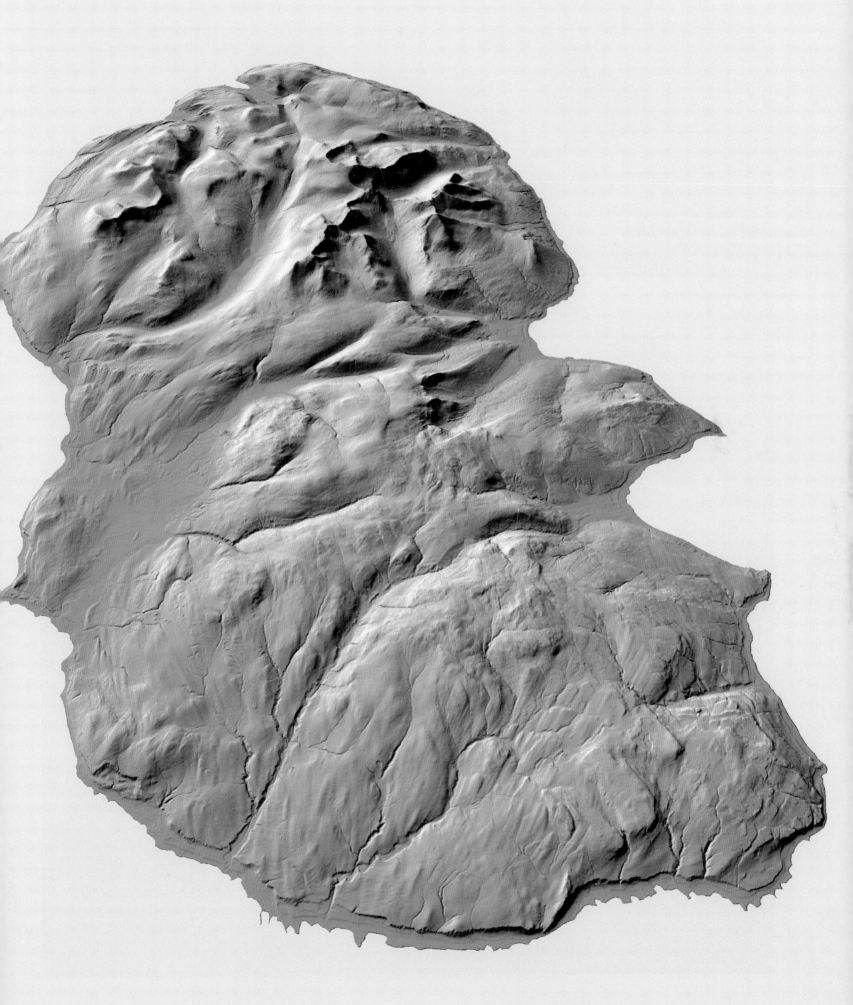

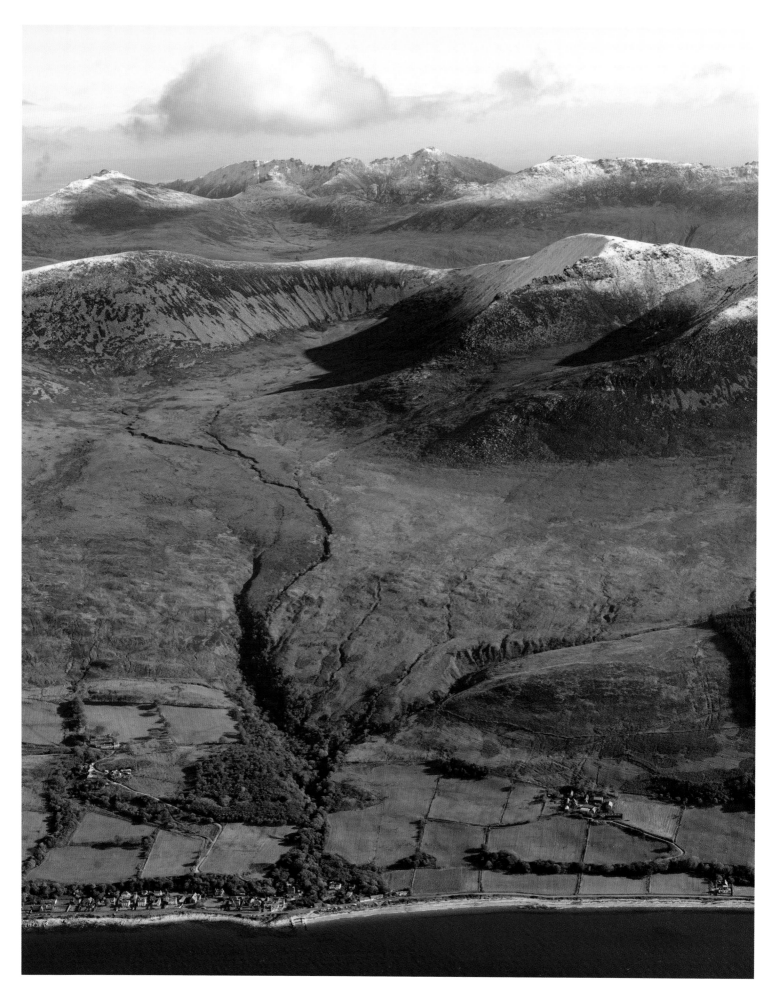

SUNSET OVER STRATHEARN

In the evening light, contours and undulations emerge from this patchwork of fields just to the north of Auchterarder. Crawford called our landscapes 'a document that has been written on and erased over and over again ... the roads and field boundaries, the woods, the farms and habitations, and all the other products of human labour; these are the letters and words inscribed on the land'.

2017 BBC

ARRAN

An aerial survey flight looks over the village of Pirnmill on the west coast of Arran. This island – famously nicknamed 'Scotland in miniature' – now has a new existence. Thanks to airborne laser scanning, it has been digitised in its entirety, translated into a computer model that archaeologists can endlessly manipulate and explore.

2008 HES AERIAL SURVEY DP056902

presence. When lasers strip the landscape bare, you can see just how much our interventions have, from the earliest times, marked, changed and scarred our world.

It's remarkable to think that the first legal protection of ancient buildings and monuments in Britain came from an 1882 Act of Parliament – and that it recognised only 21 significant sites in Scotland. It was a tiny list, made up of a few stone circles, some carved stones, a handful of ruined towers, and a couple of prehistoric tombs. There wasn't even a castle. Now that list has grown to nearly 10,000, alongside hundreds of thousands more sites that have been discovered and recorded. And we care more about protecting them than we ever have before.

For over a century, we've been grappling with what the view from above can tell us that other views can't. And by capturing it in photographs, keeping it and conserving it in the National Collection, we are building a new story of Scotland, a story of a place that has been written on again and again in the marks left behind by *people* – from great urban masterplans to the simple tracks of countless feet following the same path on a hillside.

Perhaps most thrilling of all, over the past hundred years we may only have reached the end of the first chapter. We will continue to read backwards and forwards, exploring the past and anticipating the future. From the sky, this remarkable story has no end in sight.

* * *

DOD HILL AND AND COMB HILL, MOSSPAUL, THE CHEVIOT HILLS

3

THE TIME MACHINE
IMAGERY FROM THE HISTORIC ENVIRONMENT SCOTLAND COLLECTIONS

Join the Historic Environment Scotland aerial survey team on a flight back in time. Over the coming pages, you will see a country alive with the tracery of the past; see how the modern world is everywhere marked and scarred by the activities of our ancestors, from settlement and farming to war and worship. This flight will take you all across Scotland, from Galloway and the Borders to Aberdeenshire and the Outer Hebrides. And it will show you the unique power of the view from above – how it can transform the landscape into a living historical manuscript, just waiting to be read and understood.

From the air, OGS Crawford said, the landscape emerged as a 'document that has been written on and erased, over and over again'. And, crucially, it was a document that no one had ever read before. He was creating a new language by deciphering the mysterious lines, colours, shapes and symbols that became visible from above.

ARBORY HILL FORT, ABINGTON, SOUTH LANARKSHIRE

This huge structure stares up at the survey aircraft like a solitary, baleful eye. Some 80m long by 70m wide it now stands as a ruined sentry on the summit of Arbory Hill, almost 500m above the M74 as it passes through a deep valley carved out by the passage of the River Clyde.

2014 HES AERIAL SURVEY DP208956

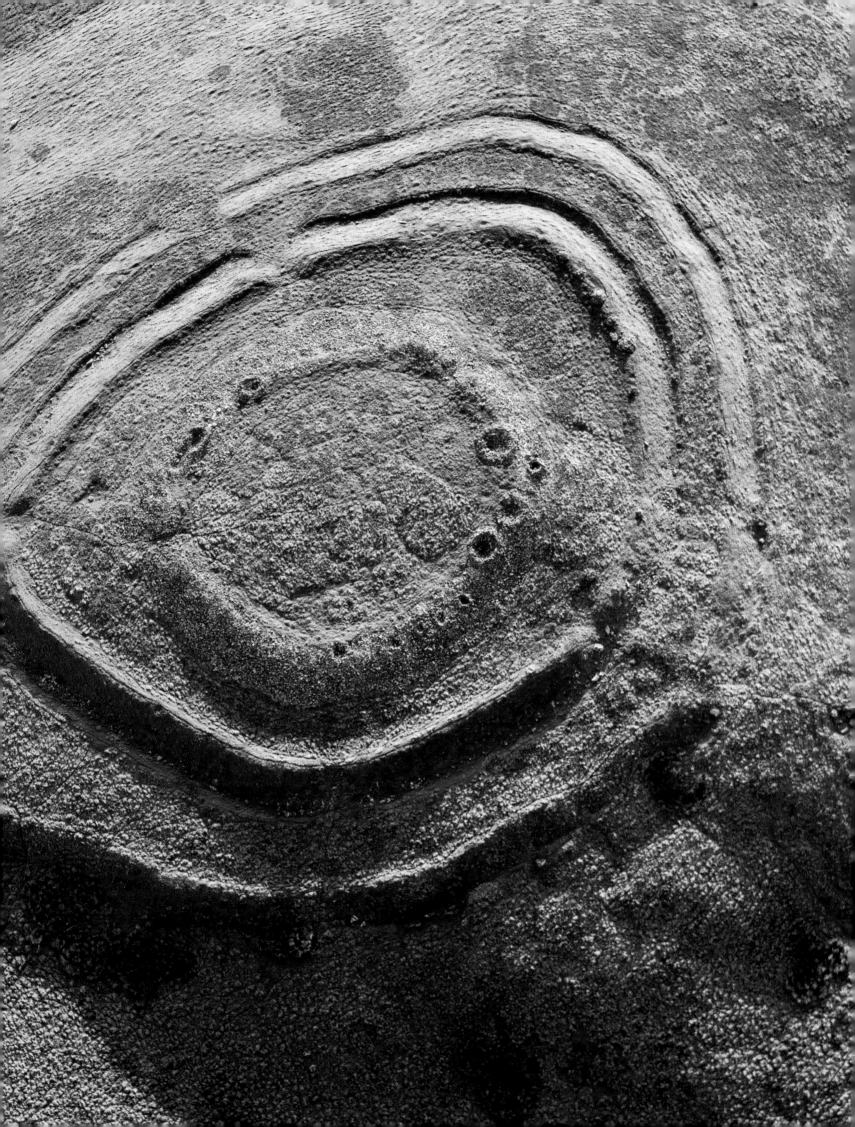

GALLOWBERRY WOOD HILL FORT, TWEEDDALE, AND NEWTON HILL FORT, ROXBURGH

Surrounded by dense forest, the remains of this ancient hill fort, set on the summit of an isolated knoll, are hidden from view (top left). From the sky, however, the distinctive pattern of concentric ovals – onetime defensive ramparts – are an obvious eye-catcher (top right). Nearly two thousand of these sites still remain today all across Scotland's landscapes, most dating back two or three thousand years to the Iron Age or the Bronze Age.

2015 HES AERIAL SURVEY DP213992, DP224793

PREHISTORIC AND IRON AGE SETTLEMENTS, MELDON BURN, TWEEDDALE, AND BRAIDWOOD, MIDLOTHIAN

Here the locations are suggestive of settlement rather than fortification. On the left, the remains sit prominently at the top of a steep slope above Meldon Burn and a modern road. To the right, smaller circles are visible inside the ramparts – impressions left behind by ancient ring-ditch houses.

2015 HES AERIAL SURVEY DP213995, DP037709

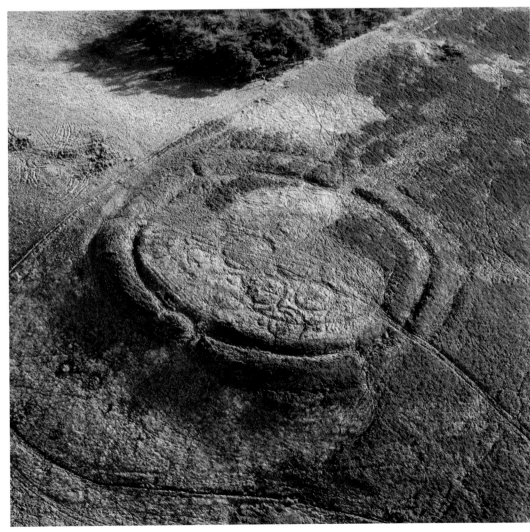

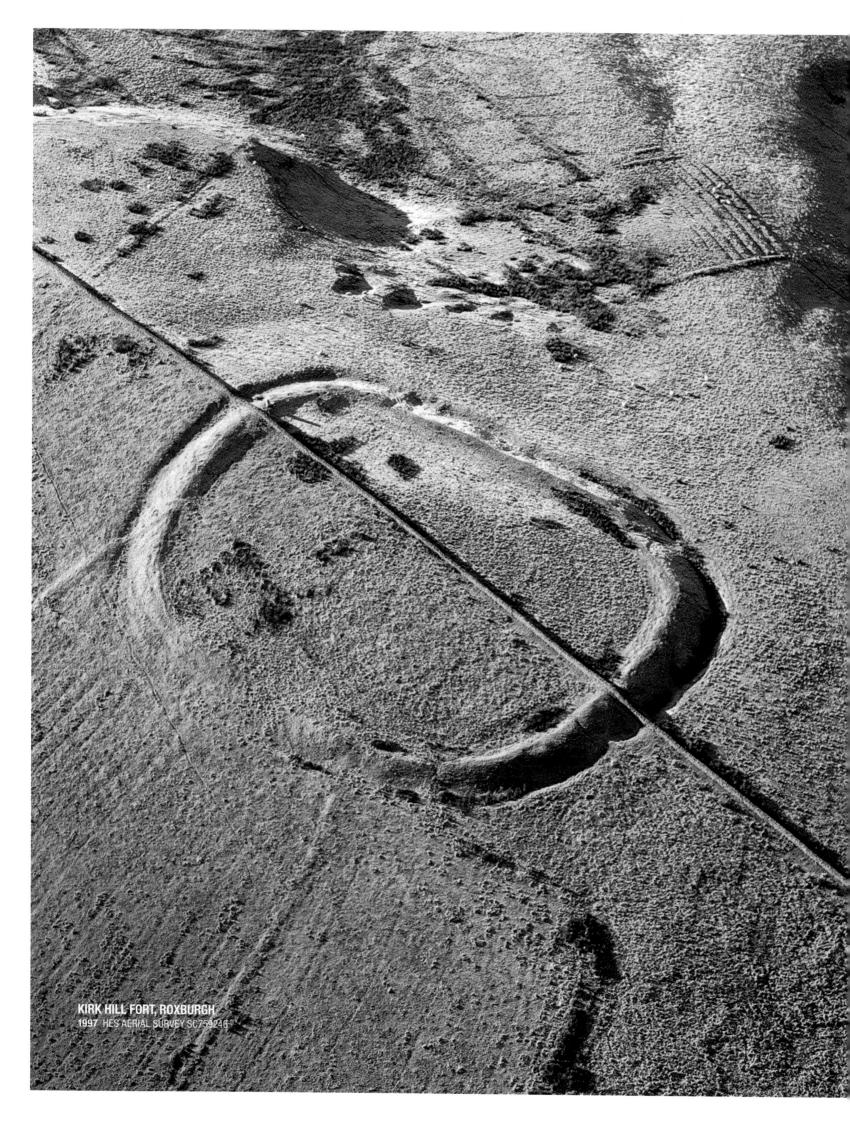

KIRK HILL FORT, ROXBURGH
1997 HES AERIAL SURVEY SC759246

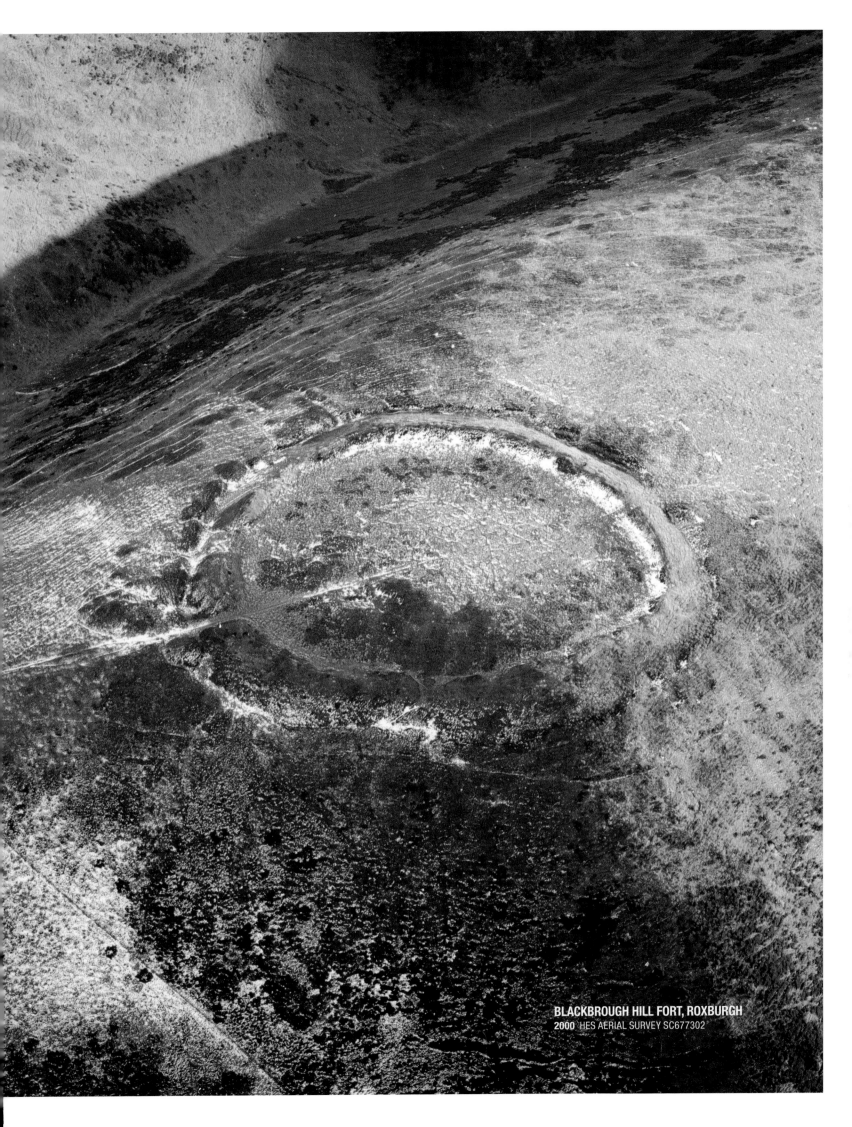

BLACKBROUGH HILL FORT, ROXBURGH
2000 HES AERIAL SURVEY SC677302

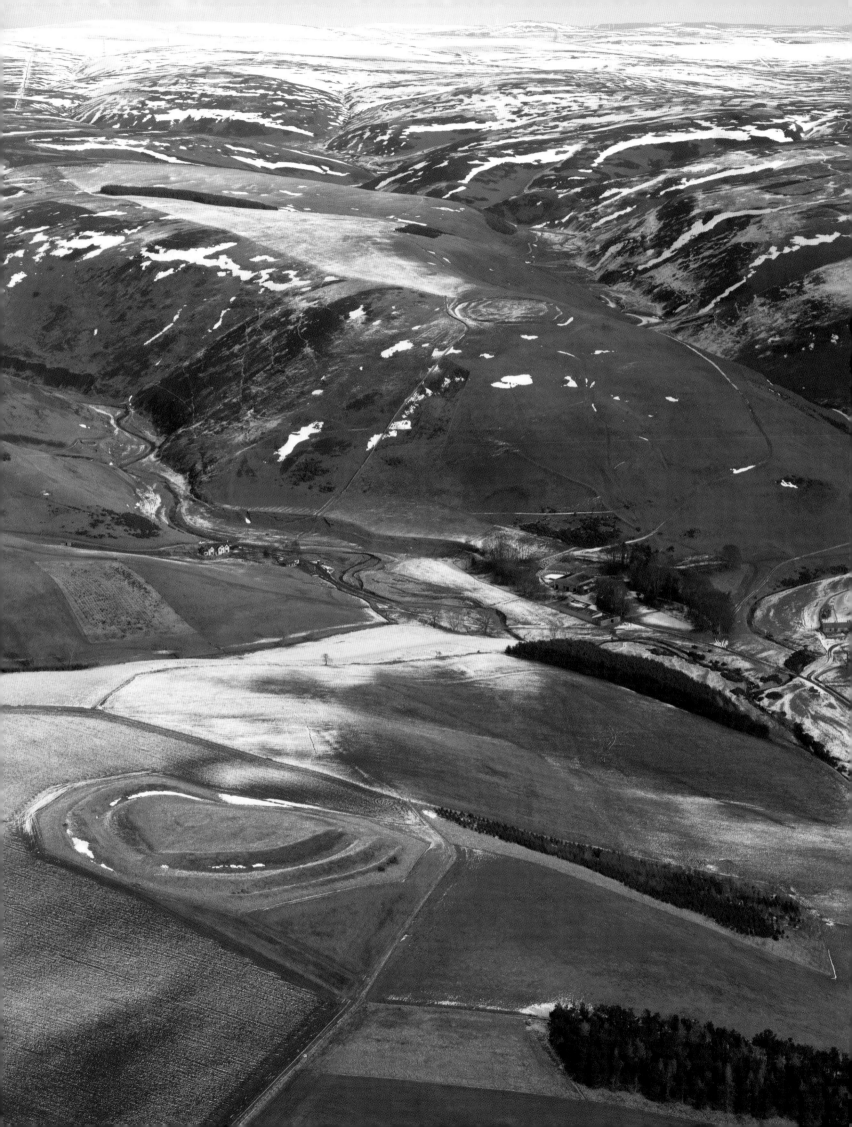

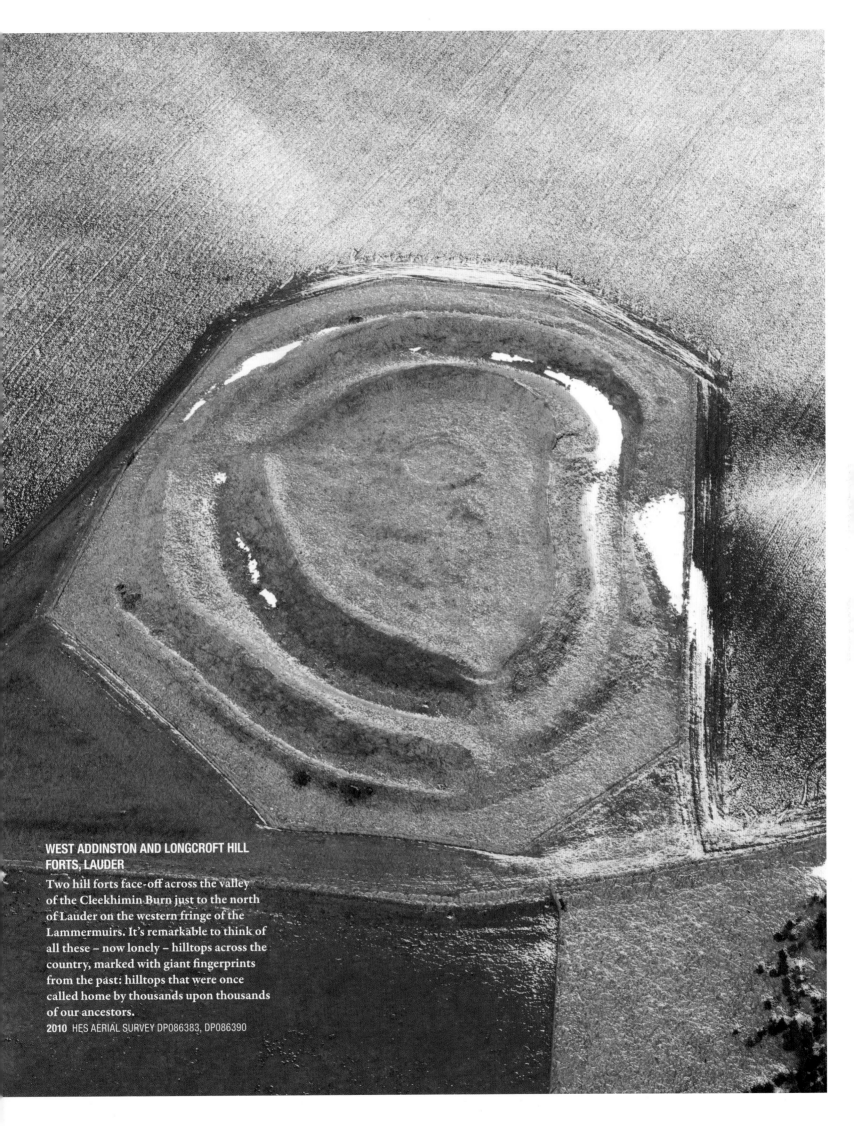

WEST ADDINSTON AND LONGCROFT HILL FORTS, LAUDER

Two hill forts face-off across the valley of the Cleekhimin Burn just to the north of Lauder on the western fringe of the Lammermuirs. It's remarkable to think of all these – now lonely – hilltops across the country, marked with giant fingerprints from the past: hilltops that were once called home by thousands upon thousands of our ancestors.

2010 HES AERIAL SURVEY DP086383, DP086390

STRATHEARN, PERTHSHIRE

This is a landscape still criss-crossed by the traces of ancient war. A major Roman road once ran through here, just to the south of the little village of Muthill in the centre left of the photograph. It linked defensive outposts and temporary marching camps at nearby Strathgeath and Innerpeffray to the massive fortifiction of Ardoch, beside Braco.

2016 HES AERIAL SURVEY DP229029

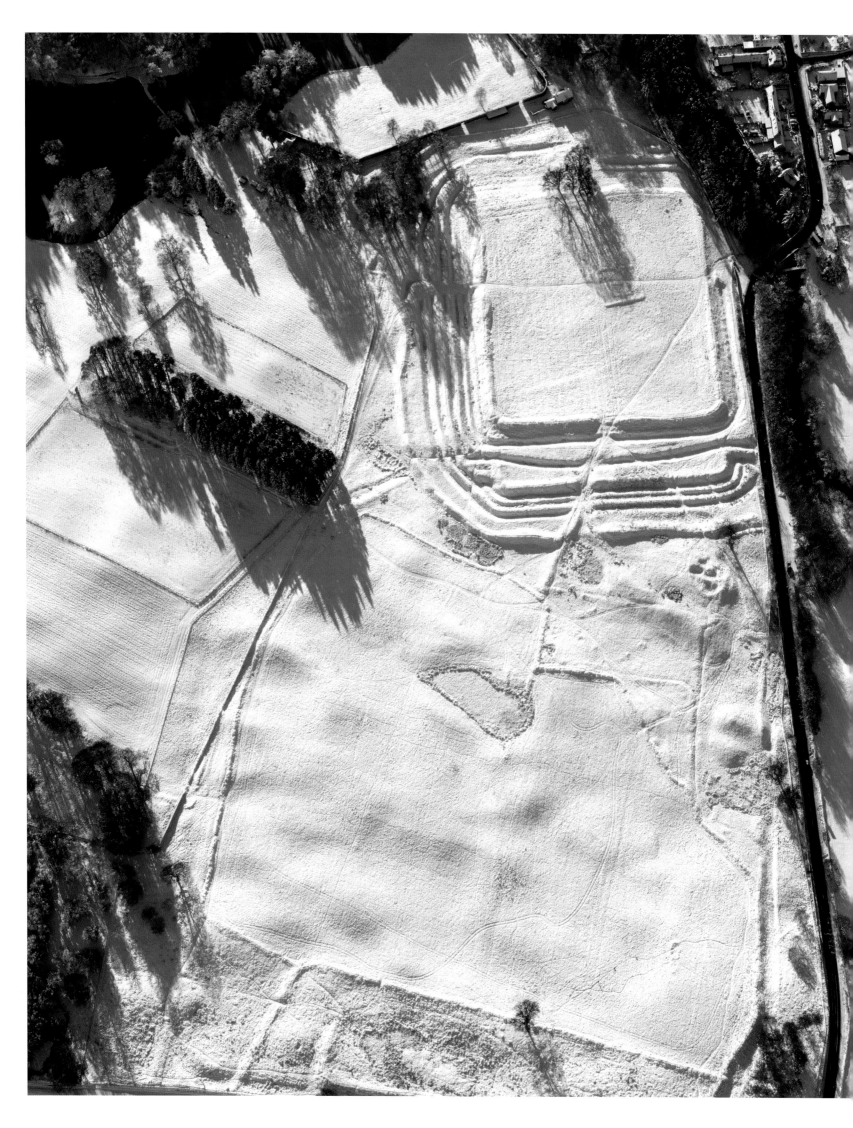

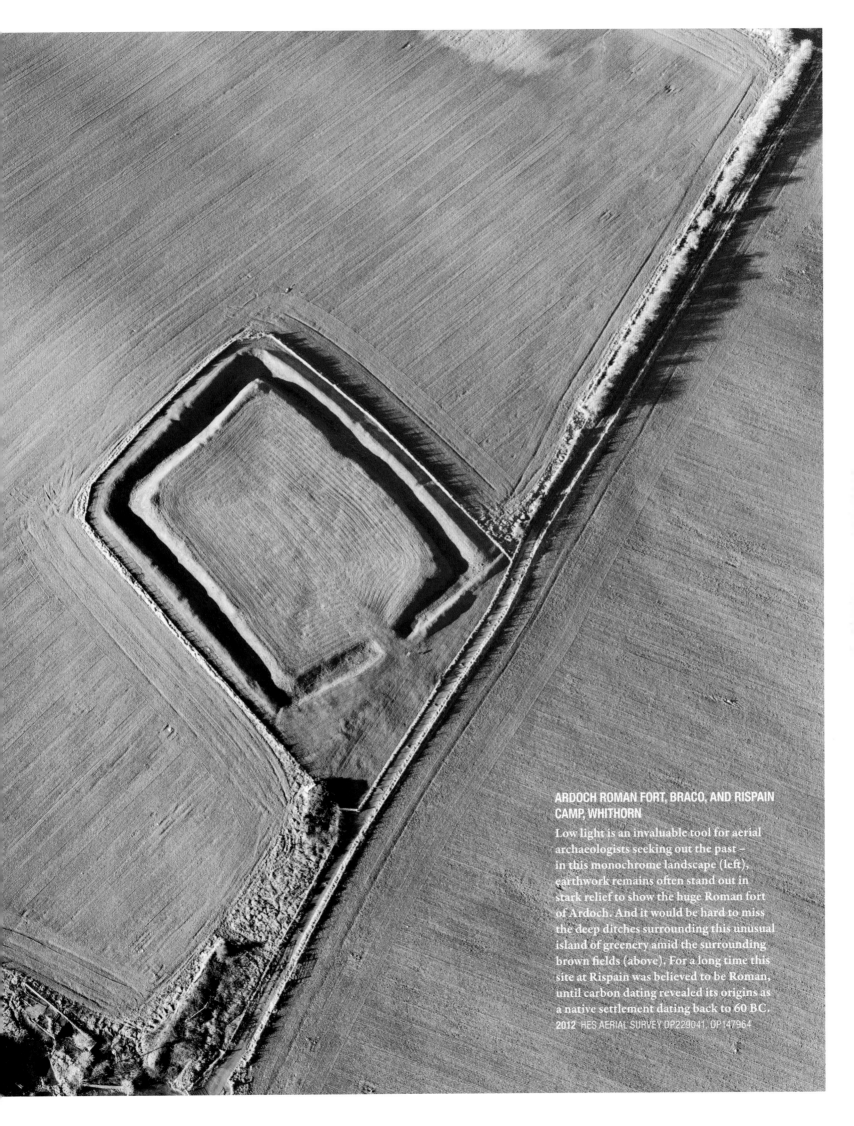

ARDOCH ROMAN FORT, BRACO, AND RISPAIN CAMP, WHITHORN

Low light is an invaluable tool for aerial archaeologists seeking out the past – in this monochrome landscape (left), earthwork remains often stand out in stark relief to show the huge Roman fort of Ardoch. And it would be hard to miss the deep ditches surrounding this unusual island of greenery amid the surrounding brown fields (above). For a long time this site at Rispain was believed to be Roman, until carbon dating revealed its origins as a native settlement dating back to 60 BC.

2012 HES AERIAL SURVEY DP229041, DP147964

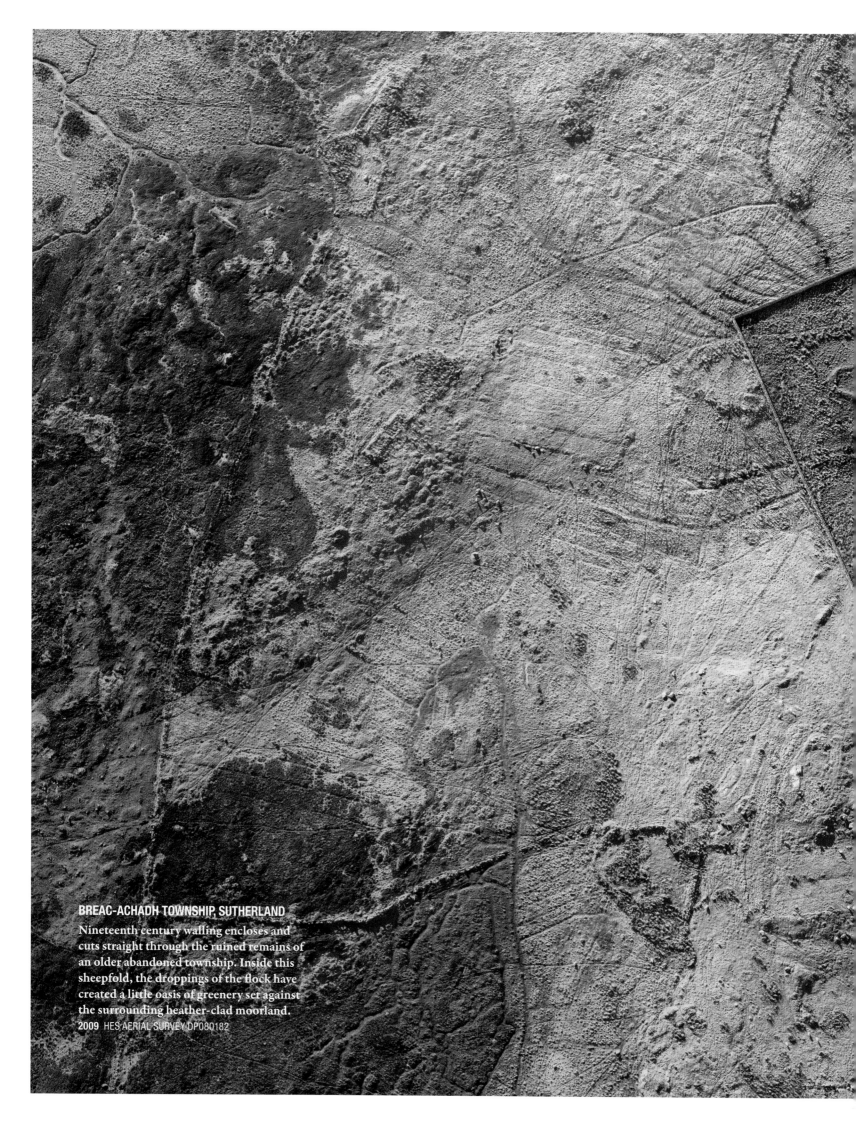

BREAC-ACHADH TOWNSHIP, SUTHERLAND

Nineteenth century walling encloses and
cuts straight through the ruined remains of
an older abandoned township. Inside this
sheepfold, the droppings of the flock have
created a little oasis of greenery set against
the surrounding heather-clad moorland.

2009 HES AERIAL SURVEY DP080182

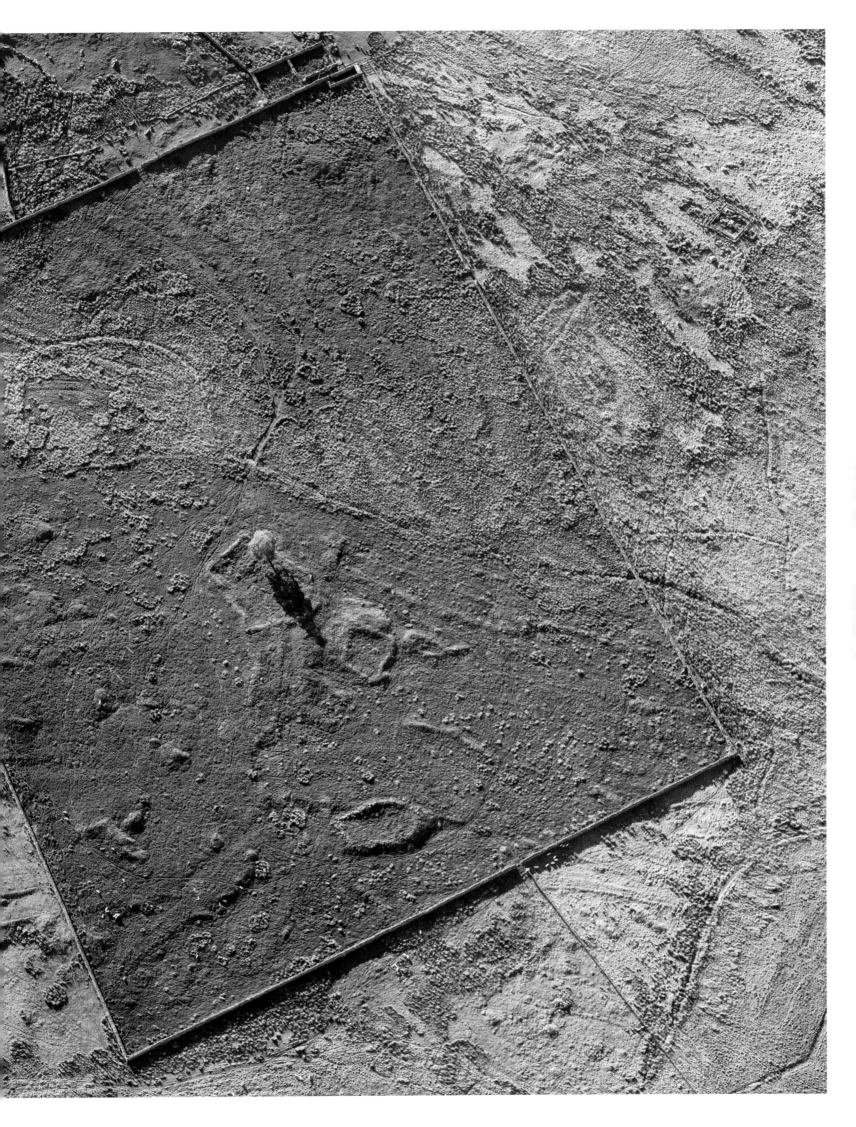

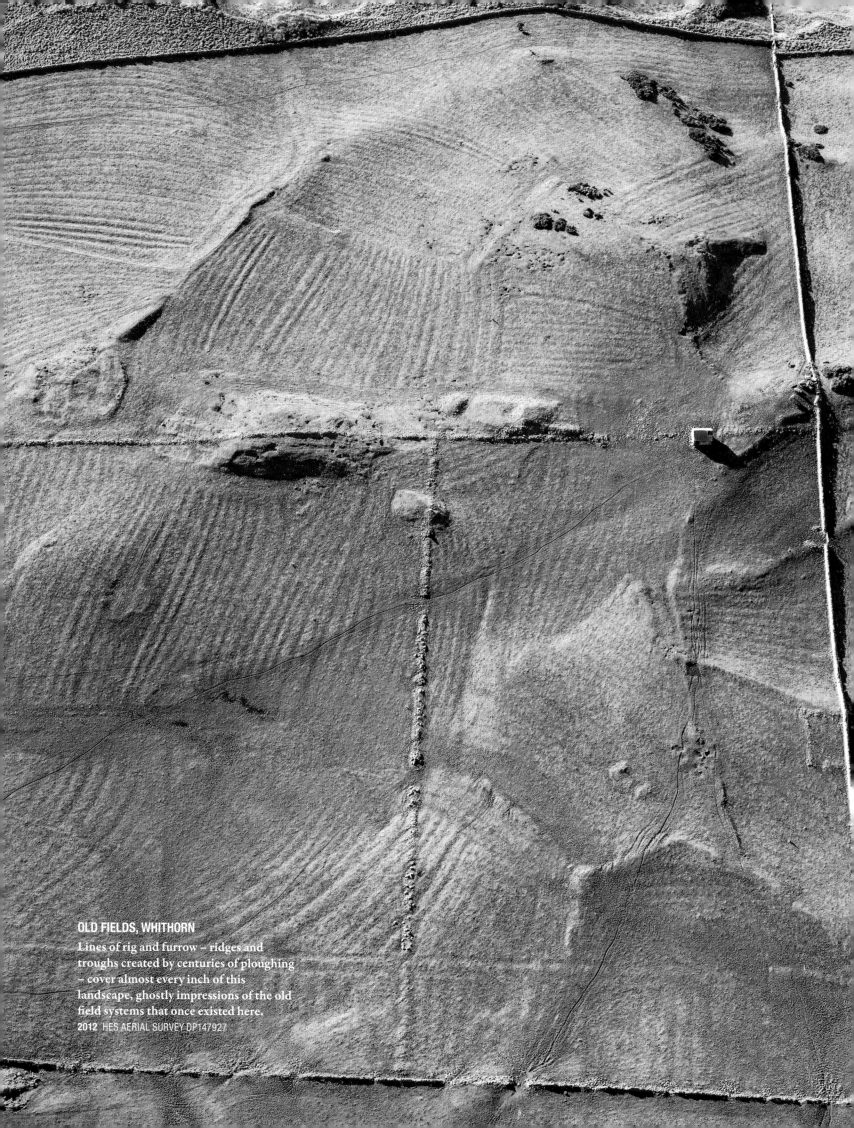

OLD FIELDS, WHITHORN

Lines of rig and furrow – ridges and troughs created by centuries of ploughing – cover almost every inch of this landscape, ghostly impressions of the old field systems that once existed here.

2012 HES AERIAL SURVEY DP147927

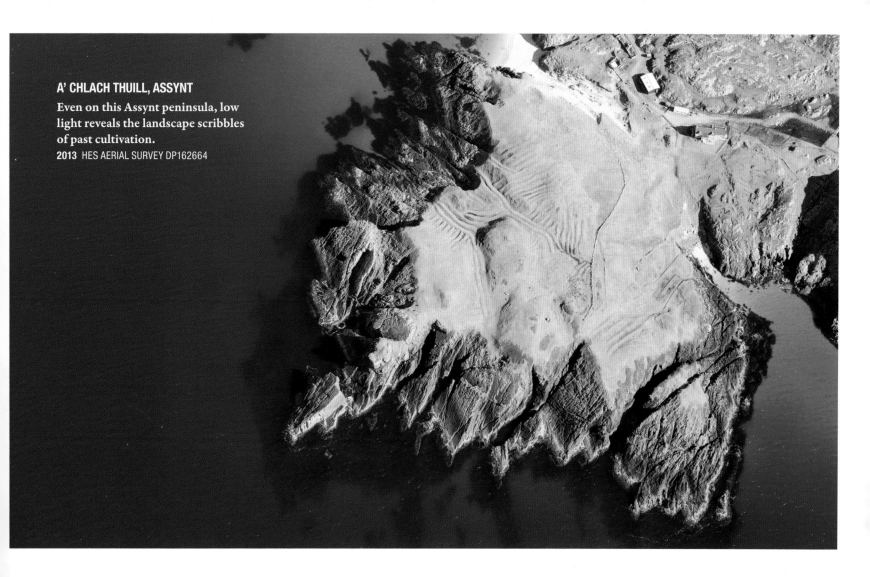

A' CHLACH THUILL, ASSYNT

Even on this Assynt peninsula, low
light reveals the landscape scribbles
of past cultivation.

2013 HES AERIAL SURVEY DP162664

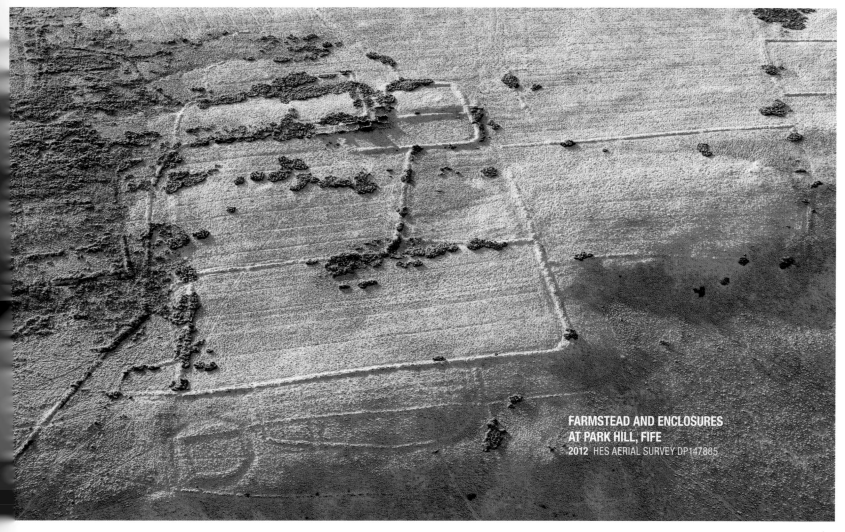

**FARMSTEAD AND ENCLOSURES
AT PARK HILL, FIFE**
2012 HES AERIAL SURVEY DP147885

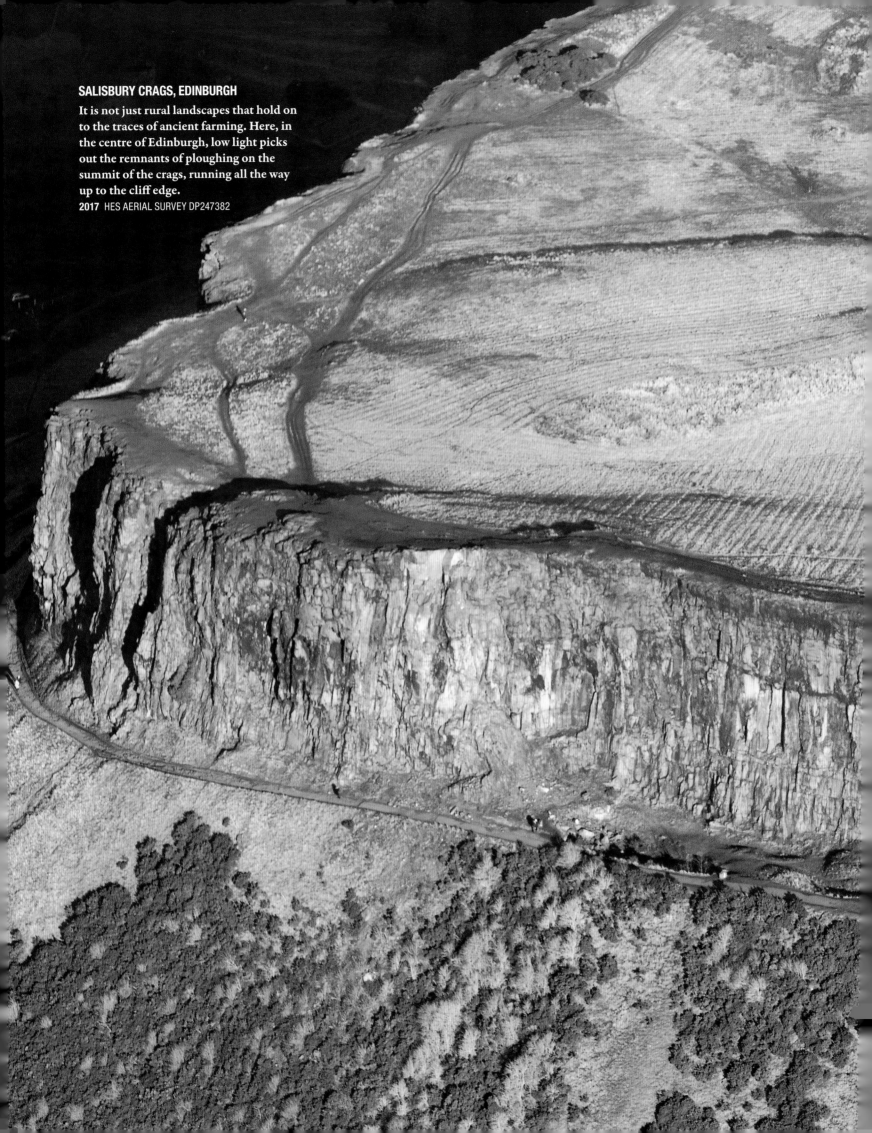

SALISBURY CRAGS, EDINBURGH

It is not just rural landscapes that hold on to the traces of ancient farming. Here, in the centre of Edinburgh, low light picks out the remnants of ploughing on the summit of the crags, running all the way up to the cliff edge.

2017 HES AERIAL SURVEY DP247382

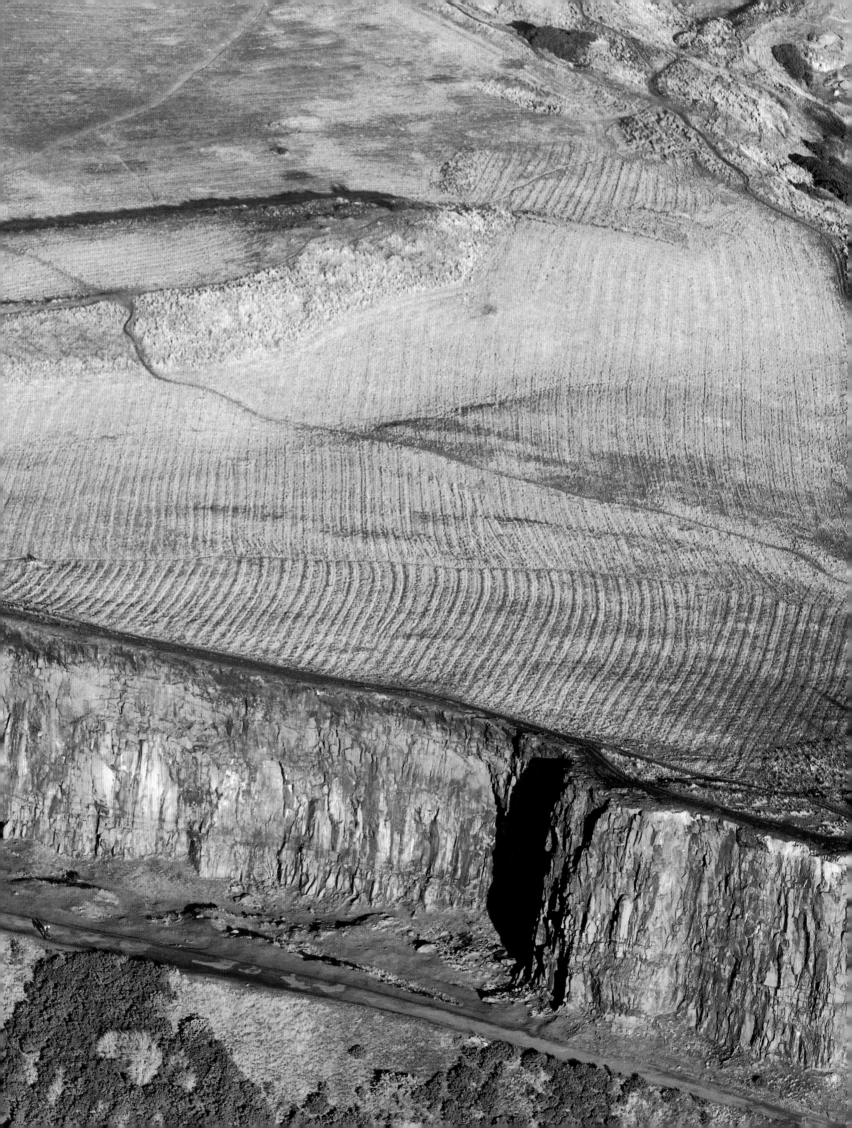

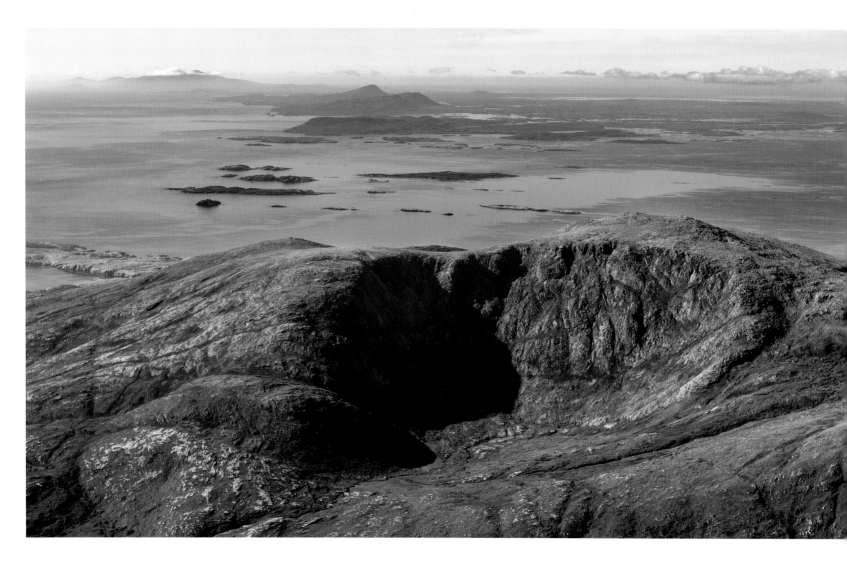

ROINEABHAL, HARRIS, THE WESTERN ISLES

In 1976, Scotland's aerial archaeology survey team first took to the skies. For over four decades now, they've been traversing Scotland from above, using flight as an invaluable tool for exploring all parts of the country – like here, passing over the mountains at the southern tip of Harris, headed towards the Uists and the southern tip of the Outer Hebrides.

2017 HES AERIAL SURVEY DP221670

TRAIGH BHAN, ISLAY
2017 HES AERIAL SURVEY DP239039

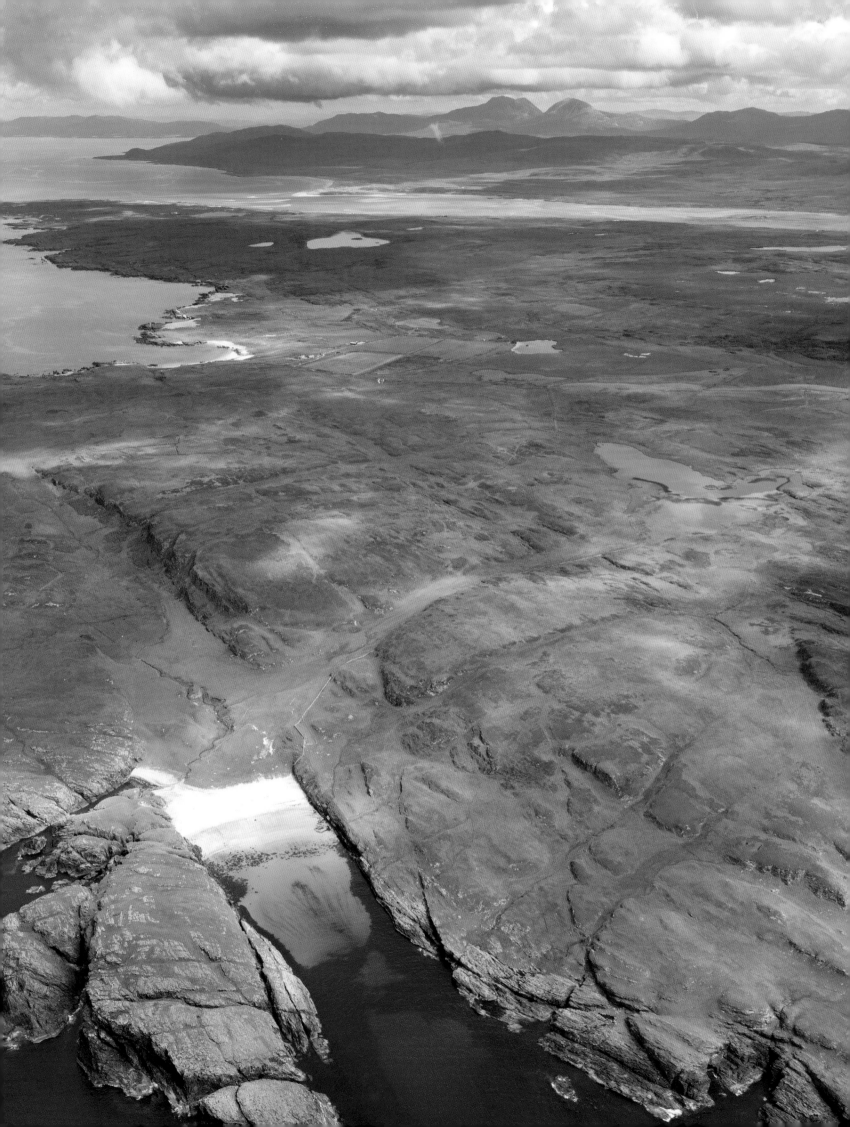

Our past was still an unexplored country. Aerial photography was to the archaeologist what the telescope was to the astronomer. Before it, they had been squinting into the dark. Now they could really see.

CROFTING TOWNSHIP, LOCH BLIANISH, ISLE OF LEWIS above

A nineteenth century crofting township parcels-up and overlies the remains of an older community.

2011 HES AERIAL SURVEY DP109569

TRAIGH THODHRASDAIL, TIREE, OUTER HEBRIDES top right

A line cutting across the headland is all that remains of an old enclosure wall. Beyond it, on the raised knoll, is the scattered residue left behind by a dun, a circular stone building once raised up on this harsh Atlantic coastline.

2013 HES AERIAL SURVEY DP162214

HECLA POINT, MINGULAY, OUTER HEBRIDES

What might at first seem like an empty, wild landscape on one of Scotland's most remote islands is revealed, from the sky, to be a site that has been extensively farmed. The lines running down to the cliffs are indentations left behind by ploughing, while traces still remain of walls that would have enclosed fields or acted as sheepfolds.

2011 HES AERIAL SURVEY DP109552

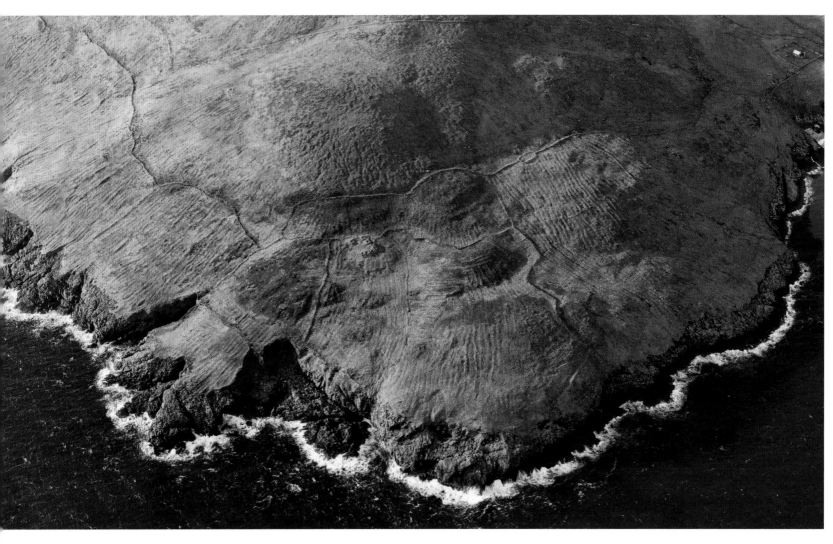

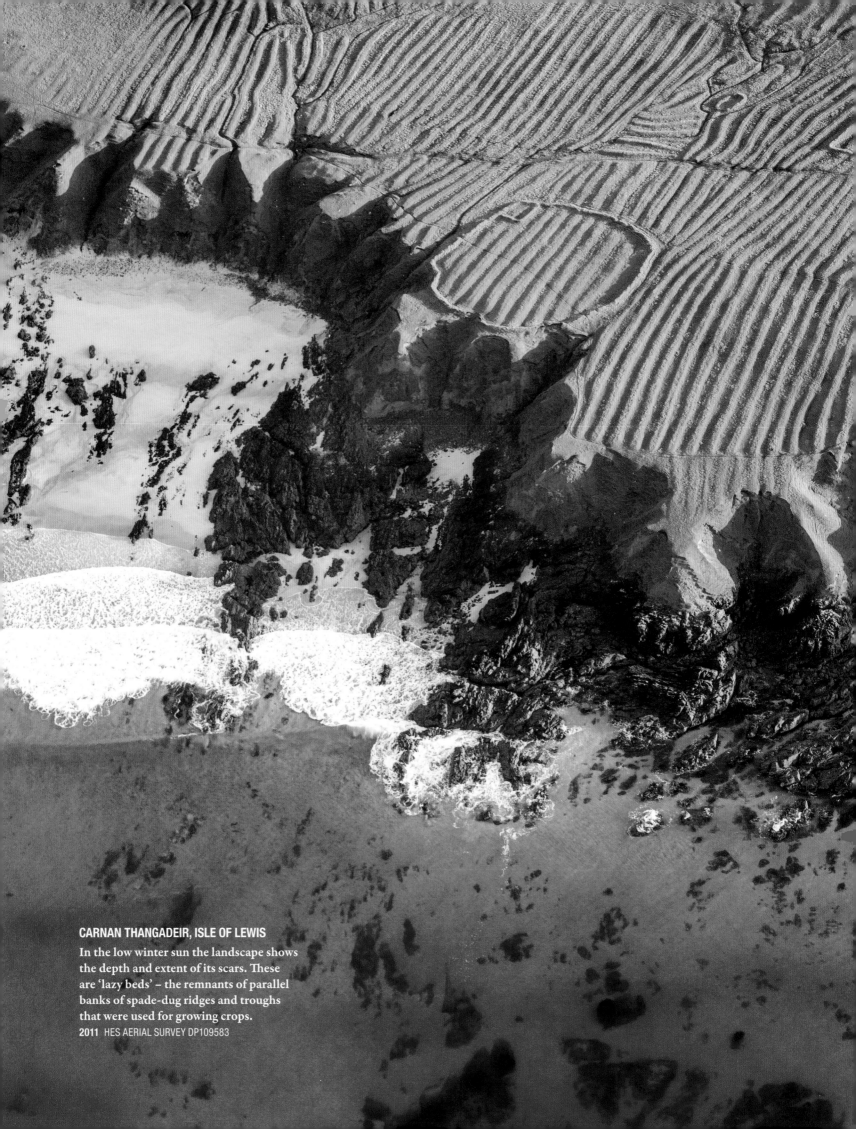

CARNAN THANGADEIR, ISLE OF LEWIS
In the low winter sun the landscape shows
the depth and extent of its scars. These
are 'lazy beds' – the remnants of parallel
banks of spade-dug ridges and troughs
that were used for growing crops.
2011 HES AERIAL SURVEY DP109583

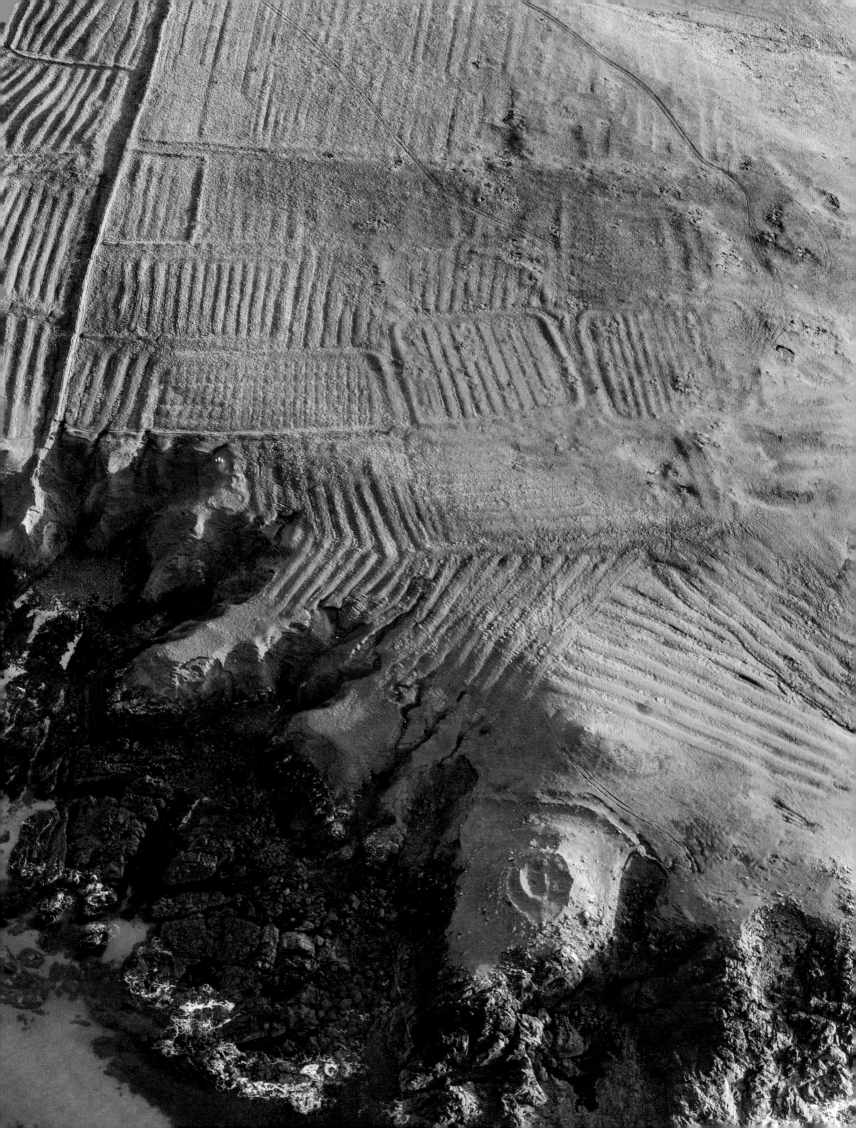

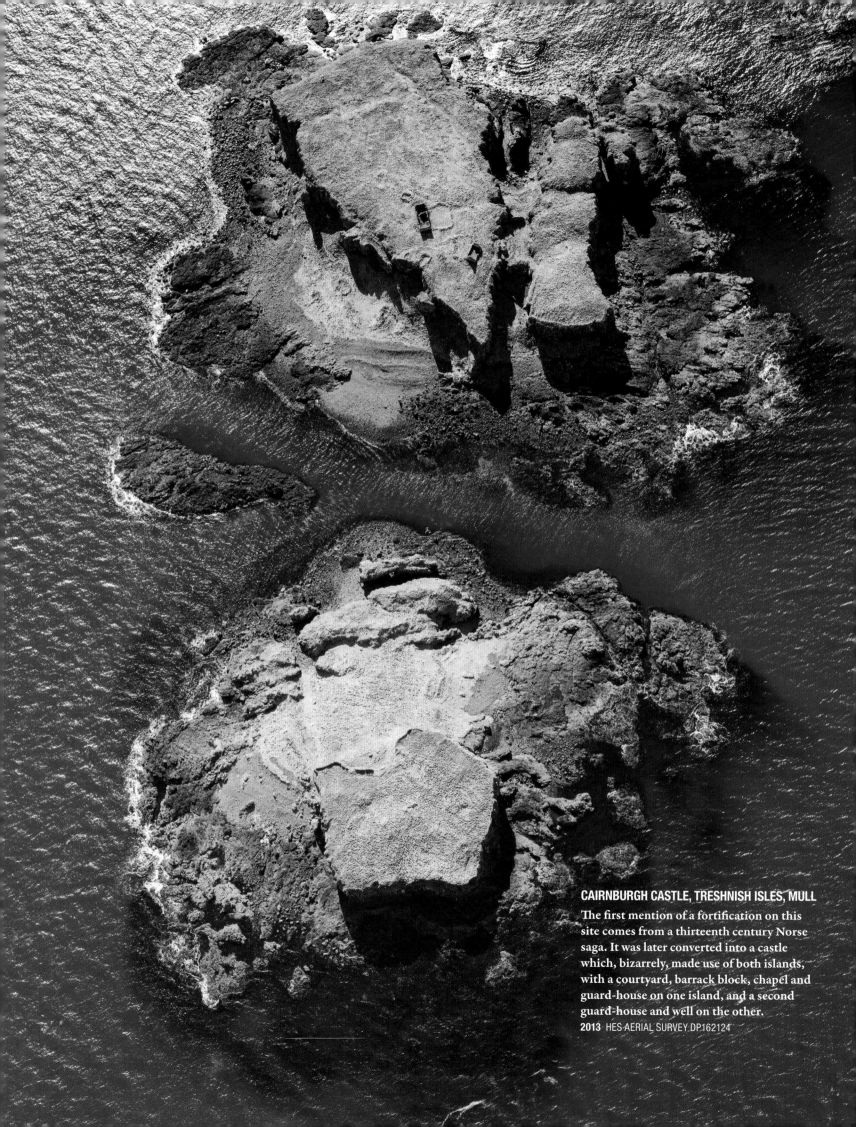

CAIRNBURGH CASTLE, TRESHNISH ISLES, MULL

The first mention of a fortification on this site comes from a thirteenth century Norse saga. It was later converted into a castle which, bizarrely, made use of both islands, with a courtyard, barrack block, chapel and guard-house on one island, and a second guard-house and well on the other.

2013 HES AERIAL SURVEY DP162124

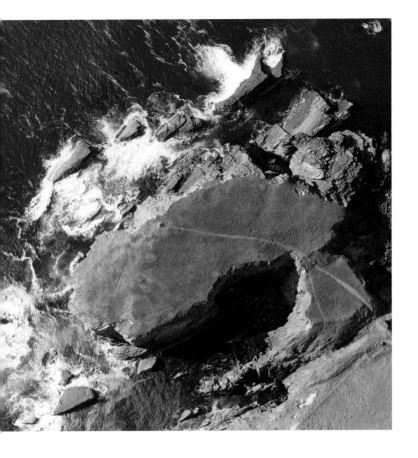

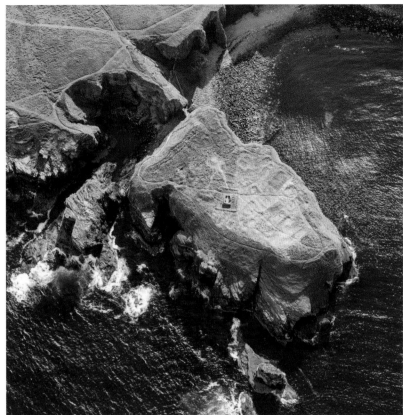

BROUGH OF BIGGING BURIAL SITE, SANDWICK, ORKNEY ISLES
2009 HES AERIAL SURVEY DP059787

BROUGH OF DEERNESS MONASTIC SETTLEMENT, ORKNEY MAINLAND
2009 HES AERIAL SURVEY DP068418

DUN BEAG FORT, TIREE, OUTER HEBRIDES
2013 HES AERIAL SURVEY DP162189

RUINED DWELLING, DUN BAN, ISLE OF ULVA
2013 HES AERIAL SURVEY DP162323

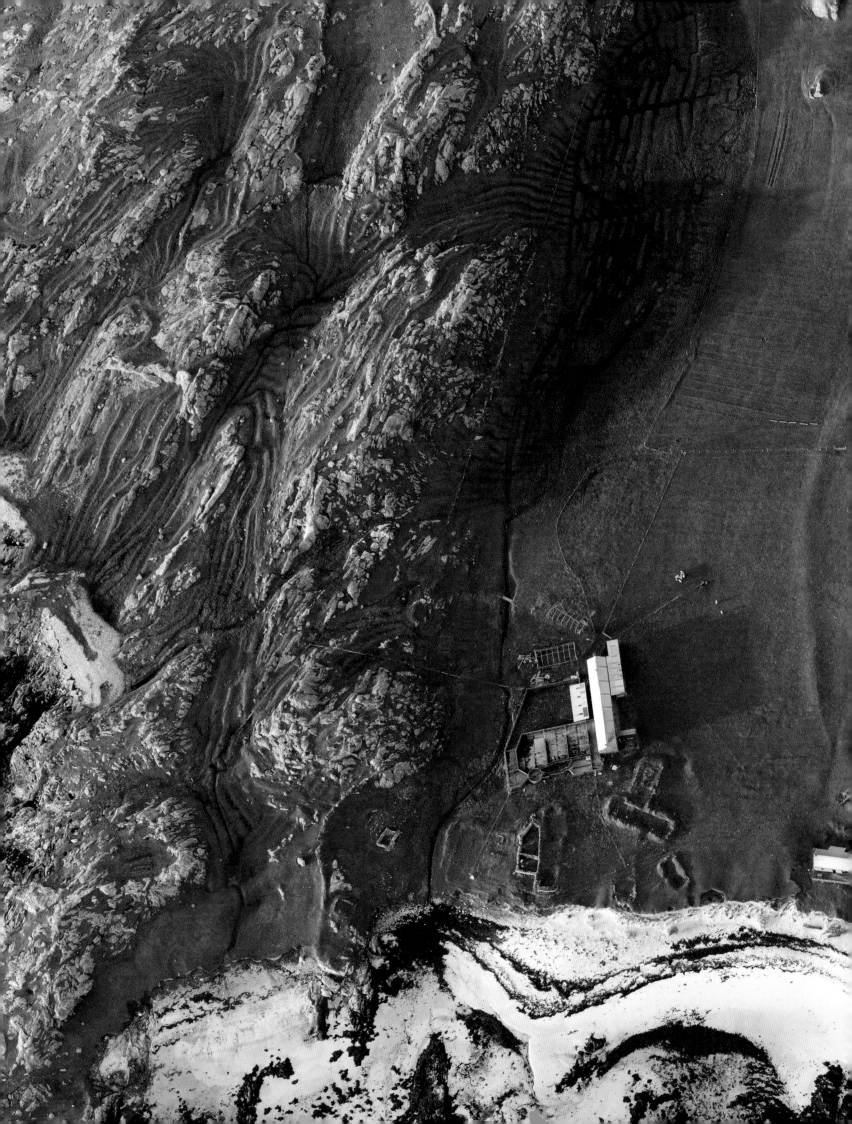

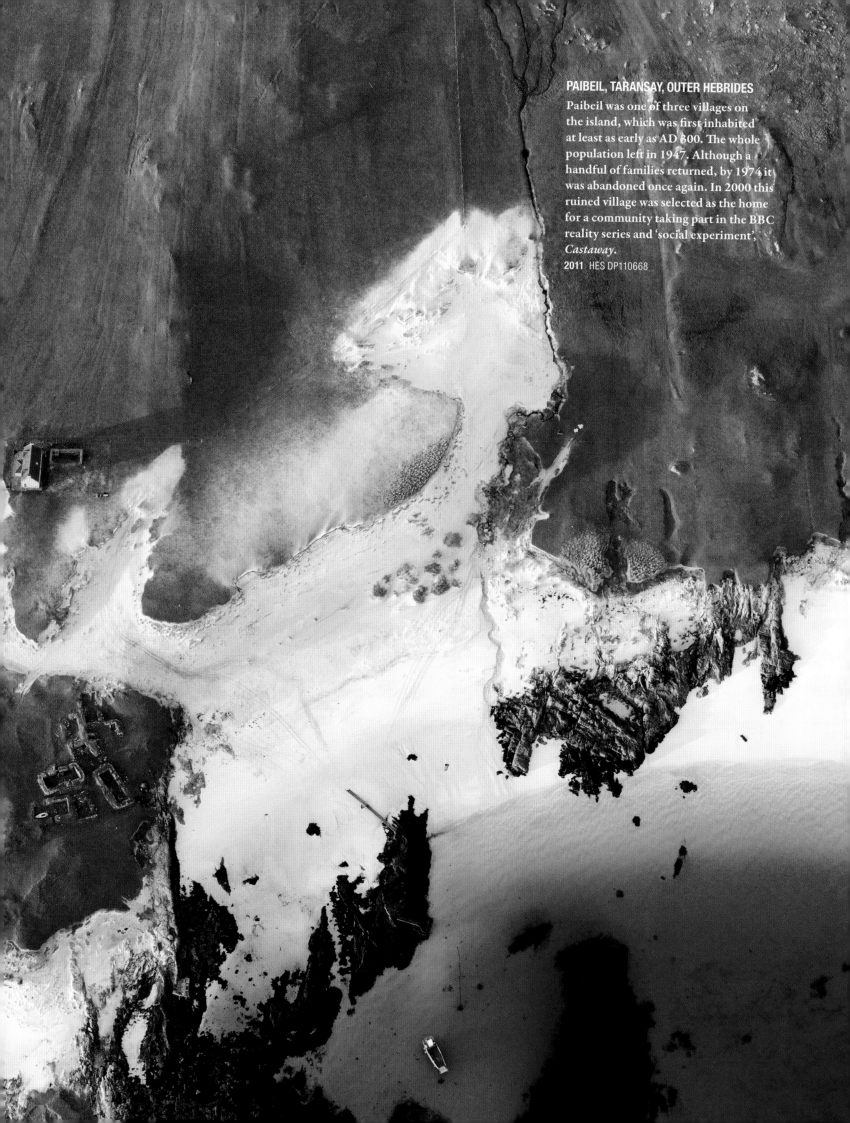

PAIBEIL, TARANSAY, OUTER HEBRIDES

Paibeil was one of three villages on
the island, which was first inhabited
at least as early as AD 800. The whole
population left in 1947. Although a
handful of families returned, by 1974 it
was abandoned once again. In 2000 this
ruined village was selected as the home
for a community taking part in the BBC
reality series and 'social experiment',
Castaway.

2011 HES DP110668

DUN NA CLEITE, TIREE

A substantial fort once rose up from
the rocky headland on the right of this
photograph, making use of the site's
obvious natural defences: high sea cliffs
on one side and a steep, boulder-strewn
approach, rising up to a 42m-high
summit, on the other. Today the remains
are all but indistinguishable from the
natural landscape.

2013 HES AERIAL SURVEY DP162253

RAAH TOWNSHIP, TARANSAY, OUTER HEBRIDES
2011 HES AERIAL SURVEY DP110667

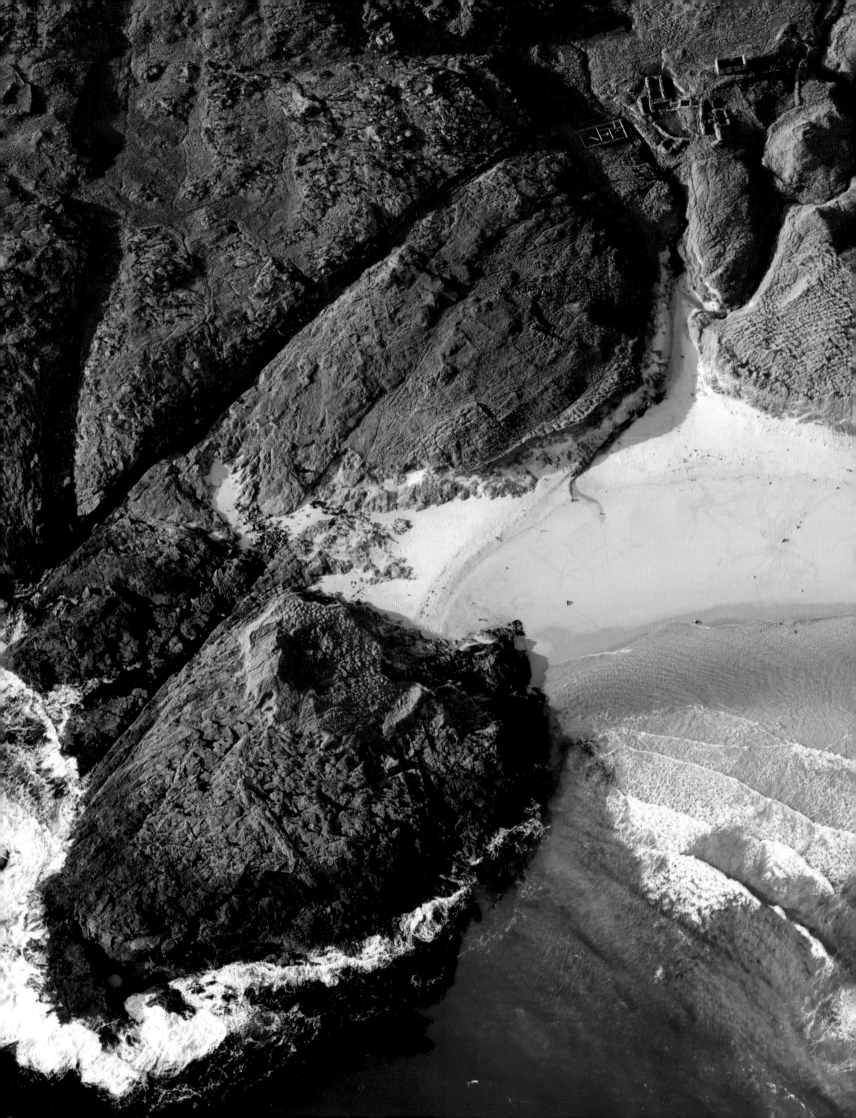

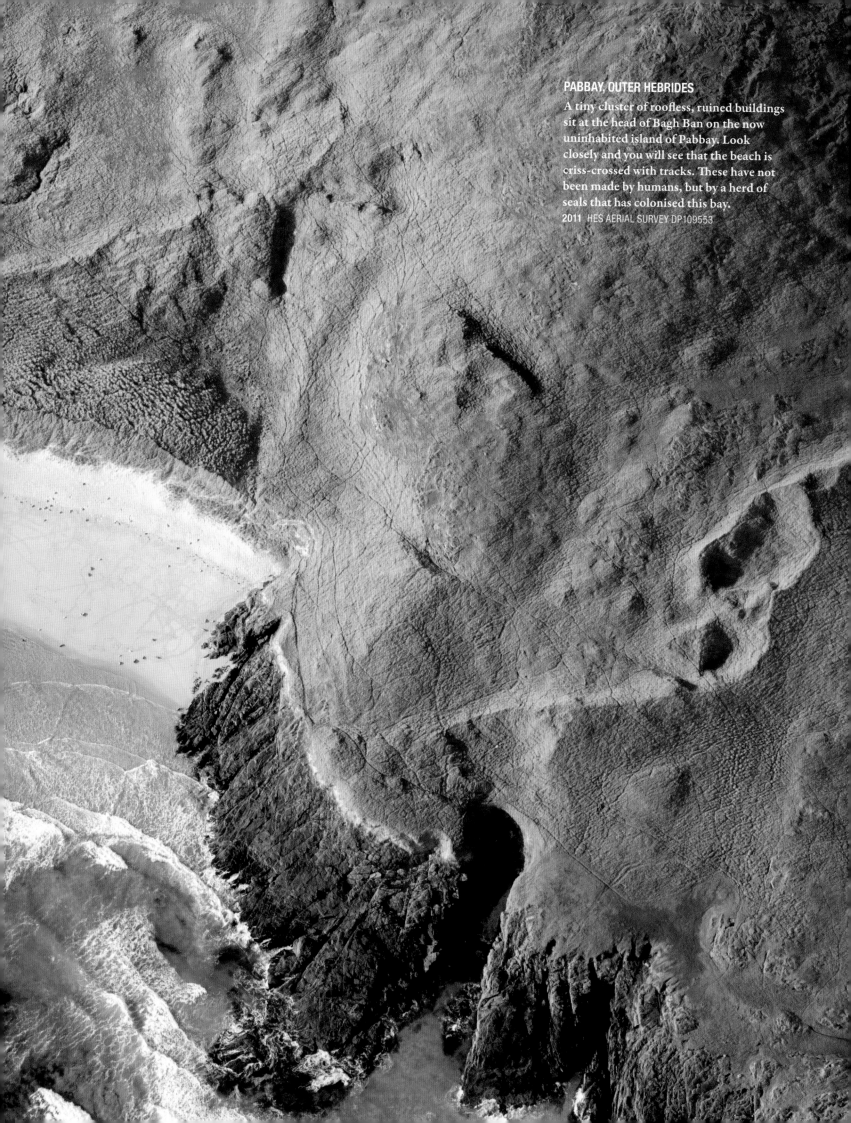

PABBAY, OUTER HEBRIDES

A tiny cluster of roofless, ruined buildings sit at the head of Bagh Ban on the now uninhabited island of Pabbay. Look closely and you will see that the beach is criss-crossed with tracks. These have not been made by humans, but by a herd of seals that has colonised this bay.

2011 HES AERIAL SURVEY DP109553

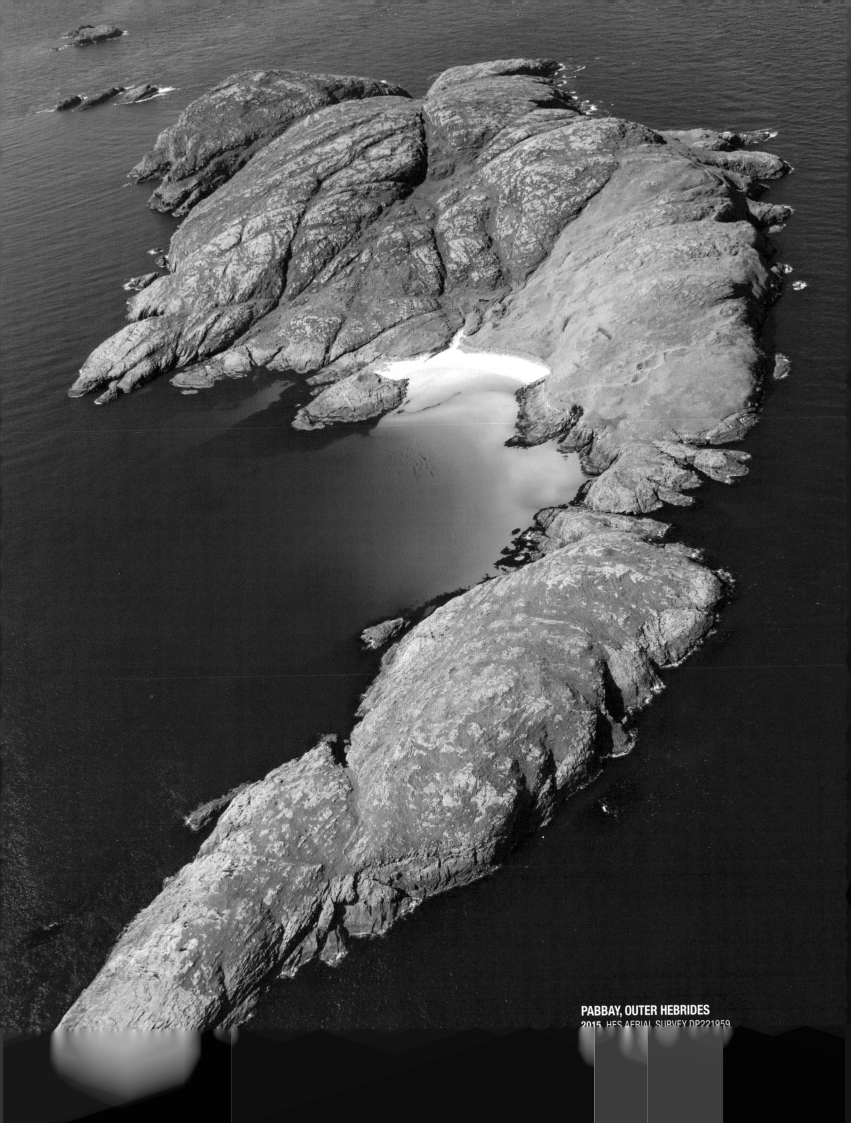

PABBAY, OUTER HEBRIDES
2015 HES AERIAL SURVEY DP221959

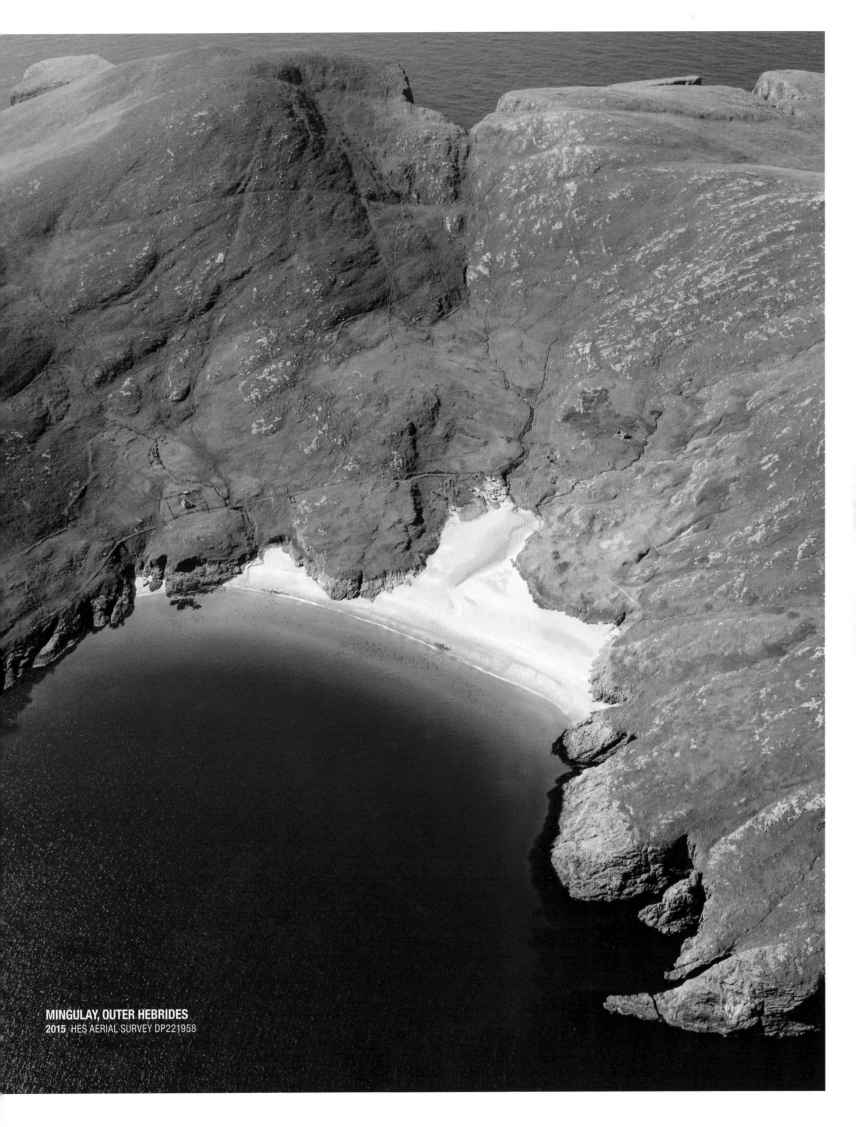

MINGULAY, OUTER HEBRIDES
2015 HES AERIAL SURVEY DP221958

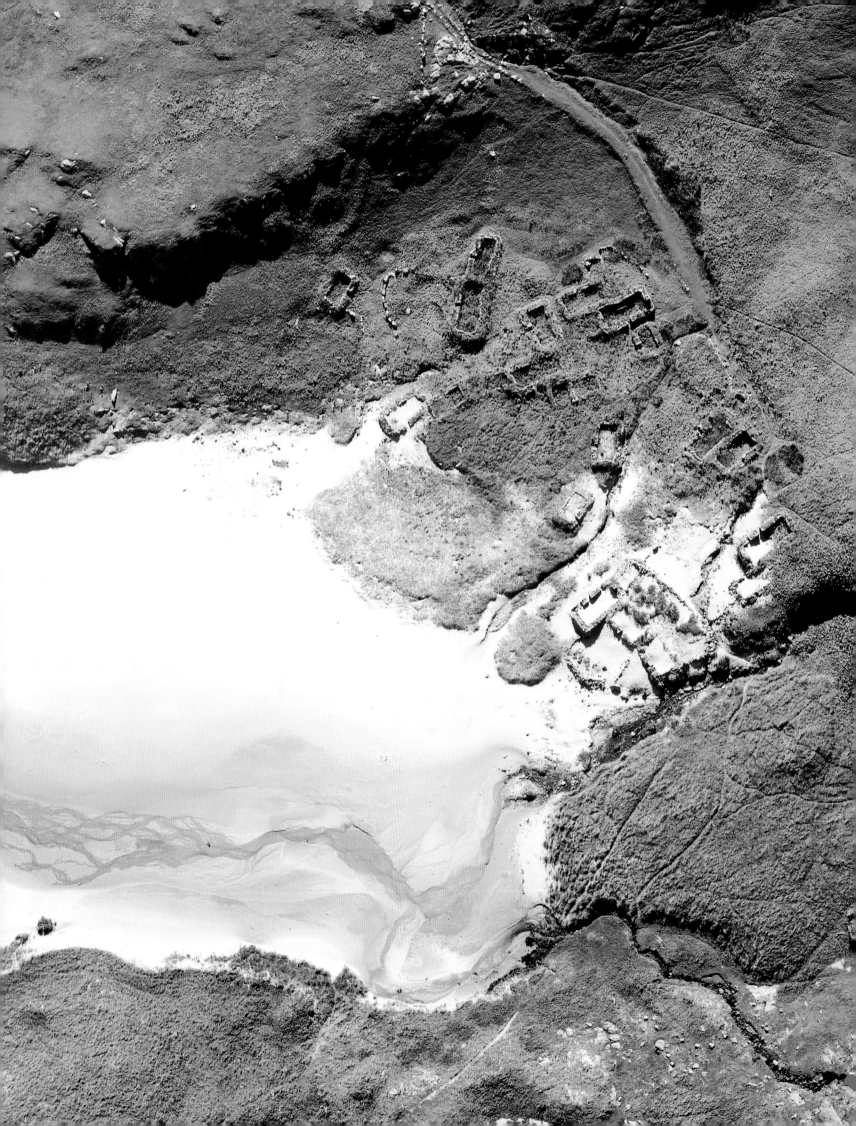

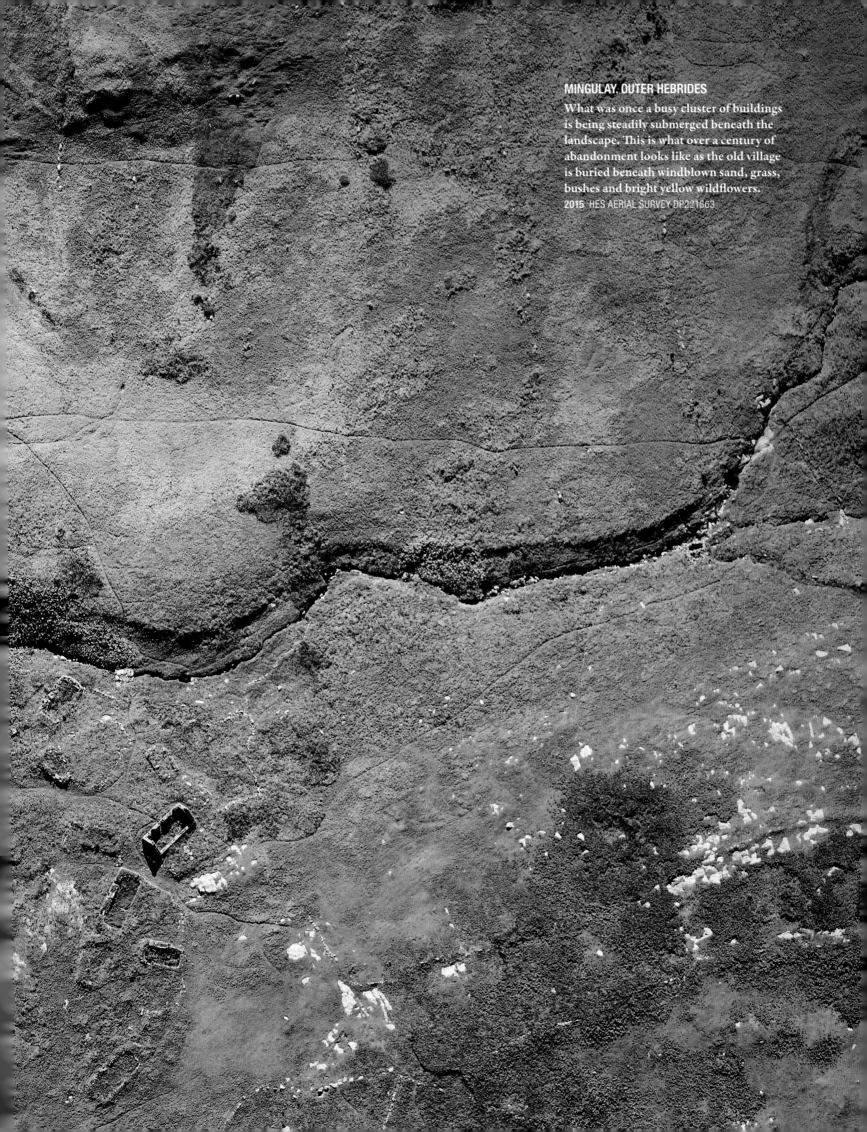

MINGULAY, OUTER HEBRIDES

What was once a busy cluster of buildings is being steadily submerged beneath the landscape. This is what over a century of abandonment looks like as the old village is buried beneath windblown sand, grass, bushes and bright yellow wildflowers.

2015 HES AERIAL SURVEY DP221863

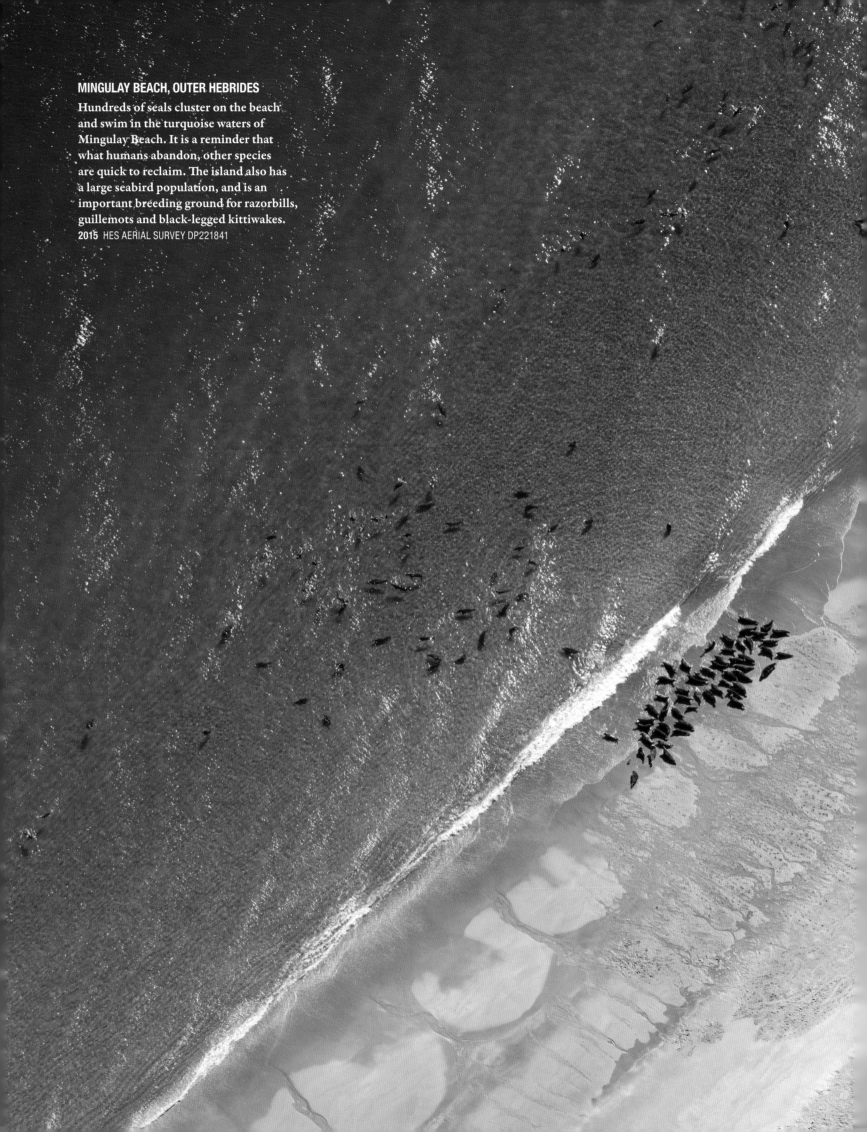

MINGULAY BEACH, OUTER HEBRIDES

Hundreds of seals cluster on the beach and swim in the turquoise waters of Mingulay Beach. It is a reminder that what humans abandon, other species are quick to reclaim. The island also has a large seabird population, and is an important breeding ground for razorbills, guillemots and black-legged kittiwakes.

2015 HES AERIAL SURVEY DP221841

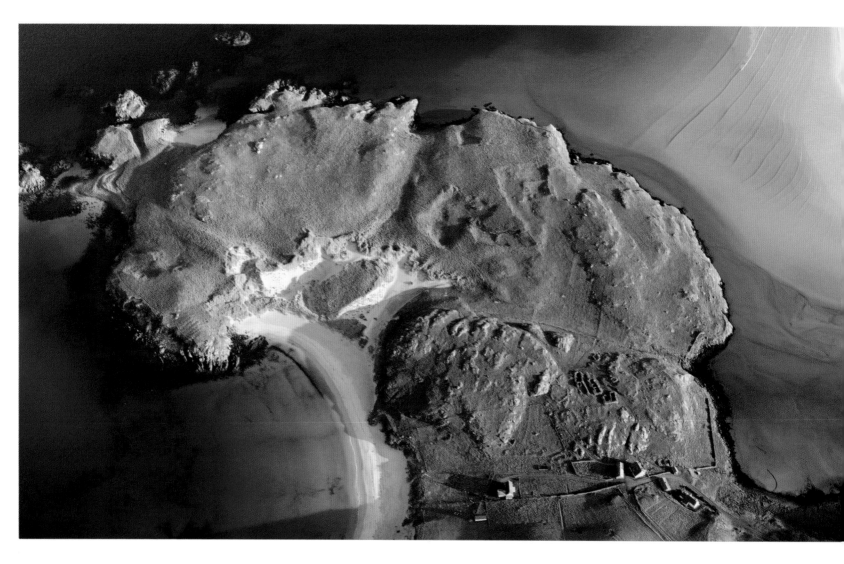

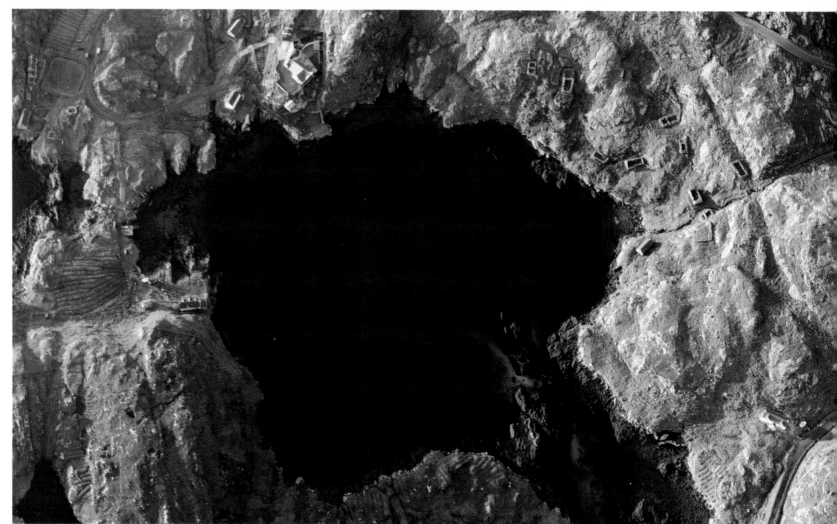

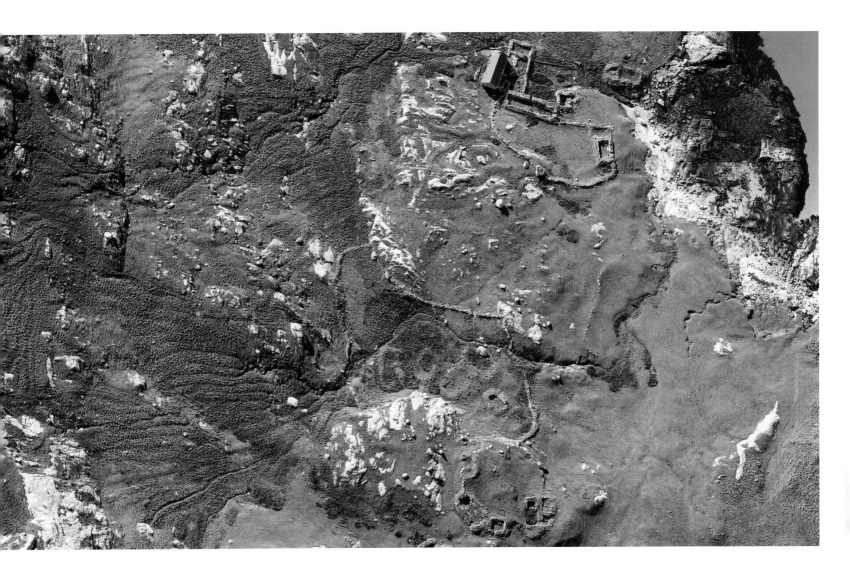

Aerial archaeology felt like the future – technology revealing, with almost shocking suddenness, how the living share the land with the dead. How ghosts are, in a sense, all around us all the time. 'The young archaeologist who wants to make discoveries must learn to fly' wrote OGS Crawford. 'Not until then will the harvest be reaped.'

RUINED TOWNSHIPS: CARNISH, ISLE OF LEWIS; MANISH, ISLE OF HARRIS; AND UIDH, ISLE OF TARANSAY

The more you look down from above, the more you realise just how much of the past still surrounds us today. Of course, as OGS Crawford and those who followed him into the skies knew, the aerial perspective is uniquely privileged – that is, once you come to understand what you are seeing, and what you are looking for. 'An air photograph', wrote Crawford, 'is virtually a manuscript which may be read by those who learn to interpret the hieroglyphs.'

2011 & 2015 HES AERIAL SURVEY DP110823, DP110656, DP221639

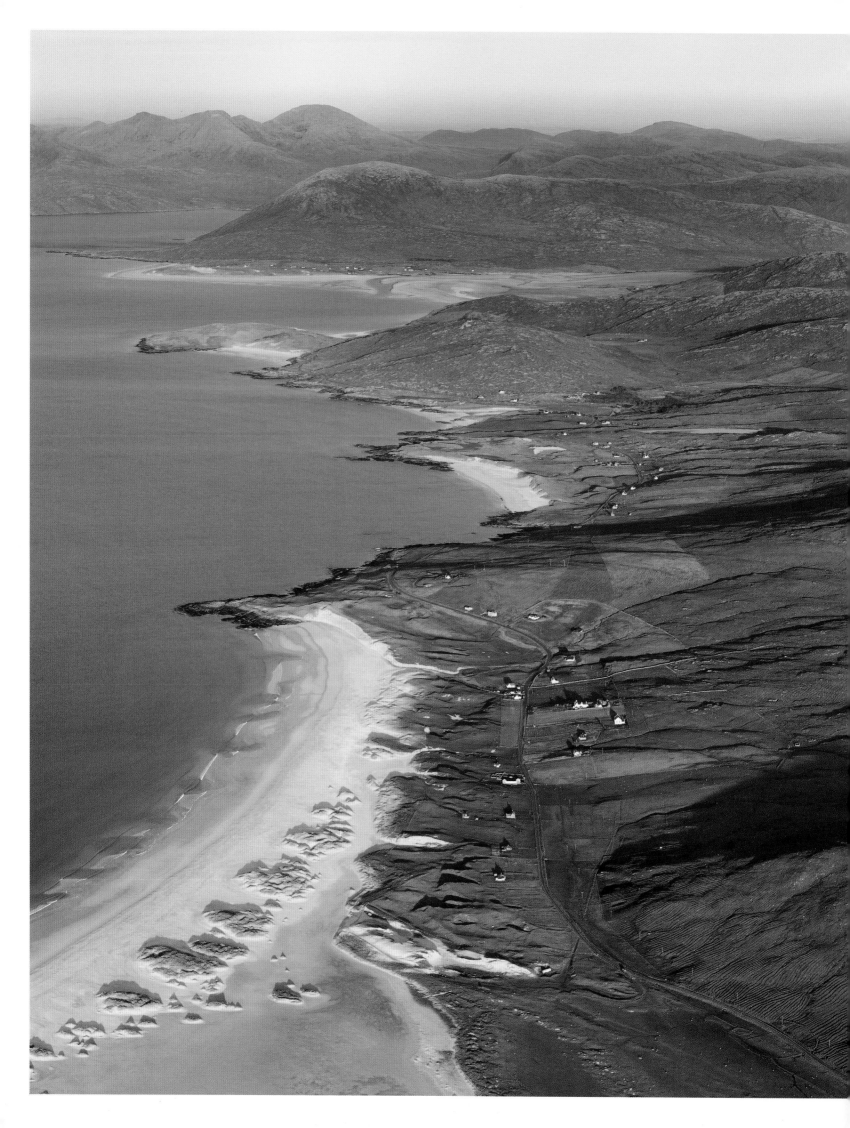

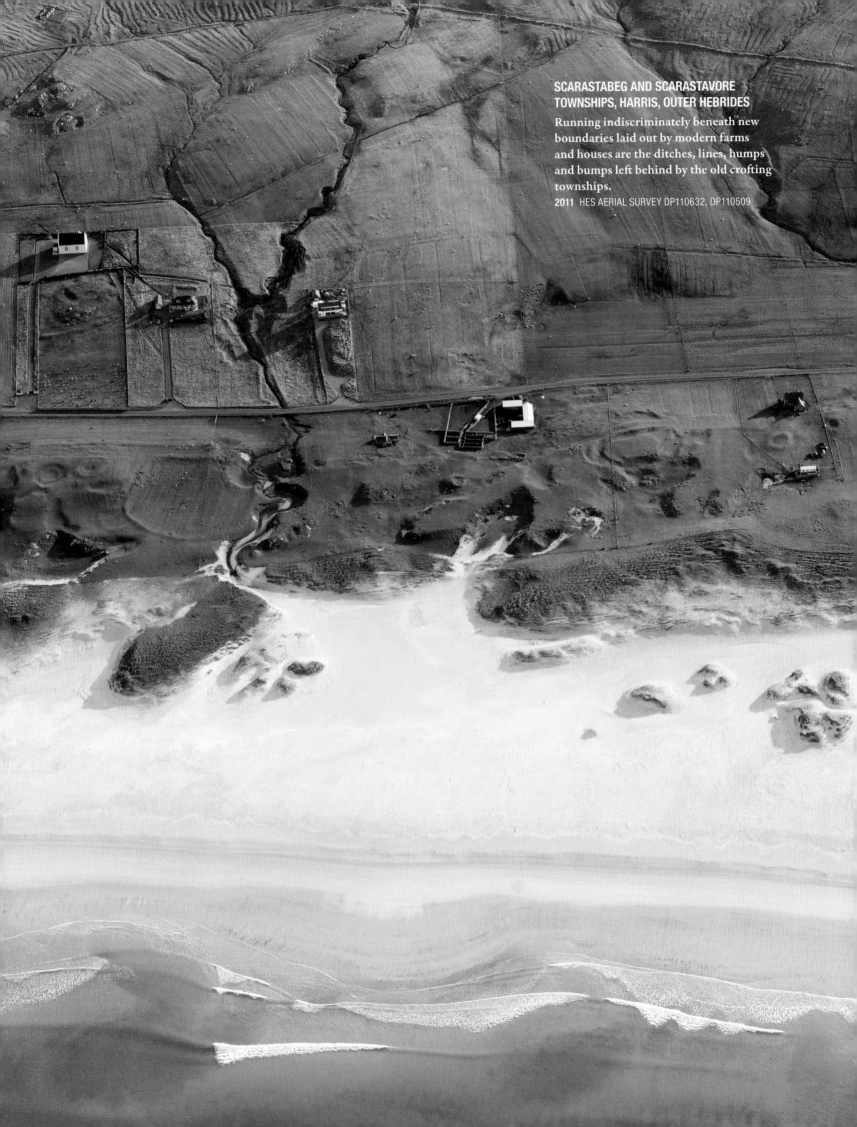

SCARASTABEG AND SCARASTAVORE TOWNSHIPS, HARRIS, OUTER HEBRIDES
Running indiscriminately beneath new boundaries laid out by modern farms and houses are the ditches, lines, humps and bumps left behind by the old crofting townships.
2011 HES AERIAL SURVEY DP110632, DP110509

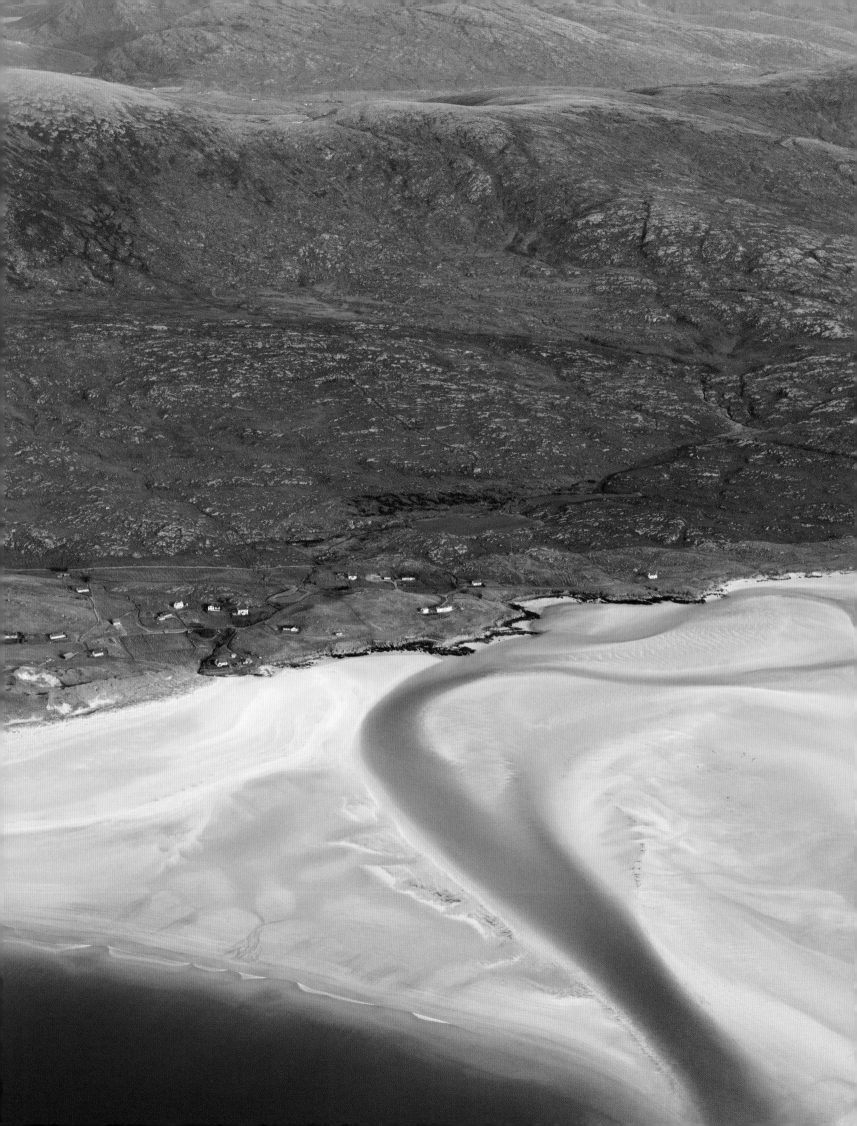

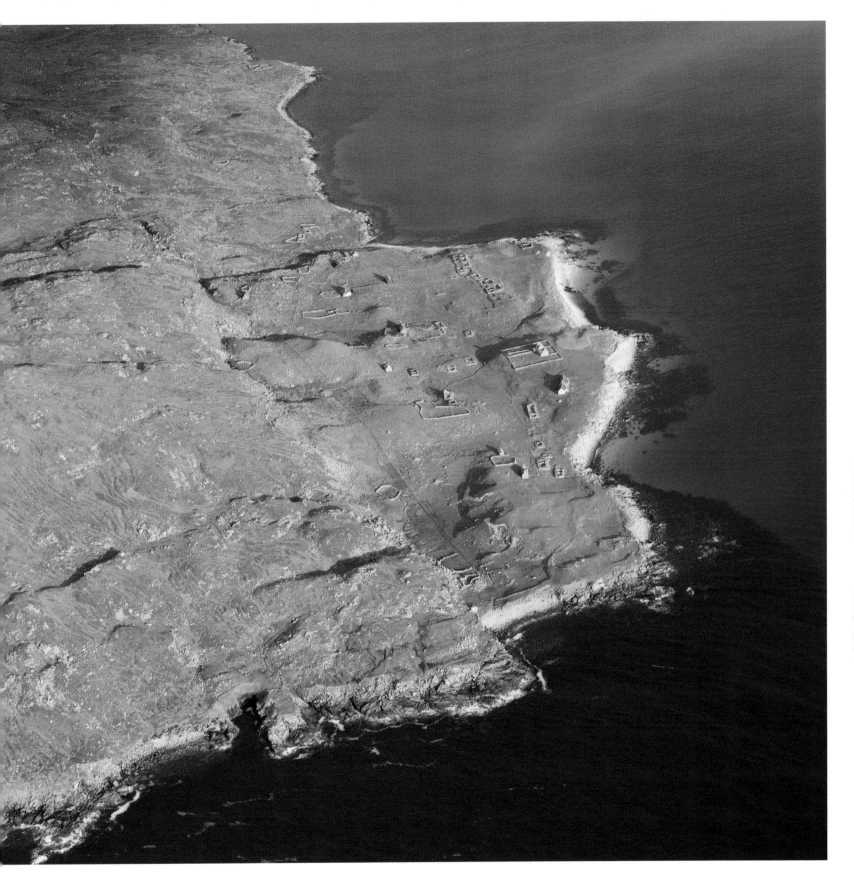

SCARP ABANDONED TOWNSHIP, HARRIS,
OUTER HEBRIDES
2011 HES AERIAL SURVEY DP110776

LUSKENTYRE, HARRIS, OUTER HEBRIDES
2011 HES AERIAL SURVEY DP110503

EILEAN NAM FAOILEAG, LOCH RANNOCH

The passing of time continually scatters our landscape with little 'islands' of history. These can be islands in both the literal and metaphorical sense – they are fragments of the past, surviving, but abandoned, in the midst of our modern world.

2017 HES AERIAL SURVEY DP263588

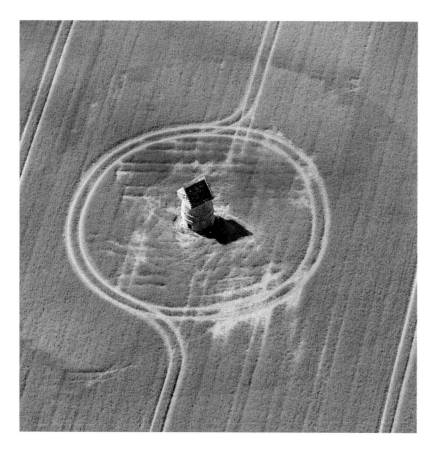

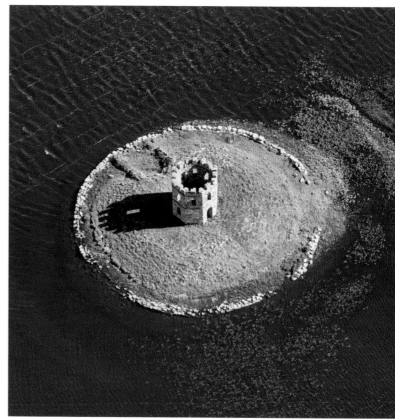

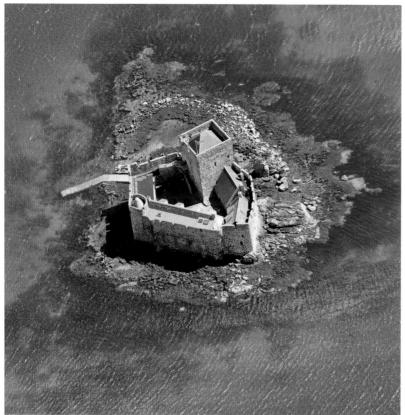

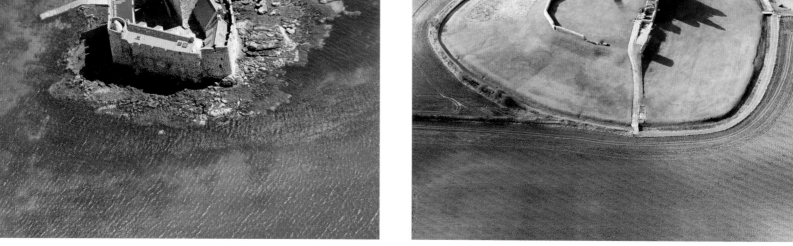

AUCHMACOY DOOCOT, ELLON, ABERDEENSHIRE
2013 HES AERIAL SURVEY DP153960

KISIMUL CASTLE, BARRA, OUTER HEBRIDES
2016 HES AERIAL SURVEY DP235346

**DUN SCOLPAIG AND LOCH SCOLPAIG FOLLY, NORTH UIST,
OUTER HEBRIDES**
2016 HES AERIAL SURVEY DP235534

DUFFUS CASTLE, MORAY
2014 HES AERIAL SURVEY DP189266

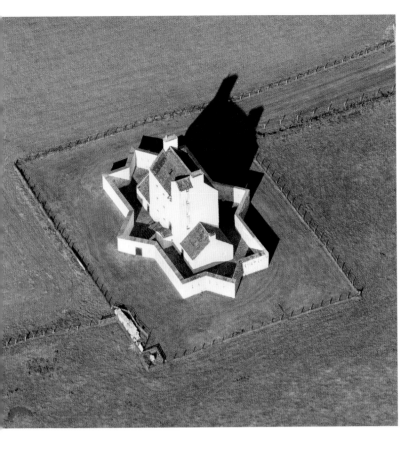

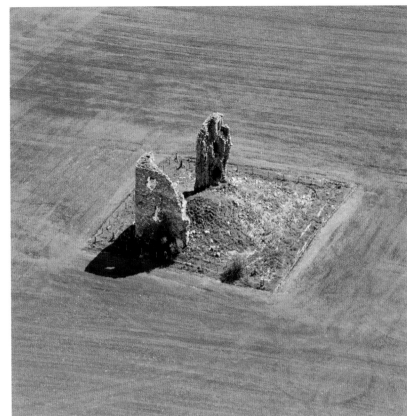

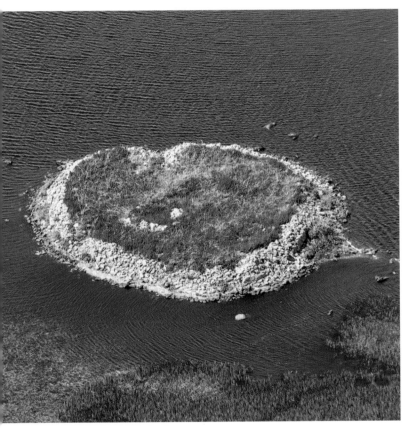

CORGARFF CASTLE, THE LECHT ROAD, ABERDEENSHIRE
2014 HES AERIAL SURVEY DP144859

FEDDERATE CASTLE, MAUD, BUCHAN
2013 HES AERIAL SURVEY DP154096

DUN AONAIS FORT, LOCH AONGHAIS, NORTH UIST
2016 HES AERIAL SURVEY DP235408

DUN BAN FORT, LOCH CARAVAT, CARINISH, NORTH UIST
2015 HES AERIAL SURVEY DP221731

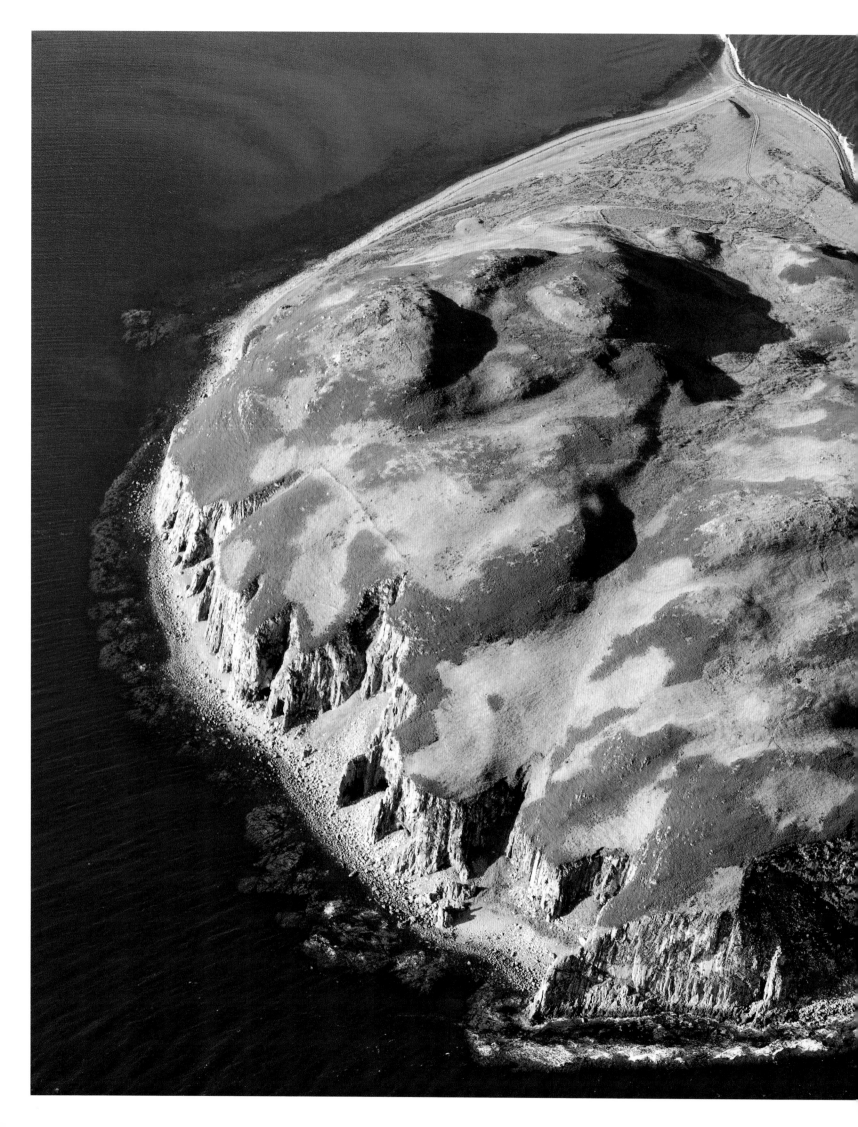

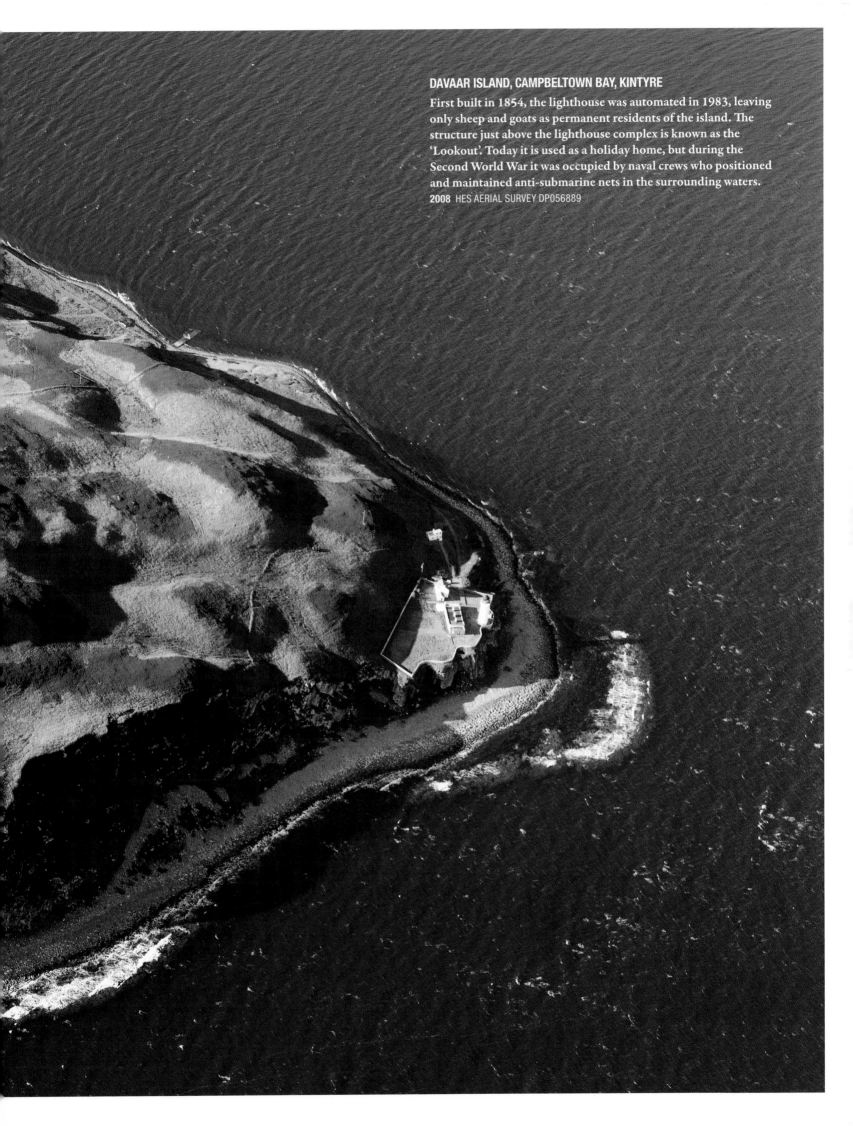

DAVAAR ISLAND, CAMPBELTOWN BAY, KINTYRE

First built in 1854, the lighthouse was automated in 1983, leaving only sheep and goats as permanent residents of the island. The structure just above the lighthouse complex is known as the 'Lookout'. Today it is used as a holiday home, but during the Second World War it was occupied by naval crews who positioned and maintained anti-submarine nets in the surrounding waters.

2008 HES AERIAL SURVEY DP056889

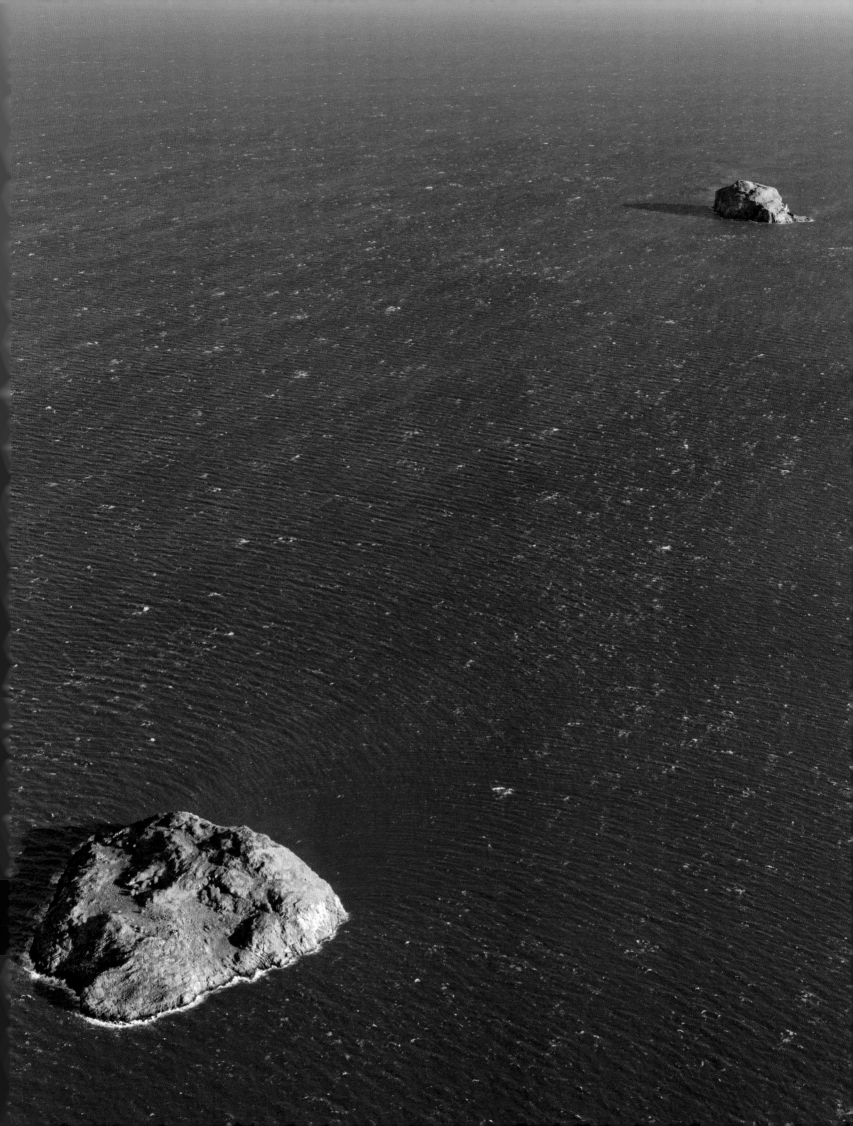

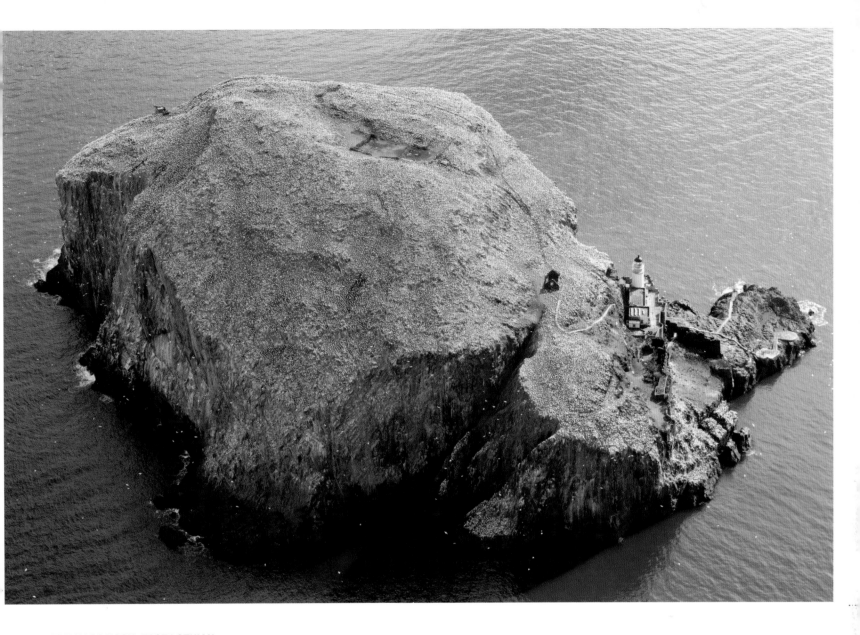

THE BASS ROCK, EAST LOTHIAN

Lying just a mile off the East Lothian coast (beyond Craigleith Island, left), this huge, seemingly inhospitable knucklebone of volcanic rock has known many uses over the centuries. Around the sixth century, it became a retreat for Christian hermits, and was later used as the site for a prominent castle, regularly hosting visits from the kings of Scotland. By the late seventeenth century, however, it had acquired a darker purpose – as an island gulag used for the incarceration of religious and political prisoners. The lighthouse was designed by David Stevenson – cousin of the writer Robert Louis, who featured the Bass Rock in his novel *Catriona* describing it as 'just the one crag of rock, as everybody knows, but great enough to carve a city from'. Today it is home to the world's largest colony of northern gannets.

2017 HES AERIAL SURVEY DP266258, DP214002

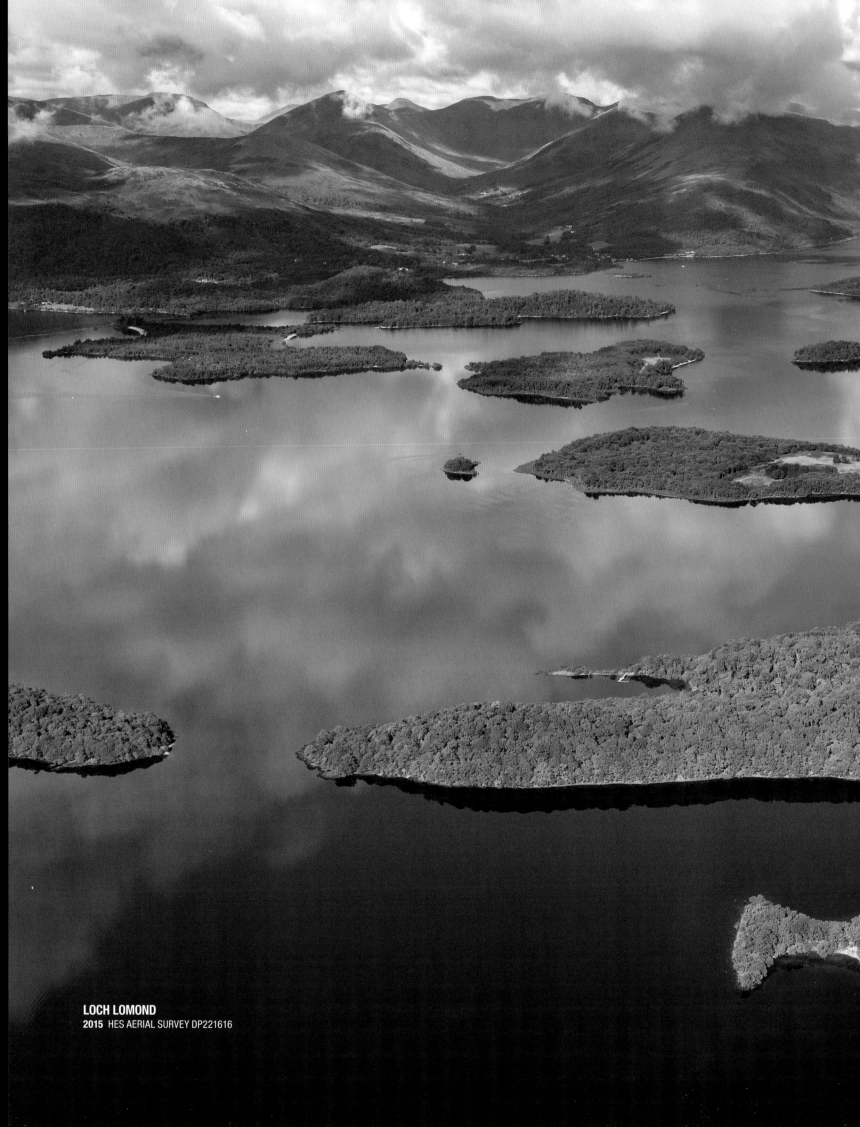

LOCH LOMOND
2015 HES AERIAL SURVEY DP221616

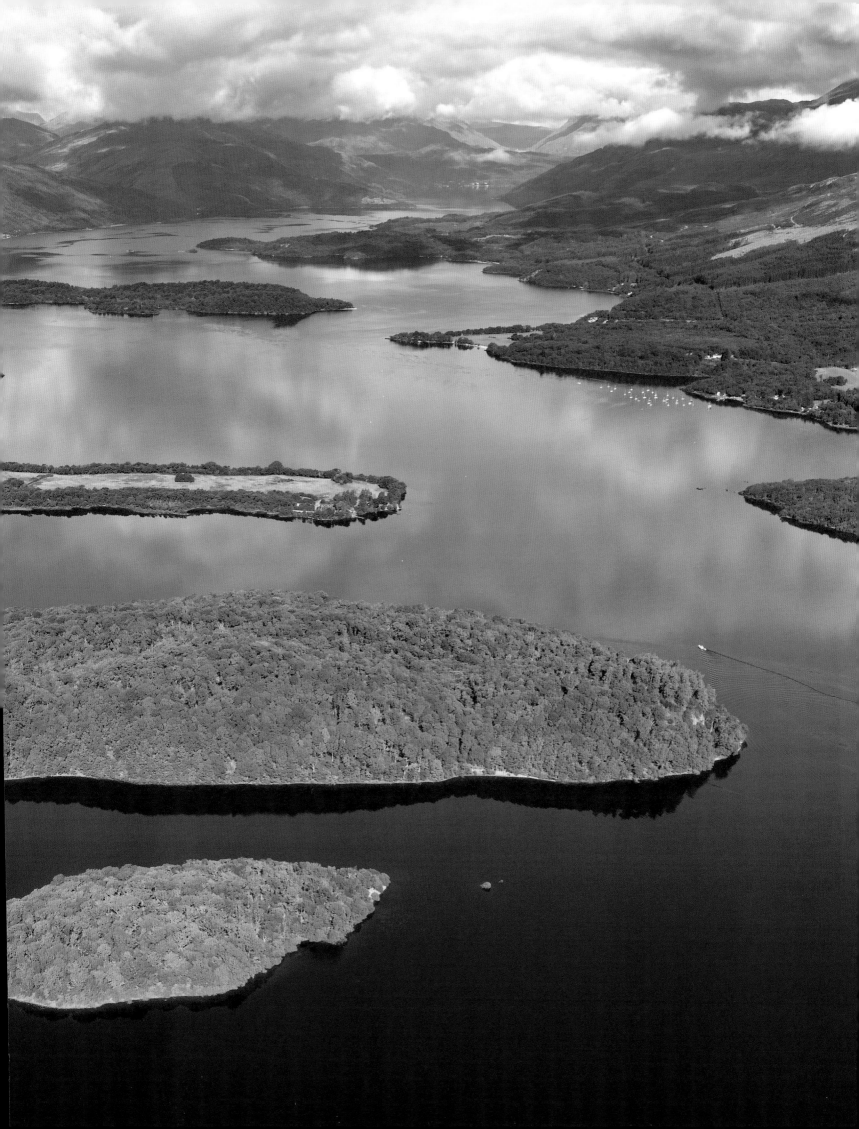

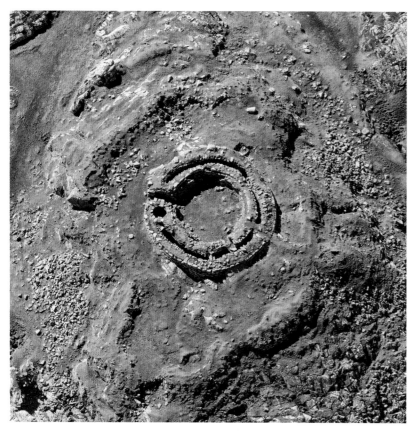

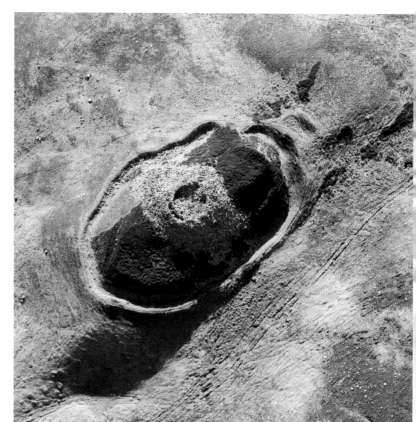

DUN BORRAFIACH, SKYE
2016 HES AERIAL SURVEY DP094809

DUN MOR BROCH, VAUL, TIREE
2016 HES AERIAL SURVEY DP210369

AN DUN BROCH, LOCH ARDBHAIR, ASSYNT
2013 HES AERIAL SURVEY DP162594

KILPHEDIR BROCH, STRATH ULLIE, SUTHERLAND
2008 HES AERIAL SURVEY DP080107

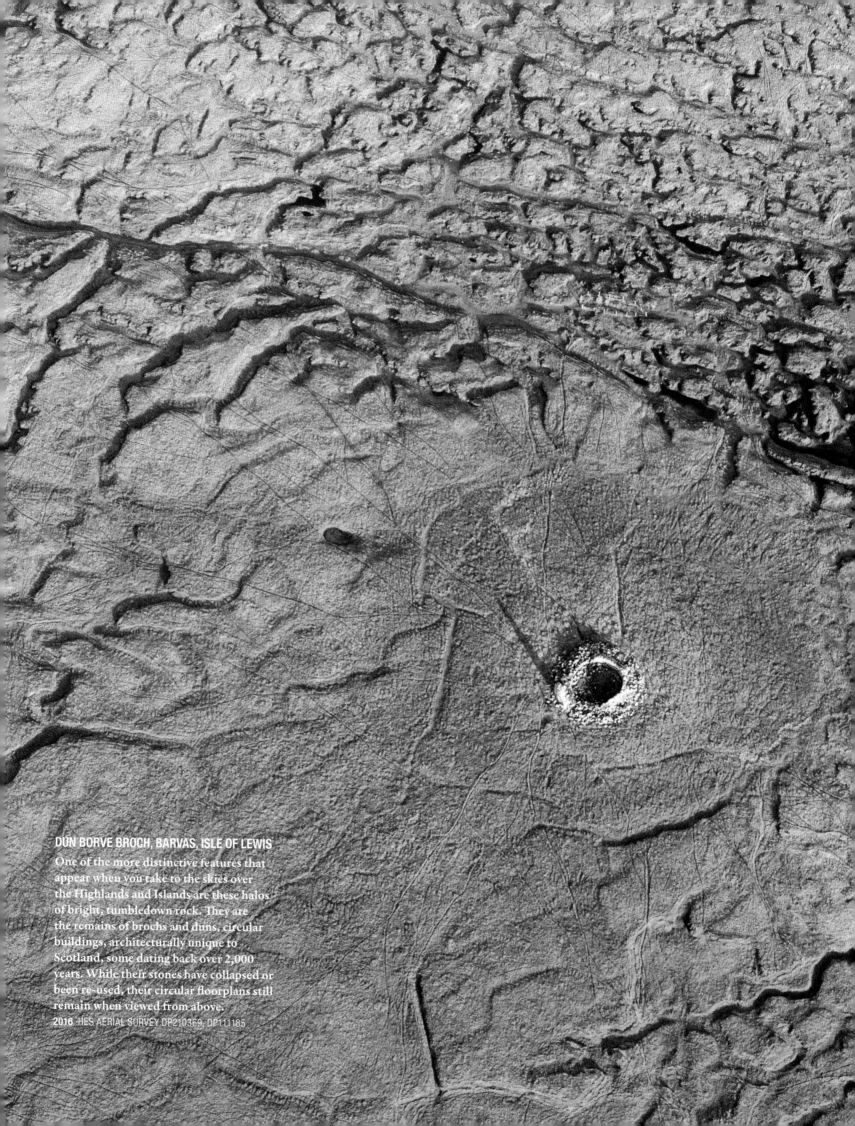

DUN BORVE BROCH, BARVAS, ISLE OF LEWIS

One of the more distinctive features that
appear when you take to the skies over
the Highlands and Islands are these halos
of bright, tumbledown rock. They are
the remains of brochs and duns, circular
buildings, architecturally unique to
Scotland, some dating back over 2,000
years. While their stones have collapsed or
been re-used, their circular floorplans still
remain when viewed from above.

2016 HES AERIAL SURVEY DP210369, DP111185

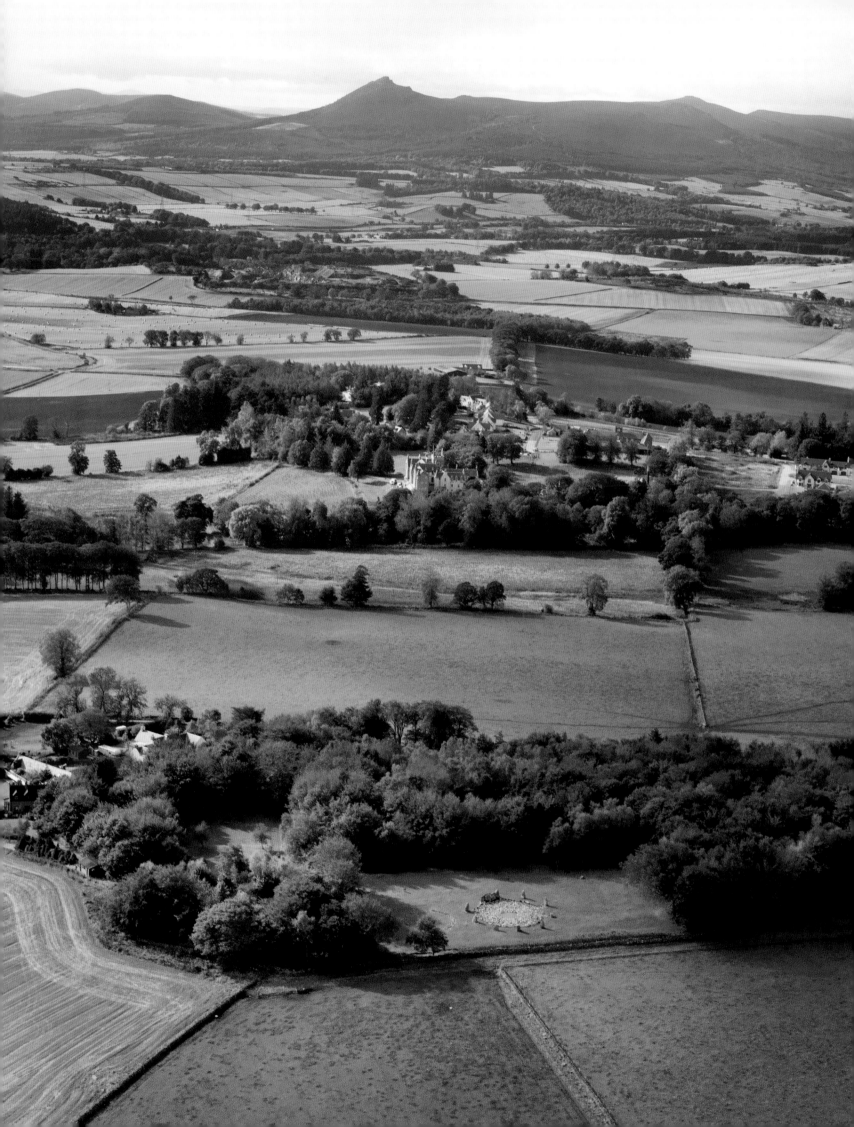

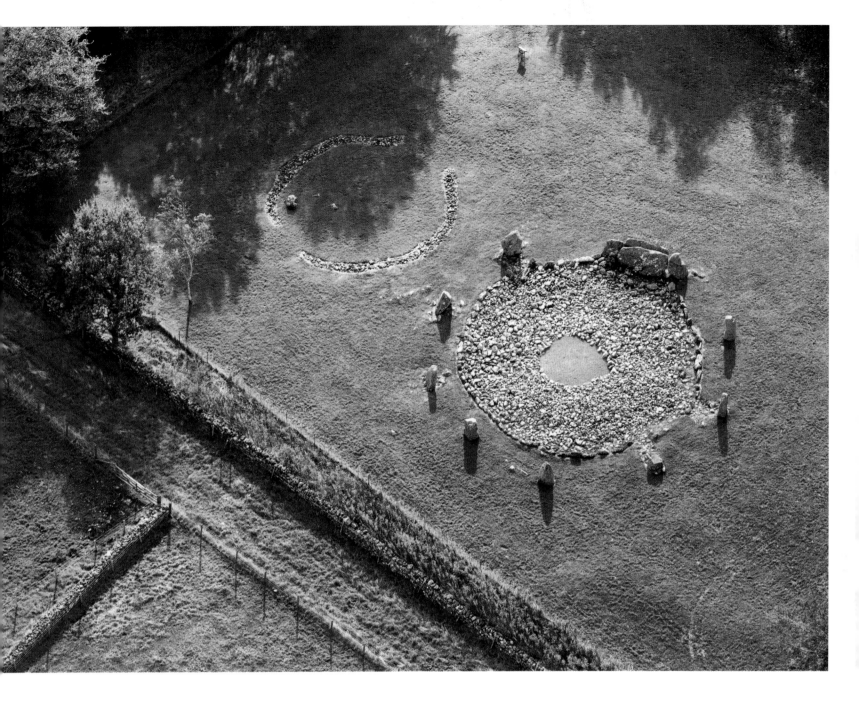

LOANHEAD OF DAVIOT RECUMBENT STONE CIRCLE, ABERDEENSHIRE

In a small clearing, bordered by trees and farmers' fields and overlooked by the distant
Bennachie Hills, can be found one of the oldest surviving structures in Scotland. This
stone circle was first erected some 4,500 years ago, in a style which is found only in
Aberdeenshire, with one massive slab – the 'recumbent' stone – set between two flanking
pillar stones. In the centre of the circle archaeologists discovered the charred remains of
human bones, evidence of an ancient ritual or ceremony now lost to us.

2009 HES AERIAL SURVEY DP082981, DP082978

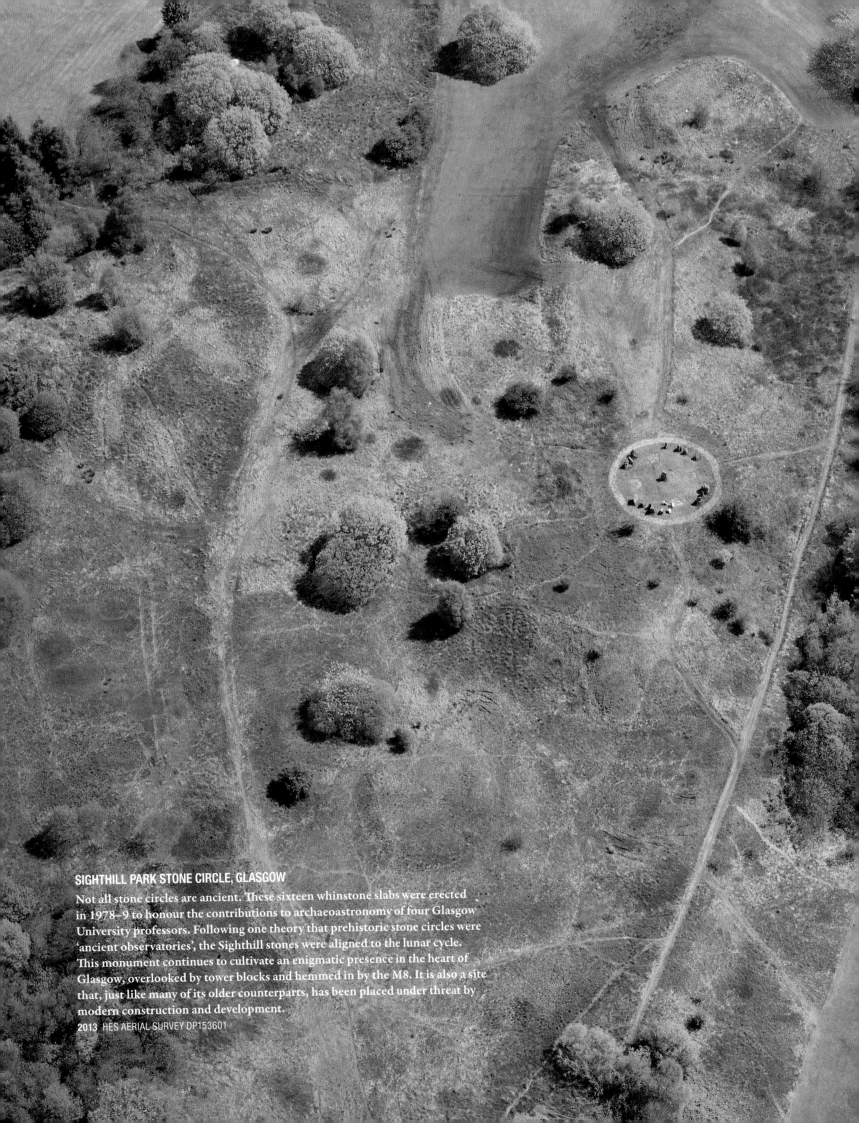

SIGHTHILL PARK STONE CIRCLE, GLASGOW

Not all stone circles are ancient. These sixteen whinstone slabs were erected in 1978–9 to honour the contributions to archaeoastronomy of four Glasgow University professors. Following one theory that prehistoric stone circles were 'ancient observatories', the Sighthill stones were aligned to the lunar cycle. This monument continues to cultivate an enigmatic presence in the heart of Glasgow, overlooked by tower blocks and hemmed in by the M8. It is also a site that, just like many of its older counterparts, has been placed under threat by modern construction and development.

2013 HES AERIAL SURVEY DP153601

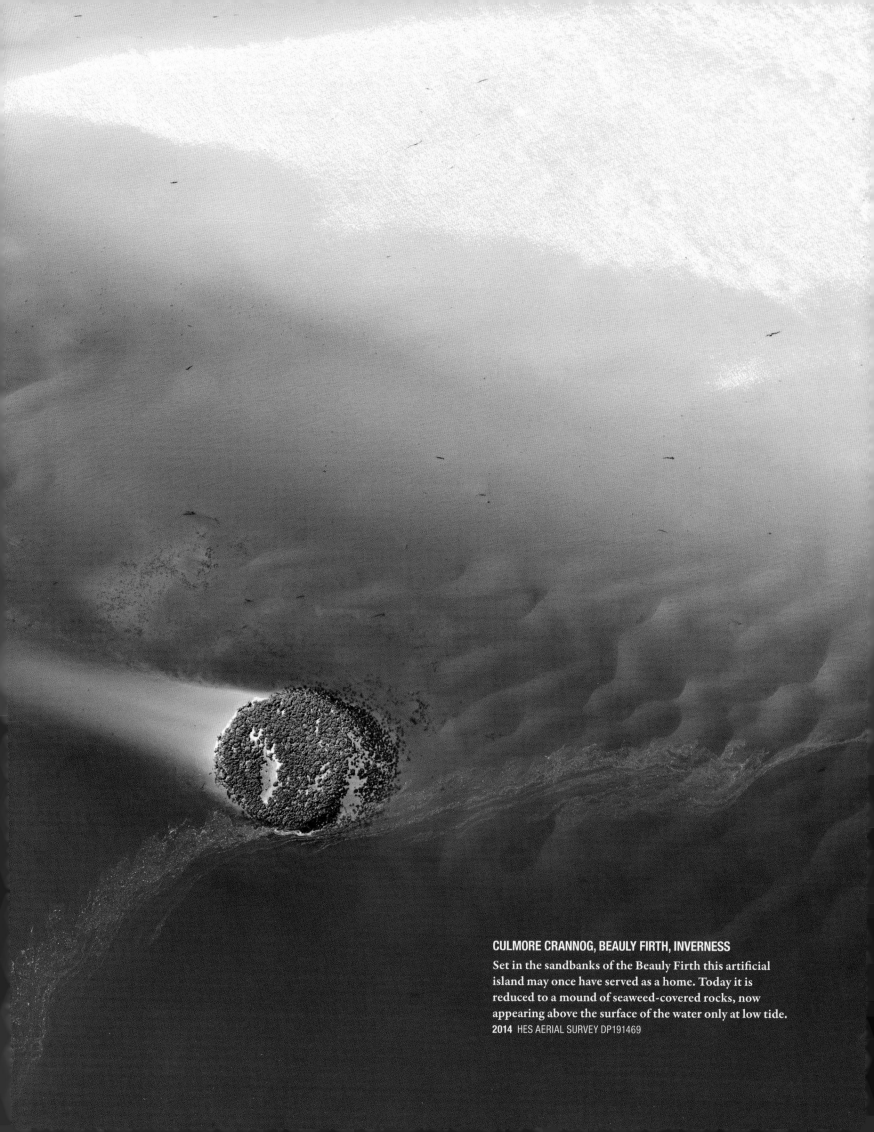

CULMORE CRANNOG, BEAULY FIRTH, INVERNESS

Set in the sandbanks of the Beauly Firth this artificial island may once have served as a home. Today it is reduced to a mound of seaweed-covered rocks, now appearing above the surface of the water only at low tide.

2014 HES AERIAL SURVEY DP191469

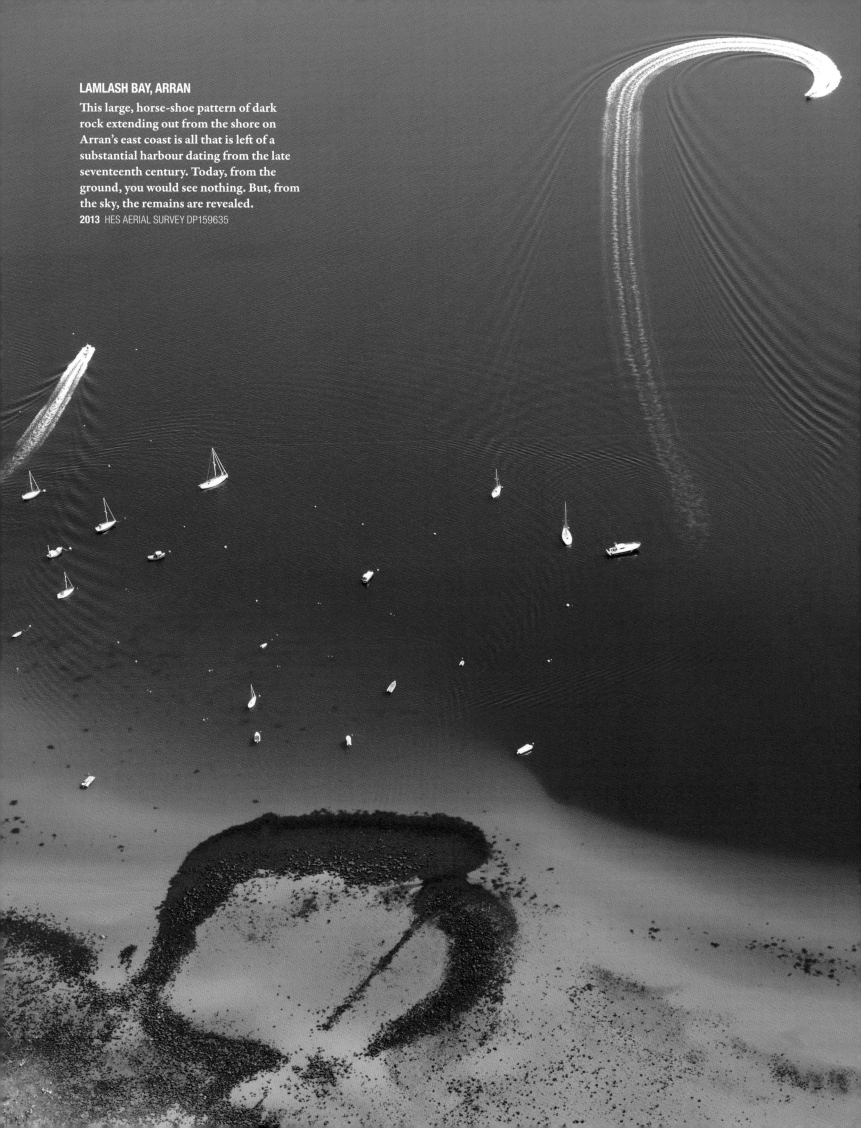

LAMLASH BAY, ARRAN

This large, horse-shoe pattern of dark rock extending out from the shore on Arran's east coast is all that is left of a substantial harbour dating from the late seventeenth century. Today, from the ground, you would see nothing. But, from the sky, the remains are revealed.

2013 HES AERIAL SURVEY DP159635

KYLE OF TONGUE, SUTHERLAND

The thin, curved line that can be seen here bowing out in the opposite direction to the road – and joining the two sand and shingle islets – is no natural feature. It would have been erected as a fish trap, an ingenious structure of stone or stakes used to corral fish and catch them in the ebbing tide.

2013 HES AERIAL SURVEY DP160294

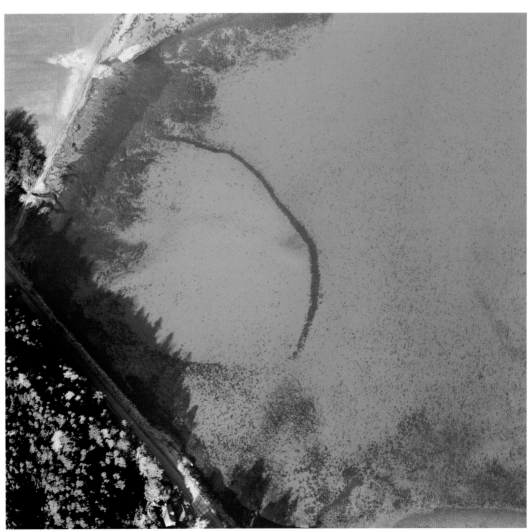

FISH TRAP, PORT ALASDAIR
A' MHUILLEIR, APPLECROSS
2013 HES AERIAL SURVEY DP156391

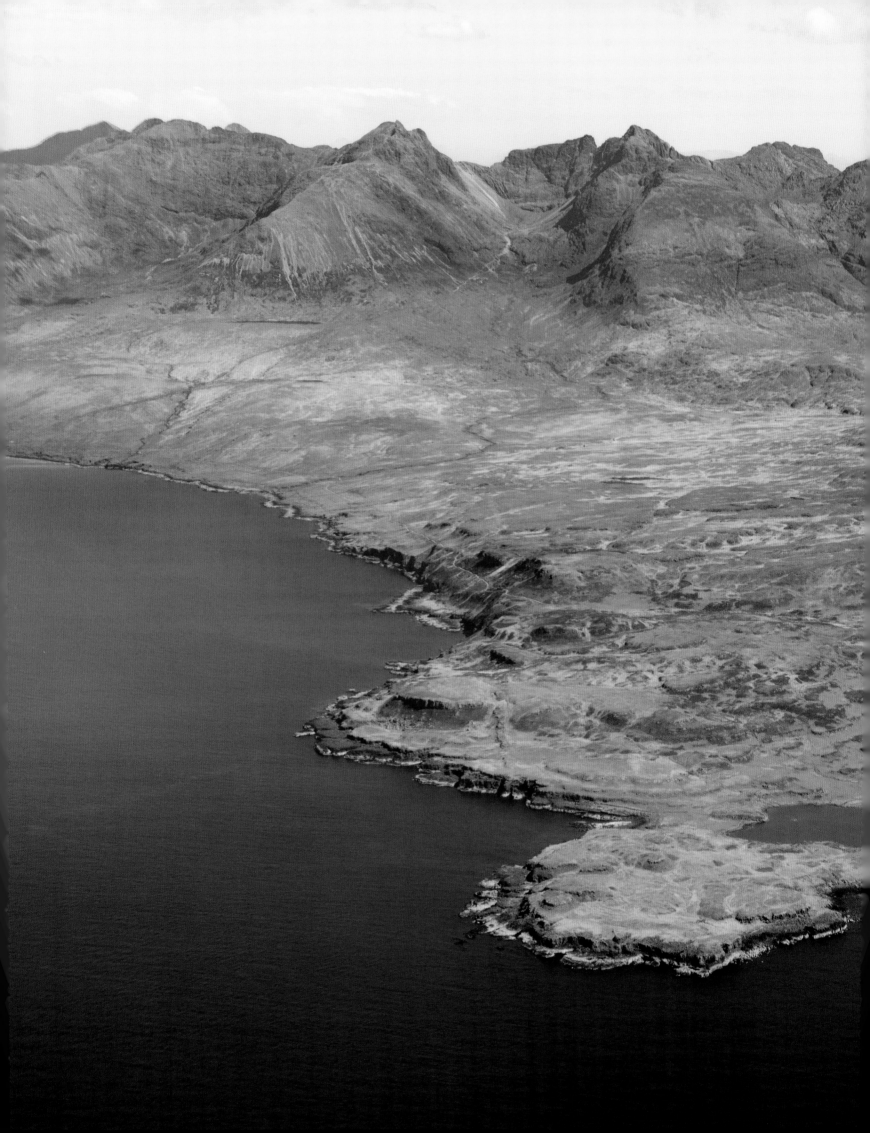

'VIKING SHIPYARD', RUBH' AN DUNAIN, ISLE OF SKYE

At first glance, this place would seem to epitomise remote wilderness – an isolated peninsula on Skye's south-west coast, sealed off from the rest of the island by the massed ranks of the Cuillins. You could be forgiven for imagining that there is nothing here. The reality is very different, however. For thousands of years the most common method of travel in Scotland was by sea, and sites like Rubh' an Dunain would have been very attractive to sailors. There are remains here dating back to the second century BC, and a history of occupation that continues up until the 1860s. Most remarkable of all was the discovery, in the small loch at the tip of the peninsula, of boat timbers dating to AD 1100. Further investigation revealed a manmade canal, built to link the loch to the sea, along with a series of quays and houses that suggested this site was once a dry dock and 'shipyard', operated by the Norsemen who held dominion over this landscape a thousand years ago.

2011 HES AERIAL SURVEY DP098285

TANTALLON CASTLE, EAST LOTHIAN

What was once a fiercely imposing
fortress – protected on three sides by tall
sea cliffs and defended on its landward
face by a massively thick curtain wall
– has today became a picturesque and
serene tourist attraction.

2015 HES AERIAL SURVEY DP228379

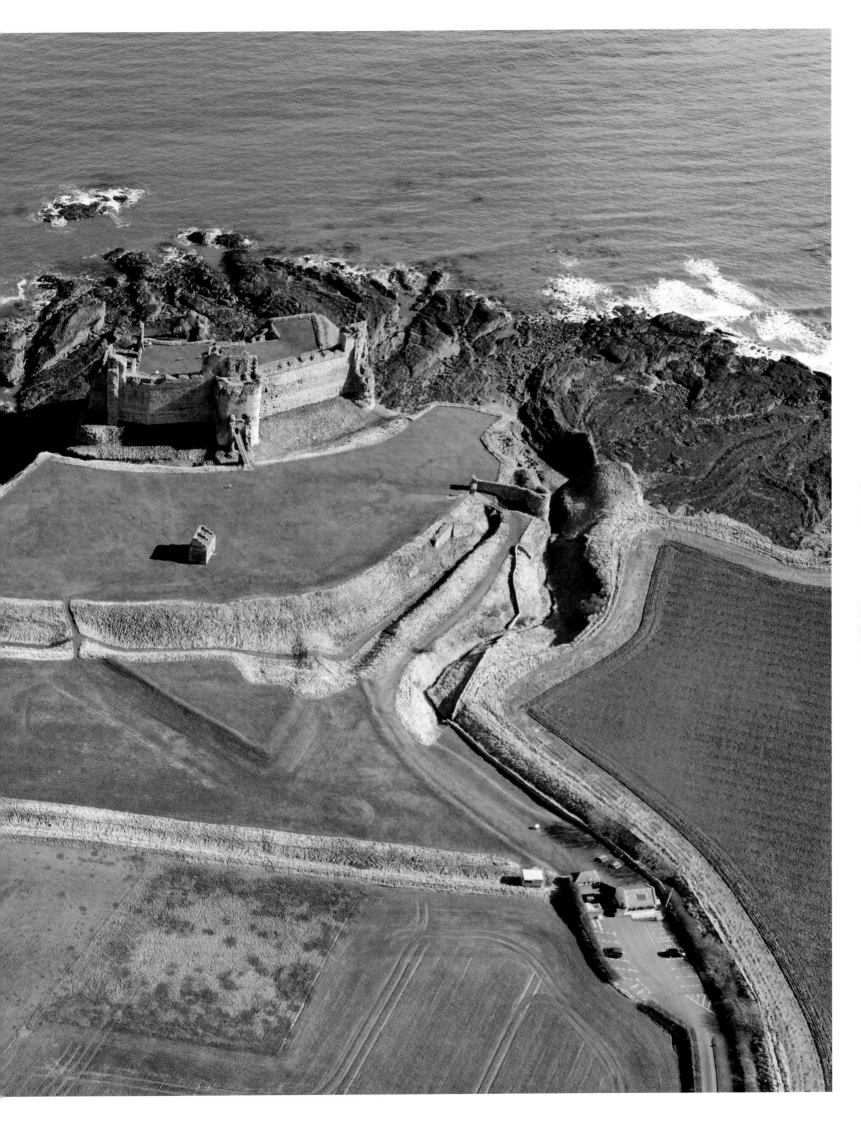

CASTLEWIGG COUNTRY HOUSE, WHITHORN

While some fragments of our past become popular visitor attractions, others fade slowly into obscurity. Here, a castle which was converted in the late eighteenth century into a country house – and then gutted by fire in 1933 – is reduced to a roofless, overgrown shell.

2009 HES AERIAL SURVEY DP071136

BUCHANAN CASTLE, DRYMEN, STIRLINGSHIRE

The ruined turrets, chimneys and gables of this baronial mansion house are drowning beneath a sea of greenery. Designed by William Burn in the 1850s, the house became a hotel in 1925 and a military hospital during the Second World War – treating Rudolf Hess after his plane crash-landed in Scotland in 1941. By the 1950s, however, it was abandoned and partially demolished. And, judging from this aerial photograph, it may soon disappear from view altogether.

2014 HES AERIAL SURVEY DP198068

AUCHANS CASTLE, DUNDONALD, AYRSHIRE

Another castle converted to a country house, Auchans was not claimed by fire, but by simple abandonment and neglect. When its last occupant, Susannah, Countess of Eglinton, died in 1780, it fell into ruin. A roof still stood on the building in the early 1920s, but collapsed soon after, allowing the surrounding trees and bushes to take up residence.

2009 HES AERIAL SURVEY DP071739

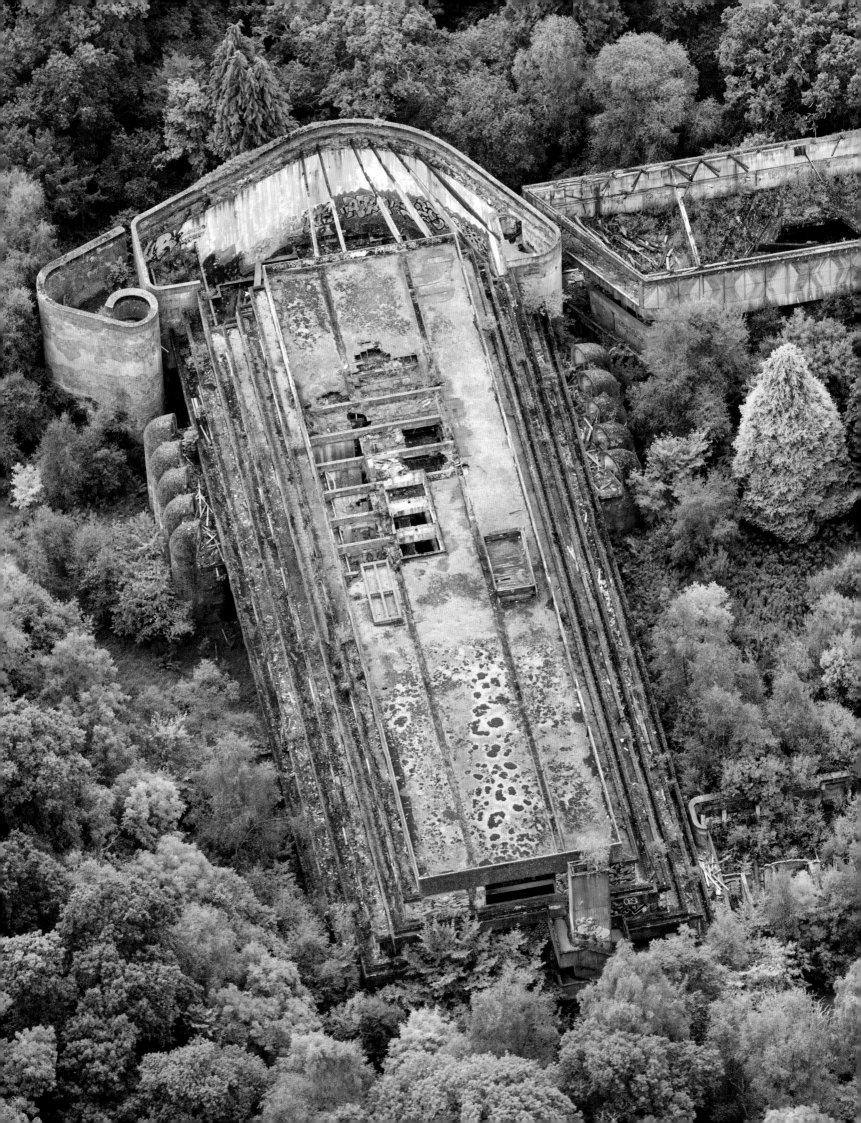

ST PETER'S SEMINARY, CARDROSS

You could be forgiven for mistaking this hulking ruin for some lost Mayan temple, hidden deep in the rainforests. Except that this is a hillside overlooking the Firth of Clyde, just to the south of Helensburgh – and the building was only completed in the mid 1960s. For just over a decade, from 1966 to 1979, it was a training centre for Catholic priests. In the 1980s it was briefly repurposed as a drug rehabilitation centre, before being abandoned to vandalism, graffiti and ruin. Over the past thirty years, St Peter's has acquired a cult-like status as a monument to the tragic hubris of modernism. One of its own architects even suggested the idea of 'everything being stripped away except the concrete itself – a purely romantic conception of the building as a beautiful ruin'. After years of uncertainty, the building has now come into the possession of the arts organisation NVA, who are working to turn this derelict shell into a cultural space for public art and performance.

2014 HES AERIAL SURVEY DP196090

MAKING SCOTLAND FROM THE SKY

That there is just one name on the cover of this book is, in many respects, ridiculous. To take an idea – that of telling a story of Scotland through the view from above – and translate it into three hours of film and some three hundred pages of text and imagery, requires the work of not just one person, but a great many people over a long period of time. Without doubt, this is the most collaborative project I have ever been involved in. And one of the most rewarding.

The initial proposal for the documentary series came out of discussions with David Devenney, Head of Factual Development at BBC Studios in Glasgow's Pacific Quay. We wanted to find a way to explore Scotland's past and present through the aerial perspective, and in particular bring to life the incredible photographic archive held in the collections of Historic Environment Scotland (HES). I confess no knowledge of the BBC commissioning process itself, although I – rather feverishly – like to imagine it as something of a dark art, carried out in dark rooms, like a scene from *All the President's Men*. Whatever the reality, David took the proposal to his commissioners Ewan Angus and David Harron and re-emerged to report that *Scotland from the Sky* had been given the green light. Time, you might think, for celebration. Except that this was really only the beginning of the journey. Now the idea had to grow and evolve, had to make the leap from intriguing concept to practical reality.

It was at this point that the core team for the series was assembled: Executive Producer Rachel Bell, Series Producer and Director Richard Downes, and Directors Andy Twaddle and Jon Morrice. Over a series of meetings narratives were proposed, dropped, picked up again and developed, and the three programmes began, bit by bit, to assume a basic shape. Two brilliant researchers, Nadine Lee and Jennifer Scammell, started pursuing story threads and searching out archive material and contributors – working with the many

subject experts within HES, including Head of Archives Lesley Ferguson, archaeologists George Geddes, Adam Welfare, Allan Kilpatrick and Rebecca Jones; Aerial Survey Manager Dave Cowley; and the HES public services team, Philip Brooks, Joseph Waterfield, Sarah Dutch and Neil Fraser. At the same time, the directors ventured out across the country to scout potential filming locations. Gradually the rough scripts were translated into 'shooting scripts' (which, to put it very crudely, bring the words and the pictures together); and a production schedule emerged for the three documentaries.

Filming began in the summer of 2017 and carried on through to the autumn. As ever in Scotland, we were at the mercy of the weather. Yet, more often than not, we were remarkably lucky. For the first two months the sun followed us wherever we went: Wick, Glenshiel, East Lothian, Aberdeenshire, Skye, Edinburgh, Glasgow. We were treated to endless blue skies or the beautiful dappled light offered by drifting cumulus clouds. The only exceptions – perhaps inevitably – were those days we had scheduled for flying. Without fail, summer storm-fronts chose those exact moments to descend on Scotland. The merits of competing predictive weather apps were discussed at length, while the sight of a black sky and a rain-lashed, drookit runway through the door of the PDG helicopter hangar at Cumbernauld Airport became a very familiar one.

These setbacks aside, filming progressed at a pace that was remarkable: thanks, not least, to the logistical gymnastics performed by Production Manager Helen Straine. This was a process that was entirely new to me, but what I found most striking – and ultimately most satisfying – was the real and overwhelming sense of team effort. It helped that I was in incredibly experienced and talented hands, from Richard, Andy and Jon to our Director of Photography Alastair McCormick, Sound Technician Jamie Flynn and Drone Photographer Peter Keith. More than anything else, it was a privilege and a pleasure to experience the wonderful skill, artistry – and humour – they bring to their work. Along with researchers Nadine and Jennifer – with the help of Production Assistant Lucy Heaton – we moved all over the country: convoying to sites, rendezvousing at motorway service stations (with Kinross an unlikely repeat-visit winner), debating the true definition of a 'pie', and working our way methodically through the shooting scripts. On occasion this crew was very ably joined by Cameraman Rick Walker and Drone Photographer Liam Anderstrem.

Extended periods of travelling were an inevitability. But this brought us to places – and offered up moments – that have now been captured beautifully on film. Certainly, for me, the opportunity to be able to tell a story in situ in the landscape was uniquely inspiring: whether rowing out to sea through a 'Viking canal' on Skye at sunset, walking the main runway of Wick airport at dawn in the gaps between flight arrivals, or climbing through a Highland mist into the hills above Ullapool. And, of course, some of the most memorable experiences came once the weather finally allowed us into the skies – the process of being filmed in a Tiger Moth, a light aircraft and a helicopter, by another helicopter

flying alongside (with the brilliant pilots David Blaine and Pete Clunas at the controls, working with cameraman Pete Jones) was both exhilarating and utterly surreal.

Even once filming was completed, the work was far from over. ISO Design were using state-of-the-art graphic techniques to bring the HES archive photography to life. And our three directors, working in the cosy confines of Serious Facilities with editors Ed Horne, Stewart Barlow and John Steventon, then had to take the hundreds of hours of raw footage and turn them into three discrete hours of programming, a process of juggling imagery, sounds, stories – and timing – that I find mind-boggling in complexity (assisted by the talents of Dubbing Mixer Nick Davis, Colourist Ben Mullen and Online Editor Jason Hillier).

While all this was going on, I was able to embark on a task with which I am much more familiar: putting a book together. HES designer Alasdair Burns and I looked through hundreds of thousands of photographs from the HES aerial archives to arrive at a selection of just several hundred images that we felt were both visually stunning and representative of the themes explored in the documentary series. While I wrote the text for the book, adapting the programme scripts and adding first-hand accounts of my own experiences while filming, Alasdair produced a series of beautiful draft layouts. We then moved on to the painful process of whittling this down to the selection you now hold in your hands. It is no exaggeration to say that, at one stage, this book was double its current size. With the calm and methodical assistance of Oliver Brookes and Christine Wilson in the HES publishing team, and HES photographic editors Derek Smart and Anne Martin, we have been able to produce a volume that we believe works as an excellent companion to the BBC series, but also takes you even deeper into our aerial archive – and the fascinating history that lies behind it.

And it is this last point that is perhaps the most important. Because none of this would have been possible without the photography itself. *Scotland from the Sky* is a testament to the people who have been actively capturing the aerial perspective for the past hundred years. This ranges, of course, from the pioneering aviators of the early twentieth century, right up to their modern descendants – represented today, in the work of HES, by photographer Robert Adam and aerial archaeologist Dave Cowley. Along with pilot Ronnie Cowan, they have been criss-crossing Scotland's skies now for decades, and are responsible for almost all of the modern imagery featured in this book. Their photographs combine beauty and stunning composition with a relentless desire to record and investigate. They are the heartbeat of a living, growing archive, and their ongoing work, perhaps more than anything else, defines the pioneering, curious and adventurous spirit that inspired *Scotland from the Sky*.

HISTORIC ENVIRONMENT SCOTLAND ARCHIVES

Historic Environment Scotland is responsible for extensive collections relating to Scotland's archaeology, buildings and industrial heritage, including over 1.6 million historic aerial photographs. Dating from the 1920s until the present day, these images are an invaluable research tool for everyone from archaeologists, geographers, conservationists to local and landscape historians. This unparalleled resource is made up of a number of distinct collections and can be explored through two websites.

CANMORE.ORG.UK

- The HES Aerial Collection comprises images from its annual programme of aerial reconnaissance and photography to record the archaeology and buildings of Scotland, capturing changing urban and rural landscapes throughout the country, and leading to the discovery of thousands of new archaeological sites. These images date from 1976 until present day. **150,000 images**

- The Aerofilms Collection contains some of the earliest aerial photographs ever taken of Scotland, and dates from the 1920s up to the 1990s. **80,000 images**

NCAP.ORG.UK

- The Royal Air Force Collection dates from the 1940s through to the 1990s with more imagery added as it becomes declassified. **750,000 images**

- The Ordnance Survey Collection, produced to assist map-making, features imagery dating from 1955 through to 2001. **500,000 images**

- The All Scotland Survey dates from 1987–89 and was commissioned by the then Scottish office to assess land use. **17,000 images**

Most of the images featured in this book along with a rapidly expanding selection of other images are available to explore and buy online at **canmore.org.uk**

HISTORIC ENVIRONMENT SCOTLAND | ÀRAINNEACHD EACHDRAIDHEIL ALBA

INDEX